THOMSON
COURSE TECHNOLOGY
Professional ■ Technical ■ Reference

Photo Restoration and Retouching Using
Corel® Paint Shop Pro® Photo

By Robert Correll

Learn How to Rescue Old Photos
and Improve Your Digital Pictures!

ISBN-10: 1-59863-383-X
ISBN-13: 978-1-59863-383-2
Library of Congress Catalog Card Number: 2006940097
Printed in the United States of America
08 09 10 11 12 BU 10 9 8 7 6 5 4 3 2 1

Thomson Course Technology PTR,
a division of Thomson Learning Inc.
25 Thomson Place
Boston, MA 02210
http://www.courseptr.com

THOMSON
★ ™
COURSE TECHNOLOGY
Professional ■ Technical ■ Reference

Publisher and General Manager, Thomson Course Technology PTR:
Stacy L. Hiquet

Associate Director of Marketing:
Sarah O'Donnell

Manager of Editorial Services:
Heather Talbot

Marketing Manager:
Jordan Casey

Acquisitions Editor:
Megan Belanger

Marketing Assistant:
Adena Flitt

Project and Copy Editor:
Marta Justak

Technical Reviewer:
David Rivers

PTR Editorial Services Coordinator:
Erin Johnson

Interior Layout:
Shawn Morningstar

Cover Designer:
Mike Tanamachi

Indexer:
Kevin Broccoli

Proofreader:
Gene Redding

To my family

my wife Anne, and my kids: Benjamin, Jacob, Grace, and Samuel

Foreword

IN THE EARLY DAYS OF DIGITAL photography, I had a job at a high-end professional photo lab, where I had the opportunity to work with photographers for magazines such as *National Geographic* and *Sports Illustrated*, top advertising agencies, and Fortune 500 companies.

I realized there were two simple secrets that gave these pros a huge edge in creating incredible images. But now, thanks to digital imaging, these ideas are available to everyone and are no longer professional secrets.

The first secret is simple—professional photographers shoot a ton of photos. In the film days, this was an exclusive advantage since only the pros had the budget to do it. Now, digital cameras remove the per-shot expense, and the declining price of memory cards removes the only remaining cost. So it makes sense to do like the pros—buy several memory cards and battery packs and take lots of photos (and remember to edit those shots down to the really good ones).

The other secret was that pros used high-end photo labs with highly trained people who provided custom color correction, retouching, and other services. Again, in the predigital days, this was exclusive to pros because of the high cost. And again, thanks to affordable photo editing software, this advantage is now available to everyone.

Which is where *Photo Restoration and Retouching Using Corel Paint Shop Pro Photo* comes in. This book guides you through the techniques you can use to make incredible images as good as those of professional photographers. You'll be surprised at how easy most of these techniques are, and how much they improve the look of your photos.

And you'll be thrilled by the reaction of friends and family who won't know just how easy it was to make your good photos great! In fact, you just may want to keep that secret to yourself.

Douglas Meisner
Paint Shop Pro Photo Product Manager
Corel

Acknowledgments

I HAVE MANY PEOPLE TO THANK.
Publishing this book was a team effort, from start to finish. I may have restored the photos and written the manuscript, but that's just the tip of the iceberg.

Thanks to David Fugate, my agent and the founder of LaunchBooks Literary Agency. David, you really made it happen. Thanks for taking my idea and finding the right publisher!

Many thanks to all the great people I met and worked with at Thomson. Thank you to Megan Belanger, for believing in the book; Marta Justak, for your excellent editing and encouragement; Stacy Hiquet, for your support and guidance; Shawn Morningstar, for your great layouts; Mike Tanamachi, for your work on the cover; Jordan Casey and Adena Flitt, for your marketing efforts.

Tremendous thanks go to David Rivers, our technical reviewer. Thank you David, for your technical expertise and great ideas.

Thank you to many people at the Corel Corporation. You've got a great product and I'm very proud to have created this book with it. Thank you for your support and help, which was consistent and enthusiastic from the time this was simply an idea to the end. Special thanks go to Doug Meisner (Senior Product Manager), Gail Scibelli (former Vice President of Global Public Relations), Catherine Hughes (Director Corporate Communications), and Amie Hoffner (Senior PR Manager, Digital Media), and Rudi Panoch (Release Technician), and the beta team.

To the lives and memories of all those who appear in the photos of this book.

Thanks to my family for your support, ideas, encouragement, and love. Thank you Anne, Ben, Jake, Grace, and Sam. Dad, I love you very much. Also, a very special thanks to Don and Mary Anne for your support.

About the Author

ROBERT CORRELL IS CREATIVE, passionate, artistic, and dedicated. He is a digital photograph hound and family photo fanatic who can sit at the computer for 18 hours straight (until his right index finger stiffens in defiance, refusing to click one more time) restoring a photo. He loves the Clone Brush, layers, opacity, filters, and effects. He takes photographs of aircraft on static display and retouches them so they appear to be flying. Robert has been a Paint Shop Pro user for the better part of 15 years.

Robert has been an author for close to a decade (following stints with Macmillan Computer Publishing and a K-12 school corporation), and has been a consultant/independent contractor in the marketing and design industry. He is a professionally trained music producer and audio engineer, currently writing bimonthly articles for *Music Tech Magazine* and recording computer tutorials for the Virtual Training Company. He makes his own music on the electric guitar.

Robert graduated with a Bachelor of Science degree in History from the United States Air Force Academy in 1988 and served in the United States Air Force as an intelligence officer, initially as a photo interpreter.

You can reach Robert by sending an e-mail to photos@robertcorrell.com. His Web address is www.robertcorrell.com, and he is active on MySpace at www.myspace.com/robertcorrell and www.myspace.com/robertcorrellmusic. He encourages you to contact him.

Table of Contents

Chapter 7 Moving, Adding, or Removing Objects . . . 189

Introduction

WELCOME TO *Photo Restoration and Retouching Using Corel Paint Shop Pro Photo*. Follow along with me as I retouch and restore over 70 "real-world" photos from my own print and digital photo collection. I'll address a wide range of problems that many photos have, whether they are new or old, digital or print, color or black and white. I'll show you different techniques for problems with lighting, color, and contrast, tears, scratches, and other blemishes. You'll learn what works along with what doesn't, and discover how to judge for yourself. I'll also cover photo retouching topics that range from retouching people, adding, moving, or deleting objects, to retouching good photos, very bad photos, and retouching photos artistically.

Photo Restoration and Retouching Using Corel Paint Shop Pro Photo is focused, comprehensive, practical, and effective. It is not a general Paint Shop Pro tutorial/reference, nor is it targeted at any one version of Paint Shop Pro. Although tested with Photo X2, this book was written for and will appeal to users of all recent versions of the product.

Paint Shop Pro Naming Conventions

The official name of the latest version of what many refer to colloquially as "Paint Shop Pro" is Corel Paint Shop Pro Photo X2. I use many names to refer to the general family of Paint Shop Pro in the book. You'll find Paint Shop Pro, Paint Shop Pro Photo, Photo X2 (when specifically referring to X2), and possibly others. This naming approach reflects my desire to be inclusive of the past several versions of Paint Shop Pro Photo.

What You'll Find in This Book

Photo Restoration and Retouching Using Corel Paint Shop Pro Photo contains over 70 practical photo studies, each aimed at a specific photo restoring and retouching element. Each study is fully restored or retouched. The book is filled with empowering, practical examples that will cover the following topics:

- ▶ **Scanning photos and other material**
- ▶ **Organizing your photo collection**
- ▶ **Focusing on new features in Paint Shop Pro Photo X2**
- ▶ **Removing specks and dust**
- ▶ **Reducing noise**
- ▶ **Improving brightness and contrast**
- ▶ **Making color corrections**
- ▶ **Making colors more vibrant**
- ▶ **Repairing borders, scratches, creases, holes, and missing corners**
- ▶ **Erasing pen, pencil, marker, spots, and other marks**
- ▶ **Moving things**
- ▶ **Adding people**
- ▶ **Creating montages**
- ▶ **Removing red eye**
- ▶ **Covering face makeovers**
- ▶ **Introducing full-body makeovers**
- ▶ **Retouching hair**
- ▶ **Restoring very badly damaged photos**
- ▶ **Making good photos better**
- ▶ **Using your photos as the basis of artistic retouching**

Whom This Book Is For

Photo Restoration and Retouching Using Corel Paint Shop Pro Photo is for anyone who wants to restore or retouch photographs. I love restoring old photos and retouching digital ones. It's a passion of mine, and this book is designed and created to share that passion with you. It's not rocket science. All you need are the photos, Paint Shop Pro, the desire, and time. Want to learn more? Read this book and look at the sample photos. Everything you see on these pages has been done in Paint Shop Pro Photo.

Restoring and retouching photos complements many other activities. The restored and retouched photos you use will enhance whatever you're doing. If you're involved in any of the following activities (to list a few), you'll get a lot out of this book:

- ▶ **Everyday life (taking digital photos and retouching them for your family and friends)**
- ▶ **Amateur and professional photography (retouching new digital photos)**
- ▶ **Scrapbooking (restoring or retouching new and old photos, artistic retouching)**
- ▶ **Family history/genealogy (restoring and preserving family photos)**
- ▶ **Art (artistic retouching)**
- ▶ **Publishing (retouching new photos for Internet and traditional media)**
- ▶ **Small businesses (using photography to augment your business)**
- ▶ **Home businesses like direct sales (retouching your product photos)**

My focus is to show you how to restore and retouch photos—not provide a ground-up tutorial on Paint Shop Pro. If you're a beginner to computing or graphics programs, you will want to spend time outside of this book learning how to use the basics of Paint Shop Pro Photo.

How This Book Is Organized

Photo Restoration and Retouching Using Corel Paint Shop Pro Photo is organized into 11 chapters and an appendix. Following the first chapter, each chapter focuses on a specific aspect of photo restoration or retouching.

- ▶ **Chapter 1, "Preparing for Work"**—This chapter gets your feet wet. You'll find information on Paint Shop Pro Photo X2, how to scan, and considerations on starting a photo restoration/retouching business. The chapter concludes with two photo studies that walk you through the process of restoring and retouching photos from start to finish.

- ▶ **Chapter 2, "Removing Specks, Dust, and Noise"**—This chapter has four photo studies, each looking at a different aspect of removing specks, dust, and noise. Techniques range from using the Clone Brush to the Digital Camera Noise Removal tool.

- ▶ **Chapter 3, "Finding the Right Brightness, Contrast, and Focus"**—You'll learn how to make brightness, contrast, and sharpness adjustments to your photos in this chapter, which has seven photo studies. You'll compare and contrast the results of several different techniques as you search for the best method in this chapter.

▶ **Chapter 4, "Making Color Corrections"**—Old and new photos alike can benefit from the proper color balance and intensity. Follow along with five photo studies in this chapter. Multiple techniques are again compared, ranging from Fade Correction to the Histogram Adjustment tool.

▶ **Chapter 5, "Repairing Physical Damage"**—Six photo studies tackle the difficult task of repairing damaged photos. You'll learn how to repair borders, scratches, creases, cracks, holes, and missing pieces of photos, mostly with the Clone Brush.

▶ **Chapter 6, "Erasing Writing and Other Marks"**—This chapter features six photo studies that show you how to remove writing and other marks from photos. You'll learn how to separate HSL channels in this chapter.

▶ **Chapter 7, "Moving, Adding, or Removing Objects"**—Follow along with seven photo studies as you learn how to move a teddy bear, add people to a photo, or take your reflection out of a glass door. Multiple techniques are analyzed, ranging from the simple "copy and paste" to using the Clone Brush and Object Remover.

▶ **Chapter 8, "Retouching People"**—This powerful chapter uses 10 photo studies to walk you through the important skill of retouching people. Learn how to eliminate red eye, smooth skin, whiten teeth, remove distracting blemishes, perform makeovers, and hide hair loss.

▶ **Chapter 9, "Prognosis Negative"**—This chapter uses six photo studies to rescue "impossible to repair" photos. You'll be surprised what you can do with even the most damaged print.

▶ **Chapter 10, "Making Good Photos Better"**—These 10 photo studies form the basis of this chapter, which involves taking good photos and making them better. You'll learn how to critically analyze photos that you may not think need retouching and get the most out of them.

▶ **Chapter 11, "Artistic Restoration and Retouching"**—This book ends on an artistic note. Learn how to artistically retouch photos as you follow along with 10 unique examples of artistic retouching. Each photo study starts with a standard photograph and applies artistic license to transform it into a new work of art.

▶ **Appendix A, "Paint Shop Pro Tools"**—This appendix reviews every tool on the Paint Shop Pro Photo X2 Tools toolbar with an eye towards how to use them in photo restoration/retouching.

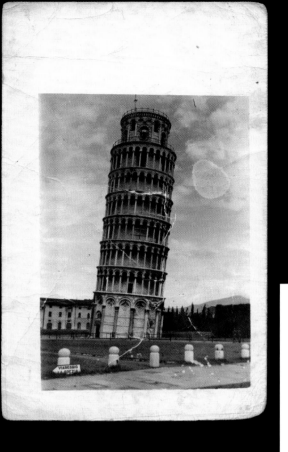
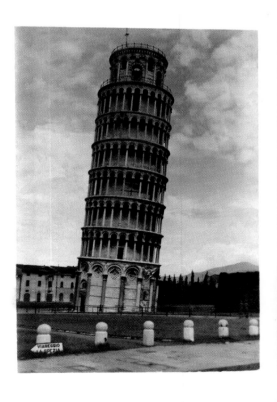

Preparing for Work 1

THIS CHAPTER GETS US STARTED DOWN the path of photo restoration and retouching using Corel Paint Shop Pro Photo. I'll cover some general aspects of restoration and retouching, introduce Paint Shop Pro, review the new features of Paint Shop Pro Photo X2, share a few organizational tips, look at the process of scanning, and talk about how to turn this into a business.

I'll finish with two photo studies, which are designed to give you an overview of photo restoration and retouching.

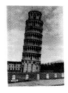

▶ **Photo Study 1: Restoring a Print from Start to Finish**—This study starts with scanning an old photo of the Leaning Tower of Pisa and walks you through the basic steps of restoring a print photo that has been physically damaged.

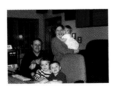

▶ **Photo Study 2: Retouching a Digital Photo from Start to Finish**—Digital photos call for a slightly different workflow than print photos, and they generally involve addressing different issues. I'll introduce the process of retouching people and lighting issues in this digital photo.

Photo Restoration and Retouching

PHOTO RESTORATION AND RETOUCHING are artistic endeavors. They use the side of your brain that sees beauty and value and tries to preserve them. They are also practical and technical activities. Evaluating light, color, contrast, and composition may invoke the artist, but repairing cracks, scratches, and tears and covering blemishes calls upon the craftsman in each of us. It takes technical acumen to understand how to use all the tools Paint Shop Pro Photo has to offer. In addition, retouching and restoring photos requires a degree of hand-eye coordination as you operate your mouse or pen tablet. There's a little bit for everyone to enjoy, no matter where you place yourself on the artist-craftsman-technician spectrum.

Photo Restoration

Photo restoration (in this context) is the process of digitally repairing old, damaged, and deteriorating print photos. Damage occurs from the natural process of aging and handling and includes things like torn corners, creases, dust, specks, tears, and other physical problems. You may be able to fully restore a photo to its original glory. There are times, however, when your satisfaction will come from doing the best you can, because the photo is too badly damaged. The end product is a graphics file that you can view on your computer or print out. I love printed photos. They are real. You can hold them in your hands and look through albums of old photos together with your family and friends without hunching over the computer monitor. Before there were scanners and digital cameras, this was the only choice you had. Or rather, the choice you had was whether or not to take slides or photos. Sadly, slides seem to be a relic of the past now.

Boxes of photos and photo albums are steadily deteriorating as I type this sentence. They take up a lot of space, but they are precious. They capture the memories of your life and are a link to your past and the past of your ancestors. Photo restoration saves, restores, and preserves these memories. You don't have to be an art expert or have a degree in antiquities conservation to start restoring photos.

Photo Retouching

Photo retouching is oriented toward the digital camera explosion and digital pictures. Who doesn't have a digital camera today or a cell phone with a built-in digital camera? Digital cameras have taken over the photography market and are here to stay (until the 3D holographic positronic image revolution begins in 2030). As a result, we're not taking as many film-based photographs. We receive a good deal of instant gratification taking digital photos. We can view them almost instantly and don't have to send them off to get developed.

Digital pictures are stored on hard disk drives, so they don't have torn corners or faded colors. Common problems are those of lighting, color, and composition. Photo retouching enhances these pictures and can take a poor to marginal photo and makes it better. You can also start with a pretty good photo and make it great.

Using Paint Shop Pro Photo

PAINT SHOP PRO PHOTO is an amazing program for the price and has a long history as the leading contender for the amateur and semiprofessional graphics market. I've used various versions of Paint Shop Pro since it began life in 1992 as a shareware program and was owned by Jasc Software, Inc. Paint Shop Pro was enthusiastically embraced from the beginning and continues to have a very loyal following.

Jasc?

Jasc stands for Jets and Software Company, two of the passions of Robert Voit, Paint Shop Pro's inventor and the founder of Jasc Software, Inc.

Corel Corporation bought Jasc Software in 2004 specifically to acquire Paint Shop Pro, which they began to reposition as a photo-retouching tool for amateurs and semiprofessionals. Version X was released in September 2005 and was favorably received. The transition in emphasis away from basic image creation toward digital photo manipulation was further emphasized in September 2006 when Corel renamed the product and launched Corel Paint Shop Pro Photo XI. Today, Paint Shop Pro Photo X2 is the latest version produced by Corel. Photo X2 continues to focus Paint Shop Pro's emphasis on the digital photo retouching market by introducing tools like the Express Lab and including new Makeover tools, which are aimed squarely at photo retouchers' needs.

If you have Paint Shop Pro Photo installed, go ahead and fire it up as I take you on a quick tour around the interface. I'm going to focus on the elements of the program that make it particularly useful for photo restoration and retouching.

Paint Shop Pro Versions

The figures in this section were taken from the final Paint Shop Pro Photo X2 beta. Most of these have the new Graphite Workspace theme inactive, but those in the "New in X2" section showcase this dramatic new theme as I summarize some important new features in this latest version.

Aside from the color of the theme, the interface differences between Paint Shop Pro versions X through X2 are negligible. Therefore, the other figures in this book show Paint Shop Pro Photo XI for reasons described in the introduction of this book.

Kicking the Tires

The interface of Paint Shop Pro Photo is both logical and easy to use. And if that's not enough for you, you can customize it by turning palettes on and off, dragging them around the interface, docking them to various sides, and even changing the menus and toolbars. Figure 1.1 shows the Paint Shop Pro Photo X2 interface with some of the palettes turned on. The Graphite Workspace theme, which is new to version X2, has been turned off for many of the X2 figures that follow.

Menu

Standard toolbar

Learning Center palette

Tools toolbar

Tool Options palette

Other palettes

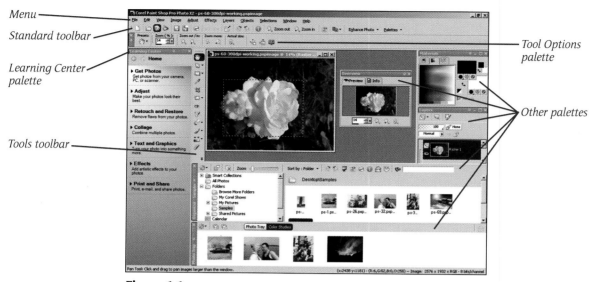

Figure 1.1
The Paint Shop Pro Photo X2 interface is powerful and flexible.

I've annotated the interface elements in order to provide a quick overview of what each piece does.

▶ **Menu bar**—Most commands and many options are located here.

▶ **Standard toolbar**—The toolbar that has many common commands within easy reach, such as New, Open, File Save, Undo Last Command, Resize, Palettes, and so forth.

▶ **Tool Options palette**—Looks like a toolbar but is really a palette. Palettes change based on what tool you have selected and display the options applicable to that tool. You can do things like select brushes, enter pertinent data (such as the dimensions of a selection box), make adjustments (such as the line thickness of a vector object), and accept or reject an operation here. This is one of the most important interface elements in Paint Shop Pro. Master it!

▶ **Learning Center palette**—Gives assistance to quickly lead you through various tasks. It is context sensitive. When you click on different tools, the content changes to match what you are doing.

▶ **Tools toolbar**—Known as the bad boy of the entire program. You'll use this to choose and select from many of the tools Paint Shop Pro has to offer.

▶ **Other palettes**—View the other visible palettes; their importance depends on what you are doing. If you are painting or entering text, for example, you'll need the Materials palette to select the color and material of the object you are creating. The Layers palette is another important interface element to master. I use layers all the time, even when I am working to restore or retouch a photo.

Reclaiming Space

I turn off the Learning Center palette, Organizer, and Photo Trays but keep the Materials and Layers palettes visible at all times. This gives me more room to work and keeps information I use a lot on screen. Give yourself even more room to work by turning off the Materials and Layers palettes when you are working on a photo intensely and don't need to quickly change materials or layers. I will specifically address the Organizer, Photo Trays, and Express Lab (new to X2) later in this chapter. They are helpful tools that you can use to organize and work on your photos.

Figure 1.2
Paint Shop Pro's tools.

Stop! Go to Appendix A (or Do Not Pass Go)

Before you go any further, please take a look at Appendix A, "Paint Shop Pro Tools," to get a complete description of each tool. In addition, I've specifically indicated the ones that I find the most useful in my work—and why.

Before we continue, I want to point out all the tools on the Tools toolbar. Since the list is rather long, you'll find a brief description of what they do in Appendix A, "Paint Shop Pro Tools," in the back of the book. I've found that I use many more tools than I would have thought, so it pays to become familiar with them. Sure, you'll develop your favorites as I have, but you need to be able to use any tool in the arsenal. The Tools toolbar is illustrated in Figure 1.2. You'll notice that many of the tools have a dark triangle (it is light when you have the Graphite Workspace theme active) in the lower right corner. This indicates that there are tools grouped together to save space. Click on the arrow to show the tool group.

New in X2

If you've been using earlier versions of Paint Shop Pro, you'll take to Photo X2 like a duck to water. Although there are new features, the overall functionality of the program remains the same. Photo X2 runs very smoothly. I started working right away without skipping a beat.

New Graphite Theme

The first thing you will notice after installing Photo X2 is the dark gray interface, as shown in Figure 1.3. This is called the Graphite Workspace theme and is active by default (in my beta version).

Figure 1.3
Photo X2 comes Graphite themed.

Figure 1.4
Express Lab consolidates photo tools.

My first reaction was shock. When I settled down and started using Photo X2, I began to like this new look. Corel's developers say that the new theme should make working on photos easier because you'll be able to perceive color changes better with the darker interface. If you don't like it, turn it off from the View > Use Graphite Workspace Theme menu. I like being able to turn it off and find myself switching back and forth, depending on what I'm doing.

Express Lab

The Express Lab is a new feature of Photo X2 that consolidates many photo retouching and restoring tools into one less-cluttered window. Veterans of Paint Shop Pro may not need this feature, as it only serves to take a portion (some, not all) of the existing tools and move them into another window. New users may appreciate how the Express Lab makes the most common tools more convenient and obvious to use. The Express Lab is displayed in Figure 1.4.

New Makeover Tools

Two Makeover tools make their appearance in Photo X2: Eye Drop and Thinify. Eye Drop takes the bloodshot out of a person's eyes, and Thinify deforms the photo to make (theoretically) a person thinner. Although they both have ramifications on how you might restore or retouch photos, I will cover their uses here and not elsewhere in the book.

The Eye Drop tool works like the Color Changer tool. When you click in the sclera (the white part of an eye), the tool lightens the region you clicked. You don't have to use Eye Drop on bloodshot eyes for it to have an effect. I have applied a small dose of drops to my wife's eyes in Figure 1.5.

Thinify acts like a type of Warp Brush oriented vertically. Clicking in an image contracts pixels at the spot you click. Stronger applications compress more and stretch the pixels furthest from the tool to make up for the contraction. The effect (when overapplied) is like looking in a funhouse mirror. I have applied a small amount of Thinify to Anne in Figure 1.6. You can compare this figure to Figure 1.5 to see the strength of the effect.

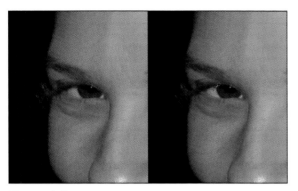

Figure 1.5
Eye drops anyone?

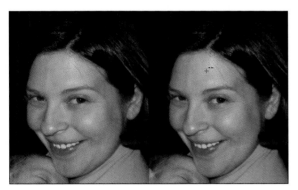

Figure 1.6
Thinify in action.

Other Changes

There are other changes to Photo X2. One of the most interesting is the HDR Photo Merge tool. This tool uses photos that were taken with brackets and uses the best features (lightness and contrast) from several photos and combines them together into one photo. Bracketing is the practice of taking a series of identically composed photos with different camera settings.

The last change I'll address is a change in how the Histogram Adjustment dialog box displays the histogram. In prior versions of Paint Shop Pro, the histogram displayed in the Histogram Adjustment dialog box showed you one histogram: the one you were editing. If you made any changes, the histogram changed to reflect the effects. Photo X2's Histogram Adjustment histogram shows you two histograms. The first is exactly the same as before. Make changes, and the changes are reflected in the histogram. The second histogram is the original, unmodified histogram. This is displayed in gray, behind the "live" histogram. It does not change and serves as a reference point, as seen in Figure 1.7.

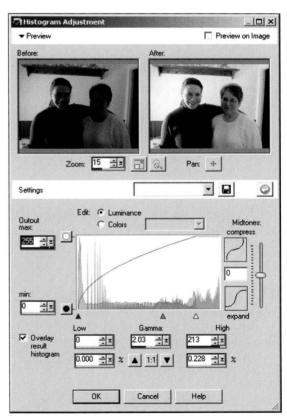

Figure 1.7
Histogram Adjustment histogram changes.

Using a Pen Tablet

I used to use a mouse for all my computer pointing and clicking needs, but I was talking to a friend of mine who is a radio, TV, and film professor at Cal State Fullerton one fateful day, well before the Ides of March. It was a gray morning. Mostly gray with some gray in it. The gray air was heavy with anticipation. Grayly laden. Then the phone rang. I jerked awake. My heart raced. I was afraid to pick it up. Could it be?

Um, sorry. I was lost in a "film noir" moment. Anyway, my friend teaches film and radio at Cal Fullerton. We were talking about his experiences as an animator for Disney (he sounds like a cool friend to have, and he is) and the fact that I had heard about these pen tablet things from a DVD we own. It had a behind-the-scenes segment on Disney animators that showed them using their pen tablets to draw actual animations from the movie. I asked him about them, and he said he used one all the time.

I immediately thought of my wife, who is a very talented artist. A plan was born. I did some research and some budgeting and then secretly bought her a Wacom Graphire4 6×8 pen tablet for her birthday. Figure 1.8 shows a picture of the product provided by the folks at Wacom (www.wacom.com).

Figure 1.8
Our wonderful Wacom pen tablet.

Can I just tell you how much easier it is to paint and draw with a pen than a mouse? It is, trust me. I love it. She loves it. Our kids love it. As an added bonus, it integrates perfectly into Paint Shop Pro Photo.

Practice That Thang

The pen tablet takes some getting used to. Our minds and muscles have been indoctrinated into *mousing* so much that you have to retrain yourself. It's well worth it, and you can use the pen tablet in many other applications besides Paint Shop Pro Photo.

You'll have to run the installation program in order to get your system to recognize the pen tablet as a valid pointing device, but once you do this, you'll be off and running.

Updating the Program

Let's talk about updating and patching. Updating Paint Shop Pro should be a priority you don't ignore. Programmers do their best to release software that is functional and doesn't break down all the time, but with the geometric rise in the complexity of coding since PCs first appeared, bugs and teething pains are inevitable. Bugs and teeth are never a good mix.

Corel, however, continues to provide support for each version of Paint Shop Pro Photo after it is released. Their team of developers releases updates, often called *patches*, that continue to improve the program. Take advantage of this free service by keeping your version of Paint Shop Pro Photo in tip-top, updated shape.

Activating the Message Center

Select the Help menu and choose Message Preferences (called Message Settings in older versions); then click the Yes button if you would like Paint Shop Pro to automatically check and notify you when program patches and updates are available.

You can also manually update the program. The following steps will walk you through the process.

1. Make sure that your computer has a working, active connection to the Internet.

2. Select the Help menu and choose Check for Updates. Paint Shop Pro will connect to Corel and determine whether or not there are new patches available for download. If not, you will see a message box telling you there are no updates available. You can click it away and continue with the knowledge that you've got the latest version of the program.

3. If there are updates, you'll see a message from Corel. Download and install the updates to your version of Paint Shop Pro Photo.

Organizing a Digital Photo Collection

WE'VE GOT THOUSANDS OF DIGITAL pictures that we've taken over the last several years. They pile up like crazy once you realize, "Hey, we don't have to pay to have these things developed!" Aside from being able to store the photos on your hard disk drive and retouch them at your convenience, not having to pay to have them developed is one of the greatest conveniences of going digital. Later, when you realize it would be nice to have prints, you can decide whether or not to print them at home or have them professionally printed.

Printing and Archiving

I've written sidebars in four chapters that cover various aspects of printing and archiving. Here is a quick reference of what they address and where you can find them.

Printing at Home, Chapter 2, "Removing Specks, Dust, and Noise"

Retail Outlet Printing, Chapter 4, "Making Color Corrections"

Professional Printing, Chapter 6, "Erasing Writing and Other Marks"

Archiving, Chapter 10, "Making Good Photos Better"

Organization is the key to not going crazy when you have this many digital photos to manage. I also try to think long-term. When it's time for me to pass them down to my children and I'm no longer here, how are they going to make sense of things? Are things logically organized so that my children and their children can spend their time reminiscing and not fighting the system?

Folder Organization

Most digital cameras store the photos they take on their memory card in a folder, named after a convention the camera chooses. Most likely, it's just a numerical sequence. Ours is up to "200CANON" at the moment. When it gets up to 100 pictures in that folder, then the camera creates a new folder and names it in sequence, ad infinitum. When we transfer the pictures to our computer, we can directly copy these folders or allow a program to copy the folders and pictures for us.

Digital Photo Downloading Options

Programs that automatically download pictures to your computer from your digital camera normally come with the camera you have. These programs can also be associated with a graphics application or photo-editing program, such as Corel Paint Shop Pro Photo.

How you do this, of course, is completely up to you, but I have my system that I would like to share with you. I've broken up my organization scheme into short- and long-term categories. When I download pictures from our camera, I copy them over in the folders they are in and leave the folders alone. I create a backup copy of all these folders and put that copy in a safe place so I don't accidentally

edit them. I also back up that safety copy to DVD for archival storage. I can then use the temporary folder structure to view the pictures, print, or edit them. Figure 1.9 shows the basic camera folders.

Figure 1.9
Folders created by our camera with up to 100 digital photos inside each folder.

Later, I go through and reorganize the folders into a final form. My current scheme (not saying it will never change) is to organize first by year, then by month. I used to organize by day as well, but we're getting so many pictures that I'm not sure I can keep up with this. I tend to do this in January, or at least after a new year begins so I know the previous year's worth of taking photos is over. I will create a 2007 folder sometime in January of 2008 and then create folders that correspond to the month within the year's folder (see Figure 1.10). Because I'm basically crazy, I name them numerically, with the month name appended: 01-Jan, for instance. That way the computer will intelligently sort (I have to supply the intelligence) my months in the correct order.

Figure 1.10
My own monthly folders, with all the digital photos we take each month.

Free Undelete

We just had a major crisis where 150 digital photos were accidentally deleted from our camera's memory card while it was attached to our computer. We hadn't had a chance to save them to the hard drive yet. If this happens to you, don't do anything to the card in question. Don't copy files to it, delete more from it, or touch it in any way. If you do, you will dramatically lower the possibility of recovering anything from the card.

First, we quarantined the card by disconnecting it from the computer. Later, I plugged it back in and ran a program called FreeUndelete (officerecovery.com/freeundelete) to successfully recover every photo. Whew.

These were important photos. They were of our son's fifth birthday!

File Naming

Ah yes, file naming. I've gone back and forth on this one, believe me. Right now I'm just ignoring the issue and leaving them alone. Back when I was new to digital photos and didn't have thousands to rename, I concocted and implemented a really great file-naming methodology that told me exactly when a photo was taken and what sequence it was taken in. Let me walk you through it.

The year was 2000, and we had just gotten our first digital camera. Like most couples with cats and no children, we took a lot of digital photos of our cats. We also took some oddball shots of ourselves and our lives, like the time we were grilling steaks (Figure 1.11) and one looked exactly like South America and the other was the spitting image of Africa (including the Arabian Peninsula).

Figure 1.11
Grilling South America and Africa.

Those were the days of 8MB memory cards and COM port connectivity between the camera and the computer. Digital photos were a new thing, and I don't think we took more than 25–30

pictures in a normal month. We just didn't think about it the same way. At that time, we organized our pictures in subject folders within one overall digital photo folder and left the names alone.

When 2002 rolled around, we had our first child, and I decided to try and organize things a bit. The subject folder scheme was getting too complicated. When I took a picture of my wife and my son and the cat was in it, did the file go in the "Robert" folder, the "Anne" folder, the "Cats" folder, or the "Ben" folder? That's when I implemented the date scheme on the folders, and it seemed natural to start renaming the files, too.

That's when I came up with a year-month-day convention that I still use. I changed all the photo names myself, one at a time (Figure 1.12). The file name of the photo of the steaks, I can proudly say, is 2000-05-09-012.JPG. It was taken in the year 2000, in May, on the ninth day, and it was the twelfth photo we kept.

Figure 1.12
My system of naming digital photos by date and numerical sequence.

Sadly, this has become a bit cumbersome. Now, we have a 1GB memory card and take hundreds of pictures a month. I've fallen behind by a couple of years now.

Know Your Digital Camera

Check the documentation that comes with your digital camera and see what file-naming options you have. You might have several to choose from, find one that fits your needs, and never have to name a file manually again.

Protecting Your Files

Unlike physical photos that are developed from negatives, there is no negative with a digital image. The image file is the only primary source you'll ever have of the photo. Protect it at all costs!

What's a Primary Source?

A primary source is the original work. It is not a copy, a duplicate, or a reference. It's the real deal. In the scholarly realm, contemporary primary sources are the most trusted sources of information. In the film and photography world, the primary or master print should be the source of all duplicates. The quality of the copies degrades from generation to generation unless you return to the master, or primary source.

I made this mistake when I got my first digital camera. I rotated, cropped, or resized a photo, then saved it, only to realize that I had just overwritten my master copy. My primary source was gone forever. Let that sink in. It was as if I had held up the negative and burned it, leaving me with a resized print that would never be as good as the original. I learned my lesson.

My wife will attest to my rigorous efforts to protect one copy of our digital photos from ever being edited, resized, cropped, or otherwise tampered with. I would suggest you get into the habit, at least for important pictures (weddings, births, birthdays, and so forth), of always making a "Do-Not-Edit" copy of the photos you download to your computer and placing all of those files into one folder that's unmistakably marked. Leave them in there for safekeeping and later, archive them away.

Organizing with Paint Shop Pro Photo

Programs like Paint Shop Pro Photo have come a long way in terms of trying to help us get organized. As I've described, organizing a photo collection used to require a lot of manual labor and the image editing program did little or nothing to help. Paint Shop Pro Photo comes with a few tools to help you stay organized built right in, and you can install extra programs like Corel SnapFire to further help you. I'm going to quickly review the two main components Paint Shop Pro Photo includes to help us organize: the Organizer and Photo Trays.

Using the Organizer

The Paint Shop Pro Photo Organizer attempts to take some of the workload off your shoulders by organizing your photo (and graphics files) collection.

At the heart of this system are folders that you select for Paint Shop Pro Photo to monitor. Paint Shop Pro scans those folders when you start it up, creates resizable thumbnails of the files in those folders, allows you to tag and categorize photos, and enables you to have quick access to the folders to edit and print your photos. Figure 1.13 shows the Organizer in all its glory.

Figure 1.13
The Paint Shop Pro Photo Organizer showing photos in watched folders.

Immediately obvious is the fact that you have folders on the left side of the Organizer and thumbnails of your photos on the right. Navigate to the folders on the left by clicking the folder in the list. It works just like Windows Explorer, but the Organizer is built right into Paint Shop Pro Photo

In addition to the folder tree and thumbnail space, you've got a toolbar that runs across the top of the Organizer. Here are many of the organizing and viewing tools that the Organizer offers. You can change how you sort photos, launch the file in the Express Lab, access file and EXIF information, print, search, e-mail, and other cool stuff. The Zoom slider changes the size of the thumbnails shown in the Organizer.

Using Photo Trays

Photo Trays are nifty constructs that enable us to organize files we want to work on. You can have as many photo trays as you like, name them what you want, and not have to mess with moving the files around on your hard drive. You can have a "To Do" tray, a "Working" tray, a "Print" tray, and any others that you can think of. Figure 1.14 shows the Photo Tray palette visible.

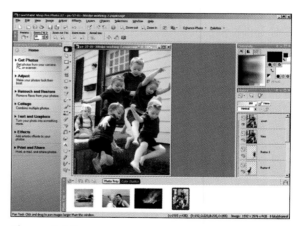

Figure 1.14
Photo Trays are useful tools that help you stay organized.

Rather than create several one-step procedures for
working with Photo Trays, I think I will put them in
a bulleted list.

► **Make sure the Photo Tray palette is
visible. If you can't see it, turn it on
by using the Palettes button on the
Standard toolbar, the View menu, or
the keyboard shortcut (Ctrl+W).**

► **Open photos by dragging them from a
Photo Tray to the workspace or double-
clicking them in the Photo Tray.**

► **Open photos in the Express Lab by
right-clicking them in the Photo Tray
and selecting Open in Express Lab from
the context-sensitive menu.**

► **Create new Photo Trays by clicking the
Add a Photo Tray icon and naming the
new tray.**

► **Switch between trays by clicking the
tray name.**

► **Delete trays by clicking the Remove
Photo Tray icon in the Photo Tray
palette.**

► **Remove a file from a tray by selecting
the file and then clicking Remove from
Photo Tray. You can also select the file
and press your Delete key.**

► **Check out the other choices you get
when you right-click a file, or when you
access the gear icon at the top left of
the palette. You'll find several menus
that enable you to rotate, print, e-mail
files, and more.**

The Science of Scanning

SCANNERS ARE WONDERFUL inventions. I love them. I can scan things for hours on end, and I've filled up many gigabytes of hard drive space with scanned photos, pictures of books, maps, and the like. They are the best way of digitizing (strange how old-fashioned that sounds) material that exists in the real world and making it available on your computer, which is what I'm after.

How Scanners Scan

Here's how a scanner works. You put a picture on a flat pane of glass that's part of a boxy thing plugged into your computer, press a button, and then you see what was on your scanner show up in your monitor. Do you really need to know any more than that? Probably not, but I'll share some interesting tidbits.

Scanner Types

There are many types of scanners. Aside from the flatbed scanner (the most common, and the one I am writing about), there are handheld scanners, rotary, drum, planetary, 3D scanners, and probably more that I didn't come across in my research. They all have different strengths and weaknesses, but most of that information is irrelevant to this book.

Scanners use a powerful light and scan it through a glass plate onto a reflective surface. This is your photo. The light reflects off your photo and gets captured by photosensitive receptors in the scanner.

These are called *charge-coupled devices*, or CCDs. Your typical flatbed scanner has three arrays of CCDs, each of which senses a different color: red, green, and blue. When combined, the red, green, and blue (RGB) values give us the colors we see. After the scanner scans the photo, it saves it to your hard disk drive (normally via a USB or FireWire cable) as an image file.

Choosing the Right Resolution

Scan resolution for the typical flatbed consumer scanner (the type you and I can most likely afford and buy) is measured in dots per inch (dpi). It's analogous to the pixel, which is the standard measure of resolution for computer monitors and graphics files. When you ratchet up your screen resolution, you are adding more pixels-per-inch of screen space. In the not-too-distant past, a screen resolution of 640×480 was more than adequate. Today, the minimum resolution we tend to use is 1024×768. I am in 1680×1050 widescreen mode as I write this. Thus, I am looking at 1,764,000 pixels instead of 307,200—on roughly the same physical size screen (adjusted for inflation). I say "roughly" because I am using a new, larger monitor, and it is widescreen, but even so, it's not over five times larger than my old one. I can discriminate much smaller objects on my monitor and have much finer detail with a higher resolution. Edges don't look as jagged, and I have the appearance of a much larger workspace (even though sometimes the icons are much smaller). Having a larger number of pixels is better in almost every instance, but it does demand more from your computer system—for example, more RAM, a better monitor, etc.

What's a Pixel

Pixel is short for picture element, which is short for useless trivia.

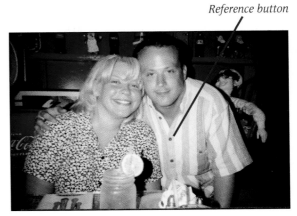

Reference button

Figure 1.15
Showing the difference between 72, 150, 300, and 1200dpi.

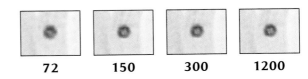

72 150 300 1200

The effects of increasing the dpi of a scanned image are similar to the effects of increasing your screen resolution. More dpi equals more fidelity to the true image, allowing you to capture greater and finer details. However, since we don't live in Utopia with a terabyte of RAM in each computer, unlimited disk space, and super-ultra-fast peripheral connectivity (someday this sentence is going be very funny), we scale the dpi we choose to the application we are scanning for (see Table 1.1). Figure 1.15 illustrates the quality and size difference between photos scanned in from 72 to 1200dpi.

As you can see from Table 1.1, the file sizes start to get ridiculous when you get to 1200dpi. This data is for a 4×6 inch photo, which is on the small side of things. If you are working at 5×7 inches or larger, the sizes are going to be even greater.

Table 1.1 Typical DPI Uses and File Sizes

DPI	Use	File Size (4×6 photo, 24-bit color)
72-100	Internet or desktop use	509KB @ 72dpi
100-300	Higher-resolution computer use	1.68MB @ 100dpi
300	Standard photo work and reasonable printing quality	6.30MB @ 300dpi
Up to 1200	High-quality photo work and printing	98.5MB @ 1200dpi
Over 1200	Ultra-high fidelity restoration and archiving	393MB @ 2400dpi

The Terabyte Barrier

Since I first wrote this chapter, I've had the pleasure of buying component parts and building a new computer. As I was putting it together, I realized we had officially crossed the Terabyte Barrier. Our three internal hard disk drives each have a capacity of 320,062,062,592 bytes, and our external drive has a capacity of 249,995,624,448 bytes. There are 1,073,741,824 bytes in a (computer) gigabyte, making our grand total of 1,210,181,812,224 bytes equivalent to 1127.06964111328125 gigabytes, which is a terabyte no matter how you add it up.

Another adverse effect of higher scan resolution is that you start to scan the actual microscopic surface (and defects) of the photo, and not the photo itself. Sometimes, it's good *not* to know all the pits, specks, and microscopic dust that are present on a photo. You'll be tempted to want to restore things that, to be honest, won't be caught if you scan the photo at 300dpi. Figure 1.16 shows the difference between a photo scanned at 300 versus 2400dpi.

When Not to Preview

I often find it helpful to turn the Show Preview feature of Paint Shop Pro Photo's File Open dialog box off. This is especially helpful when you are working with very large file sizes (normally the result of scanning something in at 1200dpi or more) because you can just click the filename, and it will open. When Show Preview is on and you click the image, you have to wait for a preview to appear before you can open it.

Notice that there is a trade-off that occurs. At 300dpi, the photo is clearly not as sharp as at 2400dpi. However, there are far more scratches on the 2400dpi version. You'll have to experiment to find the precise resolution you prefer working with. I've found that the resolutions I use the most are those that my computer can handle without choking. That's somewhere between 300 and 1200dpi, depending on the photo size. There are times when I scan at 2400, but for the most part this is to save a high-res scan for archival purposes only. I reduce the resolution when I plan on working to restore the photo. Yeah, I know. Reality sometimes stinks.

We're ready to get down to the task of scanning photos and other objects. We've covered a bit about photo restoration, Paint Shop Pro, organizing photo collections, and the science of scanning. Here's where we begin to put some of this information to practical use.

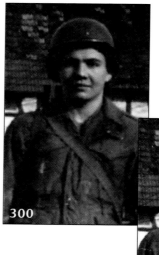
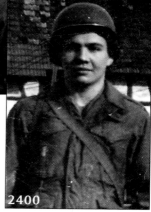

Figure 1.16
The visible difference between 300 and 2400dpi.

Scanning Photos and Other Objects

ALTHOUGH I MOSTLY REFER TO photos, this information applies to other objects as well. Don't forget about old newspaper clippings, obituaries, baseball cards, postcards, letters, patches, maps, diplomas, and other historical objects. Be creative with objects that are larger than your scanner bed. I scan a small portion at a time and later put all the pieces together like a puzzle using Paint Shop Pro Photo. I do this all the time, especially with maps.

Cleaning Your Scanner

Be fanatical about cleaning your scanner. Clean it before every use. I use a popular brand of glass cleaner that stays next to the scanner at all times. This saves me the time and trouble of having to get up, go to the kitchen, look under the sink, get the cleaner, come all the way back to the computer, and then clean the scanner. I'm serious. I'm looking over at my spray bottle as I type this. It's sitting right between the printer and scanner, within easy reach.

I Started Here

This was the first section I wrote for this book, which provides some insight on how important I think it is to clean your scanner. That and the fact that the bottle of window cleaner is staring me in the face all the time.

Right next to my cleaner I have a pile of unused coffee filters. The brand-name isn't really that important, but experiment with the size. Mine are for a small coffee pot, which I think is a four-cupper. I just walked to the kitchen to check, and yes, they are four-cup filters. We've got a larger coffee pot downstairs, but since those filters are more expensive I don't use them to clean glass. There are commercial coffee machines that take much larger filters. Oh yeah, baby. I love cleaning sliding glass doors with the commercial filters. They are nice and large, and you can clean a lot of glass with those guys.

My point about using coffee filters comes from years of glass-cleaning experience. I've come to the tried and tested opinion that the lowly coffee filter is the best, often cheapest, and most dust-free solution to glass cleaning. When I was in college at the United States Air Force Academy, we underwent rigorous room inspections. Newspapers were our tool of choice to clean the mirrors and glass in our rooms. The problem with using newspapers, however, is the ink. When you get done cleaning the glass, you need to clean your hands!

The dust-free part is pretty important, and that's the reason newspapers work well, but it's also why coffee filters shine. Who wants to drink coffee that has lint in it from the filter?

Cleaning Photos

If your photos need to be cleaned, you should consult a professional or research photo cleaning on the Internet and follow the advice that best suits your problem. I will only suggest that you

dust your photos with the same type of pressurized air canister that you find to blow the dust out of your computer's keyboard and out of the case (and scare the cat).

Handling Photos

It goes without saying (but I'm going to say it anyway) that you should handle all of your photo prints with care. Make sure to clean your hands prior to touching old photos or, better yet, wear protective gloves. The oil your skin naturally produces will damage photos over time. If you decide not to wear gloves, by all means handle the photos from the edges and support them from underneath. This will prevent your fingerprints from getting all over the photo. When you scan in a photo at 300dpi, things like fingerprints will stand out far more than you can see with your naked eye.

I try to be very careful when I handle photos or other documents that are in an album. Older albums are especially prone to grabbing onto photos and not letting them go. The first step in restoring an old photo is often rescuing it from a poorly designed storage environment.

Be Careful How You Treat Other People's Photos

If you plan on restoring or retouching others people's photos, especially if you are going to do it for money, please take every possible safety precaution to protect the photos and yourself. Wear gloves when you handle the photos, scan them carefully, and get them back to their owner quickly.

The plastic "protective" sheet (or sleeve, as the case may be) may stick to the photo, or the sticky paper of the album may be sticking too much. If this is the case and the photo is important, you should seek the assistance of a professional conservator or photographer with this type of experience. If you are going to remove the photo yourself, carefully try to peel the protective sheet back, but if you feel the surface of the photo starting to give way, stop immediately. Never try to peel the photo off the page. You may bend and damage the photo irreparably.

Sometimes it pays to think outside the box. I had a problem with one of the photos I've chosen to feature in this book not coming out of the album. I was able to peel back the plastic sheet, but the photo was stuck to the page. Want to know what I did? I just put the album down on the scanner and scanned the photo in, stuck and all.

Running Your Scanner Software

You'll need to make sure your scanner is plugged in, powered on, and connected to your computer. You'll also need to make sure you've correctly installed the scanning software that came with your scanner and that it is operating correctly. Once you've accomplished that, you're about ready to start.

Be on the lookout for automatic corrections that may be turned on by default. There's nothing intrinsically wrong with them, but you're scanning in photos so that *you* can restore them, not the scanner. Look at Figure 1.17 to see all the automatic corrections my scanner is capable of, as well as the overall software interface. Most scanner software will feature similar options.

Figure 1.17
A typical scanner software interface.

It's quite hard to place a photo or other object on the scanner perfectly straight. If you put your photo at the edge of the scanner bed, you're very likely going to lose a little bit of your photo because it's outside of the scanning area. Try it and see. That's why I use a ruler that rests against the bottom or any side of the bed. I use the ruler to get a straight offset from the border of the bed, and I crop it out later. This method keeps the number of operations I have to go through to a minimum. Otherwise, every time you scan something in you'll have to straighten it in Paint Shop Pro Photo.

Now let's get on with establishing a general scanning workflow.

1. Open the lid and clean the scanner bed.

2. While the scanner glass is drying, gather the material you want to scan. Make sure that the scanner bed is now clean and dry.

3. Place your ruler or other straightedge on the scanner bed to give yourself a square, straight photo placement helper.

4. Place the photo against the rest. Make sure that it doesn't go under or over it.

5. Close the scanner lid.

6. If you haven't started your scanner software, do so now.

7. Depending on your software, you may have different options here, but you'll probably want a preview or overview scan of what is on the scanner bed. This is done very quickly at a much lower resolution than the final scan.

8. Select the area you want to scan. When you are scanning small photos, this really helps keep file sizes down. For sizes of 8×10 or so, you won't save on file size, but it will keep cropping down to a minimum. I like to leave a little border around each side that's larger than the photo itself so I can decide later exactly how I want to crop it.

9. Select a scan resolution.

10. Make sure that the automatic corrections are turned off.

11. Scan. You can normally select to scan to a file or image type. If you choose .jpg, make sure that the image quality is set to "highest," or 100%. I normally choose uncompressed .tiff, which is a high-quality image format.

12. Bask in the glow of a job well done.

Choosing a Commercial Solution

Believe it or not, you don't have to scan everything yourself at home. You can choose to have photos commercially scanned at a fairly reasonable rate. This would be most cost effective if you were restoring and retouching photos as a small business and could offset the expense by including scanning costs in your quotes, but in small batches, paying a professional to scan your photos isn't too costly. You can also take your photos to photo-printing kiosks, but this is no better than scanning at home (unless, of course, you don't have a scanner).

I use a local print and copy business that I became familiar with when I was freelancing in the marketing and design industry. We would send them quite a bit of professional printing business and had a good working relationship. When my wife's grandfather died, we used them to scan in several old photos so that the family could concentrate on other, more important matters.

Search your local area for print and copy companies that might perform this service, call them up, and ask for their rates. If you plan on using them a lot, ask for a discount. Make sure to verify what dpi they are capable of scanning and what format you want the files to be saved in before closing the deal.

Making a Business Out of Photo Restoration

THIS SECTION IS FOR THOSE OF YOU who have or will get the bug of photo restoration and retouching and decide to make a small or part-time business out of your passion. I want to encourage you to go after your dreams. Don't let these general "things to think about" scare you or make you not try. *Try. Go for it!*

Passion

Passion. I think it starts with passion. I have a passion for this. I can stay up late at night working on photos and cleaning them up. You obviously have more interest in photo restoration and retouching than the average person, otherwise you wouldn't have bought my book. Good on ya, mate! That means you have what it takes to pursue this as a hobby, and if you are interested, to think about this as a part-time gig where you get paid for your efforts.

Infrastructure

Before you begin pursuing this as a side business, you should take a look at the infrastructure you have or plan to have. Think about your computing power and whether it is up to snuff. Got enough RAM to handle working on a 500MB 1200dpi photo? Is your processor fast enough, or do you have a system on its last legs? Have enough hard disk drive space? What kind of scanner do you have? Do you have a Web site that you can set up with FTP access so people can send you large files without them bouncing when they hit your e-mail server?

About Me

My other passions are my family, the guitar, recording, music, writing, genealogy, computer graphics, woodworking, football, motorcycles, technology, and more.

Some of this is to save you frustration when the pressure is on and people are depending on you to restore their family heirlooms. It's nice *not* to have to battle the computer when the stakes are higher than retouching your own photos. You can still succeed with a more limited system and fewer resources, but it may take you longer to work on the photos and finish them.

Time

Time is another factor in deciding whether or not to pursue photo restoration and retouching as a side business, or how much you are willing to take on. If you have a 9–5 job, you'll have to work on photo restoration at night and on the weekends (or whatever your days off are). Factor this information into when you tell clients their photos will be done.

Advertising

It helps if people know you are selling your services as an independent photo restorer. Initially, try marketing yourself through word-of-mouth advertising. Use your family and friends as advertisers. Tell people at church, your job, school, your softball team, and other places where you meet and know people. Seek out opportunities to use your skills in your community. Chances are, your first clients will be people you know. Do a good job so they will happily refer you to others. Seriously consider buying a domain name and putting up a Web site, even if you are doing this part-time. You can put information about yourself, your services, prices, terms, and conditions and display samples of your work on the Internet.

Money and Taxes

You can set the prices you charge in a few different ways. Start by researching what other people charge to restore photos. Look around on the Internet and investigate Web sites where people list their prices. Often, you'll find the price is dependent on the type and amount of restoration that needs to be done. It will be less for small touch-up work and more for a major overhaul. I would forego an hourly rate and charge per job, because, quite frankly, you'll price yourself out of a job if you want a decent hourly rate. Be open and honest about how you price, and be prepared to give quotes.

Tax Disclaimer

Taxes (be they local, state, or federal) are a touchy subject. The laws are sometimes difficult to understand and can change. I make no claim at being any sort of tax expert, especially if you are reading this outside of the United States. You should consult an accountant or your tax preparer for official guidance on how to start your small business. This section of the book is more or less to tell you to do just that.

If you are legitimately conducting a side business, you should look into how it will affect your taxes. You may be able to write off part or all of your computer equipment, Web site, software, and advertising expenses. Be careful that you include any sales taxes your state or locality may require and report all your income accurately. You may never make a profit at photo restoration or retouching, but it's quite possible that it could help your tax situation.

I think it's time to get our hands on some photos and start restoring. The next two sections will walk you through my efforts to restore and retouch an old print and a brand new digital photo. My purpose here is to show you what happens from start to finish. The rest of the book will focus on addressing specific problems. This is where I get to step back and show the big picture as I restore an entire photo. Rather than get into the details of how to do every small thing, I will refer you to the other appropriate chapters in the book. Ready? Let's go!

Photo Study 1:
Restoring a Print from Start to Finish

FIGURE 1.18 IS A PHOTO MY WIFE'S grandfather took when he was in Europe during World War II. He saw his first combat in North Africa, and his unit was involved in the invasion at Anzio in 1944. He continued to serve in Europe until the end of the war.

While Bud was in Italy, he found the time to take this photo of the Leaning Tower of Pisa. It's a compelling photo of an immediately recognizable landmark, taken during a historically significant time in modern human history. The topper is that someone in our family took the photo. I can't think of a better candidate for photo restoration.

Before I began work, I took a close look at the photo with a critical eye towards what was wrong and could be fixed. First, there is a huge blob of gunk, or whatever it is, staining the sky. That's going to have to go. There are several creases and cracks in the finish. I think I can fix those. The border is looking shoddy. Check. And, in general, it's faded and yellowed.

Critical Viewing

Learn to look critically at photos. You're going to need this skill to see what's wrong with a photo. There are times when it will be immediately obvious, but at other times the problems will be more subtle. Imagination and some experience will help you get into this groove.

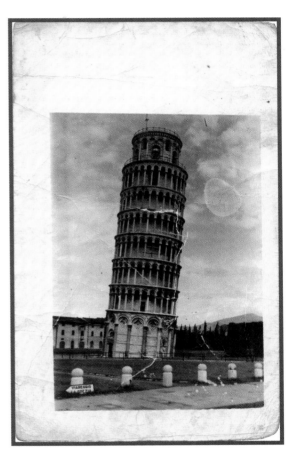

Figure 1.18
Wartime photo of the tower at Pisa, Italy.

Having identified several flaws and turned them into my restoration goals, the following steps took me through the process of restoring this wonderful photo from start to finish.

1. Scan the photo. This photo was scanned at 300dpi. It's a fairly small photo to begin with, so you could easily work at 600dpi and have it not be too unwieldy. (See the previous sections in this chapter for more information and tips on scanning.)

2. Open the photo in Paint Shop Pro Photo and straighten it, if necessary. I straightened it a bit. You'll find that most photos, even modern 4×6 prints, aren't perfectly straight on all sides. In this case, I chose one of the long sides of the photo itself, not the border, to use as a straightedge. Save the file as a .pspimage in order to preserve the original scan.

3. Next, I went to work on cleaning up the photo border. It's a fairly easy way to get started on a photo and work your way up to the harder parts. This border is yellowed and cracked with age. There are several approaches you can take, ranging from throwing the original border away entirely and creating a new one to lightening the original border. After I duplicated the Background layer, I lightened the border with the Lighten/Darken Brush (see Figure 1.19) on the new working layer. For borders, it can be useful to cut the border out of the picture and put it on its own layer. See Chapter 5, "Repairing Physical Damage," for more information on repairing borders.

4. Next, I addressed the sky, with the exception of the large, gunky spot. I used the Clone Brush to cover up the most obvious creases and spots. This photo didn't have a dust or a speck problem. For large Clone Brush operations (as is the case with this photo), I create a new raster layer to use as my Clone Brush destination. See Chapter 2, as well as Chapter 5 for more information.

Figure 1.19
Use the Lighten Brush to wipe away an old photo border.

5. With the majority of the sky repaired, I moved on to tackling the gunk. I used the Clone Brush to cover up this unsightly stain (Figure 1.20). I needed to be very careful not to be obvious about it. Larger sections of cloning can be much more visible than smaller areas if done improperly. I used the Soften Brush to make the edges of my clone work less visible. See Chapter 6 for more information on cleaning gunk.

Figure 1.20
Go away, gunk.

6. I worked on the grounds (see Figure 1.21) next. This included the pavement at the front of the photo, the trees on the right side, and the buildings on the left. Once again, the Clone Brush was my friend.

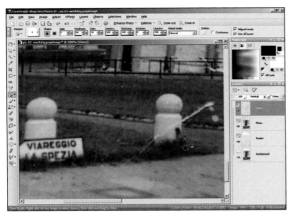

Figure 1.21
Focus on getting the right texture as you clone.

7. I made a lot of progress up to this point, but I hadn't touched the central feature: the tower. The tower (Figure 1.22) proved to be a more time-consuming process than the rest of the photo. In situations like this, take your time and don't feel like you have to repair everything in one sitting. The key to restoring the tower was to vary the size of the brush so it was not too large and to pull the right source material from columns and spaces that had the same shadow and tone. I pulled material from areas above, below, and to either side of the feature I was restoring. It takes a bit of practice to get this part right.

8. The final touches were next. I always leave these for last, because I want to work with a clean photo. Since this is a black-and-white photograph, I will first rid the photo of its yellow cast. See Chapter 4 for more information.

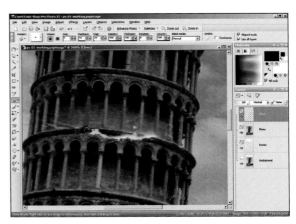

Figure 1.22
Imaginative cloning.

9. Finally, I looked at lighting and contrast. The contrast needed to be improved slightly (see Figure 1.23). I used the Levels dialog box, one of many ways to change the lighting and contrast of a photo. See Chapter 3, "Finding the Right Brightness, Contrast, and Focus."

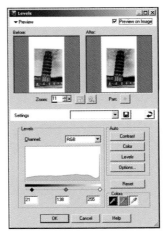

Figure 1.23
Changing contrast through Levels.

10. With work on the photo done, I saved a final version, which was ready to be printed and archived.

As you take a look at the finished photo in Figure 1.24, I want to explain something that may surprise you. I purposely did not restore every pixel of this photo to its original state. First, that would have been too time consuming. Second, there are times when it is impossible. You may have to step back and say "it's done," even when there are still flaws. At those points, you may actually do more damage to the artistry of the original photo if you continue, as well as making it obvious to one and all that you've retouched it. That's a bad thing, and in my opinion, it's better to stop at the point where your hand is still invisible. This isn't a zero-sum game. In other words, if you make it better, you are doing your job. How much better is mostly an artistic decision, but worse is definitely worse.

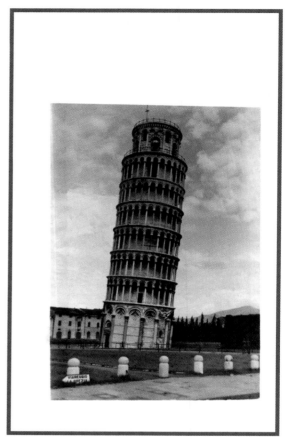

Figure 1.24
Presenting the restored Leaning Tower of Pisa.

Photo Study 2: Retouching a Digital Photo from Start to Finish

FIGURE 1.25 IS A DIGITAL PHOTO OF me and my family in a recording studio. There is no dramatic historical narrative to relay like the Allied invasion of the mainland of Italy, but this was a significant time for us. Less than nine months earlier, I had begun to pursue a passion that had lain dormant in me for a long time: music. I began to play the guitar and create my own music, which eventually led me to school, where I was officially introduced to the art and science of music production and audio engineering. I loved every minute of it!

I chose this photo because it's a good picture of my wife and me and all four of our kids, it's digital, and I know it can be improved. The decisions you have to make when you retouch a digital photo are different than with an older print. First, you know you needn't scan the photo in. The resolution and overall quality have already been determined by the camera. Being digital, there is no dust, no scratches, no gunk, or any other surface damage that you will have to deal with. Digital photo retouching is largely in the domain of lighting, color, focus, and composition.

Here are the steps I took to retouch this recent digital family photo.

1. I began by downloading the photo to our computer from our camera's storage card. You may receive photos over e-mail or from family and friends on CD-ROM. If so, copy the photo to a working location of your choice as if it were any other computer file.

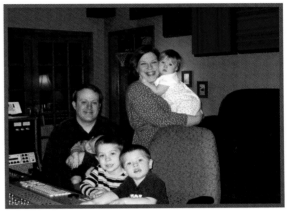

Figure 1.25
My family.

2. I immediately made a copy of the file and placed it in a different folder on my hard drive than the original. This keeps the working copy separate from the original photo and ensures that you have the master to return to if needed.

3. I opened my working copy of the photo (digital photos are often in .jpg or .tif format) in Paint Shop Pro Photo and saved the file as a .pspimage.

4. With the housekeeping done, I started retouching by fixing our red eyes. Red eye is caused by the camera's flash. You won't see red eyes on photos taken outside or in natural light. See Chapter 8, "Retouching People," for more information on correcting red eye.

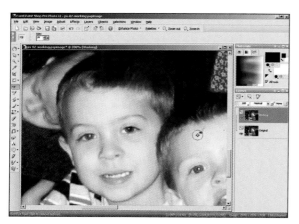

Figure 1.26
Getting rid of red eye.

5. Next, I whitened Anne's teeth (Figure 1.27). They weren't horribly bad, but I might as well make everyone look as good as he or she possibly can. I used a Makeover tool for this job, the Toothbrush. See Chapter 8 for more information on whitening teeth.

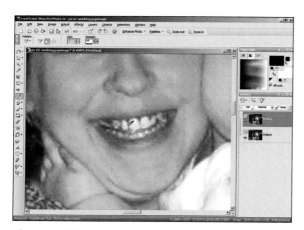

Figure 1.27
Whitening teeth.

6. The next step is an obvious one for the two boys, Ben and Jake, but less so for the rest of us. Everyone is too light. The main control room of this studio is tall, and the flash went off a little too brightly. I think the camera was trying to compensate for the darkness of the room. I used the Burn Brush to darken us all slightly (see Figure 1.28). See Chapter 3 for more information on dealing with brightness issues.

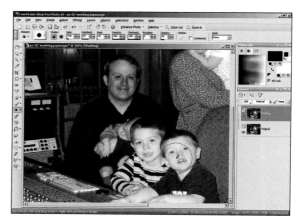

Figure 1.28
Using the Burn Brush to darken subjects.

7. After this, I wanted to improve Ben and Jake. I used the Suntan tool to continue to darken their skin tone (Figure 1.29). See Chapter 8 for more information on applying a suntan.

8. Next, it looked like my face and Anne's were too red. I improved our skin hue by selectively applying the Hue Brush to our faces (Figure 1.30). I experimented a bit to get it just right. See Chapter 4 for more information on hue and color.

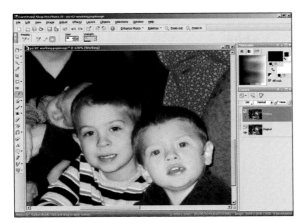

Figure 1.29
Continuing to darken with the Suntan tool.

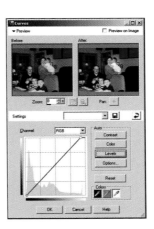

Figure 1.31
Sometimes, the auto settings work great.

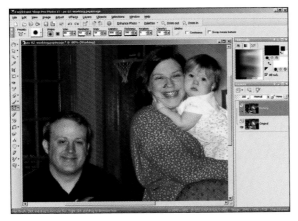

Figure 1.30
Changing the hue of our faces very carefully.

9. At this point, I looked at the overall picture in terms of light, contrast, and color. I opened the Curves dialog box (Figure 1.31) and improved some of the overall lighting and contrast. I chose to apply the Auto Contrast setting in this case, and it turned out pretty well. See Chapter 3 for more information on dealing with brightness issues.

10. Next, I improved the composition by cropping the photo so that we were in the center. I kept it at a 4×6 aspect ratio by using the Crop tool with 4×6 dimensions and the "Maintain aspect ratio" setting enabled. See Chapter 10 for more information.

11. That's it. I saved the final photo. It's ready to print and archive.

The retouched photo is shown in Figure 1.32. The steps between this photo study and the first were different, but the end result was the same: a better photo.

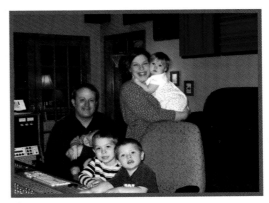

Figure 1.32
The Correll family at the recording studio.

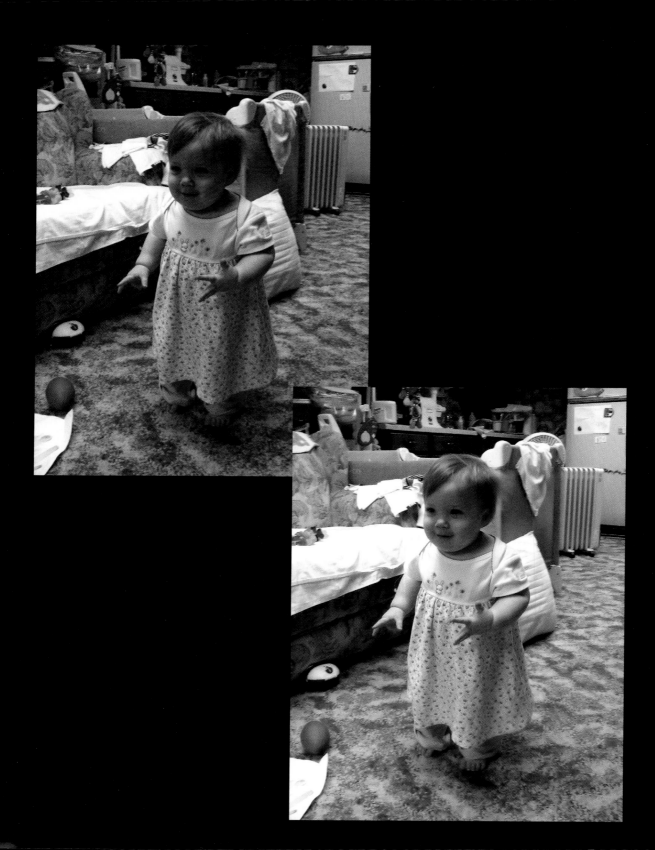

Removing Specks, Dust, and Noise

2

THIS CHAPTER FOCUSES ON SOME COMMON problems we all have to deal with at one time or another. The problems are specks, dust, film grain, and digital noise. The section on film grain can also apply to noise, but I chose a photo with an obvious film grain problem to spice things up a bit.

From now on, this book will highlight the photo studies. Here are the photo studies I will cover in this chapter.

▶ **Photo Study 3: Removing Specks**—Specks are a common problem with photos you scan, especially at higher resolutions. The cumulative effect of a number of small specks can take clarity and color away from a photo. When they're large enough to see with your unmagnified eye, of course, that is definitely a problem. This photo study is largely about using the Clone Brush to remove specks.

▶ **Photo Study 4: Eliminating Dust**—Having a dust problem is very similar to having a speck problem. You can fight this on the front end by making sure the print and your scanner are clean, but if you must remove dust, here's how. As an added bonus, I'll show a special technique that will enable you to get at hard to see dust (or specks).

▶ **Photo Study 5: Reducing Film Grain**—Film grain is much like noise. It's pesky and very hard to remove without making the photo look worse. I've developed a special technique to make trying different options faster and easier when you are working with a large photo.

▶ **Photo Study 6: Taking Care of Digital Noise**—Noise can be a problem even with digital cameras. This is especially true when you are working in low-light situations. I walk you through several options using a photo of my daughter Grace.

Photo Study 3: Removing Specks

FIGURE 2.1 IS A PHOTO OF MY father-in-law's late brother, Jim. Jim was a retired veteran of the United States Army and a real firecracker. He had a great sense of humor. He married a German woman named Liz whom he met while he was stationed in that lovely country.

Jim and Liz lived several states away, and they would come driving up in their large, red Lincoln Town Car most Thanksgivings. I can see it in my mind's eye. Jim was a small, wiry guy. Lean and skinny, he was. Liz (who is still living) is physically Jim's opposite. She is a plus-sized woman, but beautiful in every sense of the word. They made such a great couple.

After Jim died, Liz asked me to retouch a special photograph of Jim for her. I was honored. This was also a significant moment in my photo restoring and retouching career. It was the first time someone asked me to perform that service for them.

The photo, which Liz casually took as they were driving their large, red Town Car who knows where (as they were wont to do), is simply of Jim in the car. It's not really a noteworthy photo, as you can see. Not historical. Not really that interesting. Just Jim in the car, driving. It's funny how these types of photos sometimes carry great weight. Despite the fact that it's just a casual shot that isn't otherwise artistic or important, it is highly prized.

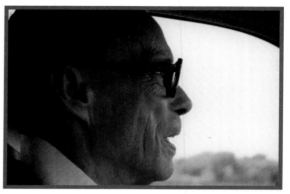

Figure 2.1
Uncle Jim looks nice, but a closer look reveals major problems.

Getting Started

Since this is the first detailed photo I will restore or retouch, I think I will include the scanning, straightening, and cropping steps. After this photo, I will assume you know how to do this and leave these details out. Okay, let's get started.

1. Turn on your scanner and clean the glass with a lint-free cloth, newspaper, or coffee filter and glass cleaner. Make sure the glass is dry before continuing.

2. Place the photo on the glass as straight as you can. I use a clear ruler as a straightedge. This allows me to place the photo away from the sides of the scanner (avoiding the dreaded "The edge got cut off!!" problem) and gives me a straight edge to align the photo against.

3. Launch your scanner software. Make sure to turn off all automatic color and focus tools in your scanner software. You want to scan the photo without any automatic adjustments.

4. Chose a resolution, color depth, and file type to save the scan. (I choose 300dpi, RGB color, and .tif most of the time.)

Measure Twice, Crop Once

I always scan an area larger than the photo and crop it in Paint Shop Pro. This gives me a warm fuzzy that I've got the entire image and didn't leave anything out. Additionally, I feel like I can get a much more precise crop in Paint Shop Pro, which also allows me to straighten if necessary.

5. When the scan is finished, close your scanner software. You can now open the scanned photo in Corel Paint Shop Pro Photo (see Figure 2.2).

Figure 2.2
Initial scan.

6. First, let's make sure the photo is straight. Select the Straighten tool and drag one of its ends to a corner of your photo. Zoom in really tight so you can place the tool precisely (see Figure 2.3).

7. Zoom out and drag the other end of the Straighten tool to the other matching corner; then accept. For borderless photos, use the edge of the photo itself as a guide to straighten. For photos with borders, I align the Straighten tool with the photo edge rather than the border.

Figure 2.3
Using the Straighten tool.

8. Next, crop out the extra area (the scanner bed) you scanned. Select the Crop tool from the Tools toolbar. Drag the crop area to a corner of your photo. Expand the crop area towards each of the other corners, one corner at a time (see Figure 2.4). You'll need to zoom in and out to get a good read on where the border of the photo is. Make sure to align the border of the crop area so that you will crop out everything but the photo.

Figure 2.4
Setting the initial crop box.

9. Zoom out and check the crop area against the sides of your photo. Adjust the crop area inwards to catch areas that aren't exactly straight. This often means you'll lose a few rows of pixels somewhere, as photos aren't always perfectly square or rectangular (see Figure 2.5).

Figure 2.5
Fine-tuning the crop area.

10. Finish the crop by clicking the Apply button.

11. Finally, save your straightened and cropped photo as a .pspimage file.

Naming Advice

I treat my scanned, straightened, and cropped .pspimage files like photo negatives. It's not absolutely necessary, but it will save you the time of restraightening and recropping the scanned file if you make a mistake and want to start over.

Zooming In

After you scan the photo and straighten, crop, and save it with a suitable name, you're ready to start working, right? Almost! Let's look around and see exactly what needs to be done. I chose this photo to illustrate how to remove specks and dust, which are plentiful. Why so much? Partly because I scanned the photo in at 1200dpi. This almost always results in more tiny specks, dust, and damage that you have to fix. If you have the patience, however, it's well worth it. Figure 2.6 shows a close-up area of some of the specks and microscopic scratches on the surface of the photo. Notice how they appear to sit "on top" of the photo? I'm not completely sure why this is the case, whether it's an optical illusion or there is some other reason, but at higher scan resolutions the damage to the surface of the photo looks like, well, like it's on the surface and not part of the image itself. This makes it easy to distinguish between surface problems and photo content.

Figure 2.6
Specks galore.

Figure 2.7 shows another area of the image. These are mostly small scratches that were probably caused by sliding the photo on a surface, perhaps into and out of an envelope. How can I tell? Because they are going the same direction.

Figure 2.7
Nice scratches, too.

Take a look at the texture of the actual photo in Figures 2.6 and 2.7. It's pretty complex. This is an example where you won't be able to zoom out and broadly paint with the Clone Brush. Nope. This calls for very close-in work. For this photo, in fact, I kept things zoomed in to at least 200%. The technique I use is the systematic erasure of all specks, dust, and scratches using the Clone Brush to capture and transplant source material over the blemishes. I make the destination a new raster layer, shown in Figure 2.8. This preserves my original photo layer underneath. Make sure to enable the "Use all layers" option in the Clone Brush and that your empty (at first) destination layer is selected in the Layers palette.

Figure 2.8
Using a special destination layer to clone on.

Negative Function

If you're tempted to use the Blemish Fixer (one of the Makeover tools) with this method, forget it. You can't fix a blemish on another layer. It will work great if you fix blemishes on the same layer, but that defeats the purpose of preserving the original detail in a separate layer. You'll find examples of using the Blemish Fixer and Makeover tools later in the book.

How to Clone

At first, cloning seems incredibly easy. Hit the tool, select a source area, and lay down the new paint over the bad area. Presto, you're done. It looks great, and everyone will applaud your magnificent skills. Not so fast. There are times that cloning is easy. This isn't one of them. Let's look at some examples from this photo and see the difficulties that must be overcome. Bad technique will make your work obvious and not improve the photo.

The importance of making sure you're getting just the right color match between source and destination is made clear in Figure 2.9. Notice that I chose a source area that was pretty close to the speck I wanted to cover up. The problem is that I got a little too far into the dark area, and the result is obvious. Undo immediately!

Figure 2.9
Poor color match from source to destination.

I am using the correct technique in Figure 2.10. I've chosen just the right color area and am brushing with the "grain" of the color gradient. The results are completely invisible!

Figure 2.10
Good color match from source to destination.

Figure 2.11 shows a different problem. Here, I am trying to cover up a rather large scratch that is running across the viewing area. See the problem? Yup, I've dragged my Clone Brush horizontally across the image, focusing on the shape of the blemish and not the result. This also shows the effects of different shades of a source and destination area, even if the differences are very subtle. The destination varies from light to dark along the scratch, but the scratch is mostly contained in a whiter "cloudy" area.

Figure 2.11
Obvious linear cloning.

I am using a better technique in Figure 2.12. I've selected a better source area that matches where the scratch is, and I am not simply dragging the brush along the scratch. I've mixed up my brushing so that I brush with a variety of fairly short strokes that don't all go in one direction. It blends in much better.

Figure 2.13
Cloning specks.

Figure 2.12
Hiding a liner scratch without it being obvious.

Figure 2.13 illustrates another common problem, the dreaded "speck transplant." I've gotten way too many specks and blemishes in the source circle of my Clone Brush and then transplanted them to another area of the photo. Definitely bad. Even if you do this on a small scale, people will notice the repeating pattern of specks, dust, or other features. You want to avoid this.

I am demonstrating the correct technique in Figure 2.14. I've chosen a smaller brush and taken special care to keep any blemished areas out of the source circle of the Clone Brush.

Figure 2.14
Avoiding "speck transplant."

Figure 2.15 illustrates the results of not matching the proper color, even though the source area I've chosen looks like a pretty close match. Part of the problem here is that the surface texture of the photo (in this case, Jim's face) is very complex. I'm not zoomed in enough to get at the details with any real precision.

Figure 2.15
Tough color match shows I'm not zoomed in enough.

I've zoomed in to 200% in Figure 2.16. Notice that each little crease now stands out very well, and I have a real chance of getting all these little specks isolated and fixed. Take special care to follow the "lay of the land" very carefully. Keep your source in the dark areas to fix dark areas and likewise for light areas. This almost looks like a contour map. Clone hills to hills and valleys to valleys.

Figure 2.16
Good color match at 200%.

Figure 2.17 shows the results of careful cloning on this small patch of skin. If you didn't have Figure 2.16 to compare this to, you wouldn't know there had been a problem (he says while patting himself on the back).

Figure 2.17
Completed section of hard-to-match skin.

Working a Pattern

Completely removing the specks, dust, and very small scratches in this photo study required successfully using the Clone Brush approximately 10,000 times. Of course, I didn't count them all up, but it sure felt like a lot. Take lots of breaks, don't be in too much of a hurry, and if your eyes get too tired, stop. I work in a grid pattern based on a good zoom percentage for the particular photo I'm working on. In this case, there are so many physical speck and dust problems that I chose 200% as my optimum working resolution. The beginning grid square is shown in Figure 2.18, filled with plenty of problems to fix.

Figure 2.18
Grid number one, before.

Figure 2.19 illustrates the payoff. Here's one little grid square cleaned of problems. Since there are approximately 300 of these grid squares in this photo (based on the photo size and my chosen zoom percentage), I've only got 299 to go! That seems like a tremendous amount of work, and sometimes it is. Don't lose hope or get too bogged down. Start. Make progress. Every little bit helps, and before you know it, you'll be done.

Figure 2.19
Grid number one, after.

Finishing the Photo Study

The completed restoration of Jim driving his car is shown in Figure 2.20. I've finished removing all the specks, dust, and other surface imperfections of the photo using the Clone Brush. I've also worked with the brightness, contrast, and color saturation of the photo. You'll learn more about that in Chapter 3, "Finding the Right Brightness, Contrast, and Focus."

Figure 2.20
Uncle Jim restored of specks and scratches.

Photo Study 4: Eliminating Dust

FIGURE 2.21 IS A PHOTO FROM THE grandstand on the front straightaway of the Indianapolis Motor Speedway. Home to the "Greatest Spectacle in Racing," the Speedway is a truly awesome place. Imagine as many people as you can possibly imagine in one place at one time, then double it. It's astounding, really. That's before a single car starts its engine and roars by. When that happens, it literally takes your breath away. The start of this 500 is a memory that will be forever ingrained in my mind due to the great seats we had and the fact that I was there with my fiancée. Thirty-three cars hurled past us at over 200 miles per hour racing for turn one. It's a tremendous adrenaline rush. It's an assault on your senses, is what it is. I'm getting all antsy just sitting here writing about it.

Wow, what a cool time we had. If you look at the figure, the shot is looking south down the grandstand towards turn one. We were literally within yards of the Start-Finish line, and you can see the famed scoring pylon rising up.

Behind the Scenes

You know, it literally took me about an hour to find the name of the scoring pylon. I didn't want to call it "that black tower thingy with all the numbers on it," so I researched different sites on the Web, including the official Indianapolis Motor Speedway site and Wikipedia to find out what the dang thing is called.

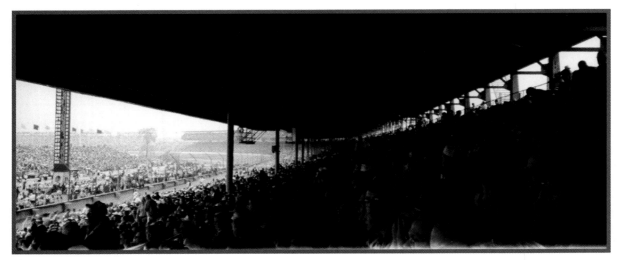

Figure 2.21
A great day at the Indianapolis 500, except for the dust on this photo.

I took one of those "disposable" panoramic cameras to the race that year. At various times, I try to take photos of different things or events with panoramic cameras. I really like them for special purposes. This camera wasn't any good for action shots of the cars whizzing by, but it was ideal for sweeping panoramas of the grandstand and crowd. This was shortly before the cars were given the command to start their engines. You can see the pit crews and cars on the front straightaway.

Obvious and Not-So-Obvious Problems

Looking at the original photo, you can see dust all over the image. It's in the crowd and in the rafters. There are other problems as well, but I want to focus on the dust in this photo study. You would think the dark rafters would be an easy fix, but let's see if we can find some hidden detail in them "thar" shadows.

Here is a technique that will allow you to use an adjustment layer to show the hidden details of a photo so you can use a Clone Brush to accurately match source and destination areas as closely as possible. After you're done cloning, the adjustment layer can be discarded.

1. Create a Levels adjustment layer in the Layers palette, as shown in Figure 2.22. Make sure it's on top of the photo layer.

The Cool Thing About Adjustment Layers

I love adjustment layers. I can make dramatic changes without actually changing the photo. I can go back and change the settings or create duplicate photo and new adjustment layers to compare effects. Totally cool and very practical.

Figure 2.22
Create an adjustment layer to bring out hidden details.

2. We're going to alter the levels, as shown in Figure 2.23, in order to bring out the hidden details. The best way to bring out details in shadows is to lower the gray and white diamond sliders towards the left side of the dialog box. This will alter the midtone and light-valued pixels in your image accordingly. You can start with the white diamond, and the gray diamond will be "squished" proportionately. Fine-tune the gray diamond to see if you can bring out more details.

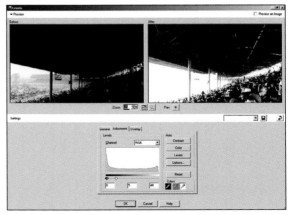

Figure 2.23
Alter levels to lighten dark areas of the photo.

Happy Little Accident

Notice the dramatic difference between the Before and After Preview windows? It's astounding and completely accidental. I wasn't originally going for this effect, but when I was altering the levels toward the end of restoring this photo, I realized there was much more detail in the rafters than I could originally see. I went back and created this technique so that my cloning would pick up this hidden detail "smartly."

Very Important

These next few steps are critically important. You'll need to pay attention to which layer you are working on when you select a source area and when you use the Clone Brush. These layers are purposefully different. Keep practicing until it becomes second nature to switch layers between each operation.

3. Next, create a new raster layer that will serve as your clone destination. I've named mine "Clone" (see Figure 2.24). Put it between the photo and adjustment layers.

6. Select your photo layer in the Layers palette (see Figure 2.25) and Shift+click in the photo to establish a source area. It's very important that you realize the photo layer must be the source and the "Use all layers" option must be turned off for this to work.

Figure 2.24
Sandwiching the Clone destination layer.

Figure 2.25
Selecting a source patch from the photo layer.

4. Select the Clone Brush tool.

5. Uncheck the "Use all layers" option. You don't want to pick up material from the adjustment layer. You'll know if you do because it looks all weird.

7. Next, select the layer you are using to clone on in the Layers palette (see Figure 2.26) and brush accordingly. You'll see that your work will be affected by the adjustment layer (because it is below the adjustment layer and above the photo layer) just like the photo. You can turn the adjustment layer off to see that this effect is temporary.

8. Continue alternating back and forth between selecting a source from the photo layer and then applying the Clone Brush to the working clone layer (the one I named *Clone*). Figure 2.27 shows what this region of the photo looked like before (the left side) and after (the right side) I applied this technique.

If I turned off the adjustment layer now, it would be too dark to see the effects of the cloning. When (or possibly if) you adjust the overall lightness of the photo, you'll be secure in knowing a bunch of cloning you did in the shadows won't show up as a big obvious messy patch in the middle of your photo.

You can apply this same technique to other areas of the photo. There are parts of the crowd where I think it will make a positive difference. Figure 2.28 shows four shots of the same area of the crowd. The top-left photo shows the original photo, and beside that is the same area with altered levels. The lower-left photo shows the effects of the Clone Brush with the altered levels visible, and finally, the lower-right photo shows the restored area without the level changes.

Figure 2.26
Applying the brush on the working layer.

Figure 2.27
Before and after cloning, with the adjustment layer active.

Figure 2.28
Showing the effects of this technique in the crowd.

Finishing the Photo Study

All that's left to do now is to complete removing the dust, specks, and other imperfections and then do some touch-ups on the overall brightness, contrast, and color of the photo. Make sure to delete or hide the adjustment layer. Its purpose is finished, and we no longer need it. Figure 2.29 shows the finished result.

Figure 2.29
Celebrating a dust-free Indianapolis 500.

Printing at Home

There's been a revolution in the photo printing industry. The advent of affordable color inkjet and laser printers means that printing photos at home is the new normal.

Most of us have high-quality inkjet printers that can print at resolutions of 1200dpi or more. You can buy specialized photo inkjet printers for under $100. It wasn't too long ago that a good color printer cost you between $200 and $300. You can still drop a lot of cash, of course, but there are quality options at very affordable prices.

There are a lot of different types of printers currently available, which can be a little confusing. They range from general printers to those targeted at a particular group, like photo enthusiasts. Features and capabilities vary widely. Some photo printers print only a few specifically sized prints, such as 4×6 or 5×7. Some printers are all-in-one printer/scanner/fax capable. You can also buy digital cameras that come with their own printer dock!

You should look at these areas to help you decide what kind of printer you need and want to buy: printer type, compatibility, connectivity, resolution, and "other."

Type—Is it just a printer or is it a photo printer? Is it an inkjet or laser printer? Is it an all-in-one contraption?

Here are my personal assessments and opinions. Inkjets are fine if they are high quality and you buy the right ink and paper for the specific model of printer you have. Photo inkjets tend to have features that make sense for photo restorers, like borderless printing, panoramic photo printing, and color photo ink cartridges. Color laser printing can get really expensive.

I prefer separate devices that do their job well rather than one device that tries to be everything. If you have limited funds, I would suggest buying the best scanner you can afford and save the printer for later.

Compatibility—Always confirm compatibility. Is your printer compatible with your computer and operating system version? Most are, but you should always check to make sure, especially when new operating systems hit the market like Microsoft Vista.

Connectivity—How the printer and computer communicate. Most often this will be USB. Make sure the printer is up to the latest specification (USB 2.0) if you want to take advantage of the highest speeds. One word of caution: The further you get into this the more you realize everything is tied together. If your computer is an older model, your motherboard might not support USB 2.0 or FireWire. You've also got to have an open port (USB, let's say) to plug your printer into. We have two USB mice (yeah, it's weird), one USB keyboard, one USB scanner, one USB audio pre-amplifier, one USB external hard disk drive, one USB external DVD drive/burner, and one USB printer, and we need at least one open USB port to connect our digital camera to. That's a total of nine USB ports that we need, and our computer only has six. I had to go out and buy extras USB ports on a card that I had to install inside the computer. Actually, make that two extra USB cards. Get the point? Another factor is deciding if you need networking capability and printer sharing over a network. If so, make sure your prospective printer is capable of that. Does it have a high-speed Ethernet connection?

Resolution—In most cases, today's printers have more than enough resolution to produce high-quality printouts. Non-photo printers, however, can sometimes have less.

Other—A catch-all category of points to ponder. Do you need auto red-eye removal in a photo printer? No, not if you are going to do it yourself. Do you want an automatic 5×7 photo paper tray? Maybe. Do you need Bluetooth? Possibly, but Bluetooth is not really necessary for photo restoration and printing. Find a printer that has what you need.

I want to encourage you to do your homework so you don't get burned. Spend time on the Web and in person looking at printers. There are a lot of reputable manufacturers to choose from (HP, Canon, Epson, to name a few). Look for reviews and ratings.

Finally, calibrate your monitor, printer, and scanner (if possible) so that your reds, greens, and blues are really red, green, and blue.

Photo Study 5: Reducing Film Grain

FIGURE 2.30 IS A PHOTO OF ME IN high school. I was a drum major of our marching band, which explains my white uniform when everyone else is wearing green. I am playing my alto saxophone. One of the highlights of my marching band experience was participating in the 1982 Macy's Thanksgiving Day Parade in New York City.

Leadership

I knew being a marching band drum major was cool at the time, but I didn't realize how important it would be to me. That experience was an important part of my acceptance into the United States Air Force Academy. I was developing the leadership qualities they were looking for in young men and women. Plus, I knew how to march.

This photo was taken by one of the photographers of our local newspaper. Some years later I was able to scan it and have a digital copy—thankfully, because the original photo has been lost. I haven't been able to find it for some time.

I think this is a fantastic photo. I like the composition and the fact that the further you go back in the photo, the more out of focus everything is. I look young, powerful, slim, musical, and somehow determined. Ah, the hair. Yes, this was the early 1980s, and my longer, somewhat wilder hair is a holdover from the 1970s.

Figure 2.30
He's a strapping young man suffering from film grain.

It's Hard, Isn't It?

When I look at this photo, the film grain stands out like a sore thumb. There may be times when you want to keep this and treat it as an artistic or historical effect, as if it were an inseparable part of the photo itself. Then there may be times when you want to minimize it, or when someone is paying you to remove it.

Nobody said this was going to be easy in every case. There are times when I sit at the computer for hours trying different approach after different approach, searching to find just the right combination to restore or retouch a photo. You're not wasting time. Remember that. You're solving a puzzle.

First Things First

I find it helpful to clean up my photos before I make any sweeping brightness, color, noise, or contrast adjustments. This photo study is about reducing film grain, but as a total restoration I would start with blemishes and surface problems before I went on to the grain.

You can treat film grain much like noise, so that's how I am going to approach restoring this photo. Since I originally scanned this photo at a very high resolution, making constant noise adjustments to the overall photo takes a lot of processing power and time. Do. Wait. Undo. Wait. Do. Wait. Undo. Wait. Wait some more. Believe me, I've sat here and done a lot of waiting.

I will, therefore, suggest an alternate technique that I use for experimentation. It should save you a lot of time.

1. Open up the photo you want to restore.

2. Look around. Zoom in and out. Find a good area that will serve as a representative sample of the overall noise problem. I've zoomed in on my face in Figure 2.31. I see a good range of light and dark values, as well as areas where the film grain stands out really well in all of those areas. It helps tremendously that there is a range of small details and recognizable features here so that I will be able to get a good "before and after" comparison.

Figure 2.31
Focusing on the film grain.

3. Select the Selection tool (Rectangular type) from the Tools toolbar.

4. Use the Selection tool to select a small portion of the photo. I've zoomed out a bit in Figure 2.32 so that I can get a good perspective when selecting.

Figure 2.32
Selecting the area to copy as a new image.

5. Copy the area using Ctrl+C.

6. Select the Edit ❯ Paste as New Image menu or simply press Ctrl+V on your keyboard.

7. Save this new image as an experimental working copy. You've now got a smaller image to work with that won't take forever and a day to apply a number of different noise removal techniques to. Whoohoo!

On to the Techniques!

This is a grab-bag section of techniques, most of which you'll immediately look at and say "UGH!" That's because noise and film grain can be notoriously hard to remove. The good part is that Paint Shop Pro Photo has a number of different ways to tackle the problem. Deciding which one is best for a particular photo takes time and determination.

One Step Photo Fix

One Step Photo Fix is simple to apply. Select the Adjust menu and choose One Step Photo Fix. Figure 2.33 shows the result. It's a tad shy of what I was hoping for, especially in the way it changed the brightness and contrast.

There will be times, I promise you, when you apply this adjustment, and it will blow you away. I don't think this is one of those times, so let's make a note of this and move on.

Smart Photo Fix

To apply Smart Photo Fix, choose the Adjust menu and select Smart Photo Fix. Smart Photo Fix allows you to change brightness, color saturation, and sharpening in a photo. I've applied the suggested values in this case, and you can see the result in Figure 2.34.

Figure 2.33
Not very good noise reduction here.

Figure 2.34
Film grain 2, automatic fixes 0.

Again, this isn't anything to write home about. I would quibble with the overall changes from a tone perspective, but if you look at the film grain, you can see it's still there.

One Step Noise Removal

This sounds promising. One step! What could be simpler? Apply it by selecting the Adjust menu and choosing One Step Noise Removal. Figure 2.35 reveals the result.

Figure 2.35
Good, but some artifacts are present.

We're finally getting a good amount of noise reduction. I've used this adjustment many times, and it has worked like a charm, but in this case it's a little overzealous. You might differ with me, and that's okay, but I think I would prefer less noise (i.e., film grain) removal in order to preserve some of the finer details. This is the trade-off when it comes to removing noise.

Despeckle

I have decided to include Despeckle because it's part of the Adjust > Add/Remove Noise menu. That's a perfectly reasonable place to expect to find tools that will help you remove film grain and noise. Figure 2.36 show what Despeckle does.

Figure 2.36
Hard to tell if anything changed here.

It doesn't seem to have done much for this photo. Keep trying on your own photos, because you never know when this will be the exact thing you need.

Edge Preserving Smooth

Another selection available from the Adjust >
Add/Remove Noise menu, Edge Preserving Smooth,
sounds promising. Figure 2.27 shows the results of
a minimal application.

Figure 2.38
Texture Preserving Smooth is not so good in this case.

Figure 2.37
Edge Preserving Smooth is quite good.

I'm actually quite pleased with this effect. It takes
some of the film grain out while preserving the
sharpness of the photo.

Texture Preserving Smooth

Texture Preserving Smooth is the same as Edge
Preserving Smooth, only completely different. In
this case, you're trying to preserve the texture of
a photo as opposed to the edges. For edges, think
focus and sharpness. For textures, think, well,
texture. It's the surface material, like my cheek,
and not my jaw line (the edge). Choose Texture
Preserving Smooth from the Adjust > Add/Remove
Noise menu.

Figure 2.38 shows the results of applying the
Texture Preserving Smooth adjustment. It appears
to have had very little effect.

Salt and Pepper Filter

Another possible solution to our film grain crisis is
the Salt and Pepper filter. The only problem is that
I don't see any salt or pepper. Seriously, this would
be a great filter to use if you had a lot of little light
(salt) and dark (pepper) artifacts, noise, or specks in
your photo. I'll use this later in the book on one
photo, and it will work very well.

Figure 2.39
A little too blotchy for my taste.

Figure 2.39 shows the results of choosing Salt and Pepper Filter from the Adjust ❯ Add/Remove Noise menu. There is a definite effect, but I don't think I like it. You can alter the speck size and the filter's sensitivity to specks in the dialog box, but this was about the best I could do with this photo. Next technique!

Median Filter

The Median filter (choose Adjust ❯ Add/Remove Noise ❯ Median Filter) is often the filter that will work the best to remove film grain or noise in a photo. In this case, I'm happy but not overly so. This is often the situation when you are restoring or retouching photos. It's sometimes very difficult to find a good solution, and there is often no solution that works the best. I would have to say the Edge Preserving Smooth filter and the Median filter are about tied here, with the nod barely going to Median filter. Figure 2.40 shows the result of the Median filter.

A filter aperture of 3 (one less than shown here) has a minimal effect, but going any higher than 5 results in a very blurry photo. So I can use the Median filter as a basis to work from. I'll apply it and continue working with my small image.

Next, I am going to soften the effect by using the Adjust ❯ Softness ❯ Soften menu. This helps blend some of the blotchiness out. After that, I will selectively sharpen critical areas of the photo with the Sharpen Brush. I am sharpening the border area around my ear in Figure 2.41. Sharpening this edge will help bring it out better and make the photo look like it's in sharper focus without having to sharpen the entire thing. With that, it's time to wrap this photo up. Removing film grain can be hard, and you don't want to do more damage than good to a photo.

Figure 2.41
Sharpening edges to bring some clarity to the focus.

Figure 2.40
The Media filter wins the prize.

Easy Does It

A little sharpening goes a long way. The best way to keep it under control is to lower the opacity of the brush. Color photos seem particularly susceptible to oversharpening, and you will see the overly sharp pixels really stand out (in a bad way). Grayscale images seem less prone to this effect.

Finishing the Photo Study

Remember, I used a small sample area of this photo to work on as I decided which technique I wanted to use. After deciding, I went back to my original working file of the entire photo and started restoring the photo from scratch.

If you read the note near the top of this section, you will not be caught off-guard by my next sentence. First, you should have cleaned up the photo and covered up any blemishes or markings and fixed any border problems. This photo has some specks and marker on it that I fixed first. Then I tackled the film grain problem, and finally, I made adjustments to the brightness and contrast. Figure 2.42 shows the finished photo.

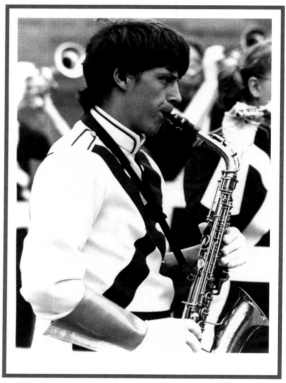

Figure 2.42
Film grain partially removed and photo restored.

Photo Study 6: Taking Care of Digital Noise

FIGURE 2.43 IS AN ACTION SHOT OF my young daughter, Grace. She is running to and fro in the basement, probably chasing after or otherwise playing superhero with her two older brothers. Grace is an incredibly cute girl, full of laughter and play. Until you try and take her out of the tub!

Pardon the mess. I didn't realize I would be putting such candid photos of my life into a book like this. But this is real. It's the type of photo you might take in your basement. That's an important ingredient to my approach for this book. I want it to include photos everyone can relate to and learn from, not just photos a professional photographer would take.

What Is Digital Noise?

We have a tendency to think the digital revolution (as compared to the old-fashioned analog way of life) has brought about Nirvana, and we no longer have to deal with pesky problems such as noise. Alas, this is not the case. We don't live in a perfect world, and we are not able to design and manufacture perfect machines or computers. Data that is digital is not immune to error, signal noise, or fluctuations in quality as it is being captured. It is precisely at this "reality-interface point," where the data is measured and converted from analog (wavelength, intensity, etc.) to digital, that we have the most trouble.

Figure 2.43
Great action shot marred by digital camera noise.

Although I've written this section from the perspective of digital noise being in a digital photo, you may find digital noise in scanned photos as well, or want to review these techniques and try them on older prints.

Trial and Error

With so many different ways to remove noise and make a photo better, we need to come up with a technique that will help us keep things straight and decide on the best method. I have found just such a technique and would like to share it with you. It involves creating duplicate layers to which you apply the different techniques. Here's how to do it:

1. Open the digital photo in Paint Shop Pro Photo.

2. Duplicate the Background layer several times.

3. Rename the duplicated layers according to the techniques you want to try (see Figure 2.44).

4. Apply the techniques. I will illustrate several different techniques in the following subsections.

5. Show and hide the layers for a direct comparison.

When you've decided on the best way to solve the problem, delete the other layers or hide them. If you want to avoid "image bloat," I would suggest deleting the extra layers. They can add significantly to the file size of your photo.

Figure 2.44
Create duplicate layers to experiment with possible solutions.

One Step Photo Fix

It always pays to try this first. Select the Adjust menu and choose One Step Photo Fix. You never know when you'll hit the jackpot and not have to do anything else. Figure 2.45 shows the result.

As you can see, One Step Photo Fix is not particularly suited to removing noise. It works best on photos that have brightness, contrast, or color problems.

Figure 2.45
Brighter but still noisy.

Figure 2.46
Smart Photo Fix isn't the answer here.

Enhance Photo

There is a button on the Standard toolbar called Enhance Photo. It's located right in the middle, beside the Palettes button. Our excellent technical reviewer, David, has suggested I mention that Smart Photo Fix and a few other common enhancements appear there. Thanks for the great idea, David!

One Step Noise Reduction

Here we go. One Step Noise Reduction is available from the Adjust menu. Simply select it and let 'er rip. Figure 2.47 shows the results.

Don't let the name fool you. Try this on digital photos, too.

Smart Photo Fix

Smart Photo Fix is a little harder to use than One Step Photo Fix, but not by much. Give it a try by selecting the Adjust menu and choosing Smart Photo Fix. You'll be given the option of changing brightness, saturation, or focus sliders to see if those work for your photo, or you can ask Paint Shop Pro Photo for suggested values. I've accepted the suggested values for this photo in Figure 2.46.

As you can see, it's about the same as the One Step Photo Fix, without the one step. Again, you never know when this will work, so it always pays to try it before you discard it.

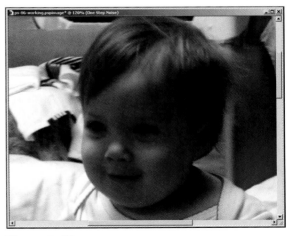

Figure 2.47
Good noise reduction, but I can do better.

Median Filter

I've included the Median filter here to show you a comparison between a photo I used it on (see Figure 2.40) and thought it did a pretty good job, and this photo, where it doesn't really help (see Figure 2.48).

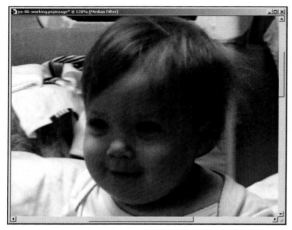

Figure 2.48
Median filter doesn't work as well with this photo.

It obviously has had an effect, but in this case, the trade-off between reducing the noise and creating other problems is an issue. I don't particularly like the blotchiness it causes, and because this is a color photo, I think it stands out more than the earlier example.

Digital Camera Noise Removal

I could have jumped right here and told you this was the effect I would use and ignored the rest, but that would have been a disservice to you and not accurately portrayed how I work. I really do go through all the above options to see if they work or not. Yes, when I'm removing digital noise from a digital photo, I have the expectation that this will be where I end up, but I will check out other options and see their results to make sure this is the best method.

Select Adjust ➤ Digital Camera Noise Removal to open up the Digital Camera Noise Removal dialog box (see Figures 2.49 through 2.53).

I've recorded several screen captures of the Digital Camera Noise Removal dialog box with different settings for you to see first-hand what effect the different values have on removing noise from a photo.

Figure 2.49 shows the effects of too much smoothing. We've lost a lot of detail in the photo. Again you are confronted with the trade-off of detail versus noise. Experiment!

Figure 2.49
Too much smoothing.

There is no blend between the corrected areas and the original image in Figure 2.50. That makes it hard to determine if there is any improvement to the photo. The noise still looks like it's present. Why? Because this is a really ridiculous setting, if you ask me. Turning the blend down to zero tells the filter that you don't want to see any correction at all. So you don't.

Figure 2.51
Overblending.

Figure 2.50
No blending.

The third example (Figure 2.51) shows a 100% correction blend setting. It's obviously blending the heck out the photo. Too much blending takes a lot of detail away. You can also see artifacts that the blending has created around Grace's forehead and the side of her face.

The effect of no sharpening is shown in Figure 2.52, which is actually not bad. I can do better, however, so I will bump up the sharpening a little in order to preserve some detail and keep it from being blended away.

Figure 2.52
No sharpening.

The final example (Figure 2.53) shows the effects of total sharpening, which are readily apparent. It looks like chicken tracks all over her face.

Figure 2.53
Oversharpening.

Having seen the extremes of smoothing, blending, and sharpening, I can come up with a pretty good middle ground for this photo. I've got the dialog box open in Figure 2.54.

Figure 2.54
Working those settings to our maximum advantage.

I have chosen a middle-ground setting and also selected a few areas in Grace's face that represent light, midtone, and dark regions that have noise in them. The result is a pretty good balance between smoothing away the digital noise and preserving important details.

Finishing the Photo Study

After applying the correct amount of digital noise reduction, I did several things to finish the photo. First, I looked closely for artifacts created by the noise reduction process and used a combination of the Clone and Soften Brushes to remove them. Next, I used the Sharpen Brush to selectively sharpen Grace's features so that she would stand out better. I set the opacity of the brush to a very small amount, 10, to avoid oversharpening, which creates more problems than it solves. I blended those sharpened areas with the Soften Brush and finally made some overall color corrections. The basement is a very yellow room, and our photos often reflect that by looking far too yellowish. Figure 2.55 shows the completed photo.

Figure 2.55
Grace, saved from the evils of digital camera noise.

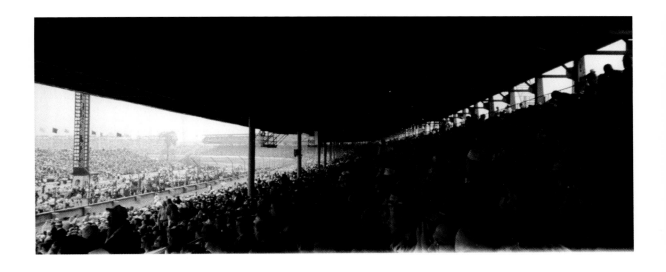

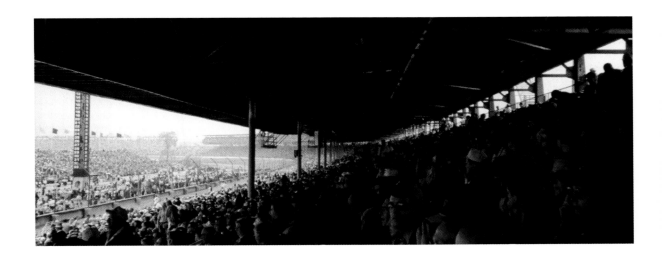

Finding the Right Brightness, Contrast, and Focus

3

THIS CHAPTER ADDRESSES HOW TO TACKLE BRIGHTNESS, contrast, and focus problems. Brightness problems reveal themselves in areas of a photo that are too light or too dark and can affect the subject, the background, or the entire photo. Most of the time when you see a brightness problem, it involves a flash issue (although it could be linked to fading as well). You are using either too much flash or too little. Contrast problems, on the other hand, make a picture look like it has too much gray in it, or there is a gray veil over it. You may have trouble making out edges or borders. This indicates there is too little contrast, which is the common case. Focus problems, however, are mostly about blurring or a soft focus. I don't think I've run across a photo that was ever too sharp to begin with. With this general description in mind, let's move on to the photo studies.

Here are the photo studies I will cover in this chapter.

▶ **Photo Study 7: Darkening Overly Bright Areas**—Quite often we take photos of people, and areas of their faces reflect too much light. This is mostly confined to the forehead, cheeks, and chin. I have developed a color changing and blending technique that handles this problem very well.

▶ **Photo Study 8: Lightening a Dark Subject**—We've all been bitten by the "flash didn't flash" bug. Sometimes, we forget to turn the flash on or have the flash on our digital camera in the wrong mode. This occurs most often when you are shooting against a bright background, or your subjects are in front of a window. There are many ways to brighten an image. We'll look at several and choose the best one for this study.

▶ **Photo Study 9: Lightening a Dark Background**—This problem is the opposite of the previous photo study. Here you've taken a photo, probably in a dark room, and the flash did go off, but it wasn't enough to illuminate the entire room. We'll look at one of my photos that has this problem and lighten the background. We'll also deal with a few other problems as we go along.

▶ **Photo Study 10: Sharpening Poor Contrast**—Poor contrast attacks older photos as they fade. You lose your darks, and everything seems to turn to a middling gray. I've pulled out an old black-and-white photo that was never very good in the contrast department to improve. You'll find yourself in this situation quite often. We'll do the best we can to recover what we can with poor photos, while keeping our actions as "behind the scenes" as possible.

▶ **Photo Study 11: Improving Brightness and Contrast**—Here is a Polaroid photo of me taken in the early 1980s, and it's obviously fading. Polaroid photos were never as good as 35mm prints developed from negatives and often suffer from fading and age.

▶ **Photo Study 12: Focusing a Blurred Subject**—Significant blurring is essentially impossible to fix. This isn't a televised crime-drama where you can press the magical "fix all the problems and magnify by 1000% and improve the clarity and resolution" button. I love those segments where they take a tiny piece of a poor photo and blow it up to read the label on a can of soda from a mile away at night in the rain. The good news is that you can fix *some* blurring, if you know how. I'll show you how.

▶ **Photo Study 13: Minor Sharpening**—There are times when a little dab will do it. I've taken an older photo that looks pretty good but could be sharper. I've used a technique that allows me to selectively sharpen areas of a photo. It's called the Sharpen Brush.

Photo Study 7: Darkening Overly Bright Areas

FIGURE 3.1 IS A PHOTO OF MY WIFE, Anne, and me on our wedding night. I love looking back at these photos of our wedding. It was an awesome day! Contrary to what many people say, it wasn't the most important day of our lives. It was the first "most important" day of many to come. A lot of people put such tremendous expectations on that day that it's hard for the rest of your lives (the hard work of forming a family team) to measure up.

Our wedding story is an interesting one. We started planning a conventional wedding, but that process became unbearable after only a week. My mother gave me wise counsel about planning a wedding that matched our personalities. I asked myself what kind of wedding really matched Anne's personality the best. The one we were planning seemed to match everyone else's expectations of what a wedding was, but was that Anne's?

No, it wasn't. She is fun loving, easygoing, happy, and not overly stuck on appearances. She dreams of being exotic, mysterious, and different. After a lot of thought, I approached her with the idea of a destination wedding. I told her we could fly down to Florida and get married at sunset on the beach. She loved the idea. We found a way to take our immediate family, and we were off to get married and honeymoon at a resort hotel on Florida's Gulf coast.

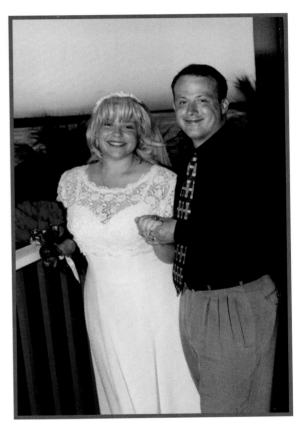

Figure 3.1
Newlyweds posing for the camera.

This photo is shortly after the wedding, during our small reception at the resort. It was a pretty hot evening, and we were sweating. The flash of the camera caused bright spots on our faces (see Figure 3.2). Our cheeks stand out the most, but you can also see bright spots on our chins and my forehead.

Reminder

This is a good time to make a point about color sampling. Use color from one photo to do something else in another. The photos can be taken at the same or at different times, places, and occasions. Remind me to use this photo as the color source for those roses. I'm going to use another photo of them later in the book, and the original red is vibrant and authentic.

Bright spots Bright spots

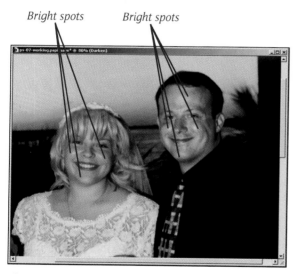

Figure 3.2
Close-up of overly bright areas.

Dr. Robert's Magical Miracle Cure

I've tried many a technique with this problem, ranging from darkening the entire image to using the Burn Brush to darken the bright spots. I haven't been happy with any of them, which is why I have developed a different approach. I came up with the idea when I was trying to use the Color Changer tool to replace the shiny spots with a better skin tone. The bright spots got better, but it made everything else look horrendous. I decided I could use the Color Changer on the bright spots only and blend them back into the photo on another layer. Here's how you can do it, too:

1. Take care of housekeeping tasks first. Scan (clean your scanner first) your photo if it is a print or make a working copy if it is digital.

2. Open the photo in Corel Paint Shop Pro Photo. Save the file as a .pspimage with an appropriate name.

3. Duplicate the photo layer and name it something clever, like *Darken* or *Blend*. The duplicate layer should be above the Background layer. Leave the Background layer alone. We're going to be working on the layer you just duplicated.

4. Select the top layer.

5. Select the Freehand Selection tool and change the Selection type to "Point-to-Point," which enables you to click and draw a multi-sided, straight-edged selection area. It's just like connecting the dots. Click where you want the dots to be, and Paint Shop Pro connects them. I will use this tool to select a general area that needs to be darkened. I am making my selection in Figure 3.3. You don't need to be too picky with this. Get all the areas you need, plus some extra space around them. That will be your blending space. You'll erase everything else in the end.

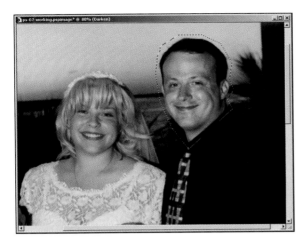

Figure 3.3
Limiting the work area.

6. Select the Color Changer tool, as shown in Figure 3.4. This tool is located with the Flood Fill tool on the Tools toolbar.

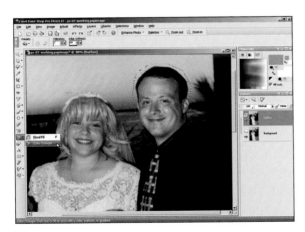

Figure 3.4
Going for the Color Changer.

7. Be patient with this part of the process. You may have to come back and try several times until you get just the right color that will blend in perfectly. Press the Control key to change the Color Changer tool temporarily to the Dropper tool and click on a darker skin color to replace the bright spots with. I can't tell you exactly what the color should be, but it should be in the same color range (skin tones to replace skin tones) and somewhat darker than the bright spot.

Alternate Idea

I've chosen to do all my selecting and color changing on one layer, but you can copy and paste each selection you've made onto a new layer every time you want to work with a bright spot. That will make erasing unneeded areas easier when the time comes to start blending, but you'll have to align the layers exactly.

8. Click a bright spot to replace the color. You may have to click, undo, click, and undo several times until you hit just the right pixel or decide to try another color. It's going to look funny even when it works (see Figure 3.5), but don't worry. You're looking for a blend between the bright spot and the surrounding areas. It took me a few tries and a one-color change to achieve my result.

9. Now go forth and do the same in other areas of the photo that need changing. Anne needs her bright spots blended, and since her skin tone is different, I will return to step 5 and repeat the process. I've used the Color Changer on her face in Figure 3.6. It looks like she put on a layer of makeup, which is exactly what I'm after. Don't worry if it looks like thick makeup, we'll blend it later.

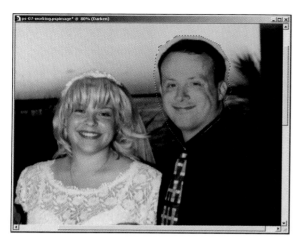

Figure 3.5
Changing the bright spots.

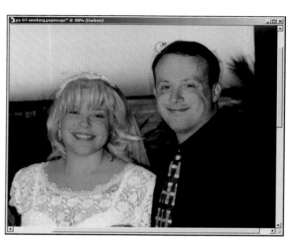

Figure 3.7
Erasing unwanted areas.

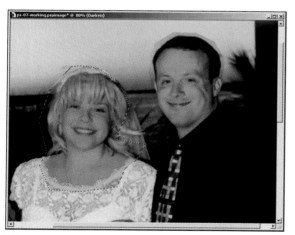

Figure 3.6
Doing the same for Anne.

11. Now it's time to blend. Double-click the layer thumbnail of the layer you've made the color changes to in the Layers palette to open up the Layer Properties dialog box (see Figure 3.8). Lower the opacity until it blends in nicely with the lower (original photo) layer. Take special care to look at how the bright spots disappear and blend in with the rest of the photo. Experiment to find just the right setting. In this case, 50% looks good.

10. Next, start erasing the outer area of your selection where the color changed but is obviously not an area where you're going to blend. I'm erasing the area around my hair where I don't want the color blended at all in Figure 3.7. Don't erase too much. You want enough area to blend with what's outside of the bright spots.

Figure 3.8
Blending with opacity.

12. Finally, it's time to do some small touch-ups. Look for areas of the blend layer that might need to be erased to make the photo better. I've chosen to erase around Anne's teeth and eyes on the blend layer in Figure 3.9. Spend some time on this step to achieve the perfect blend.

Figure 3.9
Touch-ups.

Finishing the Photo Study

Figure 3.10 shows the fully restored photo of my wife and me at our wedding reception. To complete the restoration, I erased dust and specks and tweaked the levels just a tad. I also desaturated our faces a small amount. If you are working on a photo like this, try creating a new layer by selecting everything in the photo and then choosing the Edit menu and selecting Copy Merged. Paste this new layer on top of the others. The lower layers now form an archive of your work. The new top layer will have your blended work fully integrated with the photo, and you can proceed to erase the dust and make your level changes on one final layer.

Figure 3.10
Corrected bright spots blended nicely.

Photo Study 8: Lightening a Dark Subject

FIGURE 3.11 IS A PHOTO OF MY WIFE (same wife, different hair color than in the previous photo study, but that's another story) and her mother, Mary Anne. It was taken in Mary Anne's kitchen, and the flash didn't go off. There is a window behind and to the left of Anne, which is providing natural illumination in the kitchen, but it's not enough, nor is it in the right location, to lighten Anne and Mary's faces.

This is a common problem and results in many good photos going unprinted.

Notice Something?

I spy something on the kitchen table that could be quickly and easily removed to improve this photo. Take a step back and look critically at your photos to spot things you can make better.

Finding the Right Answer

Paint Shop Pro Photo has a multitude of tools and techniques to brighten specific areas or entire photos. That's one of the really cool things about using this program. You can experiment with different solutions and find which one will work best for your photo. Time and experience will reveal which techniques or tools work most of the time and which ones are best suited for a particular application.

Figure 3.11
Daughter and mother in shadow.

Fill Flash

I'm going to use Fill Flash first. That seems obvious. Fill Flash is exactly what this photo needs. Select it from the Adjust menu and choose Fill Flash. The Fill Flash Filter dialog box with the settings I chose is shown in Figure 3.12. You can alter the strength of the filter and the saturation (color intensity). In this case, I made the effect fairly strong because my subjects were pretty dark, and I set the saturation at about mid-range. This actually isn't bad, but you can see that it brings out some flaws in the photo more clearly that we will have to fix later on.

Figure 3.12
Trying Fill Flash.

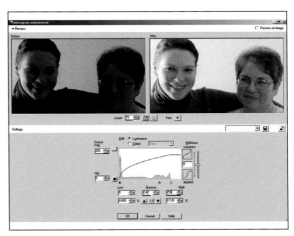

Figure 3.13
Adjusting the histogram.

Histogram Adjustment

Histogram Adjustment (Adjust ❯ Brightness and Contrast ❯ Histogram Adjustment) allows you to alter the histogram of a photo. That's another way of saying that you can correct the exposure by editing the photo's overall luminance or the luminance of each separate color channel (red, green blue). Take a look at Figure 3.13. You can see the histogram of the photo displayed in the lower center of the dialog box. The darker gray graph shows the number of pixels on the vertical axis compared to their luminance (from 0 to 255) on the horizontal axis. This photo has a large number of dark pixels, as evidenced by the spike on the left of the graph. Notice that there is an even distribution of pixels at all the other intensities until you get towards the high end and the graph stops. There are very few very bright pixels in this photo. If you press the arrow beside the 1:1 ratio, you can enlarge the graph to see very small values.

This histogram tells us what we can already see. The photo is too dark. Knowing exactly what the distribution of light-to-dark pixels is can be very helpful, however. Based on that information, I've slid the white triangle down (it's technically called the *High slider*), effectively moving some of those dark pixels into the lighter range. I've also moved the middle triangle (called the *Gamma slider*) up a bit. The Gamma slider is what actually controls the lightness of the image. If you look carefully, you will notice that the Gamma slider is tied to the other sliders (but not vice versa). When you move the High slider down, the Gamma slider is squeezed proportionately downward toward the dark side of the photo. It tries to maintain a one-to-one ratio. This is why the photo doesn't lighten when you move the High slider. After moving the High slider down to cut out some of the dead space, move the Gamma slider back up to lighten the photo.

The result? Not bad. I don't know if it's a keeper yet, but not bad.

Histogram Equalize

Histogram Equalize (Adjust ❯ Brightness and Contrast ❯ Histogram Equalize) distributes lightness across the photo, which it does in Figure 3.14. The only problem is, it looks hideous in this application.

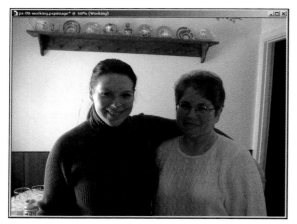

Figure 3.14
Histogram Equalize.

I don't think we need to dwell here. Try stuff like this out, and if it doesn't work, undo it. Keep trying, because you don't always know when it will be the perfect solution.

What's a Histogram?

A histogram is a graph of the light or color intensities that are present in your photo. It's a good way to display information graphically that would otherwise be in a large table. Histograms are used in statistics and other fields as well.

Highlight, Midtone, and Shadow

Highlight, Midtone, and Shadow adjustment is one of my favorite ways to quickly fine-tune the proportion of lows to mids to highs in a photo. Think of it this way: You can lighten or darken specific tones of the photo based on their original luminance, as shown in Figure 3.15.

Using the relative method (because Anne and Mary Anne are my relatives), I will lighten the shadows dramatically, lighten the midtones somewhat, and leave the highlights alone. In this case, I could have brightened the highlights to 100 and suffered no ill effects (see Figure 3.13 for the answer to why this is the case).

Figure 3.15
Adjusting Shadows, Midtones, and Highlights.

Levels

Levels (Adjust ❯ Brightness and Contrast ❯ Levels) is another way to alter the brightness and contrast of a photo. Ah, levels. I find myself turning to levels repeatedly. I'm not trying to be biased. I've tried the other methods honestly and without purposes of evasion, but I have found myself returning to

levels. Look at Figure 3.16 and tell me that's not the best technique. It's lightened the photo very well and kept the side-effects to a minimum. There are things to fix, yes, but overall, this is the best technique.

Specifically, I dragged the white diamond slider down in order to "crop out" the area that didn't have much data in Figure 3.16. Then I dragged the gray diamond slider further down to make the photo lighter.

Figure 3.16
I like Levels a lot.

Histogram Adjustment

My enthusiasm for Levels has faded. I'm pretty keen on Histogram Adjustment now. Curves is also one of my new tools of choice.

Cleaning Up

Now that I've found the technique I want to use, I will clean things up a bit. First, I'm going to whiten Anne's teeth. I've selected the Lighten/Darken Brush and am using that tool to lighten the dark pixels in Figure 3.17. I've got the opacity set at 60% so I don't sandblast them.

You might ask me why I didn't first reach for the Toothbrush in the Makeover tools. I did, which is the reason I'm writing about it here. I tried it, and it didn't work very well. I couldn't get the right settings to whiten her teeth effectively without making them look fake. When that happens, and it often does, you need to dig deeper in your bag of know-how.

Figure 3.17
Whitening Anne's teeth.

The next step in cleaning up this photo is to take some of the noise out. As you found out in Chapter 2, noise can occur in digital photos like this one. Most often, the problem rears its noisy head during low-light situations. This may not appear to be a low-light situation, but the subjects weren't exposed to the proper amount of light.

Even though the rest of the room looks relatively okay (it could be brighter), they are in the darker part of the photo. Less light normally results in more noise.

Whip out your Digital Camera Noise Remover (see the Adjust menu) and follow along with Figure 3.18. I've lessened the settings somewhat, going down from the default value to 40% noise reduction, plus I'm sharpening a little. I've also selected a few additional dark, mid, and highlight regions where I see noise. They are the crosses on the overview thumbnail on the right.

Figure 3.18
Removing noise.

Those settings do the trick nicely. I don't want to smooth out too many fine details, but the noise is distracting.

Next, I will smooth over some of the artifacts the noise reduction created. Yes, there are times when noise removal creates artifacts in the photo. That should be a criterion you follow when you are looking at noise reduction levels. How many artifacts can you live with after the noise reduction, and can you take the artifacts out successfully?

Although they may not technically be JPEG artifacts, I handle noise-reduction artifacts with the JPEG artifact remover. They don't seem to complain. Go to the Adjust menu, choose Add/Remove Noise, and then choose JPEG Artifact Removal to open the JPEG Artifact Removal dialog box, as shown in Figure 3.19.

Figure 3.19
Eliminating JPEG artifacts.

I've set the strength to low and crispness (like it's a deep-fat-fryer) to zero because the artifacts aren't too bad here. That looks good.

Saturation Issues

Now that I've brightened up my subjects, smoothed over some noise, and removed the artificial JPEG artifacts, I want to look at the color of the photo. Although I could open the Hue, Saturation, and Lightness dialog box (Adjust ➤ Hue and Saturation ➤ Hue/Saturation/Lightness) and adjust the saturation of the entire photo, I'm going to be gentle in this case. It's not an overly saturated photo, and I like that. What I would like to change, however, is the saturation of their faces. Anne's face looks pale, while Mary Anne's looks flushed.

What's All This Talk About Saturation?

Saturation is how intense a color is, ranging from none to total. It helps to know what "none" and "total" are, of course. *None* refers to gray. If you take all the intensity from medium red, it will turn gray. If you bump it up a notch, it moves towards total red. Double-click a color swatch on the Materials palette and look at the HSL values. Those stand for Hue, Saturation, and Lightness. You can modify colors here in addition to the more typical "RGB way of thinking." Make the color red and then move the S slider up and down to see what happens. Pretty cool, isn't it? I really like using HSL to lighten a color without changing the hue. That's one reason why we have it.

I chose the Saturation Up/Down Brush from the Tools toolbar and got to work. For these tools, it's best to use them with less than 100% opacity. You can experiment with the other brush settings to fine-tune the effect, but the opacity is where you modify the strength of the effect. I am raising the saturation of Anne's face with a brush at 25% opacity in Figure 3.20. That's a pretty light touch.

Mary Anne has the exact opposite problem of Anne. Her face looks flushed, which is an indication of too much saturation in that area compared to the rest of the photo. This might accurately reflect reality (in other words, maybe her face was very colorful at the moment the photo was taken), but I want to match her color with Anne's.

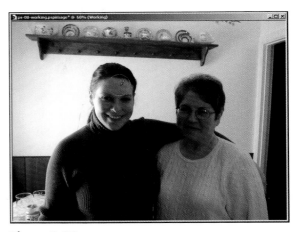

Figure 3.20
Saturating a colorless area.

I don't even have to change brushes. I'll just right-click over Mary Anne's face with my Saturation Up/Down Brush and see what happens. At 25% opacity, it was a little too much. I took all the color from her face. I am applying the brush at 15% opacity in Figure 3.21, and the result is exactly what I want.

Figure 3.21
Desaturating as required.

This is important. When you are restoring and retouching photos, it pays to have a light hand, even if what you're doing is a dramatic change. No one wants to see your work! No one wants to know that you've run amok through the photo, changing things willy-nilly. That's the paradox. You must do what you can to improve the photo while trying to keep your actions invisible to the viewer. When you've got that down, you'll be in a much better position to know when to break those rules for artistic or other reasons.

Correcting Perspective

If you thought we were done with this photo, you wouldn't be alone. I did, but then I realized something weird. The perspective is off. Take a look at Figure 3.22. I've selected the Perspective Correction tool and am about ready to accept my changes.

Figure 3.22
Adjusting the perspective.

Look at what should be horizontal and vertical in this photo. In this shot, the doorjamb, shelf, and wood paneling give the perspective problem away.

They're way out of kilter! The doorjamb should be vertical, and the shelf and paneling lines should be horizontal. The subjects look fine, but my preference is to fix the perspective problem.

Returning my discussion to the Perspective Correction tool itself (it's on the Tools toolbar with the Straighten tool), I've selected it and dragged the corner handles to areas of the photo that will help me correct the problem. I'm using the doorjamb to line up the right vertical edge of the correction marquee, and I'm using the vertical panel line in the lower-left portion of the photo to line up the left vertical edge. It takes a little practice moving the corners around to line the side up correctly. You can drag a side up or down to make sure it stays aligned. I dragged the lower side down when I was lining up the left vertical edge so I could go off the paneling and then dragged it back up to line up with the top of the paneling. Horizontally, I'm using the shelf and the top of the paneling.

When you double-click the correction window or press the Apply check mark, the perspective is corrected (see Figure 3.23). I've chosen not to enable the "Crop image" option. That way I can crop where I want to later.

Figure 3.23
That's better.

Finishing the Photo Study

Okay, that's it for this photo. Figure 3.24 shows the final product. That seemed like a lot of work just to brighten a few dark subjects, but it was well worth it. This photo also illustrated the point that problems are often tied together (brightness and noise) and can't or shouldn't be corrected alone. Solving one problem naturally leads to the next and so forth. I hardly ever approach a photo and expect to solve one problem and be done with it.

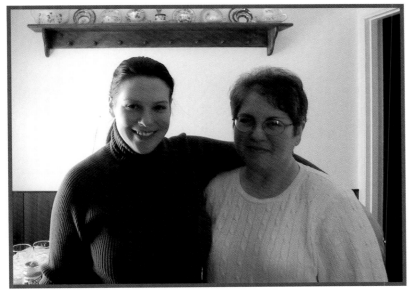

Figure 3.24
Great photo with subjects brightened.

Photo Study 9: Lightening a Dark Background

IGURE 3.25 WAS TAKEN IN A recording studio. The control room where we were sitting was a large room with a very high ceiling. It was morning, and we had the lights dimmed. The kids were sitting on the artist's couch, watching daddy work at the board. I looked tired.

The lighting in this photo mars the action on the couch, which is what I really want to see. The kids are cute, interesting, and lively. I'm sitting there tired, barely able to smile. It's hard work getting up, getting yourself ready, and helping your wife (or vice versa, as the case may be) get four small kids up and out the door by 7:30 a.m. to be at the studio by 8:00 a.m.

Getting Started

There's a lot to do and a lot to show in this photo study. If you remember from the previous example, dark lighting conditions often cause noise problems in digital photos. I often remove noise after making brightness adjustments, but I am going to reverse the process this time.

The Digital Camera Noise Removal dialog box is open in Figure 3.26, and I've zoomed in closely to see my son Ben. There is a lot of noise here, and the default noise correction values seem to do a good job at smoothing things out.

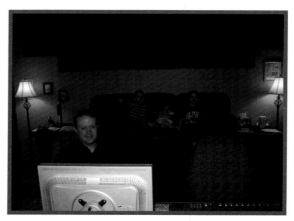

Figure 3.25
Dark background hides the action.

I've selected a few extra light, dark, and midtone areas to make sure that the noise is accurately sampled, and I've bumped up the sharpen value to 5.0.

Figure 3.26
Getting rid of noise.

Having reduced or eliminated the noise, I will move to adjust the lighting, this time with the Curves tool (Adjust > Brightness and Contrast > Curves). I know what you're thinking. What about my trusty Levels? In this case, I tried it, and the Curves adjustment looked better. When I adjusted the Levels, it took the contrast out of the photo, and my attempts to put it back in made things look worse.

Daddy's Favorite

You can have favorite tools, just like I do, but don't get so attached to them that you don't try others. This photo study shows that you need to be flexible and continue trying other techniques to find which one works best. The proof is in the pudding, so to speak. I'm also a music producer and audio engineer, and in that realm I have to listen carefully to what I'm doing. My ears are the ultimate judge. No matter what equipment or computer plug-in I become attached to, if it doesn't make the music sound better, I don't use it.

It's time to move on to the Curves dialog box, as shown in Figure 3.27. The Curves dialog box can be mysterious. You plop a few dots down in the graph, move them, and crazy things happen. Yes, that's true. There is a lot of power here, and you must use it wisely (thinking Teenage Mutant Ninja Turtles here), young one. Let's break it down.

You've got brightness in. You've got brightness out. This is what the Curves dialog box shows and allows you to change. You can change the overall RGB brightness (remember HSL and the Lightness slider?) or change each of the color channels separately.

The brightness in is shown on the horizontal axis, while the brightness out (what the input will be mapped to if you change it) is shown on the vertical axis. If you change nothing, there is a 45-degree line from the lower left to the top right, which indicates a 1:1 relationship between what's coming in and going out. The numbers in the graph show this relationship numerically, with the input, or original brightness values, on the left, and the output, or modified brightness values, on the right.

Figure 3.27
Correcting the lighting.

I've made a change to this ratio in favor of lightness in Figure 3.27. The one data point on the curve you can read says that an input value of brightness 92 will be changed to an output value of brightness 155.

Another way to get a handle on this is to double-click on the Foreground swatch on the Materials palette and choose any color. Keep the Material Properties dialog box open and look for the HSL sliders. Make the L (lightness) entry 92. Look at the color. Sort of dark, isn't it? Now move the L slider to 155. It noticeably lightens the color. You're changing one color through the Material

Properties dialog box. Using Curves in RGB mode, you're changing every instance of colors with a brightness of 92 and making them brighter. You're also affecting those values around 92 by virtue of the fact that the ratio line curves when you plop the point down and drag it (otherwise, it would be of very limited use). If you use Curves on separate channels, you are editing the brightness of each color channel apart from the others.

Correcting Small Problems

Next, I'm going to solve some small problems with the photo. The kids' eyes look funny. They are a little pixelated and have some red eye. I chose to solve the pixelation by using the Soften Brush (located on the Tools toolbar), as shown in Figure 3.28.

Figure 3.28
Softening areas.

The opacity of the Soften Brush is set to 20%, a pretty low value. I use this low opacity to blend pixels together without making them a blurry mess. I just want to soften them a bit.

Brush Opacity

You can adjust the opacity of any brush from the Tool Options palette, which is located under the Standard toolbar near the top of the workspace. I use this feature quite a bit, whether it is the Soften Brush, Eraser, Burn Brush, Clone Brush, or any other tool that allows you to change its opacity.

Now I'll address the red eyes. I tried using the Red Eye tool, but their eyes are too small in this photo for the tool to work well. You might think I would go for desaturation to take the red out, and you would be right, but first I am going to darken their eyes a bit. When I tried to take the red out first and then darken it, it didn't look as good.

I am using the Burn Brush to darken Jake's eyes in Figure 3.29. I had a few options here and chose the Burn Brush over the Lighten/Darken Brush because after trying both, the Burn Brush looked better. I set the size to 1 pixel and the opacity is 20%.

Figure 3.29
Darkening pupils.

I am using the Saturation Up/Down Brush in Figure 3.30 with size 3 and opacity 25% to carefully desaturate Jake's red eyes.

Figure 3.30
Desaturating red eyes.

Next, I need to fix my eyes. For some reason, one of my eyes has a reflection in it, and the other doesn't. I am using the Clone Brush in Figure 3.31 to copy the glint from my left eye to my right. If the glint looks too harsh, I can soften the effect very slightly with the Soften Brush.

The final problem I am going to fix here is my sleepy look. I can use the Warp Brush to ever-so-carefully push my eyelids up a bit, as shown in Figure 3.32. I'm barely pushing the corners upward to make my eyes look more open. It's a complete illusion, of course, but even a little change here will make a big difference in how I look. I need to be careful not to overdo this; otherwise, my huge eyes will make me look like I came out of a Japanese anime production.

Being a Bit Picky, Aren't We?

I fix what I notice, and my perception has increased with time and experience. There are times when I can't fix every small problem in a photo. I use my best judgment to decide what to work on and what to leave alone. When you are restoring or retouching photos with people, the face is the most important part. The lack of a gleam in my right eye and the red in the kids' eyes are very distracting, not because they are large problems, but because they were in the most important part of the photo—our faces.

Figure 3.31
Putting the glint in my eye.

Figure 3.32
Wakey wakey, Mr. Robert.

Finishing the Photo Study

Figure 3.33 shows the final product. I've lightened the photo so that the kids are much more visible, removed some of the noise that was present because of the low-light condition, softened the kids' eyes, took the red out of their eyes, added a glint to mine, and woke myself up. Not bad for one photo.

One thing that I want to leave you with is that it is possible to alter the brightness of a photo with a dark background without washing out the lighter parts. This is just such a case. If you need to lighten an area considerably, so much so that it washes the lighter parts of the photo out, select the darker area and brighten just that area. Do this on a duplicate layer and blend the lighter layer with the darker layer below it (use layer opacity to blend). In my experience, using the Lighten/Darken or Dodge Brush for large operations like this is somewhat dodgy.

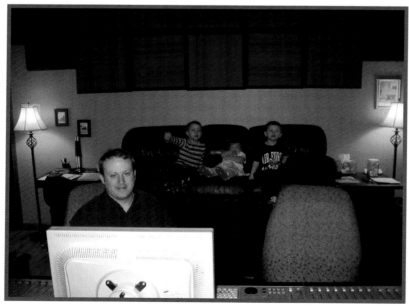

Figure 3.33
Rescuing an overly dark background.

Photo Study 10: Sharpening Poor Contrast

FIGURE 3.34 IS AN OLD PHOTO WITH, among other things, contrast problems. It's a photo of my wife's great-grandfather on her mother's side of the family.

This photo was taken sometime in 1930 or 1931, based on the age of Dwight II, the young boy. It is a good example of a very old photo that has faded, and wasn't a very strong photo to begin with. When photos fade (as opposed to turning yellow), the colors become more muted. Photos also lose contrast as they fade, which is especially problematic with black-and-white photos.

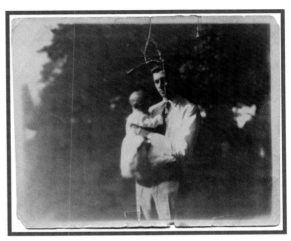

Figure 3.34
Family man in poor contrast.

Jumping Right In

I have jumped right into the contrast issue, which is what I would do outside of this book. I experiment with different contrast fixes (if the main problem is contrast related) first. After I decide on a technique to restore the contrast, I begin the overall restoration. I come back to fix the contrast towards the end of the restoration.

Working Faster

This photo was scanned in at 1200dpi, and the original file size is over 80MB. Instead of waiting forever and a day to see the results of every operation, change the resolution and create a temporary working file so you can work faster. At lower resolutions and sizes, you can also afford to create duplicate layers and adjustment layers to compare techniques. When you've decided which technique to use, go back to your original image.

Technique Shootout

Let's examine several techniques and see what will work and what won't. I am not going to dwell for long on each technique. I want you to be able to see the results, make a determination, and move on. Trust your feelings, Luke. That's a skill you will need to develop. You should be able to run through your bag of tricks quickly to see where your best prospects are.

One Step Photo Fix

First, let's try the One Step Photo Fix, located at the top of the Adjust menu. Figure 3.35 shows the result. It lessened the fade and discoloration and quite possibly helped contrast.

Figure 3.35
One Step Photo Fix performed fairly well.

Smart Photo Fix

Using Smart Photo Fix (just under the One Step Photo Fix near the top of the Adjust menu) is almost as easy as One Step Photo Fix, but there are adjustments you can make to customize the result. The Smart Photo Fix dialog box is shown in Figure 3.36. I hit the Suggest Settings button to see what Paint Shop Pro says I should do and then continue from there. I'm pleased with this result. Smart Photo Fix successfully minimizes the fade and discoloration, as well as enhancing the contrast by making the blacks a bit blacker and the whites a tad whiter.

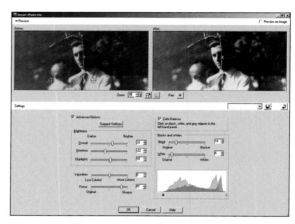

Figure 3.36
Working with the Smart Photo Fix settings.

Fade Correction

Choose Fade Correction from the Adjust ❯ Color ❯ Fade Correction menu. Figure 3.37 shows the dialog box with my settings. You can set the correction amount from 1 to 100. I've settled on a figure of 20 for this example.

I am pleased with the result. It's corrected the fade, although it's left the photo a bit dark.

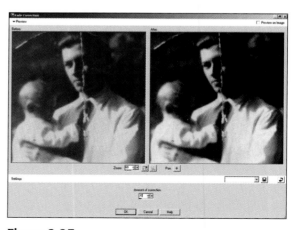

Figure 3.37
Correcting the fade helps contrast.

Adjusting Brightness and Contrast

Next, I'll adjust the brightness and contrast of the photo. If you haven't used adjustment layers yet, create a Brightness/Contrast adjustment layer on top of your base photo layer. I am entering my settings in the adjustment layer in Figure 3.38.

I've been impressed by the prior techniques. They've taken the color cast out of the photo and handled the fade better than the brightness and contrast adjustment. The photo needs to be brightened, and it needs better contrast, but this is not the answer.

Figure 3.38
Adjusting brightness and contrast.

Changing Curves

I am creating a Curves adjustment layer and entering the settings in Figure 3.39. Normally, making curves adjustments is a pretty good choice, but this photo resists this technique. I spent a good deal of time trying to find the right settings that would enhance the contrast but not darken the photo too much. These settings were as good as I got with curves.

Figure 3.39
Trying curves.

Adjusting Levels

Normally one of my favorite techniques, the rather disappointing result of adjusting the levels of this photo is shown in Figure 3.40. This photo presents a very hard balancing act. I want to enhance the contrast, remove the fade, take out the color cast, and not make the photo too dark. In fact, I will lighten it once the contrast is fixed.

Figure 3.40
Altering levels.

Using Clarify

Figure 3.41 shows Clarify in action. Choose Clarify by navigating to the Adjust menu, selecting Brightness and Contrast, and then choosing Clarify. I bumped up the settings a notch or two to 5, and I like how it sharpened the photo. It doesn't fix all the problems, but I will keep this technique in mind.

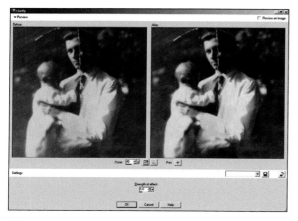

Figure 3.41
Using Clarify.

Adjusting the Histogram

Although I normally choose to work with Levels over making a Histogram Adjustment, the opposite is true in this case. I have entered my settings in the Histogram Adjustment dialog box in Figure 2.42. I've expanded the midtones and made some other small adjustments. They result in a better photo.

Histogram Equalize

Figure 3.43 shows the effects of Histogram Equalize on this photo. Although it darkens the photo too much, I'm not displeased with this result. I may use it as a basis to continue working with other techniques.

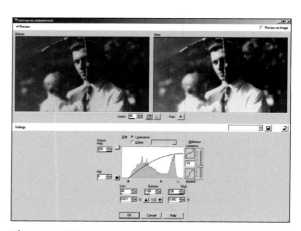

Figure 3.42
Adjusting the histogram.

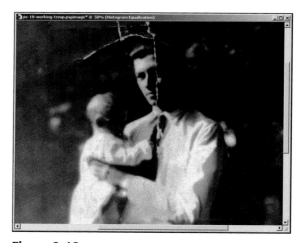

Figure 3.43
Histogram Equalize.

Fine-Tuning Highlights, Midtones, and Shadows

Finally, I am performing a Highlights, Midtones, and Shadows adjustment in Figure 3.44. I've decided to brighten up the midtones dramatically, bump up the highlights a little, and darken the darks in the photo to try to improve the overall contrast. The photo looks clearer.

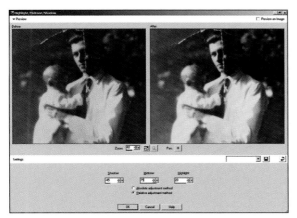

Figure 3.44
Changing Shadow, Midtone, and Lightness values.

Figure 3.45
Using multiple layers to compare results.

Layer Bonanza

In order to compare all these techniques, I created layers for each one (see Figure 3.45). I can toggle them on and off to compare the results of each technique head-to-head. I've tried saving different files in the past, but this becomes too unwieldy in cases like this. I would have to manage 10 files and keep them all straight. It's very easy to hide or show layers in one file. Pay close attention to what layer you have selected, whether it is the uppermost visible layer, whether there are any adjustment layers on, and masks. You want to know what you're looking at is what you think you're looking at.

Finishing the Photo Study

This photo study (Figure 3.46) involved a lot of experimentation with different techniques to find the best one, or possibly the best combination of techniques, that would improve the contrast. After deciding which technique to use, I fixed the surface damage (tears, tape, and so on) and then returned to improve the contrast.

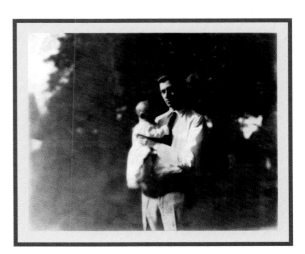

Figure 3.46
Trying my best to restore contrast.

Photo Study 11:
Improving Brightness and Contrast

THE PHOTO IN FIGURE 3.47 WAS taken in Muncie, Indiana, one summer in the early 1980s.

I played the alto saxophone and was in Jazz Band throughout school. This was a summer jazz ensemble, and we were performing on a downtown sidewalk. I'm sitting third from the left on the front row. That's me with the high tube socks. Although this was a long time ago, I clearly remember my tennis shoes. They were made by Saucony.

This photo is an example of a Polaroid print. Those are the types of photos that come in large packages that look like toaster pastries. You put the film package in the camera and pulled each photo out with tabs after you took the picture. The cameras were fairly large and bulky. The main draw of a Polaroid camera was the film developed "instantly." This development process was aided by body heat. That's what I call "old school." Our family had a Polaroid Square Shooter, and I had fun holding the film under my arm while it developed. When it was time, you peeled the print off the "negative," and you had your photo.

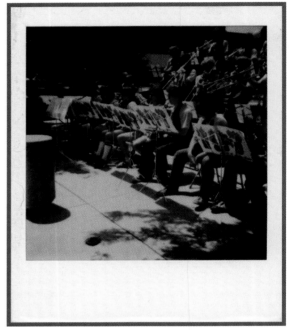

Figure 3.47
Polaroid photo suffering from brightness and contrast issues.

Using Curves and Levels Together

I am going to combine techniques for this photo study—that is, Curves and Levels. The Levels adjustment that I originally made (see Figure 3.48) didn't give me the brightness I wanted. The Curves adjustment (see Figure 3.49) went a bit too far.

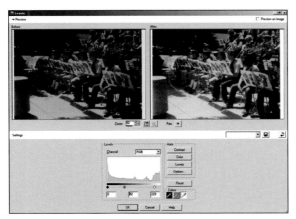

Figure 3.48
Altering levels.

To blend the techniques and get exactly what I wanted, I created two duplicate layers (above my safety Background layer with the untouched photo) and made a Levels adjustment to the lower layer and a Curves adjustment to the top layer. I then altered the opacity of the top curves layer to blend it in with the darker levels layer.

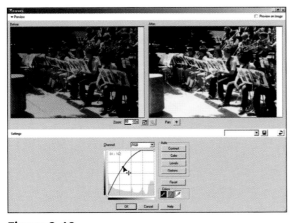

Figure 3.49
Changing curves.

Finishing the Photo Study

This photo had a lot of small specks and dust to clean up. Figure 3.50 shows the final, retouched photo, which used a combination of Levels and Curves adjustments to achieve just the right balance of brightness and contrast.

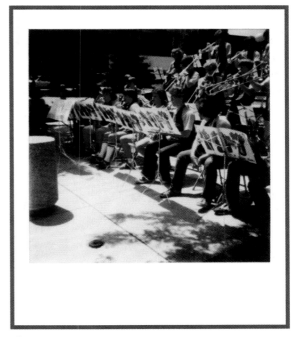

Figure 3.50
Much improved brightness and contrast.

Photo Study 12: Focusing a Blurred Subject

T HE PENULTIMATE PHOTO STUDY for this chapter is a photo of my second-eldest son, Jacob. Figure 3.49 captures him at the tender age of nine months.

This is a nice photo, but it's a tad dark and a bit out of focus. Blurring is one of the hardest problems to correct and *pert-near-impossible* in most cases. For extreme blurring, you might as well try to do something artistic with the photo, accept the blurring, or delete it. In this case, I can subtly rescue some clarity, especially around Jake's face.

Getting Right to It

Here's what I'm going to do: get rid of some noise first and then work on the focus.

1. I will begin this study by reducing the noise. A darker photo is more prone to digital noise. One Step Noise Reduction worked best for this photo. The result is shown in Figure 3.52.

2. Next, I duplicated this later so I had two identical noise-free layers to work with.

3. I hid the top layer and selected the bottom noise-free layer.

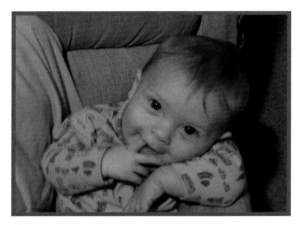

Figure 3.51
Cute, but a little blurry.

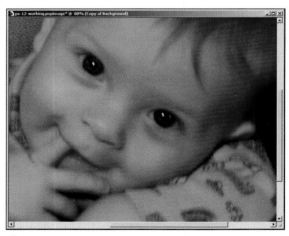

Figure 3.52
One Step Noise Reduction.

4. And now for something completely different. Noise reduction, of course, does nothing to improve the focus of the photo. It reduces sharpness as it blends pixels together. This is how the noise is removed. I will use a High Pass Sharpen filter (Adjust ❯ Sharpness ❯ High Pass Sharpen) with a Soft Light for blending (see Figure 3.53) to put some of that sharpness back. The soft light looks better on Jake's face, but doesn't work as well on his hands or the chair. I'll sharpen the chair in the next step.

Figure 3.54
Using Hard Light Blend for the chair.

Figure 3.53
Sharpening with High Pass.

Finishing the Photo Study

After finishing with the sharpen techniques, I applied a Levels and Color adjustment to brighten the photo and make the colors a tad cooler (to get rid of the overly yellowish color cast). Figure 3.55 shows the final result.

5. Next, I made the upper, noise-free layer visible and selected it. I applied a High Pass Sharpen filter to this layer, but with the Hard Light Blend mode (see Figure 3.54) this time. This created a harsher effect.

6. Now all I needed to do was blend the two sharpened layers together. I altered the opacity of the upper, harsher layer to blend it in with the lower, softer layer.

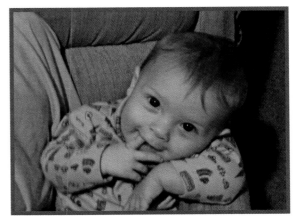

Figure 3.55
Sharper and brighter.

Photo Study 13: Minor Sharpening

THE FINAL PHOTO STUDY FOR THIS chapter is a photo of my father-in-law, Don, as a young boy. He is standing with his Aunt Jo and Uncle Sam in front of their car in Figure 3.56. Don says it's an old Dodge. From markings on the back of the picture, we know that the photo was developed on May 26, 1944.

Don lost his mother some time later, and his Aunt Jo raised him as her own. The family calls her Grandma Jo. She was a vibrant woman who lived into her 90s. Jo was a wonderful cook and wasn't afraid to use butter—lots of it. We celebrated her 100th birthday this year by cooking some of her favorite foods and drinking Coca Cola from those lit-tle 8-ounce bottles that she always had in her house.

Jo was the manager at the Dairy Queen in Fairmount, Indiana, in the 1950s and gave ice cream cones to people's pets if they brought them to the store. James Dean fans will recognize Fairmount as his home town. Jo knew his aunt and uncle. We've been to Fairmount during the annual James Dean Festival and visited his grave. Somewhat creepy, but still fun.

When Just a Little Will Do

Take a look at Figure 3.57 for a moment. Notice Sam's uniform in the left preview pane? It looks a tad noisy, doesn't it? I will get rid of that with Edge Preserving Smooth, which is in the Adjust menu under Add/Remove Noise. This noise-reduction technique smoothes out noise in photos without taking away the detailed edges. It works pretty well in most cases. The uniform looks a lot better, and you can see that Don's face didn't lose any clarity.

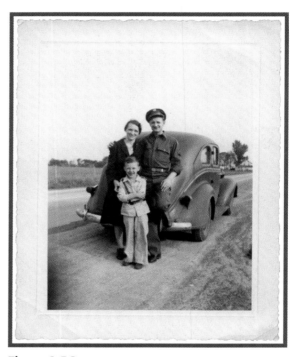

Figure 3.56
Lighthearted moment, 1944.

Always Look at Faces and Eyes

When you are smoothing a photo or reducing noise, always look the person in the eye. From this vantage point, you'll easily be able to see any drop in clarity and decide whether it's worth it or not.

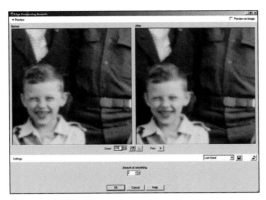

Figure 3.57
Taking out some noise.

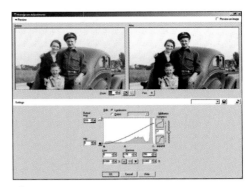

Figure 3.58
Improving contrast.

Having eliminated some noise, I will address contrast next through a histogram adjustment. Choose Adjust ❯ Brightness and Contrast ❯ Histogram Adjustment to open the Histogram Adjustment dialog box. Figure 3.58 shows my alterations to the histogram. I expanded the mid-tones, altered the gamma, and trimmed the top and bottom with the Low and High sliders.

Finally, I selectively sharpened parts of the photo with the Sharpen Brush. I use this technique when I think the photo is basically good, but I want to add clarity to certain areas. I am sharpening Sam's cheek in Figure 3.59. I will apply this to other edges and areas in the photo that I want to pop out more (around the car especially).

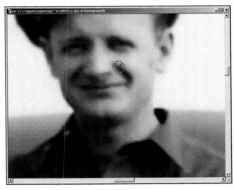

Figure 3.59
Selective sharpening with the Sharpen Brush.

Finishing the Photo Study

One of the lessons from this chapter is that there are few hard and fast rules. Some techniques work for some photos and not for others. You should not be afraid to experiment and find what is best for each individual photo. Your persistence will pay off, and you will soon be able to judge which techniques to try first. You'll still be surprised at times, but that's part of the fun of restoring photos. Figure 3.60 is it—the final figure. Ciao!

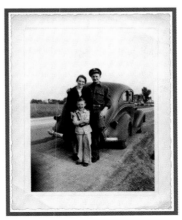

Figure 3.60
Fully restored photo with selective sharpening.

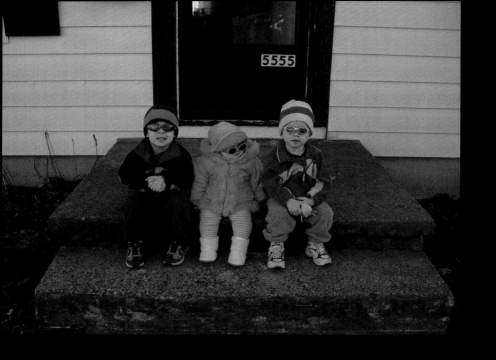

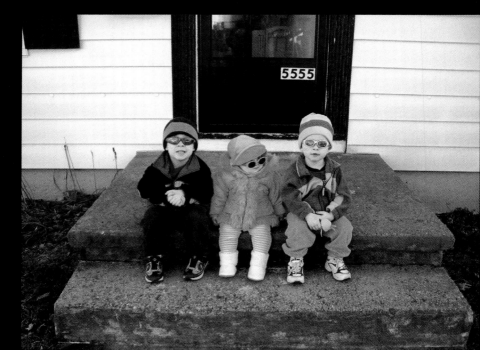

Making Color Corrections

4

T HE SUBJECT AT HAND IS COLOR CORRECTION. That can include older photos (even black-and-white ones) that have aged, yellowed, or were not vibrant to start with. It can also include newer digital photos that have color problems. Digital cameras, in and of themselves, don't guarantee a good photo or good color. Although color problems may appear to be insurmountable, you can do a lot to correct them—probably more than you realize. Let's examine five photos in this chapter from the vantage point of color.

▶ **Photo Study 14**: **Improving an Overly Yellow Color Balance**— New photos aren't immune to color problems. I'll show you how to subtract specific shades of color out of a photo and enhance what's left.

▶ **Photo Study 15**: **Warming a Cool Color Balance**—There is too much blue in the photo, resulting in a "cool" appearance. I'll warm it up dramatically by taking out the excess blue.

▶ **Photo Study 16**: **Restoring Photos Yellowed with Age**—This is a very common problem with older photos, even if they have been stored properly. Air and the oil from our hands react with the print and cause it to chemically "age." I'll restore a very yellow photo and make it look almost as good as new.

▶ **Photo Study 17**: **Improving Muted Colors**—Saturation is our focus in this photo study. I will improve the vibrancy of a photo of my dad's 1968 Pontiac Firebird.

▶ **Photo Study 18**: **Dealing with Oversaturated Colors**—This is the opposite of strengthening muted colors. In this photo, colors are too strong—so strong they almost hurt your eyes! I'll show you how to turn down the color "brightness."

Photo Study 14:
Improving an Overly Yellow Color Balance

W E HAVE A TRADITION IN OUR family where we take our children to the mall on their first birthday for a special treat: a large teddy bear. We broke with tradition with Grace. Unlike the boys, who each got a teddy bear, we decided on an orange tabby cat for her (we have now rectified that situation). She reminded us of one of my mother's special cats, named Margie.

Figure 4.1 is a photo of Grace holding Margie in the store. This photo is marred by the fact that it's overly warm (yellow). The problem was that the store was filled with yellows and oranges. The wood floors were sort of a yellowish brown, and the walls were a similar color. Grace's skin tone is in the same color range, and Margie is also orange.

There are several ways to alter the color balance of a photo in Paint Shop Pro. Let's belly up to the smorgasbord and see what's for dinner.

Figure 4.1
Grace holding Margie the orange tabby.

Technique Smorgasbord

Interestingly enough, you can use many of the same techniques to fix color problems that you can use for brightness and contrast issues and extend those techniques by adding color-specific fixes. Let's break color down into three components and talk about each one briefly:

▶ **Hue**—the perceived color, which for computer graphics (including digital photos) is a mixture of red, green, and blue values. The strength of each RGB component (from none, or 0, to full, or 255) determines the overall color.

In the context of an RGB triplet, pure red would be written as 255,0,0. Hue also exists in different color spaces, such as HSL, which stands for hue, saturation, and lightness. In this context, hue is a continuous wheel of color ranging from red to yellow, through green and blue, to purple, and then back to red. Think of hue as the color, with different ways to measure and change it.

▶ **Saturation**—the balance between the color itself and gray. A totally saturated color would be pure, such as pure blue, with no gray in it. Think "vibrancy." Blue with a lot of gray in it is muted by comparison. We can saturate (take gray out) or desaturate (put gray in) photos. Saturation is also related to contrast. The more gray a photo has, the less contrast it will appear to have. Ever go driving on a foggy day?

▶ **Lightness**—the balance of the color with white or black. This is pretty intuitive. Dark green has more black in it than light green.

As you look at the following photo studies, think in terms of RGB or HSL in order to come to a conclusion on how to fix the problem. Too little vibrancy? That's a saturation problem. Too dark? That's a lightness problem. I covered lightness in Chapter 3, "Finding the Right Brightness, Contrast, and Focus." Too blue? That's an RGB issue. Are the greens red and the blues yellow? That's something wrong with the hue.

There are several ways to turn colors up and down in Paint Shop Pro Photo, and there are a lot of ways to push colors from one hue towards another and add or subtract the amount of gray present. Let's dive into the specifics of several techniques as we attempt to restore this photo of Grace.

One Step Photo Fix

There's little to say here. I always try One Step Photo Fix, and it often works. Figure 4.2 shows the result for this photo. It didn't correctly identify the hue problem. Next.

Figure 4.2
One Step Photo Fix disappoints.

Smart Photo Fix

Smart Photo Fix, shown in Figure 4.3, is much better. The key with using Smart Photo Fix when you're addressing a color problem is to enable the Color Balance check box on the right side of the dialog box and then do what it says. Zoom in on areas in the left preview window and pick out good examples of black, white, and gray objects and click on them to give Paint Shop Pro good reference points.

Figure 4.3
Smart Photo Fix is much better—note my color spots.

I was able to get all three of my color spots visible in the figure. I decided on the dark area of the stroller as black, the lighter fabric of the stroller to be gray, and part of the tag on Margie to be white. Manually selecting these points adds your "smarts" to the equation. The "white" spot I am in the process of choosing has a little color swatch come up for us to see, and it reads out the measured RGB value. Nice touch! You can also see that what should be white is very yellow. That's the problem, right there in a nutshell.

Color Balance

If you want a faster, easier fix, try Color Balance from the Adjust menu. Figure 4.4 shows the dialog box, which is decidedly simpler than the Smart Photo Fix dialog box. Leave the Smart White Balance option enabled (normally a good thing to do) and drag the Temperature slider back and forth from cooler to warmer until you find the right balance.

Figure 4.4
Cooling down a photo with Color Balance.

This photo has far too much yellowish orange in it, which makes it too "warm." I've dragged the Temperature slider all the way to the Cooler side. It's not bad. You don't get as many same options as you do with Smart Photo, but this is often a good place to start from.

Channel Mixer

Figure 4.5 shows the Channel Mixer. You can open up the Channel Mixer from the Adjust > Color menu. This approach gives you a lot more control over the balance of colors in each channel. With great power comes great responsibility. As least Spiderman says so.

Figure 4.5
Channel Mixer is not for the timid.

Uncheck monochrome for a color photo and then choose an output channel from the top list box. Figure 4.5 shows the Red channel. The main part of the dialog box shows the percentage change to apply to each component source channel. (That was a mouthful.) The values range from negative 200 percent to positive 200 percent. That means you can change the output mix of each channel by cutting or adding red, green, or blue to that channel. Don't forget to switch to the other channels and adjust them as well.

Fade Correction

Back to something simpler. Fade Correction, from the Adjust ❯ Color menu, works to restore the proper color balance to a photo that has aged or faded. Although this is a digital photo, Fade Correction could work to reduce the yellow. Figure 4.6 shows the dialog box with a preview of what will happen if I accept these values.

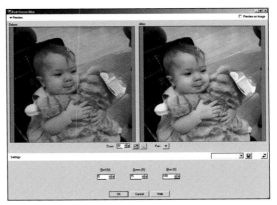

Figure 4.7
RGB is easy and effective.

Figure 4.6
Try Fade Correction to reduce yellow.

Fade Correction turned out to be pretty good. You should understand why at this point. (Hint: Old photos often yellow with age.) You can increase or decrease the amount of correction to strengthen or weaken the effect. I've put it at 60.

Adjusting Red/Green/Blue

Want to adjust the strength of the red, green, and blue component colors? Simply go to the Adjust ❯ Color menu and choose it from the other options. The Red/Green/Blue dialog box is shown in Figure 4.7.

Go to the Red, Green, and Blue colors and change them until you get a good balance. You can add or subtract up to 100 percent either way. It helps to know a little about color and where specific colors sit on the spectrum. For example, there's no option to turn down yellowish orange, which is what I need to do. Click on the foreground color in your Materials palette and look at the color wheel. Yellow and orange sit between red and green, with orange close to red. That's why I turned up blue a lot and green a little. I was able to counteract the excessive yellowish orange by turning those colors up. I love it when art and science come together!

Making Histogram Adjustments

Do you remember using the Histogram Adjustment tool in the last chapter? It's back in action here, because it's a useful tool with powerful options. Figure 4.8 shows the Histogram Adjustment dialog box, with the Edit radio button set to Colors, and the Red channel displayed. You can use the Histogram Adjustment settings to adjust the histogram of each color component of your photo by selecting the color (red, green, or blue) from the drop-down menu. Look carefully and compare the graphs for each color. This can be a diagnostic as well as restorative tool.

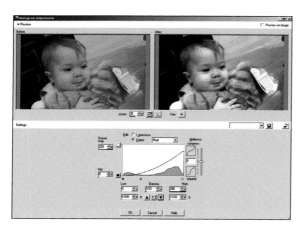

Figure 4.8
Adjusting individual colors can be powerful.

Figure 4.9
Red and green combine to make yellow.

Red doesn't actually look too bad. I've adjusted the gamma (which is related to brightness and contrast) downwards. This has the effect of darkening the red colors.

Figure 4.9 shows the Green channel. Whoa, baby. This one's out of whack. There are no (or very few) light greens present in our photo. I've moved the High value down, which has the effect of lightening up the Green channel because it's remapping the existing green (in this particular photo) to a broader, lighter range. The greens in this photo are skewed towards the darker side of the force.

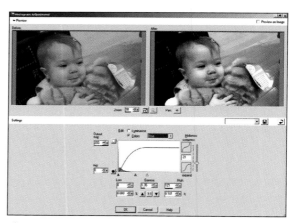

Figure 4.10
An overly warm photo lacks blue.

Figure 4.10 shows the last channel, Blue. Where is it? It's not really there. There is very little blue in this photo. This is why it looks so "warm" and overly yellowish orange. There are no blues! Drag the High slider down to lighten the blues in the photo. I've also expanded the midtones in the Blue channel.

Finishing the Photo Study

Figure 4.11 shows the final photo. It's amazing what a little bit of color correction can do. The winning technique? Good 'ole Smart Photo Fix.

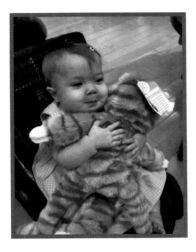

Figure 4.11
Touching photo rescued from yellow fever.

Since this is the first study of this chapter, I want to mention that my finished photo in each study is the result of *more* than what I've been showing you how to do. Each "finished" shot is the result of a combination of things, including the main teaching point. I went thought the following steps to come to the final result for this photo:

1. Applied Smart Photo Fix from the Adjust menu. This was the main teaching point for this study and did the job of correcting the color imbalance. I ended my narrative here, but you can see the fully restored (or retouched) photo in Figure 4.11. When working on your photos, you will apply a number of the different techniques, too, ranging from noise reduction to color balancing to contrast adjusting or fixing physical damage, all on one photo.

2. Clarified the photo to improve the contrast.

3. Duplicated this layer.

4. Performed a One-Step Noise Removal on the bottom layer. This worked great on the background and stroller, but did not work as well on Grace's face. The stroller lost a lot of detail in the fabric, and Grace's face was still noisy. I came up with a way to solve that.

5. Performed Digital Camera Noise removal on the top layer. This worked great on the stroller and Grace's face.

6. Lowered the opacity of the top layer from step 5 to blend the two noise reduction layers together. I was looking to keep certain details (the fabric, for example) yet reduce the overall noise.

7. Selected the top layer. Pressed Ctrl+A to select everything and then pressed Ctrl+Shift+C to copy the merged layers together.

8. Pressed Ctrl+L to paste this blended composite layer as the top layer in the Layers palette. It was then my new working layer.

9. Touched up other areas that needed smoothing or blending.

Photo Study 15:
Warming a Cool Color Balance

FIGURE 4.12 SHOWS THREE OF MY four children sitting on the front porch posing for a group portrait. This digital photo was taken in the winter. It was cold, but it wasn't to the point where they needed their Arctic gear that day. We had Ben and Jake in their fleece jackets, cool sunglasses, and light-up shoes. Gracie was decked out in her pink coat, pink pants, pink boots, and, of course, pink sunglasses.

This is probably the sort of photo you have. It's a casual shot of everyday life that turned out to be a photo that we want to try and keep. The problem is, it's incredibly blue. Photo-wise, blue is an opposite of the reddish-yellow colors in the previous photo study. Reds, browns, and yellows (think skin tones) make a photo look warm. Blue makes a photo look cool.

I'm going to run through several different ways to warm this photo up and then decide on a winner. Let's go.

Technique Trials

I won't go over the color theory again, but I want to say this photo has the opposite problem than the previous photo study. There is too much blue instead of too little. The result is a photo dominated by the "cool" hue of light blue.

Figure 4.12
Brrrski-brrr.

Smart Photo Fix

The Smart Photo Fix dialog box is shown in Figure 4.13. This opens up when you choose the Adjust > Smart Photo Fix menu. I've pressed the Suggest Settings button, as I traditionally do, to see where Paint Shop Pro Photo leads me. Then I tweak and adjust. You can see that I've selected three color balance points. I've chosen the black of the screen door, the white of the house siding, and the gray of the concrete porch as the color samples Smart Photo Fix will rely on to adjust the color balance. The result is good.

Color Balance

Trying to fix the overly blue cast using the Color Balance technique, as shown in Figure 4.14, doesn't work so well for this photo. It takes out the blues when I drag the Temperature slider toward the Warmer region, but the result seems lifeless.

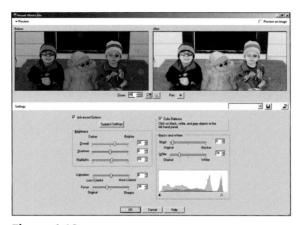

Figure 4.13
Smart Photo rocks.

Figure 4.15
Channel Mixer comes close.

Fade Correction

In the last photo, I showed you that Fade Correction could restore a yellow, faded photo. Figure 4.16 reveals that it has a certain degree of effectiveness here, too. Remember to keep trying alternative methods. If it doesn't work well for one photo, it might work for the next.

Figure 4.14
A little lifeless.

Figure 4.16
A little too much contrast.

Channel Mixer

Here again is the Channel Mixer. This time I'm showing (see Figure 4.15) the Blue output channel. I've increased the Red source a tiny bit, the Green source by a fair amount, and the Blue source a little. I tweaked the other output channels as well.

I like what Fade Correction has done, but the result has a little too much contrast in it. I will enhance the contrast in my final photo, but I will use a method that will give me greater control than this.

Adjusting Red/Green/Blue

Adjusting each component channel is the forte of Red/Green/Blue. You would think this might be the perfect solution for this problem. Too much blue? Just turn it down! I've added a lot of red (remember, adding the other components can be as effective as turning the offending one down) and some green and taken some blue out in Figure 4.17.

Figure 4.17
Good, but not vibrant enough.

It's not bad, but take a close look at it compared to the other techniques. This lacks a degree of vibrancy, which indicates a saturation problem.

Adjusting Curves

I'm going to throw you a curve ball in this study and bring back Curves. The Curves dialog box with the Red channel active is shown in Figure 4.18. The great thing about Curves, much like Histogram Adjustment, is that you can switch to each channel and change the color balance. We can see from the plot that the red is too dark in this photo. There isn't enough of it because the blue has squeezed it all out. As you make these changes, look for matching colors in the photo to help you find your way. Ben's shirt is red. That's a good signpost. Whatever we do, that shirt should be bright red.

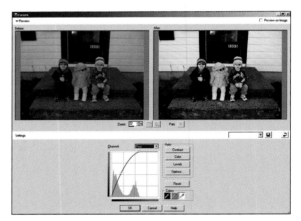

Figure 4.18
Not enough red.

Figure 4.19 shows that there is green, but it's a little squished down. I can help that out by adding a few dots at the correct places. I've sneaked the top down and the bottom up a bit and bowed the curve some to lessen the intensity of the green. In the Curves dialog box, a convex-shaped curve (think "outy") intensifies that component color, and a concave shape (like an "inny" belly button) turns the color component down for each pixel. I looked at the green ears on Jake's bug as a reference point for me to see what green should look like in this photo.

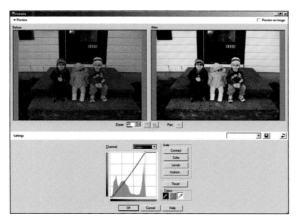

Figure 4.19
Look at the green ears on Jake's plush bug.

The Blue channel in the Curves dialog box is shown in Figure 4.20. There's a pretty even distribution of blue from dark to light. That figures. There's a lot of blue in this photo!

The solution? Bow the curve inwards and bring the right side of the plot down to mix some blue out of the photo.

Figure 4.20
Removing too much blue.

Finishing the Photo Study

This fully restored photo, shown in Figure 4.21, is one of those "miracle" restorations. It's one that you can pull out of your portfolio and show people, and they'll all go "Ahhh, how did you *do that*?"

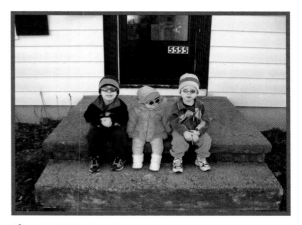

Figure 4.21
The kids are alright.

Here are the steps I took to restore this photo completely. First, I used the Smart Photo Fix as a baseline to start from. Then I fixed contrast with a Histogram Adjustment. Next, I bumped up the saturation to make it a bit more vibrant (subtly, but you can tell if you look at Grace's pink coat). I then removed some noise, but after I did, the concrete looked funny. No matter how I tried to take out the noise, the concrete suffered. My solution? I duplicated the working photo layer and then applied Digital Camera Noise Removal to the top layer. I wanted my kids' faces to look better, so I erased everything on that layer but their faces. I blended the two layers together by lowering the opacity of the layer with the kids' faces (the one on top, which had the noise removed). When I was satisfied, I did a Select All, Copy Merged, Paste as New Layer. Finis!

Photo Study 16: Restoring Photos Yellowed with Age

THIS IS A CLASSIC POST-WAR (World War II) photo, taken sometime in July or August of 1949. It's of my mother-in-law's (Mary Anne) family. She's the baby that's being held by her mother. Her dad, Bud, was a tenant farmer at this time. He had fought in World War II as an artilleryman and had come home afterwards to get married and start a family. The kids are the baby boomers you read about in the history books.

My War Memories

It *weirds* me out to think that the time between World War II and my birth (20 years) is half as long as the time from my birth to now (41 years). My very scant war memories of childhood are of Vietnam (which was going from the mid-60s to the early 70s) being on the nightly news. We were also in the Cold War at that time, which continued well after the end of Vietnam. In fact, the Cold War was still going on when I graduated from college at the United States Air Force Academy in 1988.

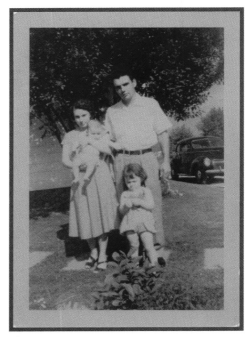

Figure 4.22
Classic Americana, but can it be rescued?

Here's an odd twist to this picture. It's somewhat rare to have a casual family photo that's in color from this time period. We are so used to seeing color photos that it took me a while to realize this was 1949, and most of the family photos we have from this time and well into the 1950s are all in black and white. Mary Anne says that the camera probably belonged to her grandmother and grandfather (the parents of the woman in the photo), who had good jobs, grown kids, and some extra leisure income to spend on a color camera. This picture presents us with a classic case of aging and yellowing.

Deciding How

I've used the Smart Photo Fix twice now. Is that the answer? We'll see. Remember, you should try a lot of different techniques. Which one looks best will depend on each photo, your skill at using the tools, and what day of the week it is. On Saturdays, don't even try Fade Correction.

Smart Photo Fix

Figure 4.23 shows the Smart Photo Fix dialog box. It's a pretty good technique to use here. The aged yellow tint is gone, and the photo looks nice. I've chosen spot colors here as well. That's really crucial to getting the right color balance out of Smart Photo Fix.

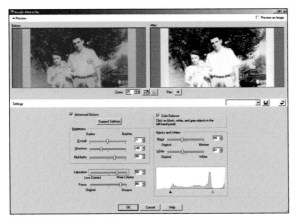

Figure 4.23
Choose spot colors for best results.

I'm not going to use this one for the final photo, even though it's pretty good. It looks a little washed out. I could lower some of the settings in this dialog box to try and correct that, but then again, those settings are part of why it looks as good as it does.

Fade Correction

Fade Correction, as shown in Figure 4.24, doesn't look too hot. The yellow is gone, only to be replaced by green. To be fair, I didn't have to apply a ton of correction to this photo to take the yellow out, but the green problem got worse the more Fade Correction I applied.

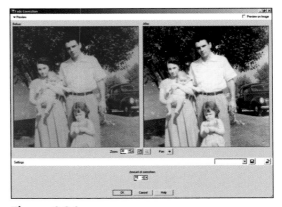

Figure 4.24
Fade Correction results in greenish cast.

I'm going to be adventurous and use Fade Correction as a basis to alter the RGB percentages. I am removing the overly green appearance caused by taking out the overly yellow appearance in Figure 4.25 with the Red/Green/Blue dialog box.

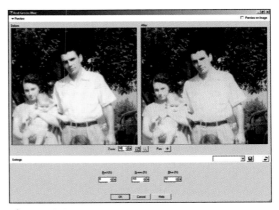

Figure 4.25
Taking the green out.

I left the red percentage alone, cut green, and added blue. I'm happy with the result of this two-stage process. Notice Bud's shirt and Louise's dress. Bud's shirt is now bright and white, and Louise's dress is blue.

Histogram Adjustment

Finally, let's look at a good Histogram Adjustment. Even though I used this tool in the previous chapter to change brightness and contrast, it is also very useful for altering the color of a photo. Make sure to press the Colors radio button and switch between the three channels if you want to work with color. I am working on the Blue channel in Figure 4.26.

Figure 4.26
Adjusting each Histogram Color channel.

The final result for this technique is good. Worth keeping, as a matter of fact. I lowered the High slider on the Blue channel and raised the gamma to sharpen the contrast. The Red channel had most of the reds in the upper-mid range. I simply dragged the Low and High sliders to match the range and tweaked the gamma to make it look good. The Green channel didn't have many highs. It occupied the upper-mid range downwards. I performed the same operation on it as I did the reds.

Finishing the Photo Study

The final, finished restoration for this photo is shown in Figure 4.27. The color problems are (mostly) gone, and I spruced up the rest of the photo.

Figure 4.27
Aging process successfully reversed.

In this case, fully restoring the photo took a lot of work. The color problem was actually the easiest, least time-consuming part of the restoration. Afterwards, I improved the contrast and then did a lot of cloning to remove specks and scratches. I took some noise out and clarified again to improve contrast; then I cloned some more as a final touch-up (to catch problems not fixed or revealed by my prior efforts). The last thing I did was select the photo itself (sans border), invert the selection, and then lighten the border to make it look as good as the rest of the photo.

Before moving on, I would like to discuss the "before" and "after" comparison briefly. I sometimes get caught up in wanting to restore the photo so that it looks "perfect." Well, that isn't possible most of the time. You could spend a year working on some of these photos, and when you finished they still wouldn't be perfect. A lot of that has to do with the original photo. Was it in focus? Was there a lot of noise? Was it developed correctly?

Always compare the "after" shot with the "before" shot, and if it's better, then you've done your job. If it's worse, or you can tell there's been an excessive amount of retouching, then you should go back to the drawing board.

For this particular study, the end result looks a lot better, but it's not perfect. There is a somewhat greenish cast to it, the right side of the photo (a vertical swath that is aligned with the grille of the car) had some problems when it was developed, and it's just not quite in focus. But it's better than it was, and that's saying a lot.

Retail Outlet Printing

In this sidebar, I want to return to the world of photo printing, only this time from a different angle: retail outlets. Printing your photos at retail outlets is a viable option, even for high-quality restorations. Today, you can stop by your neighborhood supermart and drop your digital photos off to be printed and picked up in an hour. Just like the old days of dropping off negatives.

There are a ton of places that develop (I mean, print) digital photos: Wal-Mart, Meijers, Walgreens, Sams Club, Target, KMart, CVS Pharmacy, and Sears (just to name a few) all offer digital photo printing services. Take your digital photos to the store on a memory card or CD-ROM and have them printed while you shop. For a pretty reasonable price, too. Most places give you the option of sending your files over the Internet and then picking them up or having them mailed to you when they're done. Talk about convenient!

We take advantage of these services quite a bit when we print a large number of digital photos. Anne loves putting together and sending photo albums, especially for my dad and other long-distance family and friends. The albums catch everyone up on what's been happening in our lives. You can also put together theme albums that cover events like birthday parties or holidays. Dare I mention scrapbooking? There's something about having a real photo album to look through that's nice.

The benefits of having someone else print your photos are obvious: fast, cheap, timely, and hassle-free. It's far cheaper for us not to use our own ink and photo paper for large-scale operations. The prints are normally very good quality.

Look around at the stores you frequent and ask for their prices and printing options. Some may not be able to print .tif files. Others may. JPEGs should be universally accepted. You probably won't be able to take a .pspimage in to have it printed. Make sure to save a copy of your work in a format the store will accept.

You can decide for yourself whether or not you like sending your files over the Internet. The store doesn't even have to be in your town. Kodak has services that are entirely Internet based, and they mail you the prints.

Paint Shop Pro Photo even has a button in the Organizer called *Order Prints* that automatically connects to a photo provider and orders prints from the photos you choose. You can see, choose from, and update this list of providers from the Edit > Preferences menu and then choose the PhotoSharing tab.

I'm going to close with a few semi-random thoughts. First, there are in-store kiosks that let you "do it yourself." Whether you use a kiosk or hand things over to a person behind the counter, ask whether the prints will be glossy or matte. At some places your options change based on how fast you want the prints or their size. Don't be surprised (like we were).

Anne has one more thing for me to add. We had an experience at one store where the overall product was very different depending on how fast we wanted the prints. If we wanted them done in an hour, they printed them in-house—without making any adjustments whatsoever to the photos. We learned that we had to tweak the lighting ourselves the next time to make the photos better. If we ordered them to be picked up in a few days, the printing was done in a different city, and they made lighting adjustments. If you've restored a photo, and everything is exactly the way you want it, and someone goes around automatically lightening for you, that could be a problem. Ask and test. Send some test photos to be printed and critically evaluate them. Printing is a funny thing. What you see on your monitor has to be calibrated so that you're seeing what is present in the photo, and then it has to be translated from ones and zeros to ink and paper.

And now, back to your regularly scheduled programming.

Photo Study 17: Improving Muted Colors

The Firebird

This is an iconic photo for me. It represents my father and my connection to him, which means you get to read some of my story to understand the significance of that. I won't put the majority of that story here. Look me up online, and we can get to know each other better. Suffice it to say that my mom and dad were divorced when I was pretty young. She later remarried, and we moved across the country.

Figure 4.28
Muted muscle car.

A S A RESULT OF THAT MOVE, AND other things, we weren't a part of my dad's life. I don't have many memories of my father, except for a handful from when I was very young. I remember him drawing, and I remember playing with a golf club he cut down to my size. I have a few fragments of memories that involve cars, driving, and going on a trip to see my uncle. During that time, this photo was about all I had. I treasured it. It was my Dad's car, and it was cool. I love the red stripe on the tires, and of course, I love the green color. You might like to know that Dad and I have been recently reunited. This picture could use some sprucing up. The years have taken away some of the original luster, and it looks a little bit out of focus. There are also the ever-present specks and physical imperfections we can clean up.

Examining the Options

In this photo study, we're given a photo whose colors are basically correct (i.e., the blues are blue, and the greens are green), but they aren't strong enough. Our task is to find the best way to saturate the photo.

One Step Photo Fix

Here we go. One Step Photo Fix. Figure 4.29 shows the result.

Figure 4.29
Fast One Step Photo Fix.

If all you had time to do was this, you would still have improved the photo. It lightened things up and helped with the contrast.

Smart Photo Fix

Figure 4.30 reveals our trusty Smart Photo Fix in action. I've taken care to select objects in the left-hand panel that are black, white, and gray in order to get the right color balance, but in this case it worked too well. The colors look too bright and artificial for me. I want them brighter, yes, but I'm going to keep looking for a better solution than this. If I have to, I can always come back to this and lower the saturation a bit.

Figure 4.30
Smart Photo rocks (maybe too much).

Fade Correction

Figure 4.31 shows a Fade Correction of 20 before it is applied. The fade, seemingly imperceptible until you remove it, is gone, and the colors look brighter. They aren't so bright that they look artificial either, as compared to the last figure. Tell you what. I will use this as a new starting point to see what else I can do.

Figure 4.31
Fade Correction actually does work very well here.

The thing I like most about how Fade Correction worked in this instance is that it removed the fade without compromising the colors. They still look natural, and their hue wasn't changed. However, I would like to see them more vibrant.

There's an easy way to do this. I will open the Hue/Saturation/Lightness dialog box by choosing the Adjust ❯ Hue and Saturation menu and choose Hue/Saturation/Lightness. I am tweaking the saturation upwards ever so lightly in Figure 4.32. Ah, that's it. The green of the car seems to pop a little more.

Figure 4.32
Tweaking saturation slightly.

There are only a few things left to do here. The photo looks a little blurry, don't you think? I'm going to use High Pass Sharpen to clarify things. Notice the wheels in Figure 4.33. Look for details like this that will help you ascertain the effects of what you're doing. When I look at the wheels, I can clearly tell that sharpening is working. While I sharpen, I am careful not to sharpen so much that I introduce "oversharpening artifacts" into the photo.

Figure 4.33
Sharpening slightly helps the car and shadows.

Finishing the Photo Study

Figure 4.34 shows the final Firebird in its restored glory. Realizing, of course, that we're basing our evaluation on a before/after paradigm rather than an "Is it perfect in every way?" matrix. It looks better. That's what I'm after. The best effect for this photo is achieved subtly. The sky should not be too blue, nor should the car be too green. They should be bluer and greener, respectively, than they were.

Figure 4.34
I love this car!

Photo Study 18:
Dealing with Oversaturated Colors

FIGURE 4.35 CAPTURES ONE OF MY wife's happiest childhood moments. It was Christmas of 1982 at her Grandma Jo's house, and she had just opened her last present. It was a Cabbage Patch doll.

They could hear her screams of glee in the next county. You see, everyone wanted a Cabbage Patch doll that year, and you had to be on a waiting list to even get one. There were fights in stores over these dolls, because they were such a hot commodity. Anne didn't even ask for a Cabbage Patch doll because she knew they were pretty expensive, and she didn't think there was even a chance of getting it.

But miracles happen.

Her Grandma Jo (she's in several of the photo studies in this book) had a friend who ordered nine dolls. Somehow, she was called to pick them up, but wasn't crossed off the list. She got called again. Amazingly (this is what those dolls did to fine, upstanding people), when she got the second call she complied and went back and got another nine. She sold them (at cost) to her friends who couldn't get their own. This story, and Anne's amazing reaction, remained one of Jo's favorite stories to tell until she passed away.

Figure 4.35
Anne with her dolly, glowing with color.

Thus, Lyndon Jock came into Anne's life through a variety of fortunate events. He had a weird name (part of the appeal, Anne tells me), a birth certificate, and adoption papers. Anne calls him Josh, and says he was quite popular. Anne was the only one in her circle of friends to have a boy Cabbage Patch doll, so he was the "boyfriend" to all of her friends' dolls. Josh later got a "sister" Cabbage Patch doll named Emmy Aggy.

The photo that immortalizes this event is overly saturated with color. Let's look at the options we have and try to tone it down a bit.

Desaturation Options

There are some tough calls to make with this photo. Anne's sweater, for example, is a meltdown of saturation—so much so that we've lost a lot of detail. Lowering its saturation will lessen the pain but won't make the photo as a whole look much better. What will I look at to decide how to approach this? Anne's face, the couch, the doll, and the wall. When these four elements are in harmony and not overly saturated, I'm done.

Let's get *crackalackin*.

Using the Histogram Adjustment

Figure 4.26 shows the first step in adjusting the photo's histogram. There's a lot of bright red in the photo, with a couple of really prominent peaks. I've brought the Low and High sliders in to match the actual range of the red in this photo and darkened it a bit by sliding the Gamma downwards.

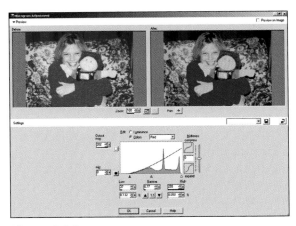

Figure 4.36
Too much red.

There's not much I can do with green, as Figure 4.37 shows. I can bring the High slider down and brighten the green by raising the Gamma slider.

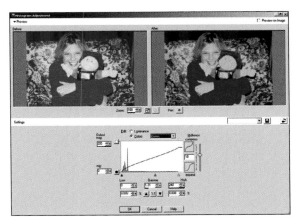

Figure 4.37
A little green.

Blue has the same problem as green in this photo, as seen in Figure 4.38. It's pretty nonexistent! The same solution applies here.

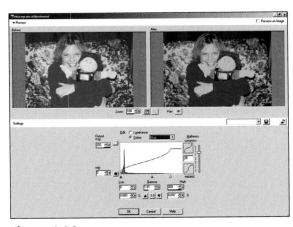

Figure 4.38
Some blue.

The overall result of adjusting each color channel in the Histogram Adjustment dialog box is mixed. The couch and Anne look marginally better, but I'm not happy with the wall or the contrast.

Adjusting Hue/Saturation/Lightness

Next, I will alter the saturation directly via the Hue/Saturation/Lightness dialog box. I've desaturated by 45 in Figure 4.39. Unfortunately, this takes a too much life out of the photo.

Figure 4.39
Desaturating somehow takes the life out.

If you look carefully at Josh's shirt, it looks fine in the left window but washed out in the right-side Preview pane. I can get some of this back if I use Curves directly after the saturation change.

I adjusted the range of each channel's curve in Figure 4.40 to match the low and high and then bowed them in or out to get the best-looking color. For red, it's a concave shape, which lowers the intensity of the Red channel in each pixel.

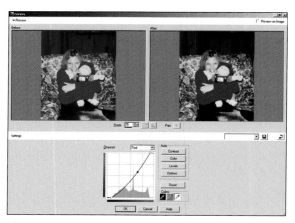

Figure 4.40
Putting life back in with Curves.

Curves Plus

I'm still not completely happy. Both techniques thus far have their merits, but I am going to continue with more techniques to see if there's anything else that looks better.

I've gone back to the Curves dialog box in Figure 4.41 and made minor adjustments. First, I brought the upper and lower parts of each channel inwards to match the graph. I've also made the red curve concave to lower its intensity. Notice the blue of Anne's skirt. It's actually blue now, like it should be. Her face and the rest of the "touchstones" I mentioned earlier also look good. It's especially important in a photo like this to look for these points and compare them before-and-after, or "between," techniques. This is our winner.

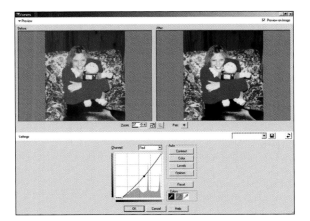

Figure 4.41
Curves by a nose.

The only thing left to do is take a bit more saturation out with the HSL dialog box and be done with it.

Finishing the Photo Study

Figure 4.42 shows the final product. Oversaturated photos lose details that can never be recovered. Anne's sweater is devoid of detail in the original, and with the exception of the shadow of her lower arm and the cuff of her upper wrist, it looked like a red blob of color. Although the saturation has been improved dramatically, the lost details are still lost. Despite this, the restored photo looks far better and was well worth the effort. You can see the details of Anne's face without being blinded by red, and the overall photo looks much more natural. Mission accomplished.

Figure 4.42
Now that's much better.

Repairing Physical Damage 5

TACKLING PHYSICAL PROBLEMS in photos suits me, which is why I love the Clone Brush. It's real. It's something you do with your hands, unlike a dialog box or menu choice. Whether you are using your mouse or pen tablet, *you've* actually got to do it. The computer can't. It takes skill, daring, and creative courage to go plopping down stuff where there isn't any to begin with.

▶ **Photo Study 19**: **Repairing Border Problems and Film Tearing**—Older photos are very prone to wear and tear, especially around the edges; however, it's possible to restore a torn border. I'll tackle that issue and film tearing, using the Clone Brush.

▶ **Photo Study 20**: **Retouching a Large Scratch**—A large scratch across my cheek ruins a photo of me from high school. So, let's restore it. I will use the Clone Brush and show you why the Scratch Remover isn't always the best tool for this type of job.

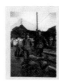

▶ **Photo Study 21**: **Fixing Creases**—In this photo, I'll use the Clone Brush to erase creasing near the bottom that is the result of years of handling. I'll also add some of the creasing back in so the photo looks improved but not overly restored.

▶ **Photo Study 22**: **Repairing Hairline Cracks in Film**—I could use the Clone Brush to erase the thousands of tiny hairline cracks in a photo, but I'm going to do something completely different. Read on.

▶ **Photo Study 23**: **Filling a Torn Hole**—This photo has a fairly obvious, albeit small, hole torn in the bottom center. I will show you how to re-create a small portion of a photo with the skillful use of the Clone Brush.

▶ **Photo Study 24**: **Restoring a Missing Corner**—This is a more advanced restoration project, re-creating a missing corner entirely from scratch and fixing a large number of creases and other imperfections.

Photo Study 19: Repairing Border Problems and Film Tearing

FIGURE 5.1 IS A PHOTO OF MARY ANNE, my mother-in-law. When I first saw it, I thought she was in college at least, but it turns out she was only 16. The year was 1965, and she was a junior in high school. She looks more mature than 16 to me, but I think kids of prior eras have a habit of looking older than they were. My mom looks 25 in her high school yearbook when she's only 18.

I spoke with Mary Anne about this photo recently, and she said her father took it. It looks like it could have been taken as part of a professional modeling shoot. She is standing outside of their rented farmhouse, which is now gone. Today, the land is part of a public school.

The photo has obvious charm, but the physical damage is threatening it. The film is tearing along the border and within the body of the photo. In addition, the photo has lost some of its pizzazz and has specks and other dust problems that should be fixed along the way.

Cloning Dos and Don'ts

This is a great chapter to go over cloning dos and don'ts because the Clone Brush will be your primary tool to repair physical damage. The Clone Brush essentially copies material from one part of your photo to another. The general workflow is as follows:

1. Select the Clone Brush from the Tools toolbar.

2. Make changes to the tool's options, such as the brush size, hardness, opacity, and whether to "Use all layers" or not. Make these changes in the Tool Options palette.

Figure 5.1
Vintage 1960s, complete with rough spots.

3. Identify what you want to cover. This is called the *destination*. Pay attention to the surrounding details because you will need to match them when you choose a source.

4. Move your cursor to the photo and identify the source spot; then Shift+click to set that into the brush. Pay attention to the "grain" of the details and match the source color gradient, texture, and brightness with the destination you've previously identified.

5. Paint the source material onto the destination with the Clone Brush.

6. Reselect sources frequently so that you don't create obvious duplications. Switch sides of a flaw as you clone and move at different angles so you don't create linear patterns.

Normally, I clone using a separate layer on top of my Background or current working layer. This preserves the original (or my interim working layer) image, and if I'm unhappy with what I've cloned I can just erase it. It also opens up a lot of blending options. I can alter the opacity of the clone layer, soften the entire layer, or select the Soften Brush and selectively blend the cloned material with the original photo.

Choosing the correct brush size is important. There are times when you want a tiny brush to get into small areas. I've used Clone Brushes of one-pixel many times to clone exact pixels. Be careful with small brushes, however. Cloning with a small brush tends to be more easily recognized. Larger brushes will blend in better.

Changing Sizes

If you're cloning, and it doesn't seem to be working well, take a look at brush options like size and hardness. Change them to see if that's the problem.

I also clone with the brush hardness set to 0. This helps the new material blend in because there are no hard edges. If you haven't guessed by now, blending is an important part of cloning.

Working Around Edges

Using the Clone Brush near edges requires that you closely monitor where the edge is in relation to your source and destination. I've positioned my source spot (the circle with the X in it) too close to the edge of the photo in Figure 5.2. When I selected my destination, my movement upwards with the Clone Brush copied the photo border. If you must select a source spot close to the edge, keep a disciplined hand when you brush and be aware of the "don't go that way" direction.

Figure 5.2
Source too close to outer border.

Figure 5.2 shows a similar problem, only reversed. Instead of transferring the outer edge of the photo, I'm transferring the boundary between the border and the picture. In this case, I've set the source spot too close to that boundary and let my brushing stray too far down.

Figure 5.3
Source too close to photo edge.

If you want to protect an area of the photo from dangers like this, make a selection and clone inside it, as shown in Figure 5.4. You can make a nice, straight cloned border without fear.

Figure 5.4
Protect the photo with a selection if needed.

If you've got a steady hand and a soft brush, you can routinely clone close to edges as you see me doing in Figure 5.5. The keys are practice, technique, the right brush hardness (softer is more forgiving and easier to blend), and a pen tablet. It doesn't take forever to learn and master. Pay attention to what you're doing, and you will learn very quickly. Develop a good technique so you are more efficient with your time and effort.

One timesaving tool that I use to clone with is a pen tablet. A pen is more intuitive and natural to hold and use than a brush. Additionally, the pen that I use is pressure sensitive, which means that I can press down very lightly with a larger brush and barely clone, or press harder, and the brush squishes more.

Figure 5.5
Freehand cloning with soft brush edge and a pen tablet.

I know it sounds like I own stock in pen tablets. I don't, really. I just want you to realize how much help it is. If you're going to casually restore photos, you might not miss it. But, if you're going to be doing this a lot, especially professionally, invest in it. Pronto.

Another cloning technique, especially on borders like that shown in Figure 5.6, is aligning the source spot exactly (either horizontally or vertically) with your destination. You might have to select a source, clone, undo, and redo several times to get the correct alignment. The material in the corner (referring to Figure 5.6), up past where the bend is, is new. I've transplanted it from the edge below. I left it undone so you could see it in progress. The key here was to precisely align the right edge of the source well below the destination. The edge looks straight and original because I've precisely aligned the source and destination vertically, while setting the source "well below" gives me room to move the brush up.

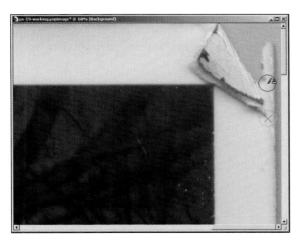

Figure 5.6
Start down to go up.

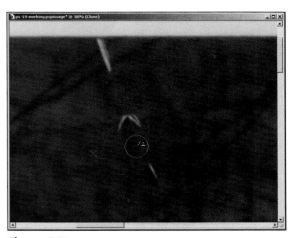

Figure 5.7
Cloning between branch lines.

Cloning Areas Separated by Lines

Figure 5.7 shows the importance of good situational awareness as you clone in a busy area. Notice the larger tree branches that run from the top right to the lower left? They separate sky and smaller, fuzzier branches. If you break the lines of the large diagonal branches, it will be obvious.

Pay attention to these details. You can clone in the area between the diagonal lines first, while leaving them alone, or work on the branches first and return later to fill in the gaps. The point is to see how they divide the photo into regions that you need to work in. Here, the separating lines are the larger branches. In another photo, it could be power lines or a swing set or a sidewalk.

I've come back and cloned the branches that run diagonally across the photo in Figure 5.8. That completes this portion of the photo. I've been careful to watch how things "flow" in this area. In fact, that dictated how I used the Clone Brush.

Figure 5.8
Finish up along the branch.

In the next example, I'm cloning in the lower-right portion of the photo, along the ground. See the different textures? The split has run between different shades of grass, making it particularly hard to match things up. I clone from one side of a split like this and then go back and work the other side. This helps balance the change in texture.

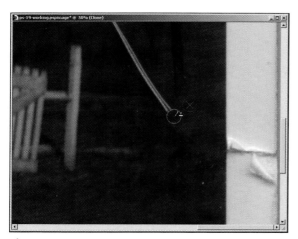

Figure 5.9
Some textures are hard to match.

Figure 5.10 shows the border area between the far background and the sky. I've chosen a source spot along this line so that I can take care of the split in the photo along the border between the two textures (grass and sky) first. Then I'll go back and tackle the rest of the split from the top and then the bottom.

Figure 5.10
Always clone along a border between textures.

Trying Scratch Remover

There are plenty of applications where the Scratch Remover does a fantastic job, but this is pretty complex stuff going on here. If the sky were a uniform blue and not covered with branches of different levels of detail, it would be dandy.

Look at Figure 5.11. I've zoomed in on one of the splits and am in the process of applying a large swath of Scratch Remover.

Figure 5.11
Trying the Scratch Remover.

Figure 5.12 shows the result. Bad. The blending is too much for the tool to handle.

I tried to tackle the split with the Scratch Remover in smaller chunks in Figure 5.13. I can still see the blending, however. It isn't as blatant as Figure 5.12, but you can see the pixelation that runs from the center down to the right. It looks like someone's appendix scar.

Figure 5.12
Not for this application.

Figure 5.13
Smaller applications work better.

Fixing the Border

One viable technique for fixing border problems is to clone good parts over the damaged parts. You've seen that in some of the previous figures. I often fix all the border problems in a photo this way, especially if I want to preserve a vintage look.

If you want a bright border, however, you can select the photo area, invert the selection so that only the border is selected, and then use the Lighten Brush to "white out" everything. For a subtler effect, you can lower the opacity of the brush.

Finishing the Photo Study

In the end, I used the Clone Brush to fix all the splits, scratches, border problems, specks, dust, and dots in this photo. It's pretty straightforward, really. Find something that needs to be fixed, zoom in, select your brush, adjust the size, select the source, and clone. Although it gets routine, you've still got to pay attention to borders, textures, shades, and colors while you clone.

Figure 5.14 reveals the final, restored photo. All the tears have been mended, the other scratches and marks have been cloned out, the border looks great, and I tweaked a few other aspects of the photo. Namely, I made a histogram adjustment and fiddled with the curves to make the photo more vibrant.

Figure 5.14
It was the Age of Aquarius.

Photo Study 20: Retouching a Large Scratch

FIGURE 5.15 IS OF ME, COURTESY OF the way-back machine we call the camera. I've spent a lot of time looking at this photo while working on it for this chapter, and I've come to the quite objective conclusion that I wasn't a bad-lookin' dude. I was completely and totally oblivious to that fact at the time, which was probably for my own good.

You can see that there's a large scratch running up my cheek. It looks like this photo has been in a knife fight. I don't have many really good photos of me during this time (I think this one and the drum major shot are the two best), and it would be a shame to lose this one because it's been damaged.

Figure 5.15
This photo is very fixable.

Removing Scanner Artifacts

If you look very closely at the unre-touched photo in Figure 5.15, you might be able to see some artifacts created by the scanner. The most obvious one runs right across the top of my eyes and is a few pixel rows high and is reddish-purple. They sort of look like digital noise, but they run horizontally across the photo in different areas. I carefully smoothed these horizontal artifacts with the Smooth Brush to reduce their visibility.

Trying Scratch Remover

Once more into the scratch. Since this is a large scratch and my cheek is not as complex as the branches in the last photo study, I think it's appro-priate to try the Scratch Remover again. You can see the application in progress in Figure 5.16.

I've chosen a rather large width to try to get the entire scratch under control. For this photo, that turned out to be 55 pixels. Figure 5.17 shows the result, which is "not bad!"

I'm rather surprised at how good this looks. I thought it would look bad or would mess up the corner of my eye or hair. The only problem is the pixelation along the blend, which I could smooth out with the Soften Brush. The reason this applica-tion of the Scratch Remover looks so much better than the trees in the last photo study is that the surface of my face is more uniform. It's easier for the tool to blend.

Figure 5.16
Trying one large Scratch Remover.

Figure 5.17
Looks good, but has pixel problems.

Since we're talking about the Scratch Remover, look what happens if you try to apply it across the scratch (see Figure 5.18).

Figure 5.19 shows the result. Hardly anything happens. That's because the Scratch Remover relies on blending the outer regions of the swath towards the center. Take another look at Figure 5.18.

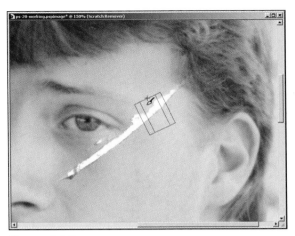

Figure 5.18
Going across a scratch is not a good idea.

The tool has a central area that should cover what you're trying to fix. The outer border is what the tool pulls from (like a clone source) in order to blend into the center.

When you go across a scratch instead of along it, you're pulling the scratch in and blending it along its own axis of imperfection, which defeats the entire purpose.

Figure 5.19
No change here.

In the previous photo study, smaller applications of the Scratch Remover seemed to work pretty well. Let's try that here. I am using several small strokes with the Scratch Remover in Figure 5.20, and there really isn't much improvement over the large swath of the original.

Figure 5.21
Close-up of pixelation.

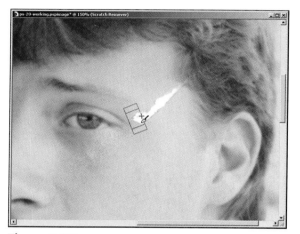

Figure 5.20
Scratch Remover in smaller applications.

Let's zoom in and take a look at the pixelation I was talking about earlier. Figure 5.21 shows a large area of "harsh" pixels running where the scratch used to be. From a distance, this may be almost imperceptible, but it affects the hue of the area. These pixels give the appearance of dithering. Dithering is using two or more colors that can be displayed in a given medium (such as your computer monitor) to appear like a third color that cannot be produced directly. When you pull back from this shot, it looks dithered.

You can select the Soften Brush, as I have in Figure 5.22, and smooth these pixels out.

Figure 5.22
Smoothing out pixelation.

One reason I prefer the Clone Brush over the Scratch Remover in photo restoration and retouching is the ability to separate what I'm doing to a new layer and blend it in later. You can't do that with the Scratch Remover.

Cloning Instead

I'm going to move on to cloning now, but I will start with a bad technique.

Figure 5.23 shows what can happen if you don't get an exact match from the source to the destination. This is the pinnacle of cloning "wrongness." Keep at it until you get it right. I might have to select a source area two or three times (maybe even more) to get the right hue and lightness at the source to match the destination. You may also have to adjust the brush size, depending on the size and shape of the source area you're pulling from.

Figure 5.24
Clone along shade lines.

> **Keep Trying!**
>
> I consider myself pretty good at this stuff, but trial and error remains an important part of my repertoire. Experience and talent mean a lot, but they don't guarantee that every time I Shift+click to select a source area it will automatically be a perfect match. There are times when the color gradient is so subtle that it takes getting it wrong a few times to see it.

Figure 5.23
Matching shades is very important.

I've done just that in Figure 5.24. Even though my original source was pretty close to the destination (as shown in Figure 5.23), it wasn't a good match. The source was clearly lighter than the destination area.

Pay attention to subtle changes in hue and what direction gradient "flows." This will keep the trial and error phase to a reasonable minimum.

Another thing to keep in mind is that this source may only be good for a very small area at the destination, meaning you need to continually move and adjust your source spot for areas of photos like this. At this magnification, this portion of my face is a very complex shape that has subtle lighting differences that result in a continually changing landscape.

I don't want you to think, though, that this is super hard or impossible to get right. It's probably harder for me to explain it than it is for you to do it.

I am using the correct technique in Figure 5.25. I've moved my source spot over to the other side of the scratch in order to find a good match for where I plan to clone. I will work both sides of a scratch like this to make sure I'm getting the tone right. It's even more important in this example.

Try and develop a habit of zooming in and out to inspect your work. You will find a "sweet spot" for each level of damage you're trying to fix. If you zoom in closer, you'll feel claustrophobic, but if you zoom out you can't see the right level of detail. Whatever your current working view, closer inspections are always a good idea to catch problems you might miss at a lower magnification. The cumulative effect of fixing a large number of very tiny problems can be dramatic.

Figure 5.25
Now from the other side.

Figure 5.26
Smaller brush for a tiny area.

Another trick is to zoom in to see some of the more microscopic cloning that you need to do. You don't need to do this on the larger elements, but in Figure 5.26 I've come much closer (600%, baby) to get at a line of damage that runs parallel to the main scratch. You can see that it hasn't broken the surface of the film so much as it looks like something on top of it. My brush size has been scaled down to 5 pixels to fit in this area. You can also see that I've got my source selected just above the destination. This was the best area to get the right "flow" of my skin tone.

I've got one final tip for you to consider. When you're done cloning, check your work by creating a temporary Levels adjustment layer. Set the levels adjustment to something wacky that brings out any possible deviations in tone and delete this layer when you're done inspecting your cloning work. I'm setting this temporary layer up in Figure 5.27. I dragged the dark and middle adjustment diamonds upwards, which has made the After preview window look pretty dark. That's okay. It's not supposed to look good. You're supposed to be able to see changes in tone that might have been imperceptible under normal lighting conditions.

Figure 5.27
Use a Levels adjustment layer to check your work.

This figure needs some 'splaining. Notice where the scratch used to be? It's not there anymore. That's good. I can see, however, where I've cloned. That's not ideal. In fact, when I arrived at this point, I studied the photo very closely because it really bothered me. I came to the conclusion that I was seeing a couple of things. First, my cloning successfully covered the scratch. When I compare where the scratch was with the tone of my cheek elsewhere, it blends in very nicely. When the photo was scratched, however, the rubbing that caused the scratch also caused additional damage that wasn't as obvious. That's the reddish tone you see in Figure 5.27, which was made more visible by the temporary Levels adjustment layer.

In my final restoration, I repaired the rub marks where I could, but I was content to leave some visible. More repair work in this case would be more visible than the original damage.

Finishing the Photo Study

My final work is revealed in Figure 5.28. I took the main scratch on my face out, but I left some smaller scratches, especially in the lower left-center. I got the photo to the point where I really liked it, and I didn't want to overdo it.

Figure 5.28
Magic Bus, circa 1983.

Why didn't I fix absolutely everything? It's the real world. We've all got deadlines, other projects, a life, wife or husband, kids or pets, other interests, and finite resources. I want to make this real. Not some fantasy book where I promise you the sun, the moon, the stars, and oh-by-the-way you'll never be able to replicate what you see here in a thousand years!

You can and will. That's what this is about. But consider this. Finish what you start. Don't get caught in the trap of working on one photo until it's perfect and never finishing it. That's a pipe dream anyway. Do a great job with what you have, and recognize the point where you have to stop.

Photo Study 21: Fixing Creases

PART OF THE REASON I AM HAVING so much fun writing this book is that I get to share some awesome pictures with you. Figure 5.29 is a photo of my wife's grandfather during World War II. He's the younger-looking soldier on the left. The actual photo is fairly small. It only measures a few inches wide. I scanned it at 1200dpi so that I can enlarge it and get at some of the finer details.

I knew Bud later in his life. We visited, played golf together, and shared stories about being in the service. I helped him put together a sundial for his yard. Anne and I would visit every summer and swim in their pool (he loved tending it), and I always felt at home. Our visits were always fun, and Casa Loma, as their old farmhouse was called, was always filled with peace and calm. It was a great retreat for us.

This photo has been through a few tough times. It's lost the top right corner and has some heavy creasing in the bottom right corner. Throughout the photo are a large number of specks and scratches.

Clone Wars

I won't kid you on this one. This is a hard photo to restore. Physical damage can be truly challenging to repair. Creases are not that much different from scratches or tears, but creases tend to multiply like rabbits. I am going to try something a little different here. I'm going to "repair" these creases by minimizing their impact on the overall photo but not completely removing them.

Figure 5.29
One of my favorite photos, heavily damaged.

Figure 5.30 gets us zoomed in to the lower right-hand corner and started. I've got a tiny brush that's only 5-pixels around, and I'm starting to tackle a crease.

Don't just jump into the middle of a bunch of creases. Work from one side or the other inwards. I've found a nice spot outside of those smallish corner creases to begin from in Figure 5.30. I'm going to slowly work my way down and to the right and "eat away" all of those creases.

The Expectations Game

Manage your expectations and those of others. If you are restoring photos professionally, come to terms with what you can do, how long it will take you, and what it's worth to you. Clearly communicate those terms with your clients. Sit down and have a heart-to-heart talk with them (if yours is an Internet-based business, have some of this information available on your Web site). Discuss what you need from them, what they can expect from you, what the final product might look like, how long it will take, and how much it will cost. Don't over promise! If it's a terribly damaged photo and you think a light touch is about the only thing that will look good, don't let them think they're going to get a perfect photo back. As you restore the photo, make a conscious decision to remember why you take a certain approach so you can explain it to your client. Take notes, if necessary, so you don't forget.

Figure 5.30
Cloning along a crease.

I'm continuing to work on the first outer crease in Figure 5.31. Notice that I've switched sides. This is a pretty hard area because there's not much room to work in, but it's important to vary the source areas so you don't copy any recognizable features.

Figure 5.31
Switching sides to match texture.

I'm continuing to make progress down a crease in Figure 5.32. I've switched sides again to work the tone. Look carefully at this figure and tell me what it is. Can you? It's pretty hard for me, and I know the photo pretty well now. In general, the lower-right corner shows the road and where the sandbags are laying. To the right is a fence, and on the other side is a lighter area, which may be the edge of the road. It's possible this was taken on a small road bridge. What you're seeing is shadow on the lower right, road, which is less shadowed, towards the left, the beginning of the bags at the top left, and possibly cabling or fence at the top right.

It's helpful to know what you're looking at and where you are in a photo. That can mean subtle but important differences in what you select as your source for the Clone Brush.

Figure 5.32
Finishing close to the border.

I've zoomed out a bit and am working on another crease in Figure 5.33. As in the first photo study of this chapter, I'm working between two linear elements, namely, cables. I think that's water down there in between, where my source spot is. I am working between the cables. I'll go back and pick them up after I get the center done.

Figure 5.33
Zoom out to get perspective.

I've completed the water and have moved to the cables in Figure 5.34. I've zoomed in much closer because there's a very fine level of detail. I'm cloning "with the grain" of the cable.

Figure 5.34
Clone along content lines.

Figure 5.35 shows where the crease gets really nasty. This area consists of sandbags, and there are a lot of variations of detail, tone, and brightness. I'm starting from the "outside" and working my way in. It really helps to think of it like you're eating the problem away. Pac Man, anyone?

I've zoomed in some and am trying to get an area that's in shadow in Figure 5.36. I've switched sides of the crease to get at a good dark area.

The remainder of the creases can be repaired in like manner.

Figure 5.35
Working a harder spot.

Figure 5.36
Notice the mold or mildew discolorations.

Surprise Ending

I start with easy stuff, generally, then move on to the hard things. I'll begin with the sky, which is easy, then move to work on the creases for a while, and switch to the corner. I'll take a break and come back to work on the roofs, then Bud, then back to the creases. I vary my work between different areas and different difficulties. This keeps my mind from locking up after staring at one microscopic part of the photo for too long. This photo has so much damage that it makes repairing the entire photo almost impossible. There's not much good cloning source space to select outside of the sky. There are creases, scratches, and what looks like mold or mildew damage all over the photo.

Take a quick peek back at Figure 5.36. See the area on both sides of the main crease? It looks milky, doesn't it? It looks like that damage has been caused by mold or mildew. Even if I fix the crease, I would have to either clone the mildew areas to make the tone match or clone over everything to take that damage out. Neither idea sounds like a winner to me.

In cases like this, it's time to think outside the box.

Most of the time, I clone to make something invisible. I'm trying to erase it from memory. Delete it. Cover it. I can change those rules. I can use the Clone Brush to make something appear less obvious, but not invisible. I'll take the power away from the creases without eliminating them.

How? I'll make the layer I used as a clone destination semitransparent. Remember all those times I suggested making your clone layer separate? This is where that pays off. Figure 5.37 shows the areas where I've worked thus far side-by-side with areas that I haven't touched. The creases I've cloned over are much less obvious, and the photo has not been destroyed in the process.

Making the clone layer semitransparent is far more forgiving than normal cloning. You can "get away" with much more, which is good for this photo. It's been terribly hard matching up all the different shadows and textures while having to work around mold and mildew damage.

Figure 5.37
A semitransparent clone layer minimizes creases.

I didn't make every cloned area semitransparent. I repaired the corner, the sky, and as many scratches and specks and lines and dots as I could normally.

Finishing the Photo Study

Figure 5.38 shows the final result. This photo shows a fine balance between fixing the important things and leaving imperfections in. The semitransparent clone layer was a fantastic solution. It kept some of the cloning from being so obvious that it became a distraction, and it minimizes the creases.

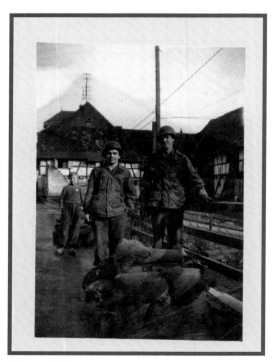

Figure 5.38
In honor of Grandpa Bud.

Photo Study 22:
Repairing Hairline Cracks in Film

FIGURE 5.39 IS ANOTHER PHOTO OF my mother-in-law. This was taken when she was somewhere approaching five years old. I just spoke with her about it, and I was struck by her instant recognition of the place and her doll. The doll's name was Bluey. She had brown hair and, you know it, blue eyes. Mary Anne said the doll was a pretty new model—one whose eyes closed if you laid her down.

Forming Narratives

Compare the car in this photo study with the one visible in Photo Study 16, which can be found in Chapter 4, "Making Color Corrections." They appear to be the same car. Details like this will help you tie photos together and form an interesting narrative. Look for details that might be in one photo to help you restore another.

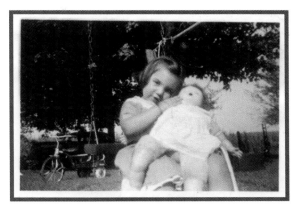

Figure 5.39
This photo has significant hairline cracks.

Figure 5.40
Scratch Remover before.

Traditional Approach

I'm going to remove the hairline cracks using a few different techniques. First, I'll try the Scratch Remover, as seen in Figure 5.40. I've selected a fairly small area that is cracked to see how the tool will work.

Figure 5.41 shows a close-up of the result. You can see the pixelation. Once again, blending is a problem. The Scratch Remover leaves pixel artifacts behind.

Figure 5.41
Close-up of pixelation.

I applied the Soften Brush with a hardness of 50 and an opacity of 34 in Figure 5.42. It took those "harsh" pixels and blended them into the rest very well, but the crack is still visible. However, his figure is zoomed in at 600%. That's pretty close.

Figure 5.42
Softening helps tremendously.

I've returned to the Clone Brush in Figure 5.43. As I expected, it looks great. I was able to select a good source area that matched the tone of my destination very well. There shouldn't be much of a problem here, except time and scale.

Figure 5.43
Cloning is the best option.

I could have spent the next fortnight of my life cloning out all the tiny cracks, but I wanted to try something a little different and imaginative for this photo.

The first photo study involved pretty straightforward cloning, but skill was needed in maneuvering around some of the textures in the photo. The primary problems were large cracks in the print and the border. The second photo study in this chapter involved removing a large tear on a complex surface. There were no borders to look at and see where one texture began and another one ended. The third photo study involved a myriad of small creases that marred a photo. The content of the photo was complex and involved multiple textures (the road, water, fence, bags) and lighting. Working in and around these creases was hard. The end solution was innovative and made the cloning more flexible.

We now arrive at a photo that has many small imperfections that can be cloned out fairly easily, but I want to continue to encourage out-of-the-box thinking. I'm going to minimize the cracks a different way.

Out-of-the-Box Method

This decision was made easier because this isn't a great photo to start with. Mary Anne is really hard to see well, and she is the centerpiece of the photo. If I can't fix that, the background will not matter. My plan involves creating duplicate layers of the photo, performing different manipulations on them, erasing what I don't need, and then integrating them together.

Let's see how it works!

First, I'm going to duplicate my base (photo) layer twice. I will hide the top layer and name the bottom layer "darken-background" and then select it. I will make a histogram adjustment to the "darken-background" layer. I am working in the Histogram Adjustment dialog box in Figure 5.44 to darken the background of the photo.

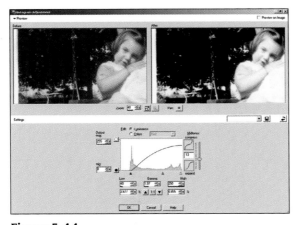

Figure 5.44
Darkening the background.

For this part of the job, I am looking at the background and ignoring Mary Anne. I've made my Low and High slider adjustments and changed the Gamma. The result is a much darker background. It looks pretty cool, and it doesn't matter how this affected Mary Anne, because, well, you'll see.

It's time to select the top layer and unhide it. I named the top layer "Mary Anne" and will use this layer to sharpen her up. I will use the High Pass Sharpen filter, as seen in Figure 5.45. I've got a pretty large radius (always experiment with these setting to see how they affect your photos), have maximized the strength, and set the Blend Mode to overlay. This combination of settings helps clarify the contrast and sharpen her up the best.

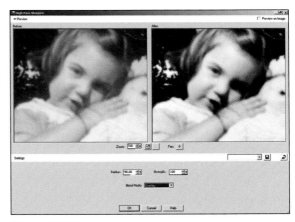

Figure 5.45
Sharpening Mary Anne.

I am erasing the background around Mary Anne on the top layer (the one named "Mary Anne") in Figure 5.46. I've got a large square brush, and I'm erasing like crazy.

When I erase a large area, I always set my brush hardness to 100% for the first rough pass. I really want to erase in this step. When you lower the opacity of the Eraser, you end up leaving half-transparent pixels around the edges. When I move closer to Mary Anne, I'll soften the Eraser and make it smaller.

Figure 5.47
Erasing closely.

Figure 5.46
Roughly erasing Layer background.

I've made my brush significantly smaller and lowered the hardness to 0 in Figure 5.47. This lets me get in close to Mary Anne and cleans up all the jagged edges left behind by the hard eraser.

For the final step, I will darken the background behind Mary Anne (see Figure 5.48). This will help her blend in.

Figure 5.48
Darkening area behind her.

That's about it. I will merge these two layers when I copy and paste them to form a composite and then use the Clone Brush to erase any specks or marks. As a last step, I will improve the overall contrast of the photo and then fix the border.

Finishing the Photo Study

The final photo is seen in Figure 5.49. I like the effect of the darker background. The whole photo looks better, too. You can clone out every crack and crevice if you like, to be sure, but there are times when you will want to reduce their negative presence another way or integrate them into the artistic presentation of your photo.

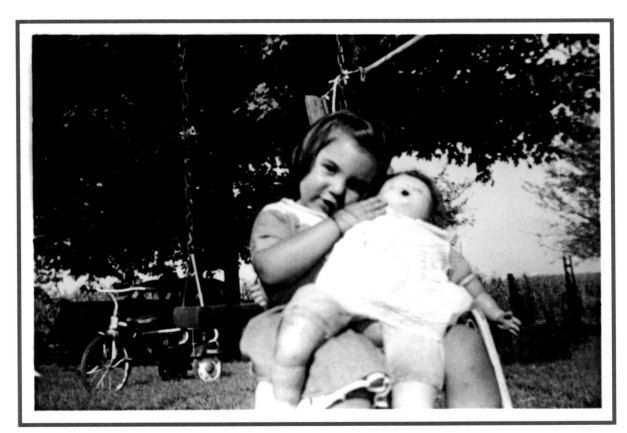

Figure 5.49
Mary Anne and her dolly artistically restored.

Photo Study 23: Filling a Torn Hole

FIGURE 5.50 IS A PHOTO OF MY mother-in-law's mom, Louise, and Louise's father, Dwight. Their family used to go up to Michigan for summer vacations, and as near as we can tell, this photo was taken during one of those times. Louise looks around three or so, which would date this to approximately 1928.

Somewhere along the line, a hole was torn in the bottom center of the picture. Aside from restoring this photo for aesthetic reasons, a photo with torn edges is always in danger of being torn more. Once I restore this, I'll be able to print out new copies for viewing and handling, while the original is stored safely away.

This photo is a classic example of a fairly minor touch-up that will make an enormous positive difference to the photo.

Working the Pant

I'm going to walk you through a rather detailed look at fixing this. Let's get started with the pant.

My first cloning operation on the pant can be seen in Figure 5.51. In instances like this, I generally choose to work from the inside out, which is why I've started at the top of the hole where the pant breaks from shadow to light. Borders like this, shadows and light, are just as important to nail as texture and color borders. In this case, I'm very fortunate to have a good amount of existing material to work with.

Figure 5.50
Notice the hole at the bottom?

Now that I've got the border between light and shadow, I'm going to fill in the shaded part of the pant, moving carefully into the hole and filling it in. Figure 5.52 brings you up to date. It's looking really good. I'm excited!

I think in terms of pieces when I restore photos. You can break the bigger picture down and down and down—until you're left with very manageable tasks. The first task here was to fix the line of the pant, which bordered between shadow and light. Check. Next, the task was to fill in the shadow area and complete the bottom of the pant. Roger.

Figure 5.51
Cloning along the pant shadow.

Notice how each of these pieces has a border that separates it from other parts of the job? Affirmative.

Figure 5.52
Finishing the bottom of the pant.

Now all I need to do is finish the pant, and that part is done. Figure 5.53 shows the final cloning on the pant in the light area.

Figure 5.53
Finishing the pant.

Starting the Ground

I've finished Dwight's torn pant, so it's time to go on to another piece. I'll work on the ground a bit. I am, again, cloning along a border in Figure 5.54. This time I am working on the ground where it turns from darker to a lighter tan. I will work this area briefly so that when I turn to Louise's skirt, I can finish the ground as I finish her.

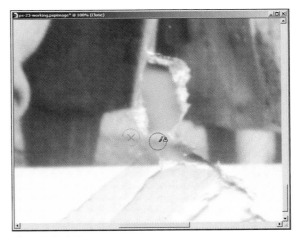

Figure 5.54
Pay attention to shading.

Now for the Skirt

I am starting to clone the bottom of her skirt in Figure 5.55 (the Triple Nickel figure). This time I am working from the outside border in. I'll grab a bit of the skirt from the right and pull it over, making sure to bring the ground along.

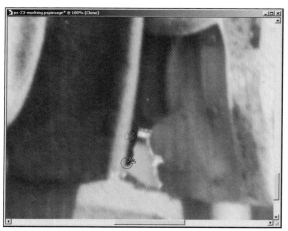

Figure 5.56
Bringing down the shadow.

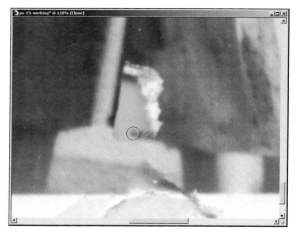

Figure 5.55
Extending the skirt.

Next, I'll focus on another border. This time I want to get the border between Dwight's pant and Louise's skirt done. I may clone "over" some existing material. No matter. I'll take care not to disturb my finished pant, but some of the border area can be refined. I extended the shadow between the pant and the skirt down and inwards in Figure 5.56.

If you want to be extra careful about things, you can consolidate your work along the way. I like working with the photo on the Background layer, and I never disturb it. I create a new raster layer on top of that to clone on, making sure that "Use all layers" is enabled when I select my Clone Brush. Make sure you've selected this clone layer when you start to work; otherwise, you'll be putting down paint on the layer you want to protect. It's simple to consolidate. Select all by pressing Ctrl+A, perform a merged copy by pressing Ctrl+Shift+C, and then paste that merged copy as a new layer on top of the clone layer by pressing Ctrl+L. This is your new working layer. You've just consolidated your work, and it's protected. Create a new clone layer (an empty raster layer) once again and go back to cloning. You can do this as many times as you need, up to the amount of memory you have.

Let's get back to work on that skirt. It's pretty tough in the interior. There are folds and shadows galore here. Tricky indeed. Figure 5.57 shows me starting to fill this in.

Figure 5.57
Starting to fill in.

If it doesn't look right, give it a little time. Don't start over immediately. There are times I clone tough areas like this, and it doesn't look good at first, but then it comes around if I keep at it.

Figure 5.58 shows the filled-in skirt, and I'm doing some touching up. I'm working with the "grain" of the skirt, which is to say, vertically. What may have looked a little dodgy in the beginning fits right in now.

Figure 5.58
Finishing the fill.

There are two final steps that are tricks of the trade and can make cloning much better. First, I'm going to push some paint around with the Push Brush (a handy tool) in Figure 5.59.

Figure 5.59
Using the Push Brush to blend.

My primary purpose is to blend my cloned work. It's still on a separate layer, but I'm pushing the paint around to blend it. I've lowered the opacity to 28, so it's a pretty light touch.

Finally, I will use the Soften Brush in Figure 5.60 to soften the work that I just completed. I turned off the photo layer so you can see what I'm doing a little better. I've turned down the opacity of this brush, too. It's set at 34.

Softening is different than pushing paint around. Soften takes the edge out of things. It smoothes the borders and creates more of a gradient between different colors.

Figure 5.60
Softening the cloned material.

Finishing the Photo Study

Figure 5.61 shows the finished photo. This is a photo where everything came nicely together. I want to make sure and point these out, too! I had enough time, it wasn't too badly damaged, and the final print is as nice as one could expect. The hole is gone, and I also fixed the other specks and scratches in the photo, plus I enhanced the contrast and color balance.

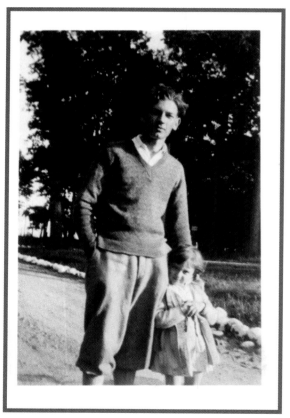

Figure 5.61
Even small repairs are very gratifying.

Photo Study 24: Restoring a Missing Corner

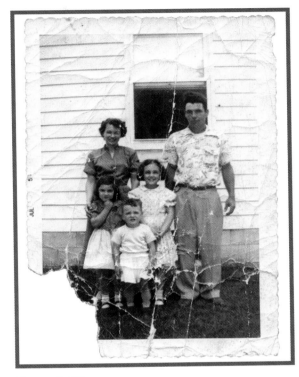

THIS PHOTO (SEE FIGURE 5.62), taken and developed in 1954, is another of my wife's family. Louise, the young girl in the last photo study, is back again, this time as a grown woman with a family. Bud, her husband and the young soldier in Photo Study 21, is also here. Mary Anne, the subject of Photo Studies 19 and 22, is the young girl on the left. She's got an older sister and a younger brother present in this photo.

This photo has been through some tough times. It's got a pretty good chunk missing out of the lower-left corner, and it looks like it's been wadded up, as evidenced by all the creases. This goes far beyond normal wear and tear. That makes it perfect for this chapter!

Figure 5.62
Mangled family portrait.

Tackle the Border First

The first thing I'm going to do is get the corner fixed. There is a pretty hefty chunk missing. I could use the Clone Brush and copy the existing borders, but it's actually much faster and easier to copy another corner and rotate it so that it fits in place.

I've selected the bottom right corner with the Selection tool in Figure 5.63.

Figure 5.63
Copy the opposite corner.

I pressed Ctrl+C to copy this selection and Ctrl+L to paste it as a new layer. While the corner I pasted was still selected as an object, I chose the Image ❯ Mirror menu to mirror it horizontally. After it was mirrored, I moved the new corner to cover the missing space, as shown in Figure 5.64.

You can see that the old content is still inside the "new" corner. Don't worry. It takes very little effort to delete it. It doesn't even matter that the inside border is a bit off. The important border to align here is the outer border, which will ensure that the new corner blends in. This photo has a scalloped edge, which makes it a bit trickier.

Figure 5.64
Paste and mirror.

With the replacement corner aligned (it's a separate layer than the Background photo layer), I returned to the Selection tool and selected the interior of the new corner to delete it, as shown in Figure 5.65. I matched the inner border of the photo frame with what was selected in this step.

Figure 5.65
Select and delete unwanted material.

After I selected the proper area, I pressed the Delete key to send it to oblivion.

All I need to do now is touch up the "joints" where the new corner and existing border overlap. I am using the Clone Brush to remove the obvious signs that this corner was pasted in Figure 5.66. I'm not worried about restoring the corner fully. That will come later.

Figure 5.66
Touching up.

Filling In

The outer border is complete. Now for the hard part—filling in the missing area of the picture.

There will be times when this will be impossible. In some of these cases, restore the border and the rest of the photo but do not re-create the missing material. Fill the area with a neutral shade of gray. This is similar to the way some architectural restorations (like the Coliseum in Rome) are handled. New material is clearly new. People can see there was a missing corner, it's not distracting, and you can handle the restored photo without fear of damaging the original any further.

For this book, I will put grass in the missing corner. I am beginning the process in Figure 5.67.

Figure 5.67
Cloning grass.

I have to take grass from the other side of the photo, as seen in Figure 5.68, to fill in the missing area.

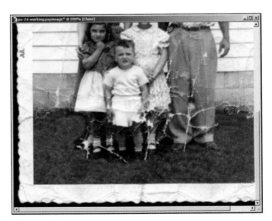

Figure 5.68
Taking material from the other side.

After the new grass is planted, I will use the Burn Brush to create a shadow behind Louise, as seen in Figure 5.69. This will make the cloned area look more realistic. I lowered the opacity of the Burn Brush to 10 to blend it in naturally.

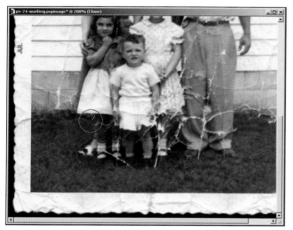

Figure 5.69
Using the Burn Brush to create a shadow.

Finishing the Photo Study

The fully restored photo can be seen in Figure 5.70. This was a tough one, and the corner was only the tip of the iceberg. After fixing the corner, I made as many other repairs as I could. I retouched the siding of the house, the window, the grass, everyone's faces and hair, and other areas. I also made contrast and color adjustments, plus worked on the border.

Figure 5.70
Large jobs are great, too.

I want to conclude this chapter by making the point that whether the job is very large or relatively minor, restoring and retouching photos is and should be fun and rewarding. Although photo restoration will challenge you as a creative artist and push your technological limits, Paint Shop Pro Photo is an economical and powerful tool. Be positive and don't get down on yourself.

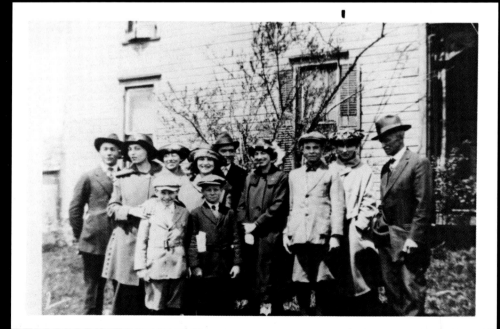

Erasing Writing and Other Marks

6

I N THIS CHAPTER, I'M GOING TO RESTORE several photos that have different types of writing on them—from pens to markers to spots. I'll use a combination of the superstar Clone Brush and a technique that may surprise you—separating a photo into its hue, saturation, and lightness channels, using the Clone Brush on each of these separate images and then combining them back together again.

▶ **Photo Study 25: Erasing Colored Pen**—Here's an old photo with a combination of different pen markings. I'll use the Color Changer and the Change to Target Brush before splitting the HSL channels.

▶ **Photo Study 26: Taking Out Handy Notations**—This is a straightforward Clone Brush operation. The catch is that there are a lot of numbers above and on people's heads. I'll have to use a lot of different cloning techniques.

▶ **Photo Study 27: Removing Marker**—I'm going to separate the photo into the HSL channels again in order to make the marker stand out much more clearly than in the original photo. That makes it easier to send in the clones.

▶ **Photo Study 28: Hiding Tape**—This photo has been torn in half and taped back together. I'll put the photo back together and hide the tape so the photo looks like it was never torn. Bonus!

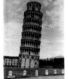

▶ **Photo Study 29: Cleaning Gunk**—The Leaning Tower of Pisa makes a return to this photo study. This time we'll look in detail at removing the large spot of gunk—or whatever it is—from the sky.

▶ **Photo Study 30: Hiding Discolored Spots**—This features a photo of my wife's grandfather during World War II. It's a posed shot that has suffered from some spotty discoloration over the years. First, I'll create a new background with the help of a mask. Then I'll separate the channels and clone out those darned spots. Finally, I'll combine everything and finish the study.

Photo Study 25: Erasing Colored Pen

FIGURE 6.1 IS A PHOTO OF MY father-in-law's mother, Grace, and her siblings, taken in 1919 (as the writing shows). Grace is the woman in this photo and the namesake of our daughter. She is much older than her siblings and is about 24 here.

Grace married in 1928, almost 10 years after this was taken, and she died in the early 1950s. Josephine, her sister, is the playful young girl on the right (she's Grandma Jo).

Once again, we have history right before our eyes. This photo was taken before the roaring twenties, before the Great Depression, before a lot of stuff. In 1919, the United States Congress ratified a constitutional amendment guaranteeing women the right to vote. It was passed by the states in 1920. Look at the people in this photo. They were alive before television, during the birth of the automobile and airplane, before spaceflight of any kind, before microwaves and cell phones and computers and most of what we have around us today. They didn't have to decide between cable and satellite TV, or between Windows and Mac.

Technique Bonanza

Paint Shop Pro offers us a plethora of options when it comes to removing ink and writing on photos. I'm going to explore a few before moving on to splitting the HSL channels. We'll first look in detail at the Color Changer tool (organized with the Flood Fill tool on the Tools toolbar) and then move on to Change to Target Brush.

Figure 6.1
Colored ink mars a classic old-time photo.

Color Changer

The Color Changer tool made its appearance with the release of Paint Shop Pro Photo XI. Older color replacement methods were designed to operate simply: see blue, replace blue. Only one shade of blue per customer, please. They were great for changing one specific color to another specific color, but not so great for using in photographs.

The Color Changer tool is optimized to replace a range of similar colors. You can specify a tolerance and edge softness from the Tool Options palette. That's nifty.

It's easy to use this tool. I've selected the tool from the Tools toolbar in Figure 6.2 and pressed Ctrl to change the tool to the dropper. I'm hovering my pen over the color I want to replace with. This is key. I would like to change those reds to an off-white, so I am going to click on the off-white in

Grace's dress to load that color into the Materials palette. You can see the RGB values pop up when you have Ctrl pressed. This is a great shortcut so you don't have to switch tools.

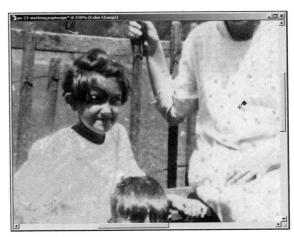

Figure 6.3
Washing those reds away.

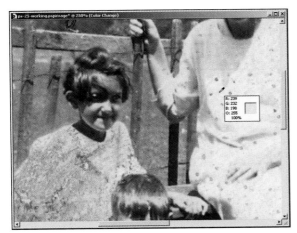

Figure 6.2
Sampling the color to replace with.

The next step is to let go of Ctrl and click on the color you want to replace: in this case, the red in Grace's dress. When you release the Ctrl key, the tool cursor changes to a bucket, as seen in Figure 6.3, where I have just clicked to change the color.

Notice a few things from Figure 6.3. First, the areas of color I am replacing do not have to be adjacent or contiguous. They can be on opposite sides of the photo, and the Color Changer will replace them. The red in the young girl's dress was changed to off-white (roughly, I will get to that), even though I clicked in Grace's dress. Second, the off-white color that replaced the red did so reasonably intelligently. It's not just a blob of solid color.

The bad thing is that it didn't completely eliminate the red from this photo.

I Know What You're Thinking

Why don't I just change this photo to grayscale and get rid of the color that way? I could, but I would still be left with the different lightness values of the colored regions that would be different than the surrounding fabric. In other words, the red dots on Grace's dress would be gray, not white, and you could still see them as dots. The other reason is that I don't find a pure transformation into grayscale very attractive. I realize this is technically a black-and-white photo, but I like preserving some of the color.

It did make the spots much less obvious, but I will still have to use the Clone Brush, as seen in Figure 6.4, to completely remove the spots.

Figure 6.4
Cloning to finish.

Change to Target

I will try a different technique on John's shirt. It's been pretty well inked over, with globs of thick color interspersed with patches of less dense blue. This time I will use the Change to Target Brush.

Learning Center

There are times when I forget how to use something in Paint Shop Pro Photo, especially when it comes to brushes that I don't use as often as others, like the Change to Target Brush. That makes for a great opportunity to promote the Learning Center palette. I normally work with this feature hidden, but it's always within easy reach if I need it. The point is to be able to use all the features of the program and get the job done, isn't it? If you need a quick reminder on how to use something, turn on the Learning Center and read along. It's faster than consulting the help file and smart enough to know what tool you have selected and show you how to get help with that.

Set the foreground color in the Materials palette to the color you want to change to with the Dropper tool, as I'm doing in Figure 6.5. I'm looking for something in the photo that has the same tone I would like to change John's shirt to. The area on that wooden post will do nicely.

Figure 6.5
Taking another sample.

I've selected the Change to Target Brush and changed the size and hardness to fit the task at hand, and I am brushing in the area I want to recolor in Figure 6.6.

Be careful when you paint with the Change to Target Brush, because it's not a "smart" tool. In other words, some tools analyze what you click on and then change a range of similar pixels within a certain tolerance, like the Color Changer tool. You're just painting along with the Change to Target Brush, completely free to paint whatever your brush covers with the target color.

Normally, it's nice that the Change to Target Brush preserves detail, as you could see in Figure 6.6. In the "Color" mode, Change to Target Brush modifies the color (a combination of hue and saturation

Figure 6.6
Using the Change to Target Brush.

in this instance), but not other properties (such as lightness, which is where much of your detail lies).

In this instance, that's not so good. After changing the color of John's shirt, it still looks like someone has drawn on it. I'm softening the leftover texture with the Soften Brush at a fairly low opacity in Figure 6.7 to correct that.

Figure 6.7
Softening to smooth the effect.

Splitting HSL Channels

I wrote a description of color and HSL in the section entitled "Technique Smorgasbord" in Chapter 4, "Making Color Corrections." I'll recap here briefly to get this section started.

HSL stands for Hue, Saturation, and Lightness. These are three "channels" that store information about a picture. They work like the Red, Green, and Blue channels, which you're probably more familiar with. RGB is purely color information, whereas HSL is much more. Here's how it breaks out in simplified terms:

> ▶ **Hue**—the color of the pixel
>
> ▶ **Saturation**—the intensity of that color from gray to pure color
>
> ▶ **Lightness**—the lightness of the pixel

If we can find a way to alter these channels independently of each another, we could change the color of something in the photo without compromising its intensity or lightness.

I'm going to do exactly that.

I'm in the process of choosing the menu item that splits the channels to HSL in Figure 6.8. You can also split to RGB (Red, Green, and Blue) or CMYK (Cyan, Magenta, Yellow, and Black). It's very important to note that if you have more than one layer in a file, the currently selected layer is split, not every layer. If you must, perform a merged copy (let's say of a cloned layer and the original background), paste that as one layer and then split it.

CMYwhat and RGwho?

CMYK stands for cyan, magenta, yellow, and black and is used mainly in professional printing. These printers use four colors of ink to create a full-color product. When you hear someone talk about four-color printing, they are referring to the number of inks used and not the color depth of the printed material.

RGB stands for red, green, and blue. Color television screens and computer monitors (older style CRTs, anyway) use three electron guns (one of each of the RGB colors) to shoot electrons onto a cathode ray tube, which is coated with red, green, and blue emitting phosphors. (They emit that color when excited by the electron beam.) The RGB guns and RGB phosphors are why computer colors are so RGBcentric.

Paint Shop Pro Photo splits the photo in the HSL channels and opens up three new images, entitled appropriately. Hue1 is the hue channel, Saturation1 is the saturation channel, and so on. If you split more images (or the same image multiple times), the numbers keep going up.

This is going to look freaky if you've never done it, but it's fun to work with HSL channels. I'm going to do it a lot in this chapter, so you'll get a lot of experience seeing what it's like.

Careful, You're Using Indexed Color Now

The HSL channels split into palette-indexed grayscale files, not your typical 8-bit-per-channel RGB format. When you look over at the Materials palette (make sure you're looking at the Rainbow tab), you'll see that the color wheel has been replaced by discrete chunks of gray, ranging from white to black. These are the indexed colors. If you change this or increase the color depth, you'll have a hard time remapping the grays to what they were before. Some tools, such as the Change to Target Brush, will change the color depth when you use them. Stick with the Clone Brush (it's one tool that doesn't change the indexed colors), and you'll be fine.

One other thing: It's important to keep all three images open, so you'll have them to combine together at the end of this process.

Figure 6.8
Splitting to HSL channels.

Figure 6.9 shows the Hue channel, and I've selected the Clone Brush and am working the writing out of the sky. It's important to note that this is hue, which is color information. It won't really affect the detail of this photo. For example, I could select this entire image (in this or in the Saturation channel), delete the current content, and fill it with a randomly chosen swatch of gray from the Materials palette and not lose any of the details in my photo. I would just be changing the hue of the entire photo to one value. This is basically what happens behind the scenes when you use the Image > Grayscale menu to turn a color photo into black-and-white; only instead of a shade of gray, the Hue and Saturation channels will be black. Go ahead and try it out for yourself. Take a color photo, change it to grayscale, and then split to HSL and check out the different channels.

Figure 6.9
Cloning the Hue channel.

The writing really stands out well here. That's one great advantage of splitting the channels.

I should discuss this a bit more before moving on. When you're looking at Figure 6.9 and you see something that's mainly unrecognizable, you're looking at a scale. White is at one end of the scale, and black is at the other end. For saturation and lightness, you can think of white as "full on" and black as "full off." (I sounded quite British there.) The specific shades of hue are meaningless to us and could be anything. You'll get used to this over time.

Full Color Photos and HSL

In this chapter, I'm using the technique of splitting a photo into its HSL channels with (color) scans of black-and-white photos. This simplifies the H and S channels tremendously. Because I'm using black-and-white photos, I can quickly see color aberrations and will easily be able to spot those that I might accidentally introduce as I edit.

Try separating color photos and working with their HSL channels, but be aware that it will be much harder to successfully alter the Hue or Saturation channel of color photos without throwing things completely out of whack.

Compare Figure 6.10 with Figure 6.2 and look at the spots on Grace's dress. I can clearly see what I need to fix in the Hue channel. I'll use a hue from Grace's dress to cover the dark spots with the Clone Brush.

Figure 6.10
The spots really stand out.

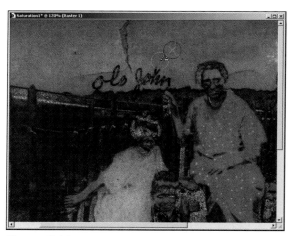

Figure 6.11
The names stand out in the Saturation channel.

Let's switch gears and move on to the Saturation channel. This is a separate image in the workspace that was created when I split the channels. Since this is the first split, this image is called Saturation1 and is shown in Figure 6.11. Once more, I am cloning out the writing.

There is quite a bit of detail in this channel, which would, of course, not be present in a true black-and-white photo. I can clearly discern the differences between the sky and the woods and between the writing and everything else. The writing is easily cloned out.

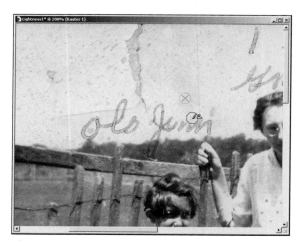

Figure 6.12
Cloning the Lightness channel.

Finally, let's move on to the Lightness channel, as seen in Figure 6.12. This channel most closely approximates the actual photo, because the photo was originally black and white. You'll find this is the case even for color photos. The Lightness channel looks most like what we see.

This technique can triple the amount of work you do on a photo. Yeah, that stinks. For the most part, instead of cloning once on the composite photo, you're cloning over the same thing three times, once in each channel.

Why would I even suggest such a thing? Because there are times and photos where you need this level of control over the different channels, and perhaps the best way to see the damage is to split the channels out. This photo study, as well as Photo Studies 27, 29, and especially 30, shows real power in using this technique. I don't think I could have done the same job without it.

Two last things before we combine the channels.

First, I'm going to use the Dodge Brush to lighten up John's shirt (see Figure 6.13) on the Lightness channel. The Dodge Brush, as with the Soften Brush below, can be successfully used on the channel images without altering the color depth.

Figure 6.14
Softening the dress.

After you've done all the work you need to do on each separate channel, it's time to combine them back together.

> **Checking Your Work**
>
> You can combine the channels in interim stages to check your work. Follow the same procedure, but don't close the individual channel images. You can close the merged image without saving it when you're done with your inspection.

Figure 6.13
Using the Dodge Brush to lighten the shirt.

Finally, I want to soften the clumps of color on Olo's dress. I'll use the trusty Soften Brush for this, as seen in Figure 6.14.

Figure 6.15 reveals the correct menu, Image ❯ Combine Channel ❯ Combine from HSL. I've got all three channels arranged, and the original working copy of the photo study is minimized. What I'm going to do is combine these channels, copy the result, and paste it back as a new layer into my working study file, which is a .pspimage.

Figure 6.15
Combining from HSL.

Figure 6.16
Choosing the HSL channel sources.

When combining channels, you're presented with the Combine HSL dialog box, as shown in Figure 6.16. Select the correct channel sources from the drop-down menus. Check "Sync hue, sat, and light if possible" to make it easy on yourself. When this is checked, select one source (which sets the correct numbering), and the other channels automatically look for and select their appropriately named source images. If you deselect the Sync option, you will have to identify your channels manually.

Figure 6.17 shows the combined result. Splitting the channels out and working on them separately proved to be a great idea. This photo combines easy stuff with "pert-near impossible" stuff. The writing in the sky and Grace's dress were really easy to fix. John's shirt and Olo's dress were much harder.

Figure 6.17
Good result, although a bit yellow.

Let's run this through the fade corrector (Adjust ❯ Color ❯ Fade Correction) to take out some of the yellow (see Figure 6.18).

Figure 6.18
Correcting for fade.

Finishing the Photo Study

Figure 6.19 shows the final photo. I ended up working on this far beyond removing the writing. I did several variations of color balancing and a High Pass Sharpen, complete with a few rounds of cloning touch-ups.

To finish the photo, I decided to do something different with the border. After saving the file, I copied my final work (a merged copy) and pasted it as a new image; then I applied the Time Machine photo effect to the new image. This is in the Effects ❯ Photo Effects menu. All I really wanted was the border, so I browsed through the different offerings, chose a border I liked, made sure that Photo Edges was checked, and applied the effect. I then lifted just the border out of that temporary image and pasted it into in my working file.

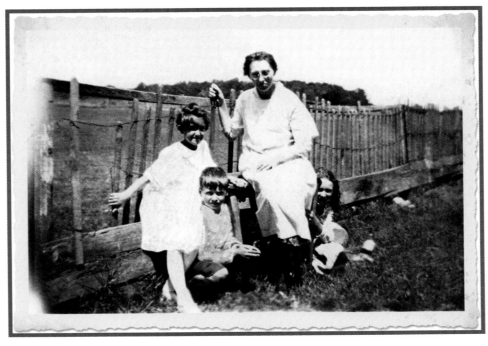

Figure 6.19
Attractively restored.

Photo Study 26: Taking Out Handy Notations

FIGURE 6.20 IS ANOTHER EXAMPLE of someone writing on a photo to give us an idea of who is in it. This time, there are no names, but numbers are above and on everyone's head. There's also a pretty long tear in the photo, which runs from the right side clear past the center of the picture.

It amazes me how these photos tie together. I think you'll run into the same thing when you start restoring your own family photos. Take a closer look at the women numbered 3 and 4 in Figure 6.20. We just saw them in Figure 6.19, only this is somewhere between 15 and 20 years later. Number 3 is Grace, the woman in Figure 6.19. She looks really happy, doesn't she? Her husband, Marion, is number 1 in this photo. Jo, the playful girl in Figure 6.19, is now a woman (number 4).

I am struck again by the feeling I'm looking back in time. The man and woman on the far right are John and Clara Wissler, my wife's great-grandparents on her father's side. John was born in 1860 and lived until 1946. Clara was born in 1869 and died in 1962. John's lineage can be traced with a pretty good degree of certainty back to Heinrich Wissler, who was born in 1689 in Langnau, Canton Baselland, Swizerland, and was the original immigrant of the Wissler line to America. Clara was descended from the Rasors, who immigrated from Germany and can be traced back to the 1500s.

This type of genealogical information makes this photo especially significant. I am sure you will have the same opportunities, and it may even prompt

Figure 6.20
An impressive family photo, complete with notations.

you to begin researching your own (or your spouse's) family tree. If you are restoring photos professionally, you will probably not be dealing with your family, but keep in mind that these photos can have special emotional and historical significance to their owners. You can be a part of preserving their family treasures.

I'm going to treat this as a fairly straightforward cloning operation since there are so many marks. If I separated out the channels, it would take a long time to clone away so many marks and imperfections in triplicate. Besides, this photo makes a great cloning exercise. The markings cover a lot of different textures. There is marking on the siding of the house, on windows, shutters, hats, and branches.

Creating an Adjustment Layer

Let's work it with a twist, however. Since this is such a bright photo, I will create an adjustment layer to see what's going on. I've called up a Levels adjustment layer in Figure 6.21 and have tweaked the sliders to give the photo better definition.

Figure 6.21
Creating a Levels adjustment layer.

The point here is to see what is behind the brightness, not to create a final look. It probably won't look good, as a matter of fact. I'll hide or delete this layer at the end of the restoration.

The man labeled as number 1 looks a lot like Patrick Stewart of *Star Trek: The Next Generation* fame, doesn't he? He's my father-in-law's dad.

Cloning the Problems Away

Once again, I'm working in an environment where I have a background photo (as shown in Figure 6.22), a clone layer (for the advantages of protecting the original photo and giving us more blending options), and an adjustment layer, which shows us things we can't see well in the original.

I'll begin with number 1. It's pretty straightforward. I will clone with the siding of the house, which is made more prominent because of the adjustment layer.

Figure 6.22
Cloning along the siding.

The key, when you work with an adjustment layer like this, is to always look at the Layers palette and know where you're drawing your source from and where you're cloning to. If you get caught up in going too fast, you'll make mistakes. Select the photo layer and Shift+click the source into the brush; then select the clone layer to apply the paint. For this technique to work, you must turn off the Clone Brush's "Use all layers" option on the Tool Options palette.

I'm cloning in the window above a woman's head in Figure 6.23. You can faintly tell where the window frame tone is different than the window. These are the things that will separate you from a beginner. Find those changes in tone as you clone and work *with* them, not against (or oblivious to) them.

Figure 6.23
Cloning with the window.

Figure 6.24
Cloning siding with leaves.

This one's pretty simple in the window. It gets much harder as I move down to the hat. I will zoom in and make the brush smaller, picking up paint from below the bottom of the number 2.

I've moved on to Grace in Figure 6.24, who is number 3 (although I've cloned some of that number away already). Here, the challenge is to move with the grain of the siding and pick up branches from another part of the photo. If I just clone the whiteness of the siding here, it will look out of place.

Figure 6.25
Extra care is required for the shutters.

Ah, now for a real tricky part. Look at Figure 6.25. I'm cloning a number out of a window shutter. This is harder because of the fine details, but not impossible. I will pick up details from above and to the side, while paying attention to where all the lines are (that's the tricky part). I'm pulling detail from the central vertical frame down, but it also has to match the horizontal shutter shadow. The outer frame is easier, but it also needs to match the siding on the house.

I've moved on to a young boy's hat in Figure 6.26. We're not completely sure who this is, but he's got a dapper hat on. His hat has a lot of subtle shading, so I can't just plop paint down. I've got to examine the hat closely and see where the best match is, and then try it out and see if it works. Here, I'm cloning in an arc, from near the brim of the hat up and towards the center. That matches the shape and tone of the hat where you can see my source spot.

Figure 6.26
Follow the shadow lines.

If you can't match the tone perfectly, return with the Soften Brush. That helps tremendously. I'm working with a pretty light touch here (opacity of 50). I've found that the Soften Brush (remember, this is on the clone layer, not the photo layer as seen in Figure 6.27) can lighten cloned material, and if I work at it too much I can start to see the original photo through the clone layer. If that happens, I have to undo and come back a little softer. If I need to, I'll clone a darker patch and then come back with the Soften Brush.

Figure 6.27
Softening the cloned area.

Finishing the Photo Study

This was a fun photo. It had a good deal of cloning, which is always very rewarding. When there's a lot of work to be done (as is the case in this photo), I tackle things in stages and break the stages down into steps. Normally, I work from easy to hard. This gets me started without breaking my enthusiasm. In this photo, that meant I initially worked on a few easy numbers and then switched over to the background. I came back to the harder numbers a bit later and then worked the tear. I finished by scouring every inch of the photo at a high magnification for any imperfection I could fix.

Afterwards, I performed a merged copy and pasted that to a new layer from which to work on the brightness and contrast. I used the Smart Photo Fix, followed by a High Pass Sharpen, to finish the restoration.

Just because I chose to remove the writing in this photo doesn't mean you have to remove everything you ever come across. You can restore a photo like this a few different ways and preserve the numbering as an alternate version. Your call!

Figure 6.28
Completely restored family lineup.

Photo Study 27: Removing Marker

FIGURE 6.29 IS A PHOTO OF ME when I was in high school. I was a drum major of our marching band, which explains my white uniform when the others are in green.

Please refer back to Photo Study 5 in Chapter 2, "Removing Specks, Dust, and Noise," for more background information on this shot. I couldn't resist reusing this photo here because it's got marker, or possibly smudged ink, all over it. Look especially at my hand, arm, and near my neck strap.

I'll fully restore this here, but with attention paid to the marker.

Splitting HSL Channels

For this photo study, I want to split the channels to HSL, just like Photo Study 25. If you look at the original photo in Figure 6.29, it is very bright. The HSL channels give me a much better chance of seeing the imperfections I will need to clone out and give me a little more room for error.

Channel Images

Don't forget that the HSL channels I am editing are separate images, not layers within my working photo. When I switch channels, I am selecting a different image in the Paint Shop Pro workspace, not just clicking on another layer.

Figure 6.29
Smudged marker has damaged this photo of me.

Figure 6.30 illustrates what I mean. I'm working on the Hue channel in a sea of gray that is the majority of the right side of my chest area (in the top right, you can see a part of the X that goes across the center of my chest). The little white spots are what I need to clone out. They stand out like sore thumbs!

I am still in the Hue channel in Figure 6.31, but I've moved down to my hand. This is another area where there are heavy markings, but using the Hue channel makes it far, far easier to spot them and clone them out. This particular area is harder than my chest, but it's still very practical.

Figure 6.30
Cloning away easy-to-spot imperfections in the Hue channel.

Figure 6.31
The more difficult hand area is still easier using channels.

Let's look at my chest area again (see Figure 6.32). Although this channel is very uniform, you can still tell there are differences in tone and texture.

Above my Clone Brush, you can see an area I haven't fixed yet. What I really want to point out is that you can see the shadows of my uniform, even in the Hue channel. It's almost imperceptible, so you have to pay really close attention, but you can see them. I mention this because I always try to stay within the same range of tones. I can see the difference in the shadow of my uniform, so when I clone trouble away, I'm going to go with that "grain." My source spot is within this region, and I am moving down and to the right, following the fold of the shirt.

Figure 6.32
The texture is almost imperceptible.

For the last example on the Hue channel, let's zoom in to look at some small details. Figure 6.33 shows the center of my uniform. My neck strap travels from the bottom right to the top center. You can tell the difference in hue between my white uniform (the left center of this figure), the black markings on the uniform (the X), and the marker that I am cloning out, which stands out as a bright white.

Figure 6.33
Carefully working in small areas.

Let's move on to the Saturation channel. Figure 6.34 shows my right shoulder and arm. The marker is discernable as dark lines in this channel, and I am cloning it out carefully, following the folds of my garment where the shadow lies.

Figure 6.34
Marker is easy to spot in the Saturation channel.

I've zoomed in closer and am working in a more deeply shadowed area in Figure 6.35. I am careful to match similar hues and saturations between my source and destination areas.

Figure 6.35
Working along shaded areas.

I return to my hand in Figure 6.36, only this time in the Saturation channel. You can see more detail here than in the Hue channel, which complicates matters a bit. However, this is saturation, and that is not the channel that holds the details of a photo. Lightness holds most of the details. The strength of this technique is that I can clone here and get away with some amount of duplication. In other words, if I wanted to "paint" this area one shade of gray, it would work just fine. The glove would be saturated equally, but it would not look strange or out of place. The important thing is to get rid of the marker.

Figure 6.36
Smaller brush for the hand.

Figure 6.37
The Lightness channel completes the trifecta.

Finally, let's look at a Lightness channel example.

Splitting and Combining

You can split and combine channels as many times as you need. If you're working, and all of a sudden you remember that you have to go run an errand, combine the channels, and copy (select all, then copy) and paste the combined image as a new layer in your working .pspimage file. When you come back, split that new layer and continue working.

Finishing the Photo Study

This photo study was also in Chapter 2, where I reduced its film grain. In this chapter, we are focusing on removing the marker and ink smears. Figure 6.38 shows the final result, which was achieved by noise reduction and contrast adjustments, in addition to cloning away the marker.

Figure 6.38
The spots are gone.

Figure 6.37, the Lightness channel image, looks essentially like the unsplit photo. I will clone in this channel as I would normally do. I'll have to remember where I've cloned away the markings in the other channels and check those spots here to see if I need to work them in this channel.

Professional Printing

Had I not been an independent contractor for a marketing and design company, I might never have realized how easy it is to send work out to be professionally printed.

Even if you've got a fantastic setup at home, I doubt you'll be able to match the equipment a professional print company has. I think the professional printing avenue is the solution that will achieve the highest-quality printouts, given the quality of your originals and the dpi you've been working in.

Yes, it costs money, but even if the per-page printing costs are more than what you would pay at your local supermart, it's more than offset by two factors. You're going to have a reasonably low volume, which means you should be able to afford to pay more per copy. Secondly, the quality and features a print and copy business have are astounding. This is what they do. Full-time.

Here are a few of the products and services available from the print and copy company I use:

- Booklets
- Brochures
- Calendars
- Catalogs
- Digital Copies

- Note Pads
- Binding
- Cutting
- Folding
- Lamination

- Offset Printing
- Pickup and Delivery
- Shrinkwrapping

Call a marketing or design agency (whoever you think needs a good printer) in town and see where they get their printing done. Ask around. Talk to people.

Visit them on the Web first and then call them. Tell them what you're doing and what sort of production you'll need (numbers, sizes, format). Ask them for a price list or quote. Before you send anything in, make sure you've asked what format they require and be clear on what sort of output you want (mainly size, but also paper, cutting or folding, and finish).

I hope you can develop a good relationship with someone. These people know a lot about printing. They may even have some suggestions that you can use to prepare your work to be printed.

Send them a file and try them out. Evaluate the product and your experience, and then go from there.

Photo Study 28: Hiding Tape

EVERY PHOTO IN THIS BOOK HAS a story behind it, and most are very interesting. This one (see Figure 6.39) departs from the norm in that I don't have much of a story to tell you.

The one somewhat interesting factoid I do have to share is that the flowers next to the house are Ditch Lilies, the orange Tiger Lilies (aka Orange Lilies) you often see out in the countryside. There you have it, the sum total of what I have to say about the contents of this photo. Er, well, that and the fact that you can bake the rhizomes (part of the underground root system) of these lilies and eat them like potatoes.

This photo has been torn in half and taped back together. I propose to fix that without taking the halves apart prior to scanning (which could damage the photo further). I'll scan it in "as is" and repair it digitally.

Prepping the Patient

Before I move on to fixing the tape, contrast, sharpness, color, and other problems, I will stitch the photo back together.

To make repairs such as this, follow these steps:

1. Choose the Freehand Selection tool from the Tools toolbar and change the type to "Point to point" in the Tool Options palette. I'll use the selection tool to select the top and bottom of the photo separately.

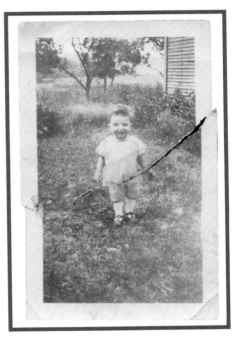

Figure 6.39
Old, yellowed, torn, taped, and wonderful.

2. Select the top or the bottom of the photo. I'm starting with the bottom in Figure 6.40. Make sure to select an area well on the other side of the taped border. You'll erase this extra area later.

3. Copy this selection.

Figure 6.40
Select the bottom.

4. Paste the selection into a new image using Ctrl+V, as shown in Figure 6.41.

Figure 6.41
Paste as new image.

5. You'll need to enlarge the canvas since this new image contains roughly half of the overall photo, and this is a good time to do it. Go to the Image ❯ Canvas Size menu. Double the vertical size of this file to make room for the other half of the photo. Make sure the "Lock aspect ratio" setting in the Canvas Size dialog box is off so you'll be able to enlarge the canvas significantly more in one dimension than another. Don't worry if the canvas ends up being too large (which is better than too small). You'll crop out the unneeded space later.

6. Go back to your original file and select the top half (or the opposite of what you just did) of the photo this time, as shown in Figure 6.42.

7. Copy the selection.

Figure 6.42
Select and copy the top.

8. Switch to your new image and paste this as a new layer, using Ctrl+L, as shown in Figure 6.43. I've pasted this as the top layer and moved the two layers in a rough approximation of where they will end up.

Figure 6.44
Straighten the bottom.

Figure 6.43
Paste as New Layer in New Image.

9. Now we need to straighten our two layers. I'm going to use the long vertical side to straighten the bottom of the photo, as seen in Figure 6.44. Select the Straighten tool from the Tools toolbar and line the two end points up. Make sure "Rotate all layers" and "Crop image" are off. I've hidden the top layer to make it easier to see what I'm doing. Make sure that you've got the right layer selected when you apply the Straighten tool.

10. Now for the top. If you hid the top, unhide it now and hide the lower layer; then select the Straighten tool, as shown in Figure 6.45. I'm using the opposite side as a reference this time, but it's still a long side. You'll get better results if you can choose the longest edge you have. Make sure that your Straighten tool options stayed the same; then apply.

11. Save your work in the appropriate location on your hard drive with a proper name. Make sure that you save it as a .pspimage so the layers are preserved..

Figure 6.45
Straighten the top.

That's it, doctor, the patient is prepped for restoration!

Joining the Pieces

Let's set the stage. A torn photo has been taped back together, and you're going to restore it. You've scanned it in and then digitally separated the two torn pieces with the power and majesty of Paint Shop Pro Photo. They've been straightened, and now you're ready to begin joining the pieces, which is the second phase of this three-phase operation.

Let's continue with the steps, although I am going to number anew.

1. Hide one of the layers; then select the other layer to work on.

2. Select the Eraser and choose a size and hardness appropriate to the area you want to erase. When I'm erasing a lot of material, I start out with a large eraser that's 100% hard and then move smaller and softer the closer I get to the edge. I may take two or three passes to get close to the edge. In this case, I can go right to a smaller, softer brush.

3. Begin erasing material from the opposite side of the tape, as shown in Figure 6.46. Work your way carefully across, trying not to erase anything from the "keeper" side. Don't worry about the rough edge of the torn paper border. You'll clone this out eventually.

Figure 6.46
Erase extra bottom area.

4. When you're done with this layer, hide it, show the other, and repeat the process, as shown in Figure 6.47. I'm working on the top of the photo by erasing everything from below the tape and tear line. This is cool stuff!

Figure 6.47
Erase extra top area.

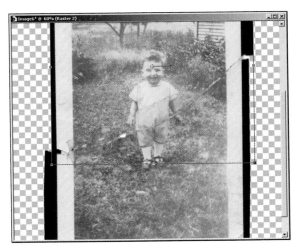

Figure 6.48
Align the two layers.

5. Now for some magic. Show both layers and then select the content of the top layer with the Pick tool and move it into position, matching the edge of the bottom layer, as seen in Figure 6.48. If you get it close and want to verify its position, zoom in. You can also use your arrow keys to nudge the selection in any direction you choose. In particular, look to match the subject of the photo first; then check out the border. Never choose a straight border over your subject. There are many ways to fix borders that don't match perfectly after the fact. For example, you could clone new material, create a rectangular selection and lighten the outside to form a new border, or crop the photo. If your subject doesn't line up, then you're toast. You'll do more damage trying to fix that (self-created) problem than you would ever do fixing a border.

6. Now it's time to stitch them together. Create a layer to clone with on top of the two content layers.

7. Make this clone layer active; then select the Clone Brush and clone the edges of the photo together along one side of the photo, as seen in Figure 6.49.

Figure 6.49
Clone them together.

8. Repeat on the other side, as seen in Figure 6.50.

Figure 6.50
Getting the other side.

Figure 6.51
Working the middle.

With the pieces fit together, the subject successfully lined up, and the photo border fixed with the Clone Brush, I'm ready to move to the center of the photo.

Continuing to Clone

This is the third phase of restoring this photo and hiding the tape. I will hide the tape with the judicious use of the Clone Brush. I am cloning grass over the taped area to the left (our perspective) of the young boy in Figure 6.51.

Figure 6.52
Careful along the arm.

I am continuing to clone and have moved on to his wrist in Figure 6.52. I need to be very careful here because there is little room to work, and the gradient of his wrist needs to match perfectly.

If cloning tape away is problematic in a portion of the photo, desaturate the area with the Saturation Up/Down Brush. This takes the color out of the tape and leaves the detail of the clothes behind, as seen in Figure 6.53.

Figure 6.53
You can also desaturate.

Finishing the Photo Study

This was another very rewarding photo to restore. The difference between the before and after (see Figure 6.54) shots is amazing. When you can put together a photo that has been torn in half and then taped back together, you start to see the world of possibilities that is open to you.

After I got the photo together and cloned much of the tape and other problems away, I worked on the brightness, contrast, and color with histogram adjustments, fade corrections, and some desaturation.

Figure 6.54
Smiling child recovered.

Photo Study 29: Cleaning Gunk

Now for gunk. What better photo to use (see Figure 6.55) than the Leaning Tower of Pisa, complete with gunk? Waiter, we'd like a large Pisa, hold the anchovies, but we'll take double gunk.

This is another photo from a prior chapter—Photo Study 1 in Chapter 1, to be exact. Please refer back to that text for a more complete background description of this photo.

Rather than clone the gunk away, which would be my first option, I'm going to use a completely different technique this time. Notice those clouds that the gunk is covering. Clouds make traditional cloning much harder because you can tell quite clearly when they start to look alike. I have come up with a solution that will work around that problem.

This photo study is gonna be quick. Split the channels, clone, combine, and salt to taste.

Splitting Channels

Figure 6.56 shows the Hue channel in the area of sky where the gunk was. I have pulled hue from a similar part of the sky to cover the gunk up.

I have moved on to the Saturation channel (a close cousin of the History Channel) in Figure 6.57. The gunk was more visible here. You can still see part of it in the top left area of my Clone Brush. In this case, I chose to pull material from below the gunk. Remember, this is saturation, not the true details of the photo. It's okay if there are some duplications that are visible in this channel.

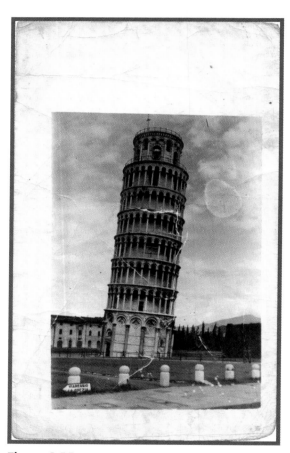

Figure 6.55
The gunk is an extremely unattractive feature.

Breaking My Own Rules

When I split channels, I dispense with creating a separate layer to clone on and clone directly onto the Background layer.

Figure 6.56
You know the drill—cloning in the Hue channel.

Figure 6.57
A little more obvious in the Saturation channel.

For once (see Figure 6.58), the Lightness channel has the least amount of detail (in the gunk area only). I am cloning over the gunk using some nice clouds to the upper right of the gunk spot.

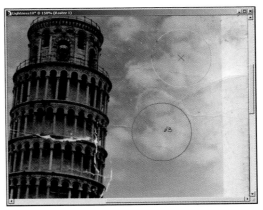

Figure 6.58
Less obvious in the Lightness channel.

Finishing the Photo Study

There was so much to this photo, I realize just talking about removing the gunk might leave you thirsting for more. There were quite a few tears in the film, caused by creasing and age, not to mention spots and specks all over. The details of the tower are the most important part of this photo, and I was able, with time and patience, to use the Clone Brush to repair most of them. The final version is shown in Figure 6.59. After the cloning, of course, there were the necessary brightness, contrast, color, and sharpness tweaks. I used the Levels adjustment and desaturation to get the final effect.

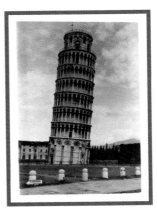

Figure 6.59
Gunk-free but still leaning.

Photo Study 30: Hiding Discolored Spots

FIGURE 6.60 IS A PHOTO OF MY wife's grandfather taken in 1944, when Bud was 19 years old. He was young, but not immature. He'd already seen a lot of combat in Africa, Italy, and France. Here, we get to see a gentler moment of his time at war. Bud was in France at the time and was able to sit for a photographic portrait to send home to his family. He was engaged at the time, and I am sure Louise treasured getting these photos.

There are several spots on his sweater, shirt, and background. The photo has been lightly bent or creased in a few spots. I will use the HSL technique again to split the image and do most of the repair work in the separate channels.

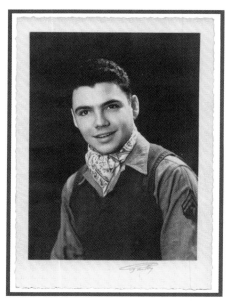

Figure 6.60
Marvelous photo lessened by discoloration.

Creating a Mask and New Background

First, I will create a mask to separate Bud from the background. If you want to work with a mask for a project like this, follow these steps:

1. Select the Background, or base photo, layer and duplicate it three times, so there are four layers. Hide the bottommost Background layer (the first few steps become clearer if you peek ahead to Figure 6.61).

2. I'll name my top layer "Border," the middle layer "Bud," and the next layer of the three "Solid." The Border layer will contain the restored photo border, Bud will serve as the mask layer, and Solid will be the solid color background I will use to replace the existing background with.

3. Make the Border layer active and hide the rest.

4. Use the Selection tool to select everything but the photo frame and delete it. When I create the mask, I want to focus on Bud and don't want to have to worry about preserving the visibility of the photo border.

5. Select the subject layer, which is Bud in this case.

6. Select Layers > New Mask Layer > Show All from the Layers palette menu. This creates a new mask layer within a layer group that has nothing on it. Everything is visible.

7. I will paint black on the mask layer to hide the background and keep Bud visible. The whole point of this is to be able to make the background a selection down the road. The easiest way to create a very complicated selection is to make a mask. Choose the Paint Brush from the Tools toolbar, load pure black into the Foreground color of the Materials palette, and start "painting away" (it looks like you're erasing it) the background, as shown in Figure 6.61. I start with a large, hard brush to get most of the background painted black; then I make the brush smaller and softer as I zoom in and work closer to the border. You can get a very precise mask this way.

Figure 6.61
Painting black to hide the background using a Mask layer.

8. Once the mask is done and the background is totally hidden, choose the Selections ❯ From Mask menu. This converts the mask you've just created into a nifty selection. In my photo, Bud is the selection. Now choose Selections ❯ Invert to switch that to the background. This inverts the selection and selects the background instead of Bud. I'll use this selection to create the solid colored background.

9. Choose an appropriate background color from the photo with the Dropper and load it into the Foreground swatch of the Materials palette. Although you don't have to choose this color from the photo, the background will be much more realistic if you select a color that is in the photo.

10. Select the Solid layer, which is underneath the Mask layer, and make it visible.

11. Select the Paint Brush and paint the new background onto the Solid layer, as seen in Figure 6.62. In my case, I don't have to worry about painting over Bud, because he's safely outside of the selection. Had I tried to paint the new background on the Mask layer, it would have been hidden because everything but Bud is masked out. I could reverse everything and mask the background layer out, but I was able to get a more precise border by masking the background out, selecting Bud, and then inverting the selection.

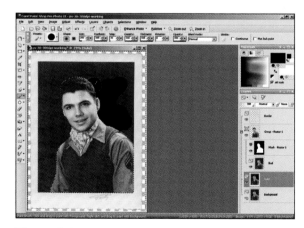

Figure 6.62
Painting the new background.

When you're done, you should select all, copy merged, and paste this as the top layer in your file. I've completely replaced the background color, which was pretty spotty, with a nice smooth solid color. I'll continue working on the rest of the photo now.

Splitting Channels

I'm going to split the layer I just pasted (it has the new background) into HSL channels and work the spots out of Bud's uniform. I'm working on the Hue channel in Figure 6.63.

Figure 6.63
Spot removal in the Hue channel.

I'll keep working on each of the three channels, cloning out what problems I see. Because this is a black-and-white photo, the HSL channels make the spots visible and more manageable than if I were working with them combined. I don't have to worry about the background now, which makes this go much faster.

Finishing the Photo Study

The final photo is shown on the next page. The problems weren't huge, but they definitely had a negative impact on how the photo looked. The mask enabled me to create a very detailed selection and use that selection to preserve my subject and create a new background. Splitting the channels enabled me to find the discolorations and clone them out effectively. I also spruced up the border and finished up with brightness and contrast adjustments.

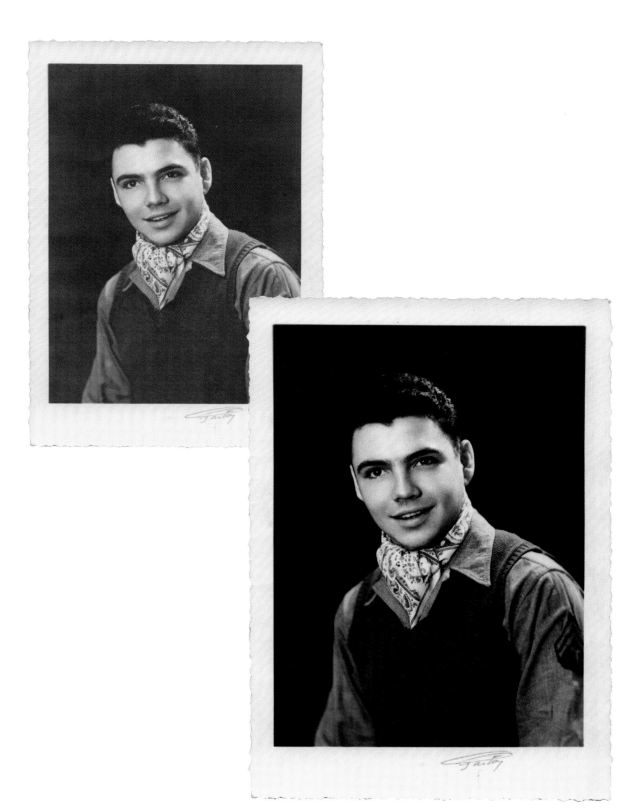

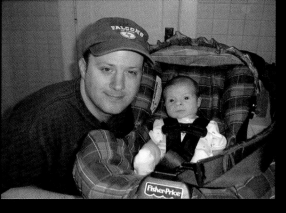

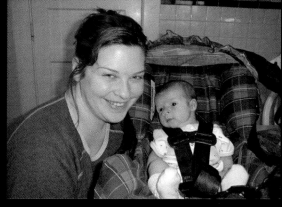

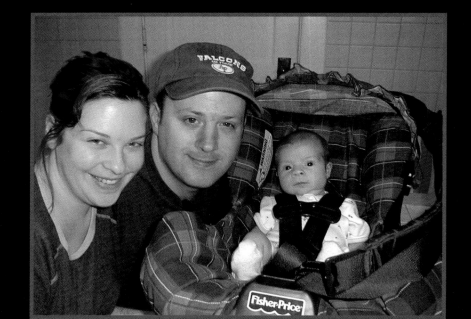

Moving, Adding, or Removing Objects

<div style="text-align: right;">7</div>

YOU'LL USE MANY OF THE SAME SKILLS IN this chapter that you've honed thus far, plus add some new ones—namely, copying, pasting, and erasing. Removing objects is very much like fixing damaged photos, but instead of covering up a scratch, you're covering up your thumb, camera strap, or a reflection.

▶ **Photo Study 31: Moving a Teddy Bear**—In this photo, I'll alter the placement of the teddy bear. The basic procedure is to copy what you want to move (the bear), paste it as a new layer, cover the original up, and blend the new layer into the context of the photo.

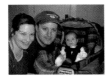

▶ **Photo Study 32: Tank Top Touch-Ups**—Unlike the first photo, this does not use cut and paste. I'll remove the logo on the tank top I am wearing and add material with the Clone Brush. This is pretty straightforward cloning, but the purpose isn't to fix something torn or ripped, but rather to change the content of the photo.

▶ **Photo Study 33: Adding a Person to a Photo**—Do you want to add someone to a photo? I'll show you how to take content from more than one picture and composite it together. The process is similar to moving an object because you're moving someone or something from one photo to another.

▶ **Photo Study 34: Removing Thumbs or Camera Straps**—You'll learn about the Object Remover and how to remove a thumb or camera strap from a photo.

▶ **Photo Study 35: Reflections and House Numbers**—I'll use a combination of techniques to remove my wife's reflection from the front storm door and change the house numbers around.

▶ **Photo Study 36: Improving Photo Composition**—You can improve a photo's composition by removing distracting objects. I will use the Clone Brush and the Object Remover in this photo.

▶ **Photo Study 37: Creating Montages**—I could easily fill a good-sized chapter with montages I've made over the years of our family's faces, of us sticking our tongues out, of our kids, and of our pets. If you can copy, paste, and erase, you can montage.

Photo Study 31: Moving a Teddy Bear

O UR KIDS LOVE THEIR TEDDY BEARS and pillows. My oldest son, Benjamin, is napping on the couch in Figure 7.1 with both his pillow and one of his smaller bears, Baby Grace.

I'll use Baby Grace in this photo study to show you how to move something around in a photo. She's fine where she is, but would look cuter if she were under the blanket with Ben.

Getting Started

First, I will copy the bear. I use the Freehand Selection tool in "Point to point" mode (modes are accessible in the Tool Options palette at the top of the screen) for selection operations like this. The Freehand Selection tool in "Freehand" mode takes more effort to use quickly, and I will erase around the edges anyway. I want to just make a fast selection and go. There is no need to be fancy with the selection as long as you get the entire subject. I've made my selection of the bear in Figure 7.2 with the Freehand Selection tool in "Point to point" mode. This mode lets me click at each point of the selection polygon, and I can do it rapido. Comprende?

Freehand Conventions

From this point forward, I will write "Freehand Selection tool in 'Freehand' mode" as *Freehand Selection tool (Freehand mode)*. I will shorten "Freehand Selection tool in 'Point to point' mode" to *Freehand Selection tool (Point mode)*.

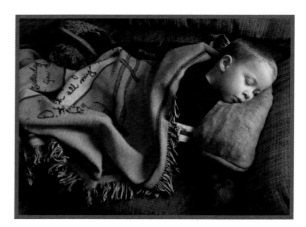

Figure 7.1
Cute, but could be composed better.

Figure 7.2
Lasso that bear.

Next, I've copied the bear using the standard keyboard shortcut (I'm a sucker for Ctrl+C) and then pasted it as a new layer (Ctrl+L by default).

I Would Pay $5 for This Tip

I'm always hitting Ctrl+V to paste things. The programs I've used over the years have trained me well. In Paint Shop Pro Photo, however, Ctrl+V pastes the contents of the clipboard as a new image. I use "Paste as New Layer" over "Paste as New Image" by a factor of about 10 to 1.

Here's the tip. Go to the View **>** Customize menu and open the Keyboard tab. Under Category, choose Edit; then under Commands, choose Paste as New Image. Select the Ctrl+V shortcut and press Remove. Assign another if you like (keep reading to find out how).

Next, go to the Paste as New Layer command and click in the Press New Shortcut Key box; then execute the Ctrl+V shortcut. You'll see it show up in the box to the left. Press Assign and then Close.

Figure 7.3
Don't wake her while you erase.

I've hidden the Background layer so I can see the bear (you would want to see whatever you're moving) in Figure 7.3. I need to be able to see the edges of the bear, so I've made sure the layer is centered. I'm ready to start erasing around the object and cleaning up its edges. If I need to erase a lot, I'll start with a large eraser and set the hardness to 100%. Then I'll work my way down to a small brush at 0% hardness for the final pass. Here, there's not much to erase, so I'll use a soft eraser from the outset.

Erasing is one of the most important aspects of this exercise. If you don't get a good clean border (not sharp—sharp will stick out like a sore thumb) around your subject, it will be obvious when you position it. Use short strokes as you erase so you don't lose a lot of work if you have to undo. Notice that I haven't rotated the bear or positioned it yet. I'm concentrating on erasing the border. That's it.

Covering Up

Now that the subject is prepped to move (remember, it's been copied and pasted to a new layer), I can put it aside and start covering the original. For this photo, that involves extending the couch material to where Baby Grace is now. I could use the Clone Brush to cover the bear up, but I have decided to copy and paste a section of the couch instead. The texture of the couch makes it hard to clone without being obviously repetitious. First, I'll need to hide the new bear layer and show the Background layer.

Having done that, I've selected my trusty Freehand Selection tool (Point mode) in Figure 7.4 and have completed a selection of the couch that will blend in the best when I move it over. Thankfully, there is a patch of couch that is a good match. There are some shadow problems, but I can minimize them later by applying an overall shadow to the area. I'm going for "ballpark" with tone, but the texture and pattern I want to align perfectly. Had I not been able to grab this area, I would look for another photo that has the couch in it or walk out of the

computer room and into the living room and take the photo for that express purpose. You can do that, you know!

Figure 7.4
Carefully selecting along the lines.

After making the selection, I've copied and pasted it as a new layer. You can paste it several times or just paste it once and then duplicate that layer several times. Your call. I've pasted the couch material about eight times, and I've arranged the pieces to fit the area in Figure 7.5. I'm not worried about the border yet. This is just to align and to get the pattern set.

After I've aligned the multiple strips, I will select the top one from the Layers palette and choose Merge Down (right-click over the layer in the palette, choose Merge, and then Merge Down). I'll keep doing this until all the couch strips are merged. It is very (I am tempted to yell that), very important not to merge this layer with the background yet.

Figure 7.5
Transplanting couch texture.

The reason for that is to be able to manipulate this layer separately from the main photo layer. For starters, I need to erase all the ragged edges (see Figure 7.6). First, I'll move along the arm of the couch, then by the pillow. It's important to remember that the "patch" is on a layer above the couch. As I erase the border of the patch, it "sinks" in and blends with the couch.

Figure 7.6
Erase to fit.

Next, I will get rid of the straight edges that form the border between the pasted patches. This is easily done with the Clone Brush (see Figure 7.7). I'm careful to match tones (colors, shadows, and lightness) and patterns now.

Figure 7.7
Couches sans borders.

With the cloning done and the original bear covered, it is time to move back to reposition the copy of Baby Grace.

Fitting In

I kept the new Baby Grace layer hidden while I was covering up the original area. This kept things visually straightforward and simple. Now, I will blend this new layer in so that she looks like she's tucked under the blanket as opposed to the pillow.

It's a simple matter to grab the Pick tool and drag Baby Grace over to the blanket and rotate her to match the orientation of the new scene I want her in (see Figure 7.8). After positioning her, I will blend her in with the Eraser to make her look like she's under the blanket.

There's something of an optical illusion going on in Figure 7.8 that I want to point out. See how it looks like I'm erasing the blanket? I'm actually erasing Baby Grace, because the layer she is on is on top of the background photo. The illusion is that she is under the blanket, and it's hard not to try and erase the blanket to fit her under there.

During the blending stage, I am careful to observe how she blends in. I will zoom in and out to get a fresh perspective.

Figure 7.8
Erase border of Baby Grace to create the illusion.

We're almost done.

Shadows are an important aspect of getting things to blend and match. They can also cover up things that you can't get to look right. For this photo, I have darkened a few areas to help cement the illusion. First, I used the Burn Brush (at a pretty light setting: opacity 10) and stroked around Baby Grace. I darkened the couch below her as if she were casting a shadow, and I also darkened her edges to give the illusion of depth (see Figure 7.9).

I've also darkened the area of the couch she came from.

Figure 7.9
Burn shadow on the couch.

I think that about does it. I will select everything, perform a merged copy, and paste that to a new layer on top of everything else. I'll make global adjustments to that layer.

Final Adjustments

Always remember to tweak things. Although the main point of this restoration was moving the bear, I will take a look at the histogram or try a Smart Photo Fix. In this case, I consulted the Smart Photo Fix and liked what I saw. I altered some of the settings slightly (see Figure 7.10), and the result was a bit livelier.

After this, I smoothed things out a touch using Adjust ➤ Add/Remove Noise ➤ Texture Preserving Smooth because poorly lit digital photos can intro-duce noise into the photo. See, it all fits together.

Figure 7.10
Tweaking merged layer.

Finishing the Photo Study

Figure 7.11 (would you like a Big Gulp® with that?) shows the final result. Baby Grace looks better under the blanket than where she was. Her new alignment matches Ben's and goes from left to right, or horizontally. Before I moved her, she was aligned vertically and was at odds with everything else in the photo.

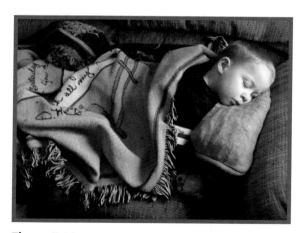

Figure 7.11
Ben and Baby Grace hibernating one afternoon.

Photo Study 32: Tank Top Touch-Ups

FIGURE 7.12 WAS TAKEN ON MY wedding day. Anne and I went down to a resort in Florida and got married at sunset on an outside veranda with our immediate family and a few close friends present.

That morning, we went out for a photo shoot by the dock, and Steve, a friend of ours, took this photo. I'm wearing a tank top with the Nike name and logo clearly visible in the photo, which is somewhat distracting. I will use the Clone Brush to get rid of the logo and extend the coverage of the shirt under my arms a little bit.

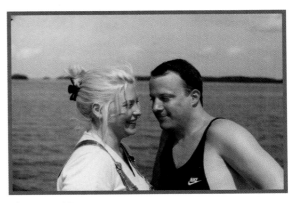

Figure 7.12
This wedding sponsored by....

Getting Started

Let's use a numbered list to summarize how I started out with this photo for review.

1. Since this was a photo print, I cleaned the scanner glass and made sure the photo was as dust-free as possible. I put the photo in the scanner, aligned with the help of my trusty ruler.

2. I turned on the scanner and gave our system time to recognize it; then I launched the scanner software. (On our system, if we launch the scanner software first and then turn the scanner on, the software can never find the scanner.)

3. I selected an appropriate resolution (300dpi) and color depth (24-bit) in the scanner software.

4. I made sure all automatic adjustments (like sharpen or enhance) were turned off.

5. I hit "preview," which had the scanner do a quick overview scan and display what was on the scanner bed.

6. Next, I altered the scanner selection box so I wouldn't scan the full 8×10-inch bed. I always give myself a little extra space around the photo, which I will crop out later.

7. Then I hit "scan to file" and saved the photo as an uncompressed .tif. This is a high-res file format that (given the correct options) will not alter the data of the photo like a .jpg can (which uses a "lossy" compression algorithm).

8. After that, I got the photo out of the scanner (easy to forget), put it back in its album, closed the scanner software, turned off the scanner, got a soda, went to the bathroom, checked e-mail, kissed my wife, and then came back and fired up Corel Paint Shop Pro Photo X2, or CorPaShoProPho as I like to call it for short. Oh, I'm just kidding. I actually call it CPSPP. I'm still kidding. X2 is kind of catchy.

9. Next, I opened the file in X2 and saved it as a .pspimage, put the .tif away for safekeeping, made sure the photo was straight, and cropped out the extra material from the scanner bed.

10. I then stopped for a bit and just looked at the photo in Paint Shop Pro. I looked for what needed to be fixed and what didn't. When you work on your photos, develop a game plan. It might be something like, "I want to fix some of the scratches, then take the logo out, then work on the tank top, then adjust the color. I think I'll use the Clone Brush for the most part, so I need to get a clone layer going."

11. That was my game plan, too. I created a new, empty raster layer above the Background and renamed it "clone." I selected the Clone Brush, made it reasonably small (20) and soft (0% hardness), and got to work zooming in and out, working over the photo in a search pattern looking for dust and scratches. When you use the Clone Brush like I do (on a separate layer), enable the "Use all layers" option in the Tool Options palette. I like doing it this way because I can blend the cloned material better (with the Soften Brush, for example) and erase it if I want to start over. This step is important. Don't get rushed and overlook the small problems in a photo.

Fixing these will make a world of difference and make the photo much clearer! If the photo is digital, you won't have to worry about scratches and dust.

12. I now return you to the regularly scheduled program, already in progress.

Restoration and Retouching Ethics

Danger! You could write a lot of damaging things with this word processing program! Use this program wisely!

That's silly, of course, and I've never seen a note like it in any other book. Pictures are powerful things, however, and Paint Shop Pro gives us the tools to do amazing things with them.

Moving, adding, or removing things from photos is fun, but also a little disturbing. We are altering a depiction of reality (the photos are not reality itself, of course, but we use them to represent it) that many would accept as the truth.

There are lines we should not cross with this capability, and I trust you will know them if you ever come to them. There is also a huge area in the middle that can be fun and rewarding to play in.

Erasing the Logo

Now, it's time to fix that shirt. I'm going to remove the logo first. A "logoectomy," if you will. I will select the Clone Brush and get at it. This is just like removing a tear or scratch. You need a good patch of source material to put over the object you want to cover. In this case, there are some folds and shadows in the tank top that make it a bit trickier than a straightforward cover-up. Pay attention to these details. Always select a source area that matches the tone and shade of the area you will be covering up.

I am grabbing material from above and dragging my brush down and to the right in Figure 7.13. This is the "flow" of the shirt. Make small strokes and vary where your source spot is several times so you're not just copying the material directly down.

Figure 7.13
Clone out the logo along shadow lines.

Altering the Tank Top

Now that the logo is gone, I can continue altering the tank top by extending its coverage under my arm. This is quite a bit of material to add, but since the tank top has a pretty even texture and tone, the result will look fine, as long as I pay attention to the shadows.

I'll first work along the side and bottom (see Figure 7.14) to give myself an outline. Then I'll go back and fill in the missing area. At this stage, I'm not worried about the border yet. I am concentrating on the coverage. After I get that filled in and am happy with it, I can switch to the Eraser, tune it to an appropriate size and hardness (you want to match the existing detail here), and clean up the edge of the tank top by erasing on the clone layer. If you can find a border elsewhere to clone, that is also a workable solution.

Figure 7.14
While we're here, a little more coverage please.

With the cloning done, I look to see if the new material matches the old, and at that point I may go over it with a Soften or Sharpen Brush.

There's one other detail to take care of. Shadows are incredibly important. They help give the impression that what you just put in belongs there. If you forget to add shadows, people may not notice it at first, but they will look at the photo and sense something is out of place. I add shadows with the Burn Brush, and I'm extending the shadow that is under my arm to the tank top material that was never there in the first place in Figure 7.15.

Figure 7.15
Burning shadows is important.

Cosmetic Changes

I was ready to wrap this up, but I realized I could do some minor cosmetic surgery on both our necks to make us look better. Who doesn't want to look their best on their wedding day? To prep, I chose the Rectangular Selection tool, selected all (Ctrl+A), performed a merged copy (Ctrl+Shift+C), and pasted that as a new layer (Ctrl+L) above everything else.

Having done that, I selected the Warp Brush and made sure it was in Push mode. This is very cool. I try not to overuse this, but if it is done judiciously, you'll look subtly better.

It's Not Paranoia, Really

When I do a merged copy and then paste that as a new layer to preserve all the work I've done, I'm protecting myself.

I've developed these seemingly quirky techniques because I have gone down paths with photos that seemed right at first, only to reach dead-ends that I couldn't get out of with Undo or History. I developed a way to preserve what I was doing in stages and have the convenience of using only one or two files.

I've tried using "Save As," but when I get 10 or more versions of a photo running around on my hard disk, it becomes overly cumbersome and drives me crazy.

With this setup, I can see from the Layers palette where I am and where I came from. If I want to go back and try something different, I can easily do it—and be able to compare the difference right away. One note of caution, however. Your (and my) ability to do this depends on the size of the photo and your computer's horsepower. I try not to overdo it with 50 layers.

I zoomed into Anne's neck area and very lightly pushed a tiny area of her neck upwards to tighten it in Figure 7.16. Being subtle about this type of effect is the key to making an improvement to the photo.

Figure 7.16
Subtle reduction for Anne.

The result looked good on her, so I will give myself a little of that magic, too (see Figure 7.17). You may not be able to discern the difference in this book, but as I look at the file and toggle the top layer on and off to compare the before and after photos, reducing our necks was worth the subtle effect.

Figure 7.17
Matching for me.

Okay, let's wrap this puppy up. For my final adjustment, I chose to run the photo through Smart Photo Fix (see Figure 7.18). The contrast of the original isn't that good, and it looks a little greenish. Smart Photo Fix handled this very well.

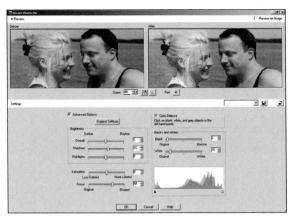

Figure 7.18
Smart Photo Fix does nicely here.

My final adjustment was to increase the blue in the photo by making it cooler (Adjust > Color Balance).

Finishing the Photo Study

The final photo (see Figure 7.19) is much better than the original. Removing the logo and extending the shirt material removes distractions and places us rightfully at the center of attention. The neck and color adjustments were also effective.

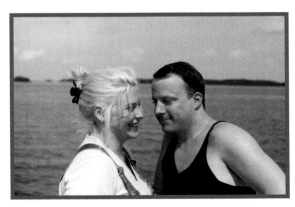

Figure 7.19
Great photo made greater.

Photo Study 33: Adding a Person to a Photo

FIGURE 7.20 IS A PHOTO OF MY SON Benjamin sitting in his car seat on the kitchen table. I'm the proud papa beside him. Where's Mommy? She's taking the picture. This happens to us all the time. She's not in the pictures she takes. I'm not in the pictures that I take.

This photo (and the one with her in it) stood out from the very beginning as good candidates for moving one of us to the other photo. They were taken at the same time and with the same lighting. In addition, they were taken from basically the same vantage point. I will keep one of the photos and use it as a "base" layer and then copy the other person in and blend them together.

Adding Anne

First, I'll add Anne from her photo (see Figure 7.21) to my "base" photo. She is sitting a little more sideways, which means more of her is visible to the camera. Thus, there is less of her for me to have to create when I move her. If you look at my chest (see Figure 7.20), much of it is covered by the car seat.

First, I will take her out of her photo. I used the Freehand Selection tool (Point mode) to select her, as shown in Figure 7.21.

I was fairly liberal with the amount of wall and pantry door I included with Anne in the selection. This is about moving her over, not making a perfect selection on the front end. Don't waste your time with that. I need the extra space for a few reasons.

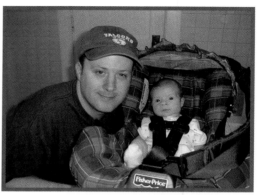

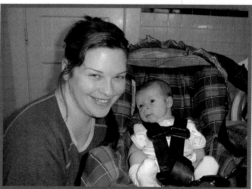

Figure 7.20
We needed someone to take our photo together.

First, when I start erasing around her, the extra border width (in general, not the wall just yet) gives me a chance to get the right eraser size and hardness, which will help when I blend her in. Secondly, I'm going to use some of this extra material to match her size and perspective to mine, because the photos are not taken from exactly the same vantage point. They were close, which makes this possible, but not exact.

Figure 7.21
Select and copy the subject from the other photo.

Figure 7.22
Paste her in the "keeper" photo.

I've copied her and pasted that image into a new layer in my photo, as shown in Figure 7.22. You see the extra wall and door space that I have included with her in this figure. Those linear features are perfect for aligning the two parts of the photos.

Next, I will lower the opacity of Anne's layer to about 80% and use the Pick tool to align (move), size (using the outer handles), and rotate (matching the tile on the wall) Anne's layer to match mine.

I'm rotating and scaling her layer to match mine in Figure 7.23. Can you see the door hinges? I've got hers to the left of mine. Although her layer is less opaque, it looks stronger than mine because she is on the top layer. I've used the hinge and the door-jamb to get the vertical alignment, and the tile lines and size to get the rotation and scale. The tile sizes match near the top, but they don't line up as well near the bottom. The scales of her photo and mine are a slight mismatch.

The reason I'm going to this extreme is so that we look good together. It would look weird for her head to be out of proportion with mine. They don't need to match perfectly, but I want them to be close.

Figure 7.23
Adjust using reference points for scale and perspective.

Erasing and Positioning

Now, it's time to erase and position Anne in the context of the photo. I've started erasing the border around her in Figure 7.24 with the Eraser. I'll make a few passes with the Eraser, and on each pass I'll zoom in closer to catch more details..

Figure 7.24
Erasing is critical.

Hair is hard to erase well, so I will share a little trick I use in these situations. First, don't worry about erasing a few straggling hairs. I just erase them. They aren't worth the trouble of trying to save. Second, you want a fuzzy border around the hair. That's what natural hair looks like (following the time when Brylcream ruled the earth). The trick is to take a large Eraser that is 100% soft and lightly touch it outside of the area you are erasing to gently eat away at some of the opacity of the pixels that border the hair.

With the perspective and scale corrected and the erasing done, it's time for positioning. I've moved Anne into position in Figure 7.25.

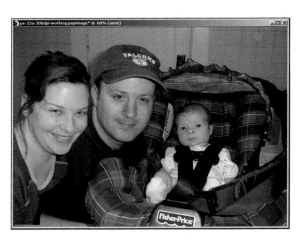

Figure 7.25
Position before making final adjustments.

I'm not done, however. She's missing some material that makes it obvious she doesn't belong in this photo. I'll need to add it to finish her.

Toying with Reality

This photo study produces a picture that is arguably fake and toys with reality. Yeah, I guess so. However, that makes it no different from any movie, painting, or sculpture ever created. They are all expressions of the artist(s), based on their thoughts, perceptions, ethics, ideologies, talents, and energies. Statues and paintings are an order removed from what we perceive as reality because of our inability to duplicate what we see with enough precision. Movies come closer, as do photos, but do you think movies are real? It may take us a while to get used to this because the average person has never had this much power to produce something as fake as this and yet be so close to the real thing. Yeah, that's a tough one.

Adding New Material

I've got another photo (see Figure 7.26) where Anne is at a slightly different angle to the camera, which picks up more of the front of her shirt. I can use this photo as a source to copy her shirt. I'll select and copy an appropriate section and paste it as a new layer in the base photo.

Figure 7.27
Go semitransparent when positioning.

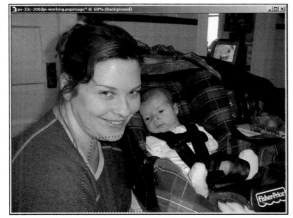

Figure 7.26
Copying extra material from another photo.

I'm aligning the new layer in Figure 7.27 by making it semitransparent and moving it around with the Pick tool.

The orientation of the new material is different enough from where I want to place it that I have to choose what to align. In this case, I think the neckline and the seam on her left shoulder are good choices. Those form the border of what I want to replace. I have aligned the new shirt material and am erasing what I don't need in Figure 7.28.

Figure 7.28
Erase unneeded material.

Next, it's time for some close-up retouching to make the new layer match her neckline. I am just starting to use the Clone Brush in Figure 7.29 to line up the seam by cloning gray material over the mismatch.

Figure 7.29
Getting ready to clone.

Figure 7.30 shows the result. You cannot tell that this neckline and shirt were from two different photos.

Figure 7.30
Now it matches perfectly.

Final Adjustments

The heavy lifting is over. It's now just a matter of cleaning things up. I'll finish with my usual flourish. Select all, copy merged, paste as new layer. As always, see if you need to (and can) improve color, brightness, and contrast. I'm using the Histogram Adjustment dialog box in Figure 7.31 to get better contrast.

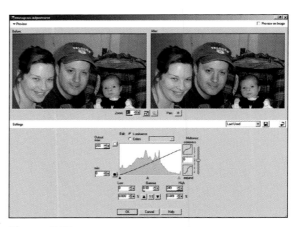

Figure 7.31
Don't forget to check the histogram.

Finishing the Photo Study

This one's done (see Figure 7.32). I didn't use more than a handful of tools for this entire photo study, but the result is dramatic. We were in two photos, and now we are in one photo. It's not about how many tools you use or how easy or hard they are, it's about the photos and the results.

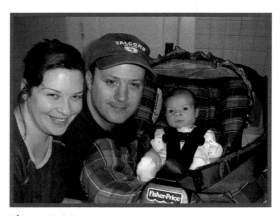

Figure 7.32
A successfully operation, doctor!

Photo Study 34:
Removing Thumbs or Camera Straps

F IGURE 7.33 SHOWS THE TYPICAL result of taking a photo with a camera that has a strap flying around or one taken by a photographer with his thumb in the way. Take your camera strap off and throw it away to keep it out of the way (or never take it off your neck). You can't do that with your thumbs, however, so you'll have to "manually" keep them out of the way.

Figure 7.33
I was all thumbs.

I am going to use this photo study to feature the Object Remover and show you when it doesn't work so well.

Object Remover Basics

Since I won't be using the Clone Brush for this photo study (alert the media!), I also won't be creating a new transparent raster layer to clone on. What I will be doing, however, is duplicating the Background layer (see Figure 7.34) so I have a "disposable" work surface that I can trash and not worry about. Savvy (ala Johnny Depp in *Pirates*)? Duplicate the Background layer by right-clicking over it in the Layers palette and choosing Duplicate.

I go to this effort in part because you can't use the Object Remover on multiple layers. When you apply it, you're locked into the Undo/History system, and once you start making other changes it's really hard to go back. I've also found this approach saves me time because I don't have to find the original scan and re-open it every time I want to start over.

Figure 7.34
Duplicate the Background layer for safety.

Now for the Object Remover tool. It's under the Clone Brush on the Tools toolbar. I've zoomed in on the offending object and drawn a selection around it (see Figure 7.35). If you can't make the selection, make sure the Object Remover is in

Selection mode. You can tell by looking at the Tool Options palette at the top of the screen and seeing the little lasso active.

This selection device is identical to the Freehand Selection tool (Freehand mode). That is, you click and hold the mouse button down to draw the selection. It can be tricky to select a complicated area. Take your time and start over if you need to.

Figure 7.35
Select offending thumb or strap.

I've selected the object I want to make disappear, and now I've got to choose an area that Paint Shop Pro will use to cover it up with. That's done in Source mode with the source rectangle, as shown in Figure 7.36.

The source rectangle appears as a large rectangle in the center of your photo when you click the Source mode button on the Tool Options palette. I dragged it to a better location and resized it so that it contains only sky.

Next, I hit Apply. The results are shown in Figure 7.37.

Figure 7.36
Choose a source wisely, young Padawan.

Figure 7.37
Oops, forgot to turn "Smart blending" off.

I left the "Smart blending" option on to illustrate this point. There are times when you want the Object Remover to blend the new and old material together. There are other times (this is one of them) when you want to cover something up completely. In this case, I will turn "Smart blending" off and get a much better result (see Figure 7.38).

Figure 7.38
Sometimes, the best results are without "Smart blending".

Other Areas

Let's see how the Object Remover works on a few more complicated areas.

I've selected the stroller in Figure 7.39 to remove with the Object Remover. The source rectangle covers the baseball diamond fence and grass. Let's see how this works with "Smart blending" enabled.

Figure 7.39
Let's try the Remover here.

Yuck (see Figure 7.40). Anne seems to be laughing at that one. The moral of this story must be that you can't successfully use the Object Remover on anything complex, right?

Figure 7.40
Nope.

Well, let's see. In Figure 7.41, I have selected Ben's pants to remove and replace with a patch of grass right next to him. Meet you on the other side of this figure.

Figure 7.41
Can this work?

Hey, it did go a lot better (see Figure 7.42). The grass, although complex, was much easier for Paint Shop Pro to replicate and replace Ben's pants with.

Figure 7.42
Yup.

The actual moral of this story is to try everything. There are times the Object Remover will stink. Other times, it will save you a lot of cloning work.

Retouching

I've undone all the trial runs with the Object Remover, and now it's time to retouch the contrast for this photo. The Histogram Adjustment dialog box is open in Figure 7.43. I'm using the Colors mode to change each color channel's histogram individually, as opposed to the overall luminance.

I've turned the gamma down slightly for all three colors and raised the low end up some. Each one had subtly different values. This photo has good examples of color to work with. There are solid patches of red (Ben's hat bill), green (the grass), and blue (Ben's hat and sleeves) that I used as reference points to make my color channel adjustments.

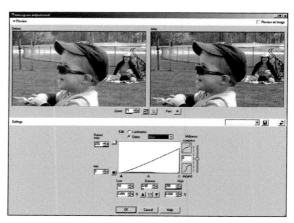

Figure 7.43
Tweaking individual color channels.

Finishing the Photo Study

All that work just to take my thumb out (see Figure 7.44). However, I got to show you some tricks involving the Object Remover, so it was worth it. This photo should take you about five to ten minutes to retouch, tops.

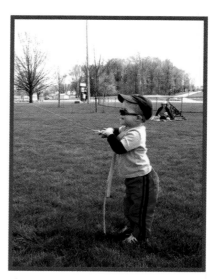

Figure 7.44
Having fun on a windy day—without Daddy's thumb getting in the way

Photo Study 35:
Reflections and House Numbers

ANNE IS STANDING OUTSIDE THE front door in Figure 7.45, taking a picture of Ben, who is sitting on the front porch watching construction on our street. He's got quite the setup and is fully equipped to relax and stay refreshed with his water!

Notice the problem? You can clearly see Anne in the glass of the storm door. That serves as another good example of when to remove an object from a photo. The other issue in this picture is the house number on the door. I've already changed them, but I will walk you through how to make this change yourself so you can post a photo that might have an address on the Internet and not have everyone know your house number.

Erasing the Reflection

First of all, let's take care of Anne's reflection in the screen door.

The details are small enough that the Clone Brush will work best. I tried the Object Remover, but I couldn't find the right combination of size and source area to make it look good. Figure 7.46 shows my progress as I clone her away, after I created a transparent layer to clone on.

The key here is to pay attention to the stuff in the living room that I don't want to clone out. There is a tray beside the TV that is showing its face to us (it looks like a brown box). The rest of the area around Anne is dark. I want to be careful not to pull down the lighter area, which leads into the kitchen.

Figure 7.45
I spy someone reflecting in the door.

Figure 7.46
Cloning is very easy here.

House Number Techniques

Now that that's done, I will illustrate several different techniques to remove the house numbers. Let's review them before we view them.

Figure 7.47
Trying Object Remover on house numbers.

- ▶ **Object Remover:** This works well, depending on the situation. This is the "automated" way to remove something.

- ▶ **Cloning:** The Master of Disaster, the Tool of Power, Ms. Congeniality, and Send in the Clones all wrapped up into one. This is "Da Tool." Want to know what the Object Remover is emulating? This. There are things this tool can't do, but there's a whole lot more it can. If I'm in a pinch, I know I can trust it.

- ▶ **The Switcheroo:** More commonly known as Copy and Paste, this is another hallmark of photo retouching and restoring. Copy something and paste it to move it around.

- ▶ **New Text:** This represents another way around this problem. We'll cover over the old number and enter new text with the Text tool. Maximus Flexibilitus. You can add whatever font face you choose. The new numbers don't have to match the original numbers at all.

Enough jabber. Let's get this shootout going down.

Object Remover

Duplicate your background and select the Object Remover tool. I've selected the numbers I want to remove and a source rectangle in Figure 7.47 (the Jumbo Jet figure).

Use Your Selection Tools!

I've been waiting for this tip since I retouched this photo a few days ago. I was using the Object Remover. I kept trying to select a straight line with the Selection tool, and I couldn't. Freehand selection meets the impossible-to-draw straight line. I dumped out of the Object Remover tool, selected the Freehand Selection tool, chose "Point to point" mode, and then made my selection. Guess what? When I kept my selection selected and immediately went back to the Object Remover tool, the selection stayed chosen, and all I had to do was press the Source mode button and finish up. Now that I know that, I will make my selections before I select the Object Removal tool. You can also create selections from masks, load selections from the Alpha channel, or load them from disk before switching to the Object Remover.

Figure 7.48 shows the result of the Object Remover. I'm fairly surprised it worked this well, which again goes to show you that you can never write a tool off without trying it first. It wasn't perfect, however, so I am touching up the borders with the Clone Brush to make it better.

Figure 7.48
Worked well, but cloning still required.

Cloning

Our next technique is to clone the whole shebang out. Clone Brush, do your thing (see Figure 7.49).

Figure 7.49
Cloning to remove all numbers.

The Clone Brush is effective, and you're left without any numbers at all.

The Switcheroo

This is the copy and paste method of changing the house numbers. You could copy and paste the black part of the door over the numbers to erase them or copy the numbers and switch them around. I've selected the first number in Figure 7.50.

Figure 7.50
Select numbers to copy.

I've pasted that number in Figure 7.51 to a new layer (not absolutely necessary, but I like keeping my creative possibilities open until I'm finished) and am using the Pick tool to position and slightly rotate the number.

I like this technique, but can you see the problem? You're stuck with whatever numbers there are to begin with. You can use some, of course, and not all, or you can rearrange them to your heart's content, but if you want to be really creative and change the numbers to something completely different, you'll need something else.

Figure 7.51
Paste and arrange.

New Text

For this technique, I will remove the existing numbers with the Object Remover and then create my own text with the Text tool.

First, I'll replace the black numbers with the shiny silver backing. I've got things set up and ready in Figure 7.52.

Figure 7.52
Preparing to use Object Remover.

Figure 7.53 shows the result. Very good. If I were going to be ultrarealistic, I would add a little noise to that selection from the Adjust ❯ Add/Remove Noise menu because the silver backing is not perfectly uniform..

Figure 7.53
Zap—there goes the number.

Next, I've selected the Text tool and am entering a new house number in Figure 7.54. You will have to choose the right font size so the numbers will fit vertically where you want them, and you might have to fiddle with the kerning or tracking (these options are on the Tool Options palette) for the new numbers to fit horizontally to your chosen space.

You can convert the type layer to a raster layer and add more noise to make it as realistic as you like.

Final Adjustments

We're on the home stretch. I used the switcheroo technique to change the house numbers and then copied everything as a merged copy and pasted that as a new layer.

Figure 7.54
Enter a new number or message.

Now (see Figure 7.55) I've got the Histogram Adjustment dialog box open and am bringing the low end of luminance up slightly. This has the effect of pushing the gamma up a bit as well, so I drag it back down. When you drag the other sliders, the Gamma slider will try and stay in the middle of the two (as opposed to the middle of the graph) and read as 1.00. The fact that the number doesn't change during this seesaw doesn't mean the gamma isn't changing!

Figure 7.55
Subtly improving brightness and contrast.

Finally, I opened up the Hue/Saturation/Lightness dialog box and increased the saturation by 5. That made the photo just a wee bit more vibrant.

Finishing the Photo Study

I only made two substantive changes to this photo (see Figure 7.56). I removed something (Anne's reflection) and changed something (the house numbers). That's something!

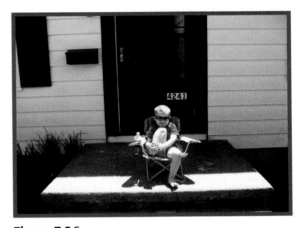

Figure 7.56
Good photo without distractions.

Photo Study 36: Improving Photo Composition

FIGURE 7.57 SHOWS *All My Children*. I'm not a Soap watcher, but I couldn't resist that one. Going from left to right, here are Jacob, Samuel, Grace, and Benjamin. They were outside playing in the heat one day, and we got them all together for what I think is one of the first group pictures of our kids.

Aside from the kids, there is the normal whatnot that we seem to always catch in pictures. There's a distracting pen and pad on the driveway, and the stroller competes for visual attention. I'm not suggesting that you have to remove all traces of normal life when you restore photos, but sometimes small tweaks here and there can dramatically improve the composition of your pictures. If you are secure in the knowledge that you can touch things up in Paint Shop Pro after the fact, taking these sorts of casual family photos is actually less traumatic on the kids, or perhaps us. We just point and shoot (after hollering at them all to look at the camera at the same time!).

I'm going to move through this photo study rapidly and use the techniques I've introduced elsewhere. Consider how I'm altering the composition of the photo by choosing to remove the elements.

Removing Pen and Paper

That pen and paper happened to be lying there because Anne and I were going over the grocery list earlier. It's not a tragic flaw, but it's a bit distracting. Let's get rid of them.

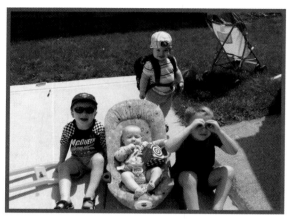

Figure 7.57
Fun photo to practice with.

I'm going to use the Object Remover to see how it performs. Everything is set up and ready to roll in Figure 7.58.

Look at the source rectangle on the driveway. See how it's canted? By default, the source rectangle is a rectangle that is, well, square. It doesn't angle one way or the other. You can change this orientation in times like this. This source rectangle is like the Pick tool. See the drag handles on the corners and sides? Click on and drag those squares to change the overall size and aspect ratio. Use the center handle to rotate the rectangle around that axis. Change the center point to rotate the rectangle around a different axis. Hold the Ctrl key down and hover your mouse over the center point of the rectangle and find the spot where the cursor changes to a thin crosshair. Click and drag the central point when that happens.

Figure 7.58
Using Object Remover on the pen.

The result is shown in Figure 7.59. I changed the orientation of the source spot to match the "lay" of the driveway, resulting in a much better performance by the Object Remover.

Figure 7.59
That worked well.

Next, I will use the Clone Brush to get rid of the grocery list (see Figure 7.60). I tried the Object Remover on this area, and it wouldn't blend right.

Figure 7.60
Cloning the grocery list away.

Removing the Stroller

Now for the stroller, or the Strolla (heavy New York or New Jersey accent there), as we like to call it.

The stroller is sitting over there behind the kids just taking up space. It doesn't contribute to the photo at all and draws your attention away from the kids. Because of this, I decided to remove it. I'm leaving the soccer ball in because it's not so large or distracting.

I am beginning to clone the center of the stroller out in Figure 7.61, while paying attention to the texture of the grass.

Grass can be very complex. When you pay attention to the different textures and colors, some grass is fine, some is coarse, some is darker green, and so on. You'll need to be very observant when you're taking out something this large (see Figure 7.62).

Figure 7.61
Although large, the stroller is easy to clone out.

Figure 7.62
Pay attention to the grass texture.

Figure 7.62 (millimeter, Full Metal Jacket) reveals that there are spots I'm duplicating and not getting enough variety. I always go back and mix things up a bit before I finish to correct this.

I'm extending the shadow of the neighbor's house into our yard in Figure 7.63 at the correct angle to match the other shadows in the photo. That little area is actually the downspout for the gutter coming off the house. I took it out completely and covered it with grass.

Figure 7.63
Shadows add to the realism of your work.

Tweak Brightness and Contrast

It's time to finish up by looking at the brightness and contrast. I am making an adjustment to the brightness in Figure 7.64, as shown in the three "channels" of brightness: Shadow, Midtone, and Highlight. I have darkened the shadows a tad, lightened the midtones a fair amount, and barely touched the highlights.

Finally, I have lowered the white point in the photo (see Figure 7.65) to brighten it up a little. This is a tough call, and I've gone back and forth over it. When I look at Figure 7.64, I like it, but it

seems a shade dark. When I switch back and forth between the two layers in Paint Shop Pro, it's almost a toss-up between the darker and lighter versions. When it's all said and done, however, it was a bright sunny day, and so I choose the brighter version.

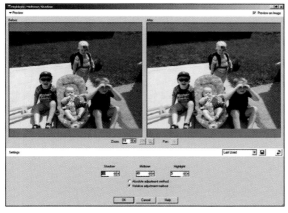

Figure 7.64
Nothing like a good Highlight/Midtone/Shadow adjustment.

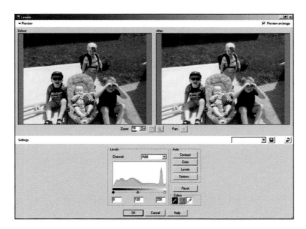

Figure 7.65
I would like it a hair brighter.

Finishing the Photo Study

I started this out by suggesting you look at the different elements of the photo and think about its composition. We don't live in a photography studio, and our casual photos are just that—casual, and for the most part, spontaneous. We're looking to capture the essence of ourselves, our kids, and our lives. We don't always clean everything up as we grab for the camera.

If I can improve our photos by a bit without taking too much time, it's worth the effort. Not for every photo we have, certainly, but this is a special photo (see Figure 7.66) with all of our kids in it at the same time. Perfect for printing out and sending to my dad.

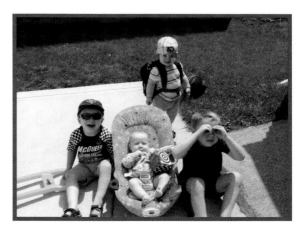

Figure 7.66
Great kids make a great photo, and Paint Shop Pro helps address composition issues.

Photo Study 37: Creating Montages

FIGURE 7.67 SHOWS MY SON BEN leaping off the front porch. Anne was taking pictures of the kids while I was mowing, and Ben decided that he wanted to show her his "tricks" and started catapulting himself into the yard.

Having one photo is awesome, but when you've got five pictures of him doing different moves, how can you decide which one to use? You don't have to. I'm going to take Ben's tricks out of several shots and create a photo montage.

Workload and Time

Let me say right up front, this is a lot of work. It's not that difficult once you get the hang of it, but the more pieces of photos you use in your montage and the more you need to erase around objects to blend them in, the more work you're asking for. I got a little carried away and selected five photos to work with, four of which I was copying material out of.

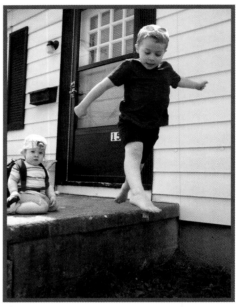

Figure 7.67
Ben leaping off the porch.

Thankfully, most were very close to each other. I did make adjustments to two of the five photos. For one, I performed a Histogram Adjustment to brighten it up, and for the other, I warmed it up a tiny amount (Adjust > Color Balance) and brightened it.

Prep

First, I needed to get my photos together and decide which ones I was going to use. Then I decided which one would serve as the background. I chose the one with Grace sitting on the porch because it really stood out. Next, I opened them all up in Paint Shop Pro and evaluated their color, brightness, and contrast. I was looking to see if they were all pretty close and if I needed to adjust any.

Copy

With the prep work completed, I started copying Ben out of the source photos. I used my trusty Freehand Selection tool (Point mode) for this, as shown in Figure 7.68. I'm giving myself a good border around Ben to erase later.

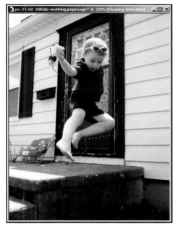

Figure 7.68
Within each source image, select the subject to copy.

Figure 7.69
After pasting, start erasing.

Paste and Erase

It starts getting harder and more time consuming here. I pasted each instance of Ben that I was going to use into my background photo as a new layer and prepared to erase. Before you erase, make sure that you have selected the right layer. To make things easier to see, I hid everything but the layer I was working on.

Erasing is a skill you're going to need to develop if you want to create montages like this. I make three main passes, each with a differently sized Eraser. I make the first pass (as shown in Figure 7.69) with a relatively large brush at 100% hardness. I eat away at the outer border, being careful not to get too close to the subject. The hard Eraser ensures I'm fully erasing whatever I brush over.

Size Is Relative

When I say "large brush," as opposed to medium or small, the actual size of the brush can vary, depending on the context of the photo and its resolution. I've had medium-sized brushes be 150–200 pixels in size when I'm working in photos that are very high resolution. The same brush in a low-res photo might cover half the image.

For my second pass (see Figure 7.70), I zoom in, shrink the Eraser (or brush—I am using both names to mean the same thing in this context), and lower the hardness to 0%. I will get close to the edge and erase very carefully. The soft brush helps blend the pixels from totally opaque to transparent.

Figure 7.70
Magnify and continue with smaller Eraser.

Finally, I make a third pass around each object with a very small Eraser. On this pass, I get into the nooks and crannies of fingers, corners, and between things. I'm working on the area where Ben's hand passes beside his head in Figure 7.71.

Figure 7.71
Third pass with smallest Eraser.

Montage

Now for some fun stuff. Figure 7.72 shows my final montage layout. I played around with different locations and orientations before settling on this one.

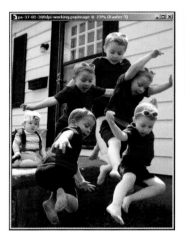

Figure 7.72
Arranging the montage.

It looks finished, but it's not. I'm almost there, though!

Erase in Context

These next steps are critically important. You can be very skilled with the Eraser, but it is still important to check whether or not you've missed pixels and how they relate in context to what is in front or behind. I do this in three steps.

1. Check each layer against a white background.

2. Check each layer against a black background.

3. Show all layers and check against each other.

I create two new raster layers (they are temporary) for my initial checks. I fill one with white and the other with black and arrange them so they are above the Background layer but below all the montage layers. Choose one photo montage layer to start with, and hide everything but it and the white layer (or vice versa).

Figure 7.73 shows why I do this. I've zoomed in on Ben's hand, and you can see there are dark pixels that got left behind because of the soft Eraser. I change my Eraser hardness to 100% and then zap them. Take a peek over at the Layers palette in this figure. You can see some of my layers and how I've got them arranged.

Next, hide the white layer and show the black layer. Repeat the checking and erasing process for each object layer (see Figure 7.74). This time you're looking for light pixels that you missed.

Figure 7.74
Black background layer helps show light leftovers.

Finally, hide (or delete) both the black and white helper layers and show everything else. I am checking every edge that rests on another in Figure 7.75 to see how they blend. I will move closer and erase the border that looks lighter now that it's on top of a darker blue. When it was on top of the white layer, I couldn't tell if this area needed erasing. Likewise, when it was on top of the black layer it was not apparent that this border was too light. I had to check it in this configuration to see if it needed altering.

Figure 7.73
White background layer helps show dark leftovers.

Check each montage layer against the white layer.

Figure 7.75
Next, check edges in context.

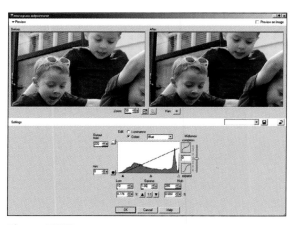

Figure 7.76
Tweaking the histogram.

Final Points

You can see why this turns into a lot of work. For this montage, the first three erasing passes covered four objects, making 12 passes. The next two passes with the white and black backgrounds amounted to eight more. The final pass attended to four objects. That makes 24 total times around, carefully erasing each time.

When it's done, it's time to select all, perform a merged copy, and paste as a new layer. I'll do a final tweak of the brightness and contrast (see Figure 7.76) with the Histogram Adjustment dialog box.

After that, I ran it through Smart Photo Fix. I liked what I saw (see Figure 7.77), so I decided to keep it.

Figure 7.77
Smart Photo Fix to conclude.

Finishing the Photo Study

This is it. This is the final study of this chapter. Photo restoration and retouching isn't always about taking scratches out or covering up imperfections in a photo. This time it was a fun exercise in creating a montage from five different digital pictures.

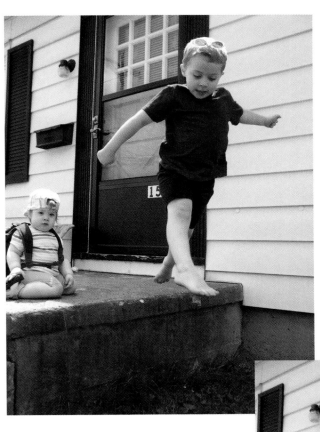

Retouching People 8

A S I WORKED THROUGH THE SERIES OF PHOTO studies in this chapter, I came to the unavoidable conclusion that you're going to see me at my worst. I've got pictures that show off my blemishes, dandruff, yellow teeth, nose hair, weight, and thinning hair (twice). You, the discriminating reader, are going to benefit from my imperfections as you follow me though the process of retouching all of these problem areas.

Do you know what? It's worth it. These photos, of myself and other members of my family, are exactly the type of photos you're going to have. They're real—real people engaging in real life. They have actual problems with them that in the past might have meant that you never showed a particular photo off. This work rescues these photos. Aside from feeling good about that, it's fun. It was fun for me to give myself a makeover. Err, well, a makeover in Paint Shop Pro Photo. I'm not ready to go spend a day at the spa with cucumbers on my eyes and mud on my face. It was fun to see how I could reduce the obviousness of my hair loss. I think you'll enjoy the process also.

▶ **Photo Study 38: Removing Red Eye**—Red eyes are terrible to behold and can easily ruin a good photo. I will walk through the standard technique for taking the red out of eyes and then introduce you to my own solution (which is gangbusters).

▶ **Photo Study 39: More Red Eye Techniques**—In this photo, we'll look at the "hidden" Red Eye Removal tool, which is powerful and useful. After that, I'll return to my technique and compare.

▶ **Photo Study 40: Whitening Teeth**—They say that being on TV adds 10 pounds to a person. Teeth that aren't gleaming white can be painfully exposed by photography. Ill fix my yellowish teeth and touch up a few other things in this photo study.

▶ **Photo Study 41: Teeth, Eye, and Skin Touch-Ups**—I'm going to perform the retouching trifecta in this photo: teeth, eyes, and skin. I'll polish my wife's teeth, intensify her eye color, and use the default skin smoother.

▶ **Photo Study 42: Hiding Blemishes and Dandruff**—Yeah, ah, this is me. Blemishes and dandruff. Good thing I was already married.

▶ **Photo Study 43: Covering Cuts and Scrapes**—I'll use many of the same techniques I've used to repair other problems in other photos to cover a large scratch on my son. You'll learn to use whatever tool you want to, no matter what it's named.

▶ **Photo Study 44: Complete Body Makeover**—This is an astounding example of what you can do with Paint Shop Pro Photo and a little ingenuity. I'll show you how to lose weight, put on muscles, and get a tan in one photo.

▶ **Photo Study 45: Trimming Nose Hair**—Did you ever think you would buy a book, especially a book on a computer application, which had "Trimming Nose Hair" as a section title? I leave no unattractive stone unturned for you, the reader.

▶ **Photo Study 46: Darkening the Scalp**—This approach uses a light touch to minimize the glare of the scalp showing through a person's thinning hair (mine). I don't take the hair loss away, but I make it a little less obnoxious.

▶ **Photo Study 47: Hiding Hair Loss**—This is a more complete example of applying new hair to cover hair loss. In this photo, I will attempt (I sound like a magician there) to transplant some of my son's hair onto my head. Will I be successful?

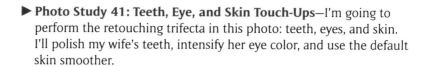

Photo Study 38: Removing Red Eye

FIGURE 8.1 IS A PHOTO OF MY youngest child, Samuel, who was born just before I began writing this book. Anne is holding him over her shoulder, and he's sort of looking beside me as I take the picture. It was dark enough in the room that the flash went off, and sure enough, it caught him with red eyes. David, our technical reviewer, tells me that red eye is caused by the eye not reacting fast enough to the flash, which allows light to reflect off the blood-filled retina at the back of the eye. Animals aren't immune to this effect, and certain animals (cats, for instance) have a reflecting layer on the back of their eyes, which increases the problem. This layer is why a cat's eyes appear to glow in the dark, and it's also why they can have "green eye" in photos.

There are a number of ways to get rid of red eyes in Paint Shop Pro. I'll start by showing you the Red Eye tool and then wrap this photo study up with my own technique.

Duplicate Layers

This photo study, and many that follow, use my technique of duplicating the Background layer and applying changes such as the Red Eye tool to that duplicate working layer. This preserves a copy of the original photo within the working .pspimage file that I can go back to at any time. If I hide all the intervening layers, I can quickly compare the top "after" layer to the bottom "before" layer and see the overall transformation.

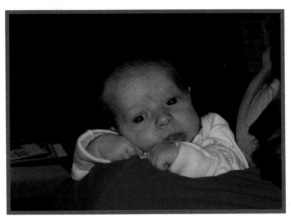

Figure 8.1
Attack of the serious red eye.

Using the Red Eye Tool

The standard method for removing red eyes in Paint Shop Pro Photo is to grab for the Red Eye tool, which is located on the Tools toolbar. There is only one option to choose: the tool's size. I've selected the tool in Figure 8.2, sized it to cover the entire red portion of Sam's eye, and clicked on the red eye to apply. It did a pretty good job in the center, but there is still a red ring around his pupil.

I've kept clicking in the red area that was left behind in Figure 8.3 to see if I can complete the repair. Yes, but with the caveat that there is the slightest touch of a red tinge in that outer area.

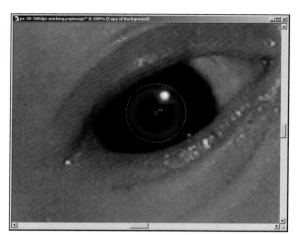

Figure 8.2
Red Eye tool does well, but not complete.

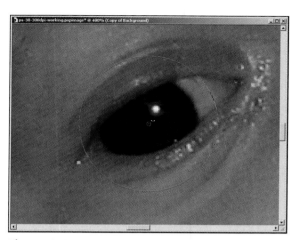

Figure 8.4
Larger tool does about the same.

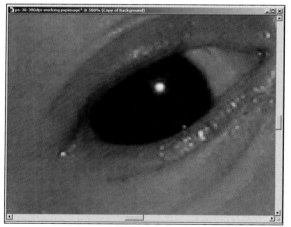

Figure 8.3
Further application is better.

You might think that if you make the tool larger, let's say much larger than the red pupil, that it would take care of all the red. Unfortunately, this is not always the case. I've enlarged the Red Eye tool to a diameter of 99 pixels in Figure 8.4 and applied it to the same eye as before. The result is essentially identical.

Here's How I Do It

I'm not saying the Red Eye tool is useless or that you should never use it, but I want to extend beyond the simple basics of "click here" for this book. There are times the Red Eye tool doesn't work the way you want it to, and you have to figure out a way to get the job done. Here's a technique that I've come up with, and I use it when I absolutely have to get the red eye out. First, choose the Selection tool from the Tools toolbar and change the Selection type from Rectangle (which is the default) to Circle.

Using Different Selection Types

You don't have to use Circle if you don't want to. Some pupils appear elliptical, and you may need to draw around the pupil of someone's eye with the Freehand Selection tool. Use the type of tool that best fits your situation.

Then select the area around the red portion of the eye, as I have done in Figure 8.5. Get all the red, but don't stray too far outside of this area.

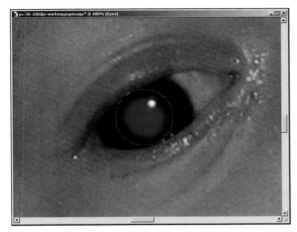

Figure 8.5
Select the red eye.

Next, choose a little-known menu option, the Channel Mixer, as shown in Figure 8.6. It can be found under the Adjust ➤ Color menu.

Figure 8.6
Choose Channel Mixer.

Now for the fun part. You're going to take the red out of the eye with the Channel Mixer dialog box. Uncheck the Monochrome box at the bottom of the dialog box and then select different Output channels to edit. Since this is a case of too much red, the Red channel is a great place to start.

Figure 8.7 shows the settings that I use most of the time. In a nod to counterintuitiveness, you should just be able to pull the red percentage down and be done with it, but you can't. When I took red from 100% to 0% in this photo, the pupil looked too blue, and the glint was more cyan than white. I had to keep searching for the right combination. Too much blue? Add green to counter it while reducing the blue. Be patient and keep fine-tuning if you need to. You can match the pupil's color to what it should be very precisely. By the way, if you take all the color out and make the pupil or iris absolutely black, you'll make people look like aliens.

Figure 8.7
Tweak Red channel.

I've accepted my Color Mixer settings, and the result appears in Figure 8.8.

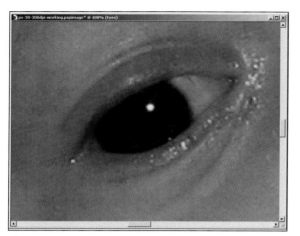

Figure 8.8
Red eye is really gone this time.

When I first removed red eye using this technique, I was astounded. I still am, really. It looks great. The red is gone, and the pupil matches the rest of the eye. Notice that there's a light area on the inside of the iris, next to the pupil. Take a look at some good close-ups of eyes without red eye, and you'll see that this is the way an eye should look. Don't try to take that out of a person's eyes.

Finishing the Photo Study

Sam's red eyes were about the only dramatic thing wrong with this photo. I've removed them with my technique and performed a Histogram Adjustment to improve the brightness and contrast. The finished study is shown in Figure 8.9. You should be able to complete retouching work like this quickly.

Figure 8.9
Ahh, that's better.

Photo Study 39: More Red Eye Techniques

M Y SON, JACOB, IS HAVING FUN AT the table in Figure 8.10. He's got a funny, open-mouthed expression on his face, like I caught him in mid-exclamation. Jake's red eyes are looking off obliquely to the camera, and his pupils appear elliptical. Red eyes that aren't perfectly circular can be more difficult to retouch.

What you can't see from this photo is that we were having a dinner in celebration of my wife's Grandma Jo, who would have been 100 years old that day. We celebrated by fixing some of her favorite foods and sharing stories about her.

Figure 8.10
Cute photo marred by red eye.

More Techniques

In this photo study, I will show you four red-eye removal techniques one after another. The first uses the Red Eye tool, the second the Red Eye Removal tool, the third a variation of the Red Eye Removal tool, and the fourth is my own technique.

Red Eye Tool

I've selected the Red Eye tool from the Tools toolbar and applied it to Jake's eye, as seen in Figure 8.11. It has about the same effect as the previous photo study. Namely, it gets the red out of the center but leaves a red margin around the outside.

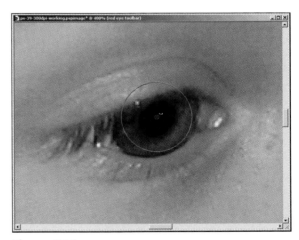

Figure 8.11
Red Eye tool on elliptical pupil.

Auto Red Eye Removal

There's a nice gem of a tool tucked in a place you may not think to look. It's called the Red Eye Removal tool and is located in the Adjust menu. I'm selecting it in Figure 8.12.

Figure 8.12
Don't forget this tool.

I've duplicated the Background layer and renamed it "Working," so that when I apply each red-eye technique, I have the original photo to compare it to.

Figure 8.13 shows the Red Eye Removal tool dialog box. It's a pretty intense tool, and there are a lot of settings that affect how the tool works. You can spend a lot of time practicing on how best to use this tool.

I'll run through a series of steps to tackle this tool and show you how to use it. Many of the steps aren't sequential. In other words, you can follow most of these in sequence, or not, or find a sequence you prefer to use instead of this one. It's your call.

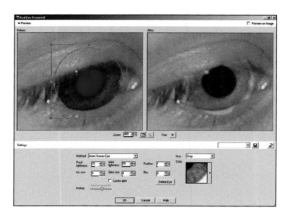

Figure 8.13
Draw box around eye.

1. Choose a method. The options are Auto Human Eye, Auto Animal Eye, Freehand Pupil Outline, or Point-to-Point Pupil Outline. You'll manipulate a shape to encompass the entire eye in the Auto methods, as opposed to manually drawing around the pupil in the Outline methods. If the eye is fairly circular in the photo, the Auto methods are more effective. For this example, I've chosen Auto Human Eye. I'll cover another method later on.

2. Select the eye in question in the left window-pane. You'll see a circle, just like the Circular Selection tool, appear as you click and drag (the center point is where you click). Drag until it looks to be the right size and then let go. When you release the mouse button, the circle appears inside a box. You can resize the circle (which represents the eye) by clicking and dragging the box around the eye. You can move this box around by clicking on the inside and dragging. If you click outside this eye, you'll draw more eyes, enabling you to perform multiple red-eye removals at once. If you want to delete an eye, select the square and click the Delete Eye button.

The trick here is to get the selection box sized just right and the circle positioned directly over the eye. You'll see a preview of the effect in the right windowpane.

3. Now it's time to size the pupil (where the red is). Do this by sizing the iris with the Iris size control. You'll want this to be as exact as you can get it. Make sure to look at the right windowpane as you change the numbers. That's where the iris size preview shows up.

4. At this point, take a look at the glint settings. Check Center glint if the glint is in the center of the eye, or uncheck it if the glint is offset, as it is in this case. You can also modify its lightness.

5. Next, change the Pupil lightness up or down. This has a dramatic effect, moving from black to a light gray.

6. You can also change the Feather and Blur settings. Feather affects the blend between the iris and pupil, and Blur takes the entire eye out of focus.

7. Next, drag the Refine slider left or right to match the overall shape of the eye and "completeness" of the iris. Paint Shop Pro will change how much of the iris and pupil to display. I've done this in Figure 8.14, and you can see the top and bottom of the eye in the right windowpane match Jake's actual eye more closely now.

8. Gray is the default color that the Red Eye Removal tool will apply. You can change what shade of gray from the Color list box (see Figure 8.14). Click on an iris that matches your subject most closely. You can also choose a different color entirely, like green or blue.

9. Finally, click OK.

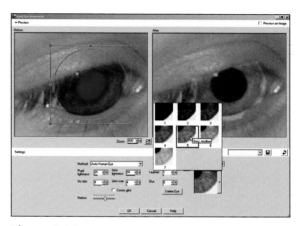

Figure 8.14
Choosing an iris hue and color.

Most of the time, the Refine control gets you pretty close to the overall shape of the eye, but it isn't always perfect. This is another reason why I duplicate the Background layer. I'm erasing the outer portion of Jake's eye, the part the Refine control didn't remove, in Figure 8.15. His normal eye appears from underneath.

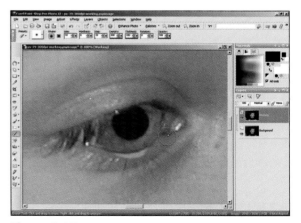

Figure 8.15
Trim away excess.

Freehand Pupil Outline

Now that you've seen how to use the Red Eye Removal tool in Auto mode, let's take a look at the Freehand Pupil Outline mode. I'll dispense with the steps and refer to Figure 8.16.

Rather than selecting the entire eye, the Outline modes prompt you to outline the pupil. This technique is best suited for pupils that aren't perfectly circular, as in this case. How you choose to outline the pupil is up to you. The difference is that in Freehand, you're drawing around the pupil just like you would use the Freehand Selection tool in Freehand mode. For Point-to-Point, click at points outside the pupil to draw around it.

The other options are mostly the same between this mode and the Auto modes. The differences are that you don't need to select an Iris size or Hue, and you will need to select what type of eye you're working on. You'll make this selection in the Color section. The choices there are Pupil, cat; Brown Pupil, dog; Black pupil, dog, and Pupil, human.

I've made a Freehand selection in Figure 8.16 and am changing to a human pupil. You can see the preview in the right side of the window. Not too shabby!

My Technique Again

I've selected Jake's pupil in Figure 8.17 with the Selection tool. I left the selection type as Circle, even though the pupil is not quite round. That's okay. You can change the type to Elliptical or even switch to the Freehand Selection tool if you like. The important thing is to get all the red out and be working on a duplicate layer.

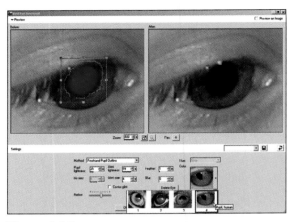

Figure 8.16
Using Freehand Pupil Outline.

You can see that a portion of his eyelid is in the selection. Depending on race (and other factors such as skin type and lighting), a person's skin will have different amounts of red. Jake's skin in this photo is pretty pink. That will cause a little problem after I apply my color change. The eyelid I've included will lose much of its red. I'll have to erase that and rely on the Background layer to pick up the correct color of his eyelid.

Figure 8.17
Select the pupil.

Next, I selected the Adjust ❯ Color ❯ Channel Mixer menu to open up the Channel Mixer dialog box, as shown in Figure 8.18. I altered the amount of red in the Red Output channel as shown. You may need to tweak this, depending on the red in the red eye and the overall color balance in the photo.

Figure 8.18
Alter red output.

The result is shown in Figure 8.19. I've deleted the portion of Jake's eyelid that was altered by the Channel Mixer so all you see is a perfectly retouched red eye and normally pink eyelid.

Figure 8.19
Great results.

Finishing the Photo Study

Figure 8.20 shows the final result. I've completed the red-eye removal in both of Jake's eyes on a separate layer than the Background, erased the portions of his eyelids that were changed, selected everything and performed a merged copy, and then pasted the result as a new layer. Afterwards, I used that merged layer as a basis to perform other brightness and contrast adjustments. For this particular photo, a Fade Correction of 20 was just the right trick to make the colors stand out more and give me better contrast. All in all, it was a very successful retouching job.

Figure 8.20
Those blue eyes are sparkling now.

Photo Study 40: Whitening Teeth

THIS IS A HILARIOUS PICTURE OF ME and my daughter, Grace (see Figure 8.21). She's wearing all pink, which is pretty common for her. Pink glamour shades, pink jacket, pink pants, and I think that's a light pink top she has on. The furry thing around her neck isn't a cat (although when it's on the floor at night it sometimes freaks me out because it looks just like our predominately black cats). It's a detachable faux fur neck that goes on an old coat. We keep it around to play with, and she's hamming it up as I hold her.

I look pretty good here, except my teeth are really yellow. I don't want to resign this nice picture to the stack that we never show anybody. I will whiten my teeth as I enhance this photo.

Whitening Teeth

Whitening teeth is another retouching job that can go a long way towards making a photo better. The simplest method is to choose the Makeover tools from the Tools toolbar and then choose the Toothbrush from the Tool Options palette (that's just below the Standard toolbar). Enter a strength and click on the yellow teeth.

Easy does it. Most of us don't have absolutely white teeth. Those who do will not need emergency flashlights when the power goes off; they just smile. To prove my point, take a look at Figure 8.22. I've applied the Toothbrush to my teeth and put the strength up to 100. Bleech. That's overkill!

Figure 8.21
Daddy with his princess.

Figure 8.22
Overdoing it.

I will ratchet that down quite a bit. A good technique is to tone down the Toothbrush and apply multiple levels of whitening until you get the desired result. I've chosen a strength of 30 for my teeth in Figure 8.23, and the result is more realistic. You'll notice that I pulled back the zoom quite a bit when compared to Figure 8.22. I can get a better sense for how the new whiteness will blend in with the rest of my face. Too much will stand out like a sore thumb, and too little is rather pointless.

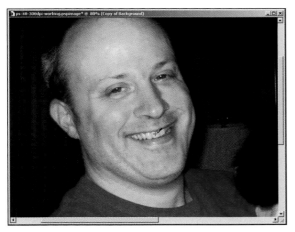

Figure 8.23
Realistic is better.

Teeth and Gums

If a person's teeth aren't touching (that sounds odd, but the gums may be separating the teeth), you may have to click multiple times on teeth in different areas to apply the Toothbrush successfully. The Toothbrush works partly like the Flood Fill tool.

Handling Blemishes and Skin Tone

Next, I will fix a few of my blemishes. If you look carefully in Figure 8.24, you can see that I've applied the Blemish Remover to a spot in my eyebrow. That's a bad thing. You shouldn't be able to see it. The problem is that the tool can blend the area around the blemish too much. In this case, that surrounding texture is my eyebrow hair, which makes blending obvious. It would be better to use the Clone Brush in this area.

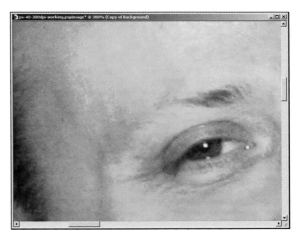

Figure 8.24
Blemish Remover softens focus on brow.

The next few figures illustrate my efforts to even my skin tones. I've got some red areas (probably dry skin) on the bridge of my nose, on my nose, and on my lip. Let's think this through.

I could use the Hue Up/Down Brush to change the hue. I could use the Saturation Up/Down Brush to lower the intensity of the red color in those areas. I could even try to use the Clone Brush to clone areas of my skin that are a more pink color over the red areas.

I tried them and wasn't happy with any of those options. It was after I switched to the Change to Target Brush that I got the result I was after. I used the Change to Target Brush in Hue mode to change the hue of the red areas of my face to match that of another, less red, patch of skin. If you ever wonder why there are tools like this in Paint Shop Pro Photo, and why they have all these different modes, this should help answer that question. This tool and this mode make this problem easily fixed.

I choose my tool first (the Change to Target Brush in this case) and then press Ctrl while I hover my mouse over an appropriate color (see Figure 8.25) to load a color into the Foreground and Stroke Properties box on the Materials palette. That changes the cursor to the dropper, which I click to load the color. I'm going to for a nice pink that isn't too red.

Figure 8.25
Select color for replacing hue.

Next, and this is pretty important, make sure the Mode (seen on the Tool Options palette) is in Hue. You want to match hues with another area, not lightness or saturation. With a good pink loaded into the right-sized brush, I will start brushing away the red, as shown in Figure 8.26.

Figure 8.26
Taking the red out.

Other Touch-Ups

Before I close this photo study, I am going to make a few more touch-ups.

First, as seen in Figure 8.27, I am softening Grace's sunglasses. They are smudged, and the softening effect reduces the smudginess and keeps it from being too obvious. Try and think like this. It wasn't a big deal, but it was, if you know what I mean. If you're going to retouch photos, use all the powers of your perception and imagination to make them better!

Figure 8.27
Softening smudged shades.

Finally, I like the levels of the subjects, but I'm not happy with the background. I can isolate the background in a few ways. In this case, I've selected all (remember, I did some cloning on my eyebrow, and when I clone I use a separate layer), performed a merged copy, and pasted that as a new layer. Then I duplicated this layer. The top layer will serve as the new background, and I am erasing us out of it, as you can see in Figure 8.28 (a mask would work, too).

Figure 8.28
Preparing to adjust background only.

After I do that, it's a matter of applying whatever color, brightness, or contrast change to the background layer (the one I erased us out of) I want, and the foreground layer (myself and Grace) is protected.

Finishing the Photo Study

To finish this photo, I applied a Histogram Adjustment to lighten up the background (the layer without us), then I copied the merged photo (select all, merged copy), pasted that as a new layer, and made an overall levels adjustment. There's a subtle sheen to the background (look at the paneling) that wasn't there, and the contrast is much better.

I almost forgot. I also cloned my thumb out. Check out the difference. It's not huge, but if I were to compose this photo "perfectly," it would be a distraction. So, it's gone!

Figure 8.29
Daddy looks better now.

Photo Study 41: Teeth, Eye, and Skin Touch-ups

FIGURE 8.30 IS ANOTHER PHOTO of my wife, Anne, and son, Sam. If you've got a digital camera and newborn children, you can relate to this. We carry around the camera constantly, looking for opportunities to take more pictures. We can take thousands of digital pictures if we want and keep the best. I'm a firm proponent of taking more pictures than you need. You're bound to capture the right moment. I am going to use this photo to polish Anne's teeth differently than if I were to whiten them with the Toothbrush. I will also show you a technique to brighten someone's eyes and also use the Skin smoother. She's in for a day at the spa!

Whitening Teeth

There will be times when you want to lighten someone's teeth but don't want to apply the Toothbrush. In this photo of Anne, I want to "polish" them a bit. It's more of a subtle approach, but they will glow with a healthy radiance when I'm finished instead of just being whiter.

To begin polishing, select the Lighten/Darken Brush from the Tools toolbar and select an appropriate size. I like to make mine smaller than the tooth, but not by much. If it gets too small, you'll see all the little brush lines. I also set the Hardness to 0%. For 99% of the time, you'll make your opacity something less than 100%. I am gently polishing Anne's teeth in Figure 8.31 and have completed one of her incisors and moved on to another.

Figure 8.30
Looking good, but worth touching up.

I'll polish each tooth separately, changing my brush size if I need to. Do I need to mention that you should be doing all this on a duplicated background (or otherwise copy-merged and pasted as new layer) layer? I didn't think so.

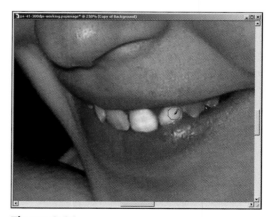

Figure 8.31
Lightening teeth.

Now that her teeth are whiter, there are yellowish areas between Anne's teeth in her gum line that should be pinker. I will use the same technique on her gums that I used in the previous photo study where I evened my skin tone.

I've selected the Change to Target Brush, made sure it's in Hue mode, adjusted the size to very small (4 pixels), pressed Ctrl to grab a good pink color from somewhere else on her gums, and am in the process of changing the hue from yellow to pink in Figure 8.32.

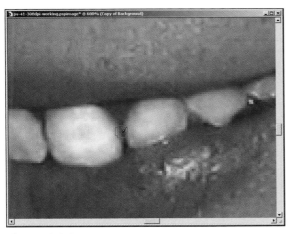

Figure 8.32
Changing hue of gums.

Retouching Eyes

Anne isn't suffering from red eyes, so why mess with her eyes? I want to make her eyes a deeper and more vibrant green. I could increase the saturation of her eyes and change their hue, but I want to try something new.

Select the Red Eye Removal tool from the Adjust menu to get started. What I'm going to do is pretend she has red eye and add a green color over her iris, as shown in Figure 8.33.

Changing Eye Color

You can change someone's eye color with this technique. It's sort of like putting on those colored contact lenses that do the same thing in real life.

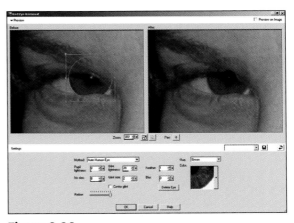

Figure 8.33
Deepening green eyes.

I've used the Auto Human Eye Method, because I can select a different Hue and Color to apply over her eye. There were a number of different shades and intensities of green to choose from, and I tried to get a pretty good match to her original eye color.

Since I am applying her "new" eyes on a duplicate layer and will erase the extra later, I don't need to use the Refine control, as seen in Figure 8.34. Erasing, rather than using this feature, gives me exact control over the area that is retouched by how much I erase.

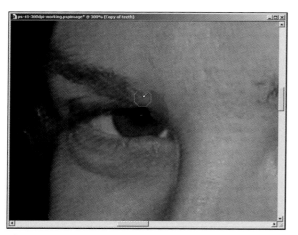

Figure 8.34
Erasing extra.

I love blending layers with opacity changes. The new green eyes look really good. I want to preserve some of the original, so I have lowered the opacity of the eyes layer to 30 (see Figure 8.35).

Figure 8.35
Lowering layer opacity to blend.

Oh, yeah. That's nice. Greener and more vibrant, but not overpoweringly artificial.

Skin Smoothing

And now for Anne's skin. This is turning into a real makeover here. Anne has beautiful skin, and she takes good care of it. But she's human, and this is the real world. Unless you're a full-time supermodel with your own personal skin smoother, you're not going to have perfect skin. Even models rely on digital artists to retouch their photos.

Figure 8.36 shows the Skin Smoothing dialog box. Select the person's face or skin you want to smooth and choose the Adjust > Skin Smoothing menu. Choose a strength that looks good in the preview window and apply the filter.

Figure 8.36
Smoothing Anne.

I advise you to select only the area you want to smooth before you start the process, rather than applying the effect to the entire photo. It's clear in this photo that Sam's skin doesn't need any smoothing—he's a few-months-old baby whose skin is about as smooth as humanly possible.

To do this, I select the Freehand Selection tool (Point mode) and select around the person's head or arms. If you need to be more precise, you should use a mask and turn it into a selection from the Selections ❯ From Mask menu.

Finishing the Photo Study

All right, let's wrap this one up. I finished the photo study by increasing the brightness by 15 and the contrast by 10 through the Adjust ❯ Brightness and Contrast ❯ Brightness/Contrast menu; then I bumped up the saturation by 5 through the Adjust ❯ Hue and Saturation ❯ Hue/Saturation/Lightness menu. The photo was a little dark and had a gray sheen to it. The brightness and contrast adjustment took care of that, and then the saturation gave more vibrancy to Anne's face.

This is one of those photos with bright subjects and a dark background. I could have separated Anne and Sam from the background and adjusted their layer differently than the background. I decided against that, as I liked the dark background in this instance.

Figure 8.37
Much better.

Photo Study 42: Hiding Blemishes and Dandruff

I'M HAVING FUN IN FIGURE 8.38, trying to look as silly as I could for Anne as she took a picture. I succeeded.

This photo was within the first few years of our marriage, and we were still living in our first apartment. It was a duplex. We lived in one half of a large, square house that was old and falling apart. The washer and dryer were in the basement, and you had to step over the slugs and dirty floor to try to get to your clean clothes and try not to drop any on the way out. Notice the terribly fashionable wallpaper in the background? It's horrid. Sort of a pink floral motif, which made us want to throw up. When we moved out, our neighbor had just found out that his kitchen walls and ceiling were infested with cockroaches. I think our wallpaper kept them out of our side. By the back door hung the wind chimes Anne gave me for our first Christmas together.

I've got some blemishes scattered around my head and face that need to be fixed, as well as some dandruff on my red shirt. Neither problem is that large in the physical sense, which points out the fact that you can improve a photo by retouching small imperfections. I will use the Blemish Remover primarily.

Hiding Blemishes

First, I will use the Blemish Remover to fix all the blemishes around my head. The Blemish Remover is an effective tool, which works a lot like the Clone Brush, but simpler. Select the tool, enter a size and strength in the Tool Options palette, and then click on some blemishes. I'm starting to do that in Figure 8.39.

Figure 8.38
Crazy man with blemishes and dandruff.

Figure 8.39
Great use of Blemish Remover.

My normal routine is, as always, to duplicate the Background layer, which I use as a working layer to fix the blemishes on. Unlike the Clone Brush, where you can create an empty layer and apply your new work to that without disturbing the original photo, the Blemish Remover has to be applied to a photo layer.

The trick with the Blemish Remover is to make it the right size and strength. If you make it too small, it won't completely cover the blemish. If you make it too large, you may pull in details that you don't want. If you look back at Figure 8.39, you can see the tool cursor is composed of two concentric circles. The inner circle is where the blemish should fit. The outer circle is where the tool pulls source material from to blend over the inner circle. It's like the source spot of the Clone Brush. You want the tool to be large enough for the inner circle to cover the blemish, but small enough that the outer circle contains only the color and texture that you want to use as your source. I leave the strength at 100 most of the time, 'cause I love zapping pimples.

I've removed the spots from my temple area in Figure 8.40 quite successfully.

Figure 8.40
Completely gone.

Areas where there is a lot of detail may not be suitable for the Blemish Remover. Figure 8.41 shows an area of my cheek, and you can see all my little whiskers there. I need a shave. Fixing blemishes in this area is much harder because the whiskers get blended in with the skin, or the blending process creates a fuzzy area. I've applied the Blemish Remover once in Figure 8.41, just above and to the right of the cursor. Can you see the fuzzy circle there that doesn't match the rest of my cheek? This is an area where I should use the Clone Brush.

Figure 8.41
Blemish Remover doesn't work as well with detailed texture.

Hiding Dandruff

Just because something isn't technically a blemish doesn't mean that you can't use the Blemish Remover to take it out. I have some dandruff on my red shirt in this photo. I don't think I've noticed it before now. Since they are point imperfections, they are essentially the same as blemishes. I've zoomed in for a closer look in Figure 8.42.

Figure 8.42
Dandruff before.

Starting from the bottom up, I'm using the Blemish Remover in Figure 8.43 to zap those flakey flakes from my dry scalp that have fallen on my shirt. Just point and shoot. It's that easy.

Figure 8.43
Washing it out.

Finishing the Photo Study

This photo had a lot of good blemishes of different types to fix. There were spots on my head, spots on my cheek, spots on my tongue, and dandruff on my shirt. I sound like one really desirable dude, don't I?

To sum up, I duplicated the Background layer, fixed the blemishes with the Blemish Remover on that duplicate layer, created an empty raster layer to use the Clone Brush on (for the blemish in my whiskers), completed the cloning, selected all, copy merged, pasted as new layer, and then applied a Histogram Adjustment to the new top layer that had all my edits. Voilà!

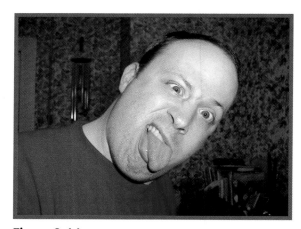

Figure 8.44
Still crazy, but looks better.

Photo Study 43: Covering Cuts and Scrapes

FIGURE 8.45 SHOWS MY SON, JAKE, with a terrible-looking gash cut into his forehead.

This photo was taken on his second birthday. His eyes are just beautiful. If it weren't for that darned cut, it would be a fantastic picture. I think that's the cue to launch Paint Shop Pro and repair his forehead.

This could not be simpler. Really. It's so simple that I'm going to show a number of different ways to take this cut out, and each one is going to do an outstanding job. The hardest part will be deciding which technique you want to use.

Technique Bonanza

There should be text here describing what I'm going to cover in this section. It's one of those publishing no-nos that you can't have headings without copy between them. I don't want to type the same thing twice, so this is the introductory paragraph for the "Technique Bonanza" section that would otherwise tell you what's coming, but in this case, won't. Buyers of the Executive Version of this book will not have read the preceding nonsense.

Blemish Remover

Now that you know how to use the Blemish Remover, pull it out at every opportunity and try to zap things with it. It's therapeutic. This one, however, may be a bit of a stretch. I don't think I've ever made the Blemish Remover this large, nor am I likely to do so again.

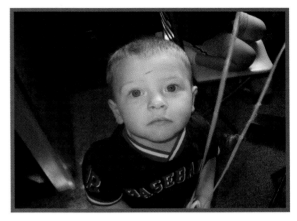

Figure 8.45
That's a doozy.

I've made the Blemish Remover 175 pixels large, as you can see from Figure 8.46, and it covers most of Jake's forehead. I'm breaking the rule I just told you about *not* to make the tool so large that it brings in other colors or textures. You can see I've got some of his hair in the tool. The problem is that the scrape is so huge I had to make the tool this large so that it would cover the cut. My only hope is that his hair is fair enough to roughly match his skin tone so the blending won't look bad.

Whaddaya know? It worked! Figure 8.47 shows the result, which surprises me. That reminds me to remind you never to write a tool off, no matter what you may be thinking. Try it!

Figure 8.46
Big-time Blemish Remover.

Figure 8.47
Worked great.

Scratch Remover

The Scratch Remover (see Figure 8.48) is a more obvious choice here because this large gash is more of a scratch than a blemish. You can also apply the Scratch Remover along the axis of the scratch. The Scratch and Blemish Removers work the same way, but the Blemish Remover is circular, while the Scratch Remover is longitudinal. With

the Blemish Remover, you pick a center point and size the tool outwards, but with the Scratch Remover, you pick an end point, make sure the tool is wide enough, and apply the tool along the length of the scratch.

Figure 8.48
Trying Scratch Remover.

Gone. If you zoom in ultra-close, you might be able to tell where the pixels were blended, but this is the Scratch Remover's element, so it has done its job.

Figure 8.49
Another fine job.

Object Remover

Two down, two to go. Let's try the Object Remover this time. Once again, don't fall into the trap of using tools only as they were intended. Yes, you read that right. You make the rules. You're the boss. You use the tools you want to use, even if they are called something completely different. If there is a tool called the "Don't Even Think About Using Me on Pimples" tool (new in Photo X14), and it works on pimples, *use* it!

I do this all the time. I make color adjustments from within the Brightness and Contrast menu. I use the Blemish Remover on dandruff. I use the Lighten/Darken Brush to whiten teeth. Get the picture? Okay, I just had to rant for a minute.

I've got the Object Remover called up, lined up, and ready to rock in Figure 8.50. I've selected the scratch with the lasso and then moved the Source rectangle to Jake's forehead and resized it so that it was small enough to fit. I've made sure (or at least tried to) that the source area matches the skin around the scratch that I'm trying to cover.

Figure 8.51 shows the result. It works, and works well.

Figure 8.51
Outstanding.

Clone Brush

Now for my favorite, the Clone Brush. I'm using the tool in Figure 8.52, and there's not really much to say here. It works. You be the judge on which tools you want to use and for what applications.

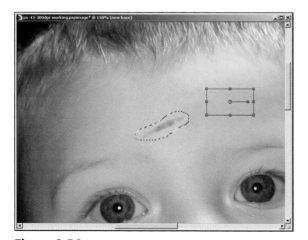

Figure 8.50
Let's try the Object Remover.

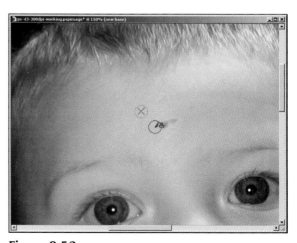

Figure 8.52
Cloning works, too.

Finishing the Photo Study

Figure 8.53 shows the final result. The scratch is gone, and I've increased the saturation by 15 to make Jake's skin a little more vibrant.

Can you tell which technique I used? I didn't think so. I can't either. The people who look at the photos you restore and retouch aren't going to be able to tell whether you used the Blemish Remover or the Object Remover either. Use the tools you want. Use the ones that achieve the effect you want.

Figure 8.53
Boo boo be gone.

Photo Study 44: Complete Body Makeover

I'M HAPPILY MOWING THE LAWN IN Figure 8.54, dressed in my lawn-mowing sneakers and shorts. I like getting air and sun while I mow, so I dress minimally. It's an hour or so that I get to be outside doing something very physical. You wouldn't know that by looking at me. I've gained some weight the last few years and have yet to work it off.

I've been an outdoor person and athlete all my life. It's in my nature. You can't get into nor graduate from the United States Air Force Academy without good physical credentials and potential. Physical education at the Academy was regular and intense. Most colleges let you get away with very little physical activity (aside from hoisting 12-ounce "barbells" at a local pub), but we were in training to become warriors. Mandatory gym classes ranged from Judo to Unarmed Combat and included things like jumping off a 10-meter platform in fatigues like we were bailing out of an airplane into the water. If we weren't in gym classes, we were in intramural sports.

Yes, methinks I protest too much. I'm pale and flabby in this photo—even if I am an athlete by nature. It doesn't matter what I did 20 years ago if I can't keep it up today. Looking at this photo gives me fresh resolve to work out and be physically fit. This photo can give us a glimpse of what I *could* look like if I did just that. I will use the Warp Brush to give myself a complete body makeover.

Figure 8.54
You don't have to say a thing.

Tummy Tucking

Conceptually, once you get the hang of what's going on here, it becomes a matter of execution.

First, I duplicated my Background layer so that I had a working layer to manipulate. Next, I started on the most obvious feature in need of repair, my tummy. (You talk funny when you've got four children under five years of age—I would have never called this my "tummy" before I had kids.)

I tried to warp it in, but after several tries I realized it wasn't going to work. I needed to think outside the box, or tummy, if you will. The solution was to copy and paste my tummy, rotate it to a new orientation, and then flatten that.

I've selected my tummy (now I can't stop calling it that) in Figure 8.55. I used the Freehand Selection tool (Point mode) to get it.

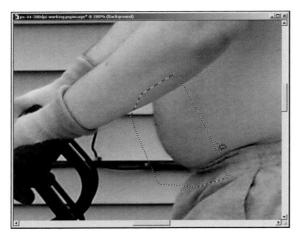

Figure 8.55
Select the offending bulge.

I copied and pasted my tummy as a new layer, and am rotating it to a more vertical orientation in Figure 8.56. I wanted you to clearly see this, so I hid my working layer. You'll want to make the tummy (or whatever you're transplanting) semi-transparent to judge the rotation in relation to the background.

Figure 8.56
Rotate to desired angle.

I then used the Warp Brush in Push mode to flatten my tummy, as seen in Figure 8.57. Take your time with these warps. They are very important. Don't get tripped up by selecting too small a brush. Sometimes, a smaller brush works worse than a larger brush. In this case, a good large brush size (150) allowed me to push the center of my stomach in as a cohesive whole, rather than make several small, disjointed pushes.

Figure 8.57
Flatten with Warp Brush.

With the new tummy prepped and ready, moved on to erase the bulging original. I'm using the Clone Brush in Figure 8.58 to push my stomach in and make it flat. I'm not worried about the outer border of the original stomach not looking perfect, because the flattened version will serve that purpose. I just need to get enough of the old tummy out of the way (arg, I hate saying that about myself) so that it doesn't stick out from under the new, flatter one (that's even worse).

I placed the rotated and warped tummy in position and toggled it on and off so that I could judge the right amount of cloning I needed to do. You will see the composited tummy in the next figure.

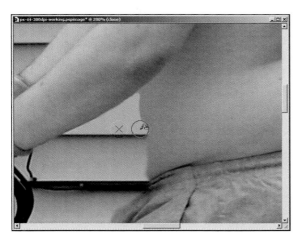

Figure 8.58
Clone away excess tummy.

Figure 8.59
Warping those love handles.

More Cosmetic Warping

With the new tummy in place, I was ready to do more cosmetic warping. I kept with the Warp Brush in Push mode and alternated the size so that I picked up enough material in my warps to make steady, integrated pushes.

I am warping my love handles and pushing my back inwards in Figure 8.59. This accentuates the curve of my back and will round the top of my buttocks. I never thought I would write two lines like that, especially consecutively, in a million years. If you're still looking at my back, notice the shadow between the hair (this is seriously funny) on my back and my love handles? That's a good candidate to use the Lighten/Darken Brush on to take out some of the shadow and reduce its visual dominance.

Next, I worked my way up and tackled my arms. First, as seen in Figure 8.60, I added some muscle to the back of my arm, or triceps. I'm clicking and dragging the arm out to get the right bulge.

Be careful with Undo and the Warp Brush. Take one area at a time (like I'm doing here) and apply the warp. Then move on. That way, if you have to undo it, you won't lose all your warps.

Figure 8.60
Adding triceps.

I needed to balance my arms, so bulging biceps were next. I clicked on my existing bicep, as seen in Figure 8.61, and pulled it out.

Figure 8.61
Bulging biceps.

Warping my biceps out had the side effect of increasing my chest, and I didn't like that, so I decided to push the chest (not the arms) back in, as you can see in Figure 8.62. I also accentuated the biceps by making my elbow look a little tighter.

Figure 8.62
Accentuating biceps.

I said that once you got the concept down, this was easy. As you can see, I'm just finding different parts of my body that need to be enhanced or minimized and then applying the desired warp effect. I'm working on my calves in Figure 8.63.

Figure 8.63
Boosting calves.

Finally, I tightened up my neck and chin in Figure 8.64. There is less margin for error working around the face and chin, and I have to be extra careful here because I've got some facial hair that complicates the texture of my neck. If I just squish it in without thinking about how the hair will look, I can make myself look much worse. To avoid that, I used smaller brushes and strokes.

Figure 8.64
Tucking chin.

Tanning

If I left the photo here, it would not be complete. I need a tan. The greatest challenge with the Tanning tool is to tan what you need and not your clothes or anything else. This is a perfect opportunity to use a mask and mask out everything I don't want to tan.

First, I selected all, copy merged, and pasted that as a new layer. I then duplicated that merged layer to work with my mask. Now, I can move on to creating the mask.

I've created a "Show All" mask in Figure 8.65 and am hiding everything but the skin I want to tan. I've also set up a white layer and a black layer underneath so that I can see where my borders are. I'll use those layers to help me see what I need to mask. Without those helper layers, I would see either one of my merged layers underneath (which would make it impossible to tell where I was masking) or, if they were hidden, transparency.

This is like painting or erasing. Modify the size and hardness of your brush and make a few passes around your subject. You're not adding to or erasing anything but the mask. You can paint the mask right back (or erase it, as the case may be) if you make a mistake.

The purpose of the mask is to set up a complicated selection—namely, my skin—and *not* to include my hair, sunglasses, clothes, or any other background. Here's how to make that selection and apply the tan.

1. Finish your mask.

2. Duplicate your photo layer and put it above the mask. This isn't absolutely necessary, but it's how I like to work. This is the layer that I will apply the tan on.

Figure 8.65
Preparing the mask.

3. Select the Mask layer (this is very important). It is contained in the layer group that gets created when you first create the mask and has a little mask icon next to its thumbnail in the Layers palette. In my case, the Mask layer is mostly black because I'm hiding most of the photo.

4. Next, choose the Selections > From Mask menu. This will be active only if you've got the Mask layer selected in the Layers palette. This makes a selection based on the mask you created and is the purpose for creating the mask in the first place. With my skin selected, I can apply the tan liberally and not worry about it bleeding into other areas of the photo.

5. Now, click on the layer in the Layers palette where you want to apply the suntan. In my case, it's the layer I put above the mask group.

6. Finally, select the Makeover tool group, choose the Suntan tool, resize it if necessary, and apply the suntan, as seen in Figure 8.66.

Figure 8.66
Applying suntan.

The Suntan tool is a little dark on me, so I will take that layer and lower its opacity to blend it with an untanned layer beneath. This will allow me to lighten the tan to exactly where I want it.

Finishing the Photo Study

That's really all there is to it. I copied and pasted a few areas (my tummy and one small area of my waistband that I didn't have room to show you), warped them, and blended them in with the Clone Brush. I used the Warp Brush again to give myself some extra bulk in the muscle department and minimize my chest and chin. Then I created a mask of my skin so that I could apply the Suntan tool and blended that layer with an untanned layer to get the right strength.

To wrap it up, I made some brightness and contrast adjustments and ran the photo through the Smart Photo Fix. The finished product is Figure 8.67.

Figure 8.67
This is what I should look like.

Photo Study 45: Trimming Nose Hair

I'M HOLDING MY SON, BEN, in Figure 8.68. We're at the Johnny Appleseed Park, and it's spring, so we have jackets on.

Figure 8.68
Funniest photo study title ever.

What's the first thing you notice when you look at this picture? Is it Ben, his smile, his eyes, his monkey, or is it the hairs coming out of his Daddy's nose? Once you spot them, you can't stop looking at them. One relatively minor blemish in a photo can overwhelm the positive things that are present.

To fix this, I first cloned away the nose hairs on the outside of my nose, as seen in Figure 8.69.

Figure 8.69
Clone hairs outside of nose.

Since there isn't enough darkness in my nostrils to clone over the hair that is still visible, I will use the Burn Brush to darken the light pixels (which is the hair). I've switched the Limit parameter (look to the Tool Options palette to find it) to Highlights to burn only the brighter values.

Figure 8.70
Burning nostril to darken.

Now that I've got one good, dark, nostril, I can clone that over to the other side, as seen in Figure 8.71.

Figure 8.71
Cloning dark nostril to the other.

Next, a little softening is in order. I want this to be an unobtrusive part of the photo, so using the Soften Brush will ensure there are no sharp pixel borders to draw our eyes to. I'm being careful, as seen in Figure 8.72, to gently soften the nostril.

Figure 8.72
Soften to blend.

Finally, it's appropriate for this chapter to show me zapping a blemish on Ben's nose with the Blemish Remover, which I am doing in Figure 8.73. Always be on the lookout for things like this to fix. I also fixed a few spots on my neck before I ended my work on this photo.

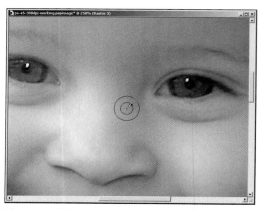

Figure 8.73
Taking out extra blemishes.

Finishing the Photo Study

This is a great example of a photo that didn't take me more than 15 minutes to retouch from start to finish. I spent the most time at the end, deciding on which method to use for my brightness and contrast adjustments. I used Smart Photo Fix and then altered the levels. The final result, as seen in Figure 8.74, is free of extraneous nose hairs and blemishes.

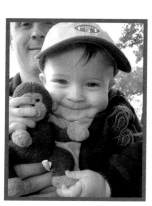

Figure 8.74
Nose hairs safely trimmed.

Photo Study 46: Darkening the Scalp

I'M SITTING AT THE CONSOLE IN Studio B at the Recording Workshop in Figure 8.75. I had just finished mixing a song with my team and asked one of the guys to take a few shots of me. We had already zeroed out the console and taken most of the patch cords out, so I'm pretending to put one back in.

This cool analog board is a Sony MCI JH-600 series console with 26 channels. You can see the outboard pre-amps, compressors, gates, and effects (which is what we patch in with the cords) over my left shoulder. The studio itself (I am in the control room) is behind the glass at the top of the picture.

I've got thinning hair. There's not much I can do about it but accept it. I hate accepting it. I've had some gray in my hair since my early twenties, but the thinning hair is harder for me to deal with. I like this picture a lot, but my thinning hair is made more prominent because I'm sitting right under a glaring spotlight.

I will darken my scalp to show you how to minimize the "obviousness" of hair loss without completely taking it away.

First, I duplicated the Background layer. Next, I selected my head, as seen in Figure 8.76. I'm not being ultraprecise. I don't need to be. I used the Freehand Selection tool (Point mode) and allowed myself some extra to make sure I had my entire head. I'll erase this extra later.

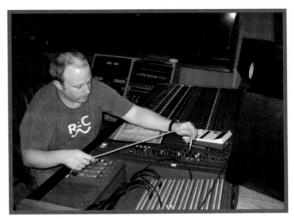

Figure 8.75
Bright lights accentuating, um, hair loss.

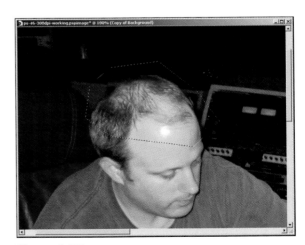

Figure 8.76
Selecting head in question.

Next, I inverted the selection using the Selections > Invert menu and deleted the excess material by pressing Delete. My head is left on this layer by itself. Don't grab for an Eraser yet. I selected more than I needed as a safety margin. After a few steps, I'll blend the layers together and finish the erasing.

Remember, this is the duplicate layer. You're not deleting your photo, just what you don't need to darken. I've hidden the Background layer in Figure 8.77 so you can see the remaining selection.

Figure 8.77
Invert and delete excess material.

I am going to darken the hair that is present on my scalp first. I spent a lot of time going through different techniques to find the right balance of what to do, and in what order. Darkening what is there first helps reduce the thinning without turning the scalp a low-contrast gray.

I am using the Burn Brush with the Limit set to Shadow in Figure 8.78. This burns the darker pixels, which is the hair. I've got the opacity set to 25 for a very subtle effect.

Figure 8.78
Burn shadows to darken existing hair.

Next, I will darken the scalp. I've still got the Burn Brush up and active, but I've changed the Limit to Highlights to darken the brighter pixels. The opacity is set to 60 for this pass, so I get a stronger effect.

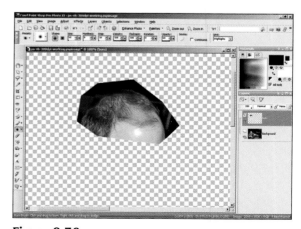

Figure 8.79
Burn highlights to darken scalp.

The best effect is achieved by blending this work with the original photo. I do this by lowering the opacity of the burned layer (it's on top), which you can see from Figure 8.80 is set to 73.

Figure 8.80
Blend layers using an opacity adjustment.

Finally, I am using the Saturate Up/Down Brush in Figure 8.81 to take a little of the color out of the reflection of the spotlight on the front of my head.

Figure 8.81
Desaturate, if necessary.

Finishing the Photo Study

It's time to wrap this one up. I selected everything, copy merged, pasted that as a new layer, and then increased the contrast by 5 to finish up.

The result, which you can see in Figure 8.82, looks natural. Remember, I wasn't trying to completely hide my hair loss in this photo, only minimize it. If you look at Figure 8.82 out of the context of the original, you would see my thinning hair and think nothing of it. When you compare the before and after shots, there is actually quite a bit of difference.

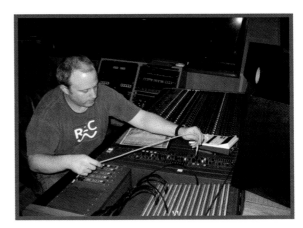

Figure 8.82
Less obvious is better.

Photo Study 47: Hiding Hair Loss

CAMPING IS FUN, AND CAMPING with your kids is even more fun. Ben, Jake, and I are setting up our tent in the backyard in Figure 8.83. I'm looking down at the tent stake as I give Ben a turn at hammering it in with me. Jake is watching intently, ready with the next stake.

And, there's my head. You can clearly see my thinning hair and, dare I even say it, bald spot (OUCH!) at the back.

For this photo study, more aggressive action is warranted. I'm going to use Paint Shop Pro to hide my thinning hair and balding spot rather than darken it.

First, I needed to find a suitable hair replacement. I scoured our digital photo collection and found a recent photo of my son Jacob from the back, as he was looking out the front door (see Figure 8.84). His hair looks great! I've made a selection of the hair I wanted to take and copied it.

Next, I pasted that hair as a new layer into the photo I wanted to modify, as seen in Figure 8.85. I am using the Pick tool to shrink it down and match the two hair textures. It wouldn't look right if I had hair that was as thick as ropes!

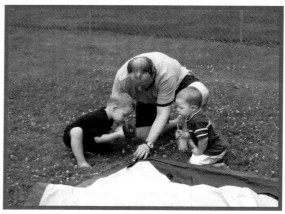

Figure 8.83
Remind me not to look down again.

Figure 8.84
Copying Jake's hair.

Figure 8.85
Paste, resize, and position.

After resizing it, I have positioned it over my head and trimmed it down to fit (see Figure 8.86). Because Jake's hair is lighter than mine, I had to use the Burn Brush (Link set to Highlights) to darken his hair to match mine.

Figure 8.86
Burn to match darkness.

I'm trimming Jacob's hair transplant to match the hairline I want to have in Figure 8.87.

Figure 8.87
Trim to desired hairline.

Finally, I didn't want it to look like I had a toupee on, so I reduced the opacity of the hair transplant layer to 57. This blended it with my balding head and made it look more natural, as shown in Figure 8.88.

Figure 8.88
Blend using Layer Opacity.

Finishing the Photo Study

This study has surprised me by how natural my new hair looks. After selecting all, copy merged, and pasting as a new layer, I increased the contrast and ran the photo though a filter. I used the Effects ❯ Photo Effects ❯ Film and Filters menu to access the film filter effects and applied the Vibrant Foliage (because there's a lot of nice green grass in this photo) filter to get the final effect. Figure 8.89 shows the result.

I want to point out that I didn't just copy and paste someone else's hair on my head. I worked it. I chose someone I'm related to, carefully burned the transplanted hair color, erased it to fit a realistic hairline (improved for a man of 41 but not trying to make me look 18 again), and then blended it into the photo by making it more transparent. This approach is very effective.

Figure 8.89
One of my best jobs.

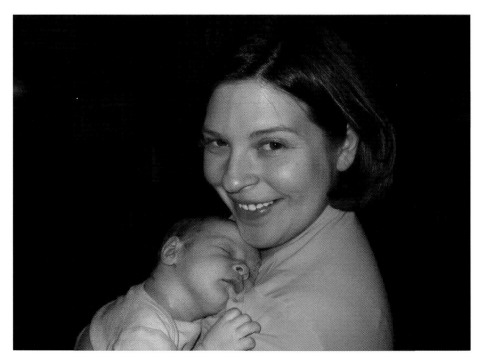

Prognosis Negative 9

S EINFELD FANS WILL GET THE REFERENCE in this chapter's name, but what am I trying to get across? Prognosis Negative is about saving photos that you think are useless and would probably throw away or delete. Maybe it's out of focus, or overexposed, or too bright, or perhaps some other flaw ruins the photo. What is there to do? Well, let's see.

▶ **Photo Study 48: Maximum Blur**—This photo is one of probably hundreds of photos we have where the subject is blurry. In this case, it's my daughter Grace. Instead of deleting this forever, I can turn it into stationery for notepads or letters.

▶ **Photo Study 49: Spiderweb Ornament**—Looks like another blurry photo that seemed destined for the recycle bin. I saved it and created something that looks like an ornament.

▶ **Photo Study 50: Kids and Cameras**—Our kids enjoy taking photos, and Ben took several of himself one day where you can't see his face. As photos go, they aren't worth keeping. Or are they? I can create a cool montage where I'll group a few of these funny photos together to show them off.

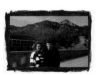

▶ **Photo Study 51: Last Picture Overexposure**—Overexposed photos come from film cameras, and there was something invariably wrong with the last picture on the roll. In this case, my mom's side of the picture is ruined by the overexposure. Instead of throwing it away, I will salvage something out of it.

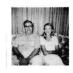

▶ **Photo Study 52: Mega Flash**—Here is another photo of my mother. This time she's on the couch with my grandfather, and the flash probably blinded them because the picture looks completely washed out. Instead of throwing it away, I will recover a good degree of detail.

▶ **Photo Study 53: Prognosis Pink**—Here is another poorly exposed print, which is of my wife at her third birthday party. It's so pink that you can barely make out any of the details. Instead of throwing it away, I will rescue what I can.

Photo Study 48: Maximum Blur

FIGURE 9.1 IS A PHOTO OF GRACE, but you almost can't tell because it's so blurry. She was playing in one of the boys' new shirts. We call them their vacation shirts because they are silky button-up types that you would wear on a vacation to Hawaii or some other tropical paradise. Normally, I would look at this picture and toss it away or delete it. It's hardly worth keeping. It's "Prognosis Negative."

Don't always believe that. With Paint Shop Pro Photo, I can make something else out of it that doesn't rely on clarity for its value. How about stationery or notepad paper?

Let's follow some steps for this exercise.

1. Open your photo (digital or otherwise) and save it as a .pspimage.

2. Straighten and crop if you need to.

3. Create a new raster layer above the Background, as seen in Figure 9.2. I'll call this *White Base Layer*. It will serve as our white base layer. Isn't logic grand?

4. Click the Foreground and Stroke Properties swatch in the Materials palette and select a fill color. I will choose white, but you can choose any color you would like your stationary to be. You can even have fun with gradients, patterns, or textures.

5. Use the Flood Fill tool to fill the base layer with the color (see Figure 9.3).

Figure 9.1
Through a glass darkly.

Figure 9.2
Creating a base layer.

Figure 9.3
Making it white.

6. Although you could convert your Background layer to a normal raster layer and move it up, I prefer to duplicate the background photo layer and arrange it so that it's the top layer in the Layers palette. This preserves my original Background safely out of the way.

7. Lower that duplicate layer's opacity to blend it into the white base layer (Figure 9.4).

Figure 9.4
Change layer opacity to blend.

Finishing the Photo Study

That's all there is to it. The critical steps are choosing a good color for the "paper" and setting the opacity for the top layer. You don't want it too visible because the flaws will be on full display. You want a subtle suggestion of the photo, almost like a watermark.

Although I didn't feel the need to, you could select all, perform a merged copy, paste that as a new layer, and continue to manipulate the effect. Try using the Text tool to put your name or a message on your note paper.

Size the overall image to match the paper you want to use, or (better yet) send it to a professional printer and have them print it out and bind it into notepads. The final result (Figure 9.5) shows that you can save an otherwise useless photo.

Figure 9.5
Cool stationery or notepad paper.

Photo Study 49: Spiderweb Ornament

IGURE 9.6 IS A PHOTOGRAPH OF A spiderweb at night. Anne and I were visiting her grandparents. It was night (duh), and we had the back light on. We suddenly realized there were spiders and spiderwebs all around the back porch of the house. They were feeding on the many insects that were drawn to this area because of the light. Remembering it sends shivers up my spine because I'm not too fond of spiders.

I have no idea where all these spiders went during the day, or what happened to their webs. Did they pack them up and head off to sleep?

We decided to take pictures of them. Do you know how hard it is to take a clear picture of a spiderweb at night without a tripod? I took several, and most turned out so badly they looked like double-exposures. Except you can't have double-exposures from a digital camera. This web was the biggest and best. It was a marvel of spider construction.

I've held on to this photo for several years for some reason. Not because it's a good photo, obviously. It fits perfectly in this chapter: Prognosis Negative.

Enhancing the Web

The first thing I'm going to do with this photo is work the edges. I'm getting ready to apply the Enhance Edges More effect in Figure 9.7. Why start with this? No obvious reason, really. I was messing around with different effects, and this looked neat. I had no idea where it would lead me, but I used this as the starting point to continue with the other effects.

Figure 9.6
Spiderweb city.

I realize that may be terribly frustrating for someone looking for a series of hard and fast steps or definitive procedures to follow. This particular photo study is an exercise in free-flowing creativity. Take a road you haven't been down and see where it goes!

Figure 9.7
Choosing an Edge effect.

I'm getting ready to apply the Colored Chalk effect in Figure 9.8. I decided on a detail level of 90 and an opacity of 100. You can play with these sorts of dialog boxes all day looking for different effects.

Figure 9.8
Applying Colored Chalk.

I created a negative of this photo to see what that looked like. Go to the Image ❯ Negative Image menu to apply it. The results are shown in Figure 9.9.

Figure 9.9
Creating a negative image.

Back in the days when we used film in our cameras, the camera exposed a piece of plastic inside, called *film*, to light. Film is coated with photosensitive chemicals, and when the camera shutter was pressed, it let a carefully determined amount of light inside the camera for a precise amount of time. The film had to be developed for us to see the effects. When the film was exposed, the chemicals reacted to the light. When treated with a chemical bath (this is the development process), they became opaque. Therefore, what you see when the film is developed is a negative image. What was light in reality looked dark on the negative (the opaque part), and what looked dark through the viewfinder was light on the negative (nothing to react to, so no opaqueness). A positive (the actual photo you take home) was created when photosensitive paper was exposed to light shining through the negative. We call this a *photo print*, but it has nothing to do with printing (in the computer printer sense of the word) at all.

With digital cameras, all this is meaningless gibberish. Digital cameras use photosensitive charged devices to quickly measure the light coming in and then store that data in a file we call a *digital picture*. No chemicals. No development.

Colorizing and Deforming

Now that the web has been transformed a little, I will introduce some color into it.

I'm applying a Sepia Toning (Effects ❯ Photo Effects ❯ Sepia Toning) effect in Figure 9.10. This has the effect of aging the print a variable number of years. Fifty looks good.

Age of Emulation

I'm not calling for turning back the clock, but I wonder sometimes if we aren't losing our practical ability to create and manipulate the environment when we turn everything into a digital simulation of "real" stuff. I realize that's an odd thing for me to say in a book I'm writing about using a computer program to retouch and restore photos, including digital photos. I see this in music and audio engineering as well. We use computers and digital processing to emulate old analog gear, vacuum tubes, amplifiers, instruments, and other devices that were pretty amazing. So amazing, in fact, that we can't accurately copy them. I call this the "Age of Emulation," because it seems like we're doing more emulating than creating.

With a little color applied, it's time to get really *funktastic*. I will bring out the big guns and apply a Kaleidoscope effect through the Effects ❯ Reflection Effects ❯ Kaleidoscope menu (Figure 9.11). This is the central point of this entire photo study. The Kaleidoscope effect turns it from a spiderweb into something different. It looks like a snowflake, which makes me think of ornaments, which makes me want to continue down this path.

Figure 9.11
Here's where it gets cool.

Ornaments are colorful. The little bit of color I added with the Sepia Toning isn't going to be enough. Colored Foil sounds promising. I've got the Colored Foil dialog box (Effects ❯ Artistic Effects ❯ Colored Foil) open in Figure 9.12.

I want to spend a moment here reflecting on Figure 9.12. I'm showing you my entire workspace to illustrate some things. I've got each stage of my journey clearly visible in the Layers palette. Each time I make a change, I review it to see if it's what I want and then duplicate that layer. Then I look for more effects and ways to manipulate the photo.

Figure 9.10
Aging the photo.

When I find one (like Colored Foil), I'll apply it and rename the layer to remember what I did. I'll save the preset so I can go back and re-create exactly what happened in each dialog box.

This process lets me keep my creative options open and gives me greater flexibility to go back and change things. There are lots of dead-ends out there. When I reach one, I can go back without any trouble at all and continue down a more promising path.

I've come to this point through pain and loss. I can't tell you how many times I've forgotten what I've done, or saved the file, closed it (only to lose all my history), and been stuck when I wanted to go back and redo something. Writing this book has helped me refine this approach. I have to be able to restore and retouch these photos (which includes finding what looks like the best method) and then re-create them for you.

Figure 9.12
Colored Foil adds color and depth.

The Colored Foil added color, but it wasn't enough. Therefore, I will increase the saturation of the entire image dramatically, as seen in Figure 9.13.

Figure 9.13
Bump it up a notch.

Yeah, that's more like it. It's starting to look like an ornament now. I've kept the hue as is, which is very blue. I could alter the hue through the Hue/Saturation/Lightness dialog box and make this peach, green, or purple. Whatever looks good!

We're almost done. I want to add one more step to take some of the "straightness" out. After browsing through many of the effects, Curlicues (Effects ❯ Distortion Effects ❯ Curlicues) looked the most promising. The Curlicue dialog box is shown in Figure 9.14.

Figure 9.14
Curlicues for added pizzazz.

I wanted some pizzazz, but not too much. When I was happy with the result, I applied it and was ready to complete the transformation from spider-web to ornament. I applied the Circle effect from the Effects ❯ Geometric Effects ❯ Circle menu to turn the rectangular spiderweb into a circular ornament (Figure 9.15).

Figure 9.15
Circle completes the transformation.

Finishing the Photo Study

I applied the Circle effect to my top layer with the Edge mode set to Transparent because I wanted to be able to continue to manipulate the scene. Afterwards, I created a new raster layer underneath my ornament and filled it with black (which is what you see).

The final result is shown in Figure 9.16. This photo was useless before. Now it's an artistic ornament. It's amazing what you can do with Paint Shop Pro Photo!

Figure 9.16
Saved as a cool ornament.

Photo Study 50: Kids and Cameras

I F YOU HAVE KIDS AND YOU HAVE cameras, you'll understand where I'm going with this. Kids love cameras, and from an early age all of our kids have wanted to take pictures. They want to take them like we do, which means without our help. Figure 9.17 is one photo of a series where Ben was taking self-portraits. He didn't know this. He was trying to do what he saw Mommy and Daddy doing and didn't realize the camera was backwards. That's very cute, but the Prognosis Negative pictures started to pile up. We have quite a few photos that our kids have taken of the carpet, of their feet, of general blurriness, and of God knows what else they were trying to photograph.

We haven't deleted them because for some inexplicable reason we love looking at all of those terrible pictures of nothingness. Prognosis Sentimental?

Prep Work

The first step for this photo study involved selecting and preparing the photos. I had several to choose from and selected four pictures of Ben that he took in one session. You can choose yours based on any number of criteria. They can be themed (like photos of the carpet, or of their feet) or dated.

I've got all four photos opened up in Paint Shop Pro in Figure 9.18. Next, I decided which one I wanted to use as the background of this study and which ones would be copied and pasted into that base photo.

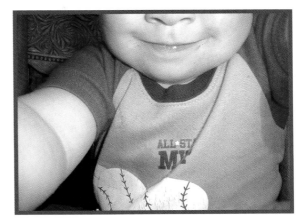

Figure 9.17
He's clearly having fun here.

Image Work

I didn't alter these photos with respect to brightness, contrast, or color. If you plan to, you should do that to each individual photo here in the Prep Work stage, with perhaps a final tweak after everything is in one file. Make sure the levels and color balance are in the same ballpark between the photos.

Figure 9.18
Selecting the photos.

There is one photo that stands out from the others that I'll use as the base. It's the one where Ben's mouth and chin are most prominent in the top-center of the photo, and it's not overflashed. Now, I'll go to the other photos, select all, and copy them (Figure 9.19).

Figure 9.19
Preparing to copy.

I've pasted one of the photos into the base image in Figure 9.20. Paste each photo as a new layer. I'm going to show the process with one photo, but you can copy and paste them all in at the same time and then go forward from there. It doesn't really matter.

Figure 9.20
Paste as new layer.

Positioning the Photos

I've rescaled layer A in Figure 9.21. This is easiest to do by making sure you've got the right layer selected, choosing the Pick tool, and then entering new scale values in the Tool Options palette at the top of the screen. I've chosen a Scale X and Scale Y factor of 30% each. You can use your mouse to drag the object to the right size if you like (still using the Pick tool), but I prefer the numerical consistency I get when I am scaling several objects to the same value.

Figure 9.21
Scale down.

Figure 9.22
Apply shadows.

When the photo is scaled to the right size, apply a drop shadow, as seen in Figure 9.22. There are a million-and-one different settings you can use to create different drop shadows. I prefer shadows with a fuzzier edge to them, so I set blur above 0. If you want a perfectly straight, black edge, set the opacity to 100, the blur to 0, and the color to black. You can even create the shadow on a new layer. I do that when I'm creating complicated layouts with things on top of each other, and I need to be able to erase or blend a shadow. Here, it's a pretty simple application.

If you haven't already, get all your photos in the base .pspimage file, resize them, and apply any effects, such as drop shadows. Now we can position each photo. I've used the Pick tool to drag them around and found good spots for each photo, as you can see from Figure 9.23.

Figure 9.23
Position each layer.

We're essentially done, but I've been wanting to try out the Picture Frame tool.

I've selected the Image **>** Picture Frame menu in Figure 9.24. This dialog box gets Paint Shop Pro involved in automatically creating a picture frame around your photo. Select a style of frame from the drop-down list (which has handy previews) and choose from a few pretty self-explanatory options. I left the default options alone and chose a nice frame.

Finishing the Photo Study

This was fun (see Figure 9.25). We've got tons of pictures like this. We have many photos where Ben is grabbing for the camera, or where Jake is making a funny face, or where the cat is walking out of the viewfinder just as I take the picture. Before now, they've been collecting dust on our hard drive. Now, I'm encouraged to make something out of these Prognosis Negative photos!

Figure 9.24
Apply a picture frame for effect.

Figure 9.25
We get the full effect now.

Photo Study 51: Last Picture Overexposure

FIGURE 9.26 IS ONE OF MY FAVORITE pictures of my mom and me. I was graduating from the U.S. Air Force Academy, and my family had come out for the pageantry and spectacle. We're over near the Chapel in this photo, with the west end of Sijan Hall in the background. Further back is the beginning of the Rocky Mountains (technically called the Rampart Range). I climbed up the rocky peak you can see with my roommate, David, one day. I took pictures but I can't seem to find them. If you look the other direction, east from the Academy, the scenery consists of undulating hills and grassland all the way to Kansas.

This must have been the last picture on the roll, because about a third is ruined from being overexposed. If we had been a little farther to the right, I could just trim the overexposed parts out and be done with it. Because the flaw covers my mom, it has always been Prognosis Negative.

Cleaning Up

This is a print, so I had to scan it in. It had some dust and scratches that I needed to clone out first, as you can see in Figure 9.27. I am going to get rid of these flaws first for this photo, because much of the photo has the correct color. In a few of the later photo studies, I hold off on cloning until I make the brightness, color, and noise corrections.

Figure 9.26
Can we rescue this?

Figure 9.27
First, clone away dust.

I haven't spoken about the Salt and Pepper filter much, but when you get down to the end of cloning away fine particles of dust, the Salt and Pepper filter (Adjust > Add/Remove Noise > Salt and Pepper filter) can save you a lot of time. I am getting ready to apply it in Figure 9.28. The key is to match the speck size and sensitivity to take out the specks on your photo without damaging what you want left behind. These small values are a conservative choice, and the result was effective.

Figure 9.28
Finishing with the Salt and Pepper filter.

Color Adjustments

This photo is really a few photos in one. There is the large difference between the correctly exposed side and the overexposed side. That's obvious. However, when you look closely at trying to mitigate this flaw, the photo naturally breaks into four areas: the sky, the mountain, the building, and mom. Those four areas are going to react totally differently to any sort of color adjustment. In fact, there is no one single adjustment I can make that will turn this photo around. It's going to take several, targeted (that's the key) color adjustments.

Before I began, I duplicated my photo layer several times so I could have separate layers to work with.

First, I matched the sky. I've opened up the Channel Mixer (Adjust > Color > Channel Mixer) in Figure 9.29 and am searching for just the right settings to make the sky look right. I'm ignoring everything but the sky as I work with the settings. This is taking place on the layer I've chosen as my sky layer.

Figure 9.29
Matching the sky first.

Next, I focused on the mountain (Figure 9.30) and attempted to get the foliage to look good. It's a challenge, and I spent a lot of time tweaking these settings to find something, anything, that looked good.

After I made these changes, I decided to mask out what I didn't want to see in order to make a composite image. I created a Show All mask in Figure 9.31 and carefully hid everything below the sky. I used the Paint Brush in various sizes and hardnesses to paint the mask on. You can see that I've hidden the layers beneath the mask group so what is masked out stays masked out. If the base layers are visible, you'll see them and think your mask isn't working.

Figure 9.30
Matching the vegetation.

Figure 9.32
Adding foliage.

Figure 9.31
Masking out all but sky.

When the sky and foliage were done, I used the Change to Target Brush on another layer that had the building and wall to change their saturation and hue to match the wall on the right side of the photo. Figure 9.33 shows the resulting composite. Everything looks pretty good except Mom, who I will turn to next.

After that, I created another mask for the left side of the mountain, as seen in Figure 9.32. Look closely at my Layers palette, and you can see this mask group rests on top of the visible sky, so you can see both. All the other layers are hidden for now.

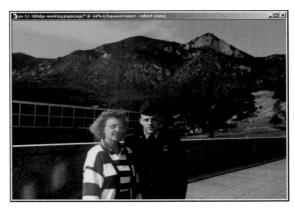

Figure 9.33
Everything but Mom is better.

Focusing on Mom

To finish Mom, I selected all, performed a merged copy, and pasted that as a new layer. I put it as the top layer in the Layers palette. This merged copy is my way of making sure all the changes I've made so far are in one layer. Next, I duplicated this layer, selected Mom, inverted the selection, and deleted the surrounding material. I wanted her on her own layer. (You'll see this in the next figure.)

I can now make a Histogram Adjustment to my mother (Figure 9.34) without affecting the rest of the photo. I'll erase around her when I'm ready to blend her in.

Figure 9.34
Adjusting her histogram.

I've done some of that erasing and am in the process of making a curves adjustment in Figure 9.35.

Figure 9.35
Adjusting her curves.

Finally, I used the Change to Target Brush to match some of her skin tone with mine and lowered her saturation. That was rather touchy.

Finishing the Photo Study

I could have done this several different ways, none of which are "right" or "wrong." I used masks for the sky and mountain but used the "duplicate layer, select subject, invert selection, delete what you don't want, make changes, erase to blend in" techniques for the building and my mother. Your call. Masks are sometimes more of a pain to create, but they definitely have their good points.

When it came to making the color adjustments, I came as close as I could, realizing this photo was Prognosis Negative. Any improvement would be welcome. I tried using the Channel Mixer with Mom, but it never looked right, so I resorted to the histogram and curves and that looked much better. The Change to Target Brush helped tremendously.

The final result is shown in Figure 9.36, complete with a frame.

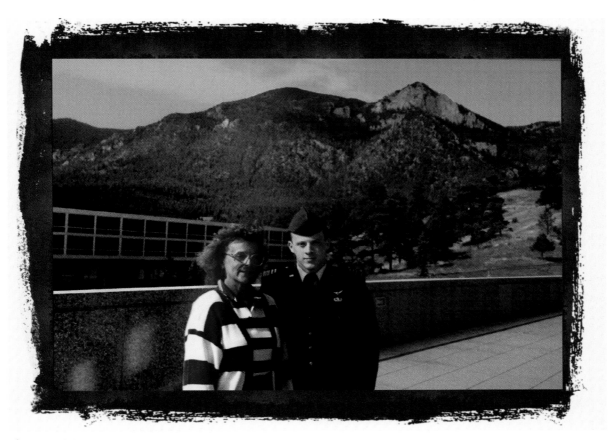

Figure 9.36
Although still flawed, this has been saved.

Photo Study 52: Mega Flash

FIGURE 9.37 IS A PICTURE OF MY mother sitting on the couch with her father, my Grandpa Johnson. She and Grandpa are sitting on our shiny blue velvet couch in front of our gold drapes. My exact recollection was dim, but I found a few other pictures from that time, and there's one of me standing in front of this couch in my Cub Scout uniform. It was the late 1970s, and Grandma and Grandpa Johnson had come to visit us. My mom looks thin, beautiful, and has a great smile in this photo.

This photo is seriously flawed. I don't know why we've kept it over the years, but I'm glad we did. In its current form, the prognosis for this photo is negative.

Bringing Out Details

The whole point with a photo like this is to see what kind of detail you can bring out. Most of the information in this photo appears to be lost.

I normally make successive changes to a picture, each change using a separate layer. It's been my experience that making one change (especially to a really damaged photo) is rarely enough. You've got to whittle away at the problem one step at a time.

The first and most dramatic step is to make a Histogram Adjustment. All the values are scrunched over in the far right side of the graph in Figure 9.38. This shows you graphically what your eyes have already told you. It's way too light. I've brought the Low slider up dramatically but left the Gamma alone.

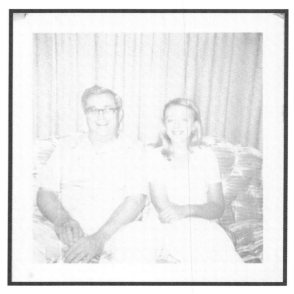

Figure 9.37
Youch, that hurts it's so bright!

Figure 9.38
Bringing out details.

That was probably the best thing I could do, and it's going to make the most difference. Now I will try and make it look better through the successive application of different tweaks.

First, I'll run it through the Smart Photo Fix (Figure 9.39). It's always a good idea to see what this tool says you should do, and many times I accept its suggestions. It's made some good contrast and tone improvements.

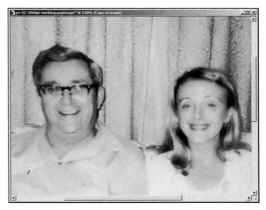

Figure 9.40
Effects of noise reduction.

Figure 9.39
Tweak with Smart Photo Fix.

Next, I'm up for some noise removal. I've chosen One Step Noise Removal from the Adjust menu, and the results are shown in Figure 9.40.

This may seem like I'm randomly applying one effect after another. It's not, really. I make one change and then evaluate where to go next, based on what I see. I normally don't go back to something far earlier in the process unless it's clear I'm at a dead end.

After reducing the noise, Levels (Adjust ❯ Brightness and Contrast ❯ Levels) are next. I can see differences on my 22-inch widescreen computer monitor that are going to be lost when these figures are printed, but the minor tweak (Figure 9.41) helped the tone.

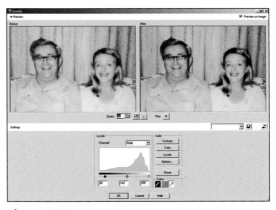

Figure 9.41
Continuing to tweak Levels.

It looked like the contrast needs adjusting, so I will see what effect Clarify (Adjust ❯ Brightness and Contrast ❯ Clarify) would have. Figure 9.42 continues to show improvement, so I press onwards.

Figure 9.42
Clarify for added contrast.

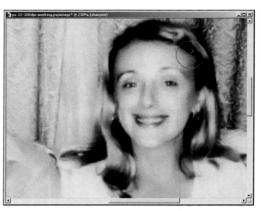

Figure 9.44
Sharpening selective details.

I am almost done. It's time to clone away the specks and spots that were made visible from all the brightness and contrast adjustments (Figure 9.43). I purposefully waited until this late stage because it didn't make much sense to spend my time working on those (the ones I could see, at any rate) before I addressed some of the more important problems.

Finally, I finished the photo study with the Sharpen Brush set to a relatively low opacity (5–10) and sharpened around Mom and Grandpa's faces in Figure 9.44.

Finishing the Photo Study

Whew. This was a string of adjustments that I didn't think would stop. I started with a photo that looked far too bright and washed out. There wasn't much detail to be had. Through a Histogram Adjustment, I was able to bring enough out to make it look really promising. The rest was gravy. I improved the brightness, contrast, and focus of the photo. Coming from Prognosis Negative, the final result (Figure 9.45) is rewarding.

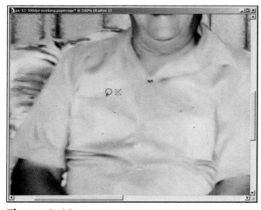

Figure 9.43
Finally, cloning away spots.

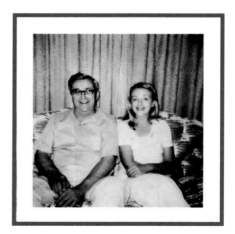

Figure 9.45
Now it's a great photo.

Photo Study 53: Prognosis Pink

FIGURE 9.46 IS AN UNSALVAGEABLE photo if I've ever seen one. You can barely tell, but this is a picture of Anne at her third birthday party. You can see part of her birthday cake in the lower left corner of the photo. She is laughing and has a big smile.

Something happened to the film when it was in the camera. I don't know what, but her mother says every photo on the roll turned out this way when it was developed. Prognosis Pink.

Taking the Pink Out

The first, most obvious, and most important step with this photo is to try and get the pink out. Before I came across my technique for removing red eye, I might have tried a number of ways to take the pink out of this photo. That solution made me want to try it here. I went straight for the Channel Mixer (Adjust ❯ Color ❯ Channel Mixer), as you can see in Figure 9.47.

Over time, you will find your own favorite methods for tackling problems. I have, and they change periodically. One thing I've been careful to avoid in this book is to tell you this is "The Way" to do something. I've tried to expand your thought processes, your imagination, your horizons, and your creativity by sharing how I do things, telling you why, and at the same time letting you know that you have the power to make up your own mind. This is creative and artistic license, which means we all have our own unique sensibilities, while at the same time sharing similar concepts of beauty and value.

Figure 9.46
One of the worst photos I've seen.

Artistry often falls far from the mathematical precision and logic of 1+1=2. It can be fuzzy. It can be messy. It can be ugly. It's yours. Go out and make it!

Figure 9.47
Taking the pink out.

The result of the Channel Mixer was good. Having the pink out opens up a world of possibilities. I can see more details, and I know I can squeeze more out of this photo. I will use a Histogram Adjustment in Figure 9.48 to help the brightness and contrast. Notice that I've slid my High and Low sliders in to match the range of values and bumped up the Gamma ever so slightly. This has resulted in a much brighter, better photo.

Figure 9.48
Improving visibility.

Now I can more clearly see a strip that runs across the top of the photo that has been exposed differently. That last Histogram Adjustment didn't reveal many details in this area. I've duplicated my working layer (the one below the Histogram Adjustment I just made) and will try a different adjustment for this top area (Figure 9.49).

I can blend these two layers together with a mask that uses a gradient to gradually hide the top layer (the one with the different strip across the top). I created a Show All mask in Figure 9.50 and applied a Black to White gradient (I reversed its orientation to make it run white to black) in the mask layer.

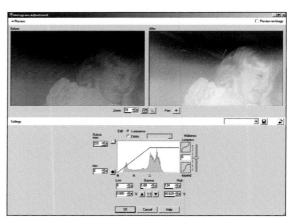

Figure 9.49
Seeing what's at the top.

This initially shows the top area but gradually hides this layer, which then exposes the main layer underneath. That's the layer that had the adjustment which benefited most of the photo.

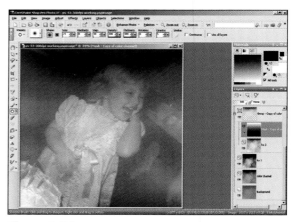

Figure 9.50
Blending two adjustments together.

With the color, brightness, and contrast pretty well adjusted, I will clone out the other problems that were visible (Figure 9.51).

Figure 9.51
Time to clone.

Finally, I applied a Texture Preserving Smooth filter (Adjust ❯ Add/Remove Noise ❯ Texture Preserving Smooth) to smooth Anne's skin a bit.

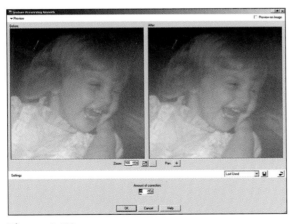

Figure 9.52
Smoothing Anne.

Finishing the Photo Study

This photo was a challenge. Its original state was Prognosis Pink. There was no way to restore it to what it was intended to capture, but with Paint Shop Pro I was able to rescue a surprising amount of detail from the beautiful photo of a young girl having the time of her life at her third birthday party.

That makes it all worthwhile.

Figure 9.53
Priceless rescue.

Making Good Photos Better

I LOVE GOOD PHOTOGRAPHS. I love looking at them, printing them out, sharing them with family and friends, and hanging them on my walls. Beauty and warmth, family and friends, places I've been, interesting things. They are all sights to behold.

I want to use this chapter to open your eyes to the fact that you can take great photos and still use Paint Shop Pro Photo to make them better. Give it a try. You will be surprised to find the things you can retouch even in a photo that doesn't look like it needs it.

▶ **Photo Study 54: Working Man**—This is an old, black-and-white photo of my wife's grandfather, Bud. He's a working man with ripped arms in this picture. I was surprised to find out that I could make this better.

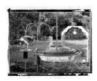

▶ **Photo Study 55: Hummingbird in Flight**—This has got to be one of the coolest contemporary shots in this book. It's an action shot of a hummingbird just outside our kitchen windows. It's beautiful. It's also the photo that made me write this chapter.

▶ **Photo Study 56: Lipstick, Please**—Here is a photo of my wife with nothing at all to repair, only after we started looking at it, we realized her lips could use some lipstick!

▶ **Photo Study 57: Waikiki from Diamond Head**—I scanned in this scenic shot and didn't think there was anything wrong with it until I opened it in Paint Shop Pro. I'll clone away the imperfections and make it brighter and more colorful.

▶ **Photo Study 58: Face Painting**—This is another picture of my wife at a local festival. Sometimes, you don't really notice these things at first, but her face is very dark in the original photo.

▶ **Photo Study 59: Fun at the Park**—This photo study is an exercise in saturation adjustment and noise reduction.

▶ **Photo Study 60: Flower Power**—Here is a stunning portrait of one of my mother-in-law's roses. Composition can add to, or take away from, a photo's impact.

▶ **Photo Study 61: Jacob the Giant**—Here is another photo of my son, Jake. He's well lit, the colors are great, and there's nothing wrong, except his skin could be a little more vibrant.

▶ **Photo Study 62: Firetruck Tour**—This is an exercise in brightness and noise. Anne and Ben are a touch dark, and there is a subtle noise level in the photo.

▶ **Photo Study 63: Pretty in Pink**—Sometimes it's only after you begin working on a photo that you realize something is amiss. I didn't know until I was performing a Smart Photo Fix that Grace had a greenish tint, which looks much better removed.

Photo Study 54: Working Man

FIGURE 10.1 IS ANOTHER PHOTO of Bud, my wife's grandfather. I've got several photos of him, Louise, and their kids in this book. As a family, they took a lot of pictures, and this is another wonderful photo. It was taken after he came back from the war (World War II). He started out farming and went on to become a very successful and wealthy salesman. He looks like quite the stud in this picture. Just take a look at his arms. They're ripped.

For its age, this photo appears well preserved. It still looks good and is a great candidate for this chapter. Let's make it better.

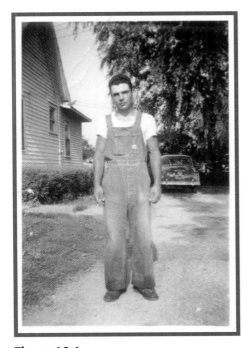

Figure 10.1
Great photo of a working man.

Getting Started

First, it's a good idea to clone the small stuff out. There is a bend in the photo in the top left corner that needs to go and miscellaneous specks throughout. I'm beginning to clone in Figure 10.2.

Figure 10.2
Cloning away minor issues.

The cloning stuff should really be old hat now. Create a blank layer (my technique) to clone on, grab the brush, adjust its size, and you're off.

Next, I'll use Histogram Adjustment to improve the overall brightness and contrast (see Figure 10.3). I've brought the Low slider up and lowered the Gamma a tad to improve contrast. Both these adjustments have the effect of slightly darkening the photo.

Figure 10.3
Histogram improvement.

Next, it could use a little sharpening. The High Pass Sharpen filter (Adjust > Add/Remove Noise > High Pass Sharpen) works very well (Figure 10.4), especially when in Overlay or Soft Light mode. The Hard Light is a little too harsh for most photos.

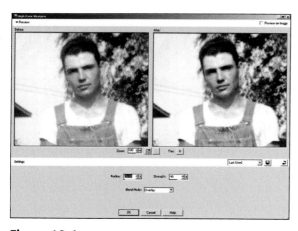

Figure 10.4
Sharpening improves focus.

Tweaking

With those adjustments completed, there's not much left to do. I want to see, however, if I can continue to tweak things a bit. I realize I just sharpened the photo, but I did that in part to prepare the way for a noise reduction. Applying One Step Noise Removal (Figure 10.5) will help smooth Bud's skin.

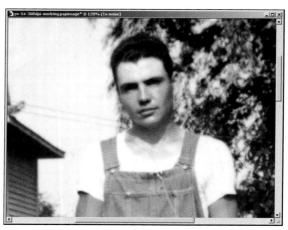

Figure 10.5
Noise reduction to smooth.

Next, I almost always take a look at what the Smart Photo Fix suggests. In this case, I clicked on objects in the left windowpane of the dialog box (Figure 10.6) to get the right color balance and left most of the other settings alone.

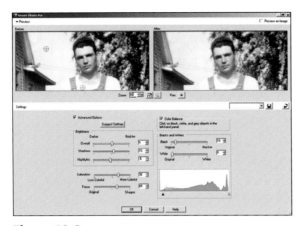

Figure 10.6
Tweaking with Smart Photo.

Cleaning up the border will almost complete my work. I'm using my top working layer and have selected the photo; then I used the Selections ❯ Invert menu to change that selection so that the border is active. I've selected the Lighten/Darken Brush and am in the process of brightening up the border in Figure 10.7.

Figure 10.7
Cleaning up the border.

Finally, there is one area in the top-left corner where the Clone Brush didn't get a good gradient. It looks too obvious. I can create a new raster layer and use the Flood Fill tool to create my own sky gradient from scratch.

First, I'll use the Dropper tool to select dark and light colors from this area into the Foreground and Background swatches of my Materials palette. These will form the "end points" of the gradient, and I chose them by looking at this area of the photo and selecting the colors that are in the picture. Next, I'll create a point-to-point Freehand selection of the area I want to fill (Figure 10.8).

Figure 10.8
Selecting a difficult area.

Finally, I'll use the Flood Fill tool to apply a Foreground to Background gradient into the selected area on the empty layer. I'm erasing (fuzzifying) the borders of that area in Figure 10.9 in order to blend it in with the rest of the photo. I've turned off the other layers so you can clearly see this. (You can see all my other working layers underneath the layer called "border.")

Figure 10.9
Blending in a gradient.

Finishing the Photo Study

The funny thing about this photo is that I actually did a lot of stuff to it. I made contrast changes, cloned out blemishes, cleaned up the border, sharpened the focus, removed noise, and created a gradient to blend part of the sky better.

It was only after I opened what looked like a good photo in Paint Shop Pro Photo and started working on it that I realized there were so many small things to fix. The moral of the story? Even good photos can be improved upon (Figure 10.10 shows the final result), and when you start working, don't limit yourself to two or three steps. Go with it!

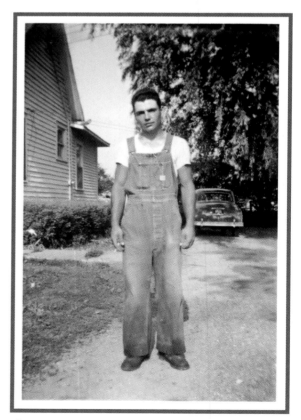

Figure 10.10
Contrast improvements make this better.

Photo Study 55: Hummingbird in Flight

FIGURE 10.11 REPRESENTS ONE OF the best pictures in this book. It's a photo of a hummingbird coming in for a drink outside our kitchen window. The thing that strikes me about this picture is that none of us are professional photographers, but this photo looks like it was taken by a pro. (Anne took this photo and the one of the rose in Photo Study 60, later in this chapter.). Animal shots are very hard to capture because of the action and nature of the subject. You can't just yell at a bird to stay still. Hummingbirds compound this due to their ultra-fast flitting to and fro.

Subtle Adjustments

The theme for this photo is that subtle adjustments can add up. The original is outstanding and hardly needs a thing done to it. However, when I opened the photo up in Paint Shop Pro and went to the Curves dialog box, I saw that the curve was off by a good deal. There was a lot of room down at the bottom where I made an adjustment upwards and then bent the curve outwards (see Figure 10.12).

Bringing up the bottom end made the photo darker, and I realized the original photo had a gray sheen over it. This indicates poor low-end levels and contrast. Bending the curve outwards lightened the photo back up a bit because I didn't want it too dark.

Figure 10.11
Close shot of a hummingbird.

Figure 10.12
Subtle curves adjustment.

These changes to the color curve prompted me to increase the saturation upwards by a small amount to help complete the photo. I was looking for a more vibrant look. I am increasing the saturation by 15 in Figure 10.13. You can tell the difference if you look closely at the red feeder and the green on the hummingbird.

Figure 10.13
Subtle increase in saturation.

Finally, I thought this photo could benefit from a frame. I chose to let Paint Shop Pro Photo help me and activated the Image ❯ Picture Frame menu (Figure 10.14).

Figure 10.14
Choosing a frame.

Finishing the Photo Study

This photo (see Figure 10.15) was not bad to begin with, but the final result is better than the original. The photo frame is a debatable proposition, and you can choose to leave these things off, but I wanted to illustrate the effect of having borders on some of the digital photos. Besides, it's fun.

Remember, this chapter is about making good photos better. Look around for some really good photos of yours and see what the histogram looks like. Open the Curves dialog box and see if there is any imbalance to the overall RGB or individual color channels. Be an investigator!

Figure 10.15
Now it's more vibrant.

Photo Study 56: Lipstick, Please

FIGURE 10.16 IS ANOTHER PICTURE of my wife, Anne. She's being playful, which is a good part of her personality. We bought the child-size cowboy hat at the local supermart, and for some reason, she's tipping it at the camera. Ben, who just turned five years old, took this photo. Great job, man!

I stumbled across the idea for this photo by accident. I was looking through all our digital photos, and this struck me as being a beautiful picture of Anne. Then, with a critical eye, I started looking for things I could fix. I didn't come up with any, but when I saw that her lips were devoid of any lipstick, that was that.

Applying the Lipstick

Since I'm going to apply lipstick, I need to decide what color it should be. You can go about this many ways, and asking the person in question is a great place to start. You could take a photo of her wearing lipstick and sample that with the dropper or just open up the Material Properties dialog box as I have in Figure 10.17 and browse through different hues and shades. This dark red color is attractive and appropriate.

My Lipstick Expertise

I know nothing about lipstick, so Anne was looking over my shoulder coaching me as I retouched this photo. It pays to have an expert tell you what's what!

Figure 10.16
Great photo, but missing lipstick.

However, and this is an important caveat, it's not going to look like this when I'm done. You may need to reverse-engineer the color by choosing a shade (or several and doing a lipstick shootout), finishing the technique to see what it looks like, and then coming back here to recalibrate.

Figure 10.17
Choosing a base lipstick color.

Next, create an empty raster layer to apply the lipstick on and then select an appropriately sized brush to paint it on with. I'm applying Anne's lipstick with a brush 50 pixels in size and a hardness of 0 in Figure 10.18. It goes on rather thick!

Figure 10.19
Erasing to fit.

Figure 10.18
Painting it on.

You don't need to be too picky when you're applying the lipstick because the next step is to switch to the Eraser and trim away at the excess. I'm doing that in Figure 10.19, being careful to use a soft eraser so there are no hard lines.

The next step uses one of those features of Paint Shop Pro that really separates the beginner from the more advanced user: Blend modes. When I first starting using graphics programs, including Paint Shop Pro, I didn't understand Blend modes at all. To me, normal was good enough, and that's what I used. I didn't even want to learn about the other modes because they seemed too complicated and fussy. After all, you just plop the layers on top of each other and that's it, right?

Wrong. Blend modes are really powerful tools for your arsenal. It doesn't take much to understand them, and they exponentially increase your creativity. I won't go into them all here (there are quite a few), but I will say that Blend modes are the rules a layer follows to determine how it will blend in with the layer(s) below it. Normal is opacity based. If a pixel is opaque and on top, it covers a semi-opaque or transparent pixel beneath it. If it's semi-opaque, you can see (partially) through it to the layer below. Overlay (which I am changing to in Figure 10.20) effectively allows me to see through the layer on top to the texture of the layers below.

Figure 10.20
Changing Blend mode.

The Overlay mode gets us most of the way there, but the lipstick is too bright. I will lower the lipstick layer opacity to blend it in better (Figure 10.21). In effect, I'm blending the Blend mode. This double blending results in a very realistic lipstick effect.

Figure 10.21
Lowering opacity for final effect.

Other Adjustments

Now that the lipstick is done, I will look around and see if there are any other improvements that can be made. I'm making a very small Histogram Adjustment in Figure 10.22, just barely bringing the High slider down. This has the effect of brightening the photo.

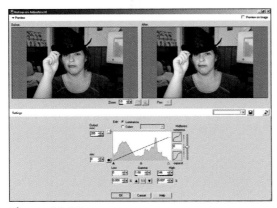

Figure 10.22
Tweaking overall Histogram.

Finally, I will bump up the overall saturation of the photo by 10, a fairly small amount. You can see the effect on Anne's face in Figure 10.23. Look at her eyes, cheeks, and lips. They're all subtly but definitely more colorful. Perfect!

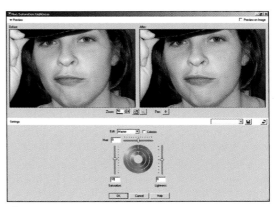

Figure 10.23
Strengthening colors a tad.

Finishing the Photo Study

Figure 10.24 shows the final result. You know, it fits in perfectly with this chapter's theme. Ben took a great photo of his mother, and by adding lipstick and making a few minor adjustments, I've made it better.

Figure 10.24
Lipstick and other subtle improvements.

Photo Study 57: Waikiki from Diamond Head

I'VE HAD BUSINESS TRIPS, AND then I've had business trips. This photo (Figure 10.25) is the granddaddy of all the business trips I've taken so far. I was stationed at Scott Air Force Base at the time, which is just outside of St. Louis, working in Intelligence Plans for Air Mobility Command.

Planning is a huge function of any military (read Sun Tzu, Napoleon, Clausewitz, or Vegetius for the importance of training and planning), and in this phase of my career, I was heavily involved in ongoing contingency operation execution and war planning (ah yes, the military-speak easily comes back to me). This was the mid-90s, and the United States Air Force was involved around the world delivering food and supplies to many areas in humanitarian crisis. I was deployed to Mombasa, Kenya for a three-month rotation as head of Air Force Intelligence during Operation Provide Relief. I helped create the intelligence infrastructure that supported Air Mobility Command operations such as that one.

As part of the war planning function, we developed the plans on paper for our area of focus (air mobility intelligence operations) that would be executed if the need ever arose to go to war in a given geographic theater. In this case, there was a planning conference in Hawaii to develop the war plan for a particular contingency in the Pacific Theater.

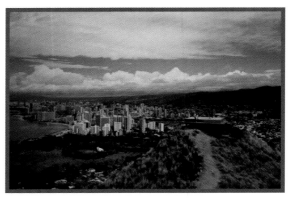

Figure 10.25
Sightseeing on the island of Oahu.

Paul Harvey

My photo study introduction reminds me of Paul Harvey. I remember sitting at my Grandma and Grandpa's kitchen table listening to Paul Harvey as a young boy. It's no wonder. He's from Tulsa, Oklahoma, which is my birthplace. And now you know... the rest of the story.

Still with me? That's how I came to be standing here, on the rim of Diamond Head volcano, on the island of Oahu, looking down on Waikiki and Honolulu.

Enhancing the Photo

Since this photo is basically in good shape, cloning out the specks and dust is a good place to start. It's a print that I had to scan in, so even the best photo will have some of these imperfections.

I'll start at a pretty high magnification (200%), and slowly work my way around the photo in sort of a search pattern, diligently looking for dust and scratches to clone out (see Figure 10.26). There are quite a few in the darker hills.

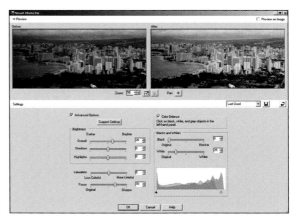

Figure 10.27
Smart Photo for starters.

I don't know if you'll be able to tell, but the buildings stand out better when looking at the right preview pane in Figure 10.28. This change is worth keeping.

Figure 10.26
Cloning away specks.

Next, I'll have a look at Smart Photo Fix. I can tell there are some overall darkness and contrast issues that this approach will quickly resolve. I have the dialog box open in Figure 10.27 and am carefully looking at the water, buildings, and sky to compare the before and after windowpanes.

The Smart Photo Fix was a success (if it wasn't, you probably wouldn't be seeing it at this point in the book), but I want a little more contrast. I'll apply the Clarify filter (Adjust ❯ Brightness and Contrast ❯ Clarify) and see how it looks.

Figure 10.28
Clarify helps contrast.

Next, I am struck by the fact that the photo looks a little grainy. I don't know if that is the result of film grain or noise, but One Step Noise Removal quickly smoothes things out. Look carefully at the water in Figure 10.29. You can tell how smooth it looks. From this distance, in the absence of strong wind and waves, the water should look smooth.

Figure 10.30
A touch cooler.

Figure 10.29
Noise reduction to smooth.

Finally, I've been looking at the picture for some time. I can tell it has a subtle yellow cast to it, which I will remove by making the photo cooler through the Adjust ❯ Color Balance menu. Take a look at Figure 10.30 and see if you can tell the difference. The buildings on the right look whiter, and the blues look a little stronger.

Finishing the Photo Study

Figure 10.31 shows my final result. There was actually more "wrong" with this photo than I realized at first. This happens a good percentage of the time. You'll look at a photo, think there's nothing wrong with it, load it into Paint Shop Pro, and after fixing or adjusting five or six things, realize how much better it is now.

That's the point of this chapter. Exactly!

Figure 10.31
The final version is much better.

Photo Study 58: Face Painting

FIGURE 10.32 IS ANOTHER GREAT photograph taken by my son, Ben. I was at the Recording Workshop for eight weeks, studying audio engineering and music production. Anne took the kids to the Johnny Appleseed Festival, which occurs annually here at the, you guessed it, Johnny Appleseed Park. They got to see a lot of exhibits of "Old Timey" life in (what would have been at the time) the Northwest Frontier of the United States.

Figure 10.33
Bumping up contrast.

Figure 10.32
The original photo looks great.

First Steps

My first step was to improve the contrast a tad. I opened up the Brightness/Contrast dialog box (Adjust ➤ Brightness and Contrast ➤ Brightness/Contrast) and increased the contrast by 10 in Figure 10.33. I want the contrast darker, but this change had the effect of darkening the entire photo. I'll remember that and come back to lighten things up later.

Next, a little noise reduction (Adjust ➤ One Step Noise Removal) will smooth the photo out. Figure 10.34 shows the effect, which does a nice job of smoothing Anne's skin. I use noise reduction a lot for things that have nothing to do with noise. When you're going to print a photo out, smoothing (even delicately) the entire photo with the One Step can make the print really nice.

I want to say that if it seems like I'm meandering through these photo studies, I probably am. Remember, this chapter is about making good photos better. That's a more meandering task than say, putting a missing corner back on. Photos that are damaged or need obvious retouching lend themselves to a more linear path from beginning to end. Not always, but much of the time.

Figure 10.34
Noise reduction to smooth.

At this point, I noticed that Anne's teeth could use a little polishing. I will use the technique I introduced in Chapter 8, "Retouching People," and gently polish her teeth with the Lighten/Darken Brush (see Figure 10.35).

Figure 10.35
Polishing teeth.

I'm ready for the first Histogram Adjustment. It was near this point when I realized the entire photo was much darker than I initially thought. It's funny how perception works. Spend time looking at your photos. Take breaks and come back. You'll be surprised at what your eyes see new, as opposed to when you first started working on a picture. This has happened to me many times as I've worked on photos for this book.

Her beautiful eyes were what caught me. I came to the conclusion that if I lightened the entire photo in order to see her eyes better, everything else would look washed out. Conversely, if I made my histogram decisions based on the rest of the photo, I would lose the details of her eyes. Therefore, I decided to make two adjustments and then blend them together. I am making my first tweak in Figure 10.36, which is to bring the ground and her body up some, but not too much. As you can see, I'm making a Gamma adjustment without touching the Low or High slider.

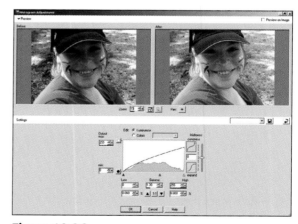

Figure 10.36
First Histogram Adjustment.

Brightening Her Face

With the rest of the photo looking better, I needed to come up with a way to brighten her face. I duplicated the layer before I applied the first Histogram Adjustment and moved it above the result of that adjustment. I then selected her face and deleted everything else. Afterwards, I made another Histogram Adjustment, looking only at her face on the new layer, and brightened it considerably. I then used the Eraser to erase everything but her face and blend its borders softly. Finally, I lowered the opacity of this layer to blend it in with the darker layer below.

Duplicate and Delete Rather than Copy and Paste

When you want to copy something in order to make a different adjustment on it, as opposed to the rest of the photo, try duplicating the layer and erasing what you don't need instead of copying and pasting your subject (except when you need to perform a merged copy). Why? Because most of the time I want things to line up exactly with the layers below. When I duplicate a layer, this happens automatically. I don't waste my time pasting something as a new layer (which centers what you paste in the image) and then having to line it up perfectly with the pixels below it. Although you can paste back into the current selection, I find that I am less prone to making mistakes (accidentally losing the selection or pasting into an existing layer) when I just duplicate the layer.

Figure 10.37 shows a shot of this top layer that I'm talking about. I've hidden everything but her semi-transparent, lightened face.

Figure 10.37
Brightening sunshine.

I've erased half this lightened layer and am showing the darker layer in Figure 10.38 so you can see a side-by-side comparison of the two effects. On the left side, you can see the result of a much lighter, semitransparent layer on top of a darker layer. (Try experimenting with Blend modes in cases like this.) The right side shows the darker layer. The benefit is clear, and because I did the extra lightening only to her face, it won't wash out the rest of the photo!

For the final step, I decided to do more skin smoothing. I selected all, performed a merged copy, pasted this as a new layer, and deleted around her face in order to capture all the changes to Anne and be able smooth her face some more without affecting the entire photo.

Figure 10.38
Compare the difference.

Figure 10.39 shows the dialog box with my settings.

Finishing the Photo Study

Figure 10.40 shows the final result. Anne's face is brighter, and her eyes are more visible in the retouched version. That's what I was after.

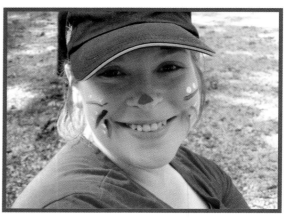

Figure 10.40
Now you can see Anne's face.

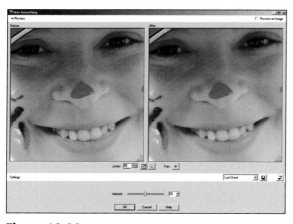

Figure 10.39
A touch more skin smoothing.

Photo Study 59: Fun at the Park

B EING A FATHER IS HARD WORK, but it's really fun. We love taking our kids to the park, and they love going. They get to run around and have adventurous fun on all the equipment. Jake is about two in Figure 10.41, and I'm pushing him on the swing. He looks so cute in his little football fleece!

There's doesn't appear to be anything wrong with this photo, which is why I want to cover it in this chapter.

First Adjustments

The first thing I'm going to do is run this photo through the Histogram Adjustment tool, as seen in Figure 10.42. The histogram looks pretty nice. I made some pretty small adjustments to the Low and High sliders, and increased the Gamma. Jake's face looks brighter, and the contrast is a hint better.

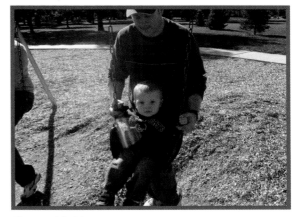

Figure 10.41
Nothing wrong with this photo.

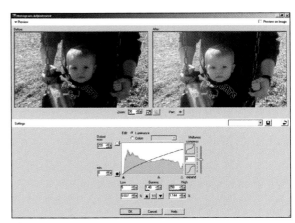

Figure 10.42
Small Histogram Adjustment.

The Curves adjustment I made in Figure 10.43 is almost so small that it's not worth mentioning, but I just took a look at my working file, and the difference in the photo is much larger than what you can see here. This tiny little change made a great contrast difference.

Figure 10.44
Selecting Noise Reduction regions.

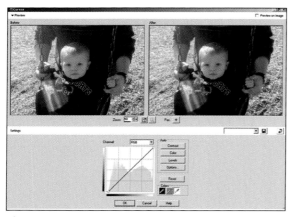

Figure 10.43
Small Curves adjustment.

Now that I can see things better, I notice there's some noise I want to remove. I've fired up Digital Camera Noise Remover in Figure 10.44 and have moved the sampling regions around the photo to places I chose. These are pretty standard settings, which I find are good most of the time. Jake's face looks a lot better!

Final Enhancements

Brightness, check. Contrast, check. Noise, check. Color? It's time to tweak the color. I'm increasing the saturation in Figure 10.45 by 15, which is enough for me to notice a difference, but not enough to blow out the photo.

Figure 10.45
Enhancing color.

Finally, I see a scratch on Jake's face that I'll clone out (Figure 10.46).

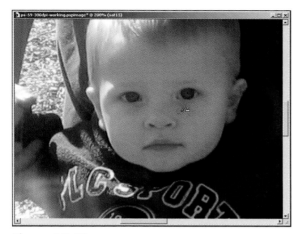

Figure 10.46
Cloning away a scratch.

What comes after finally? I'm not sure. I thought it was finally, but it appears I made one more adjustment. I was looking at the changes and realized I wanted there to be a little more contrast, so I opened up the Brightness/Contrast dialog box and bumped up the contrast by 9. It's a pretty small thing, but it made the darks a little darker, and the contrast improved tremendously.

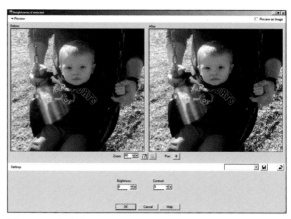

Figure 10.47
Very subtle contrast tweak.

Finishing the Photo Study

This photo was about making quite a few subtle adjustments. I covered all the bases. I improved the brightness, contrast, noise, and color and removed a scratch from Jacob's face. The final product is shown in Figure 10.48.

Figure 10.48
Subtle improvements make it better.

Photo Study 60: Flower Power

I LOVE TAKING PHOTOS OF FLOWERS, and so does Anne, who runs outside with the camera whenever there is a flower in bloom. I always took photos of my mom's roses and flowerbeds. Mom loved growing things and went to great lengths to care for her gardens and flowers.

Anne took the photo of the rose in Figure 10.49 last year. It's stunning.

Quick Enhancements

First, I'll run the photo through Smart Photo Fix and see what happens. Figure 10.50 shows the dialog box and Paint Shop Pro's suggestions, which look pretty good to me. If you analyze them, it made the darks a bit brighter, the brights a bit darker, sharpened the photo, and made small contrast adjustments. That may sound like a lot, but the preview window reveals that the differences are relatively minor.

Figure 10.49
Gorgeous.

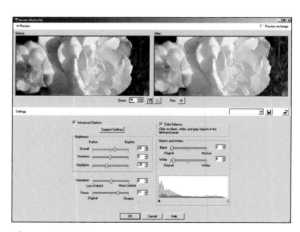

Figure 10.50
Smart Photo Fix.

Next, I turned to the Histogram Adjustment and raised the Gamma (see Figure 10.51). This darkened the photo slightly.

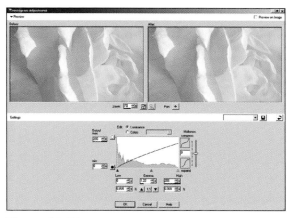

Figure 10.51
Histogram Adjustment.

Finally, the key thing to unlocking the power inside this photo is composition. It's a great photo, but if I crop it correctly, the rose will be much more prominent. I've selected an area in Figure 10.52, which is where I will crop using the Image ❯ Crop to Selection menu.

Figure 10.52
Selecting an area to crop.

Finishing the Photo Study

Figure 10.53 shows the final result, and it's a winner. Color and contrast adjustments aside, the most important thing here was to cut the extra stuff out. This makes the photo far more powerful!

Figure 10.53
Tighter focus makes the rose better.

Photo Study 61: Jacob the Giant

WE WERE JUST HAVING A conversation at the dinner table tonight about what giants eat. I say people. Anne said if she were a giant, she would eat the same things, only in much larger quantities. We laughed and laughed at that. I love laughing at the dinner table. It really brings us together as a family.

Anyway, Figure 10.54 is a photo of my son, Jake. Anne took this one day when we were at the park flying our kite. (We get this request continually now.) It was a gorgeous spring day. The sun was shining, the sky was a beautiful blue, and the white clouds floated by overhead, driven on by the wind. A perfect day to go fly a kite.

Jake was a little too young to be running after the kite with Daddy and Ben, so he and Mommy (who was pretty pregnant at the time) camped out on a blanket, watched us, and took pictures. This picture makes Jake look like a giant!

Only One Improvement

This will be easy to write. I'm making only one adjustment here. I've opened up the Hue/Saturation/Lightness dialog box in Figure 10.55 and have entered a value of 15 in Saturation. That's it.

Figure 10.54
The original looks really great.

Figure 10.55
Notice his skin.

Finishing the Photo Study

Figure 10.56 shows the final photo. So why even put this in a book? Am I trying to pass myself off as some magnificent artist for increasing the saturation of this photo by a measly 15? No, of course not. The point here is to see if we can make this better. It's not about who can go the longest, the fastest, or the mostest. That's all this photo needed, and it was a good choice. If you take a gander back at Figure 10.55, you can see it didn't take much to give Jake's skin a touch of rosiness. The blue of the sky and the red of his outfit are a little better, but the main point was to give Jake a little color, and 15 was all it took.

Figure 10.56
Subtle improvement in skin tone.

Photo Study 62: Firetruck Tour

OUR LITTLE FAMILY (we only had two kids at the time) took a trip with my best friend and his family to his parent's lake house one summer weekend, and Figure 10.57 is a photo of Anne and Ben getting a tour inside a firetruck. It was the weekend before the Fourth of July, so the atmosphere was festive, and the local Fire Department had their trucks on display.

With the photo brighter, the noise is more obvious. I've opened the Digital Camera Noise Removal dialog box in Figure 10.59 and have chosen a few extra sampling regions. This helps point the program to the areas we definitely want smoothed.

Figure 10.58
Starting with Smart Photo Fix.

Figure 10.57
Getting the grand tour inside a firetruck.

Small Adjustments

I've opened this photo up in Smart Photo Fix in Figure 10.58 to see what it says. Very minor changes result in the photo looking much brighter. It looks better, so I'll keep it.

Figure 10.59
Reducing noise.

The noise reduction softened the focus, but I like it. It adds an artistic element to the photo. Despite liking the soft focus, I want to enhance the contrast. I'll call upon the Clarify filter (Adjust > Brightness and Contrast > Clarify) to achieve this, as seen in Figure 10.60. Clarify sharpens the photo but doesn't take away the softness entirely. Just what I wanted.

Figure 10.60
Clarify for contrast.

Finishing the Photo Study

In retrospect, this photo was pretty dark in its original form. Figure 10.61 shows the final result. Much better brightness and contrast, and I think the combination of the noise reduction and clarifying really finished it off well.

Blinded by Content

If you're restoring or retouching your own photos, don't fall in love with the content so much that you forget to look critically at the color, contrast, brightness, focus, and composition. That's why you're here.

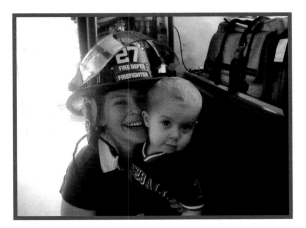

Figure 10.61
Now we can see them better.

Photo Study 63: Pretty in Pink

FIGURE 10.62 IS A FUNKY PHOTO of my daughter, Grace, playing outside in the backyard. She's wearing a pink "go-getter" combo of hat, shades, backpack, shorts, and sandals. She's a little Lara Croft! She is actually wearing the perfect outfit to be seen against the bright green foliage of the grass and plants. Pink and green go very well together (although you didn't hear that from me).

Figure 10.62
Grace on a mission.

From Good to Better

If you think I'm using Smart Photo Fix a lot in this chapter, that's because I am. Smart Photo Fix works great on photos that are pretty good to start with. I've called it up in Figure 10.63, and the main thing I want to point out is that I've selected black, white, and gray areas in the left windowpane to set the color balance. If you look closely, you can see that Grace has a greenish tint to her in the original. It's as if the green in this photo has overpowered the camera.

Having accepted the Smart Photo Fix, I'll choose a picture frame to wrap this photo up. Choose the Image ▶ Picture Frame menu to get started. Select a style from the drop-down menu that appears when you click the picture frame icon in the dialog box. The styles are shown in Figure 10.64, and there are quite a few to choose from. The Mat Rose is a good choice for this photo. It's going to complement all the pink that Grace has on!

Figure 10.63
Smart Photo Fix works well on good photos.

Figure 10.64
Selecting a frame.

After you've selected the frame, it appears in the preview window (see Figure 10.65). I won't go through all the options. My one suggestion is that you may consider saving your .pspimage file without the frame, then copying the top layer (or a merged layer) into a new file and applying the picture frame to that file. The reason is that the picture frame can affect your canvas size, which fills the extra space in the Background layer with the background color. I don't always like that.

Figure 10.65
Previewing Picture Frame.

Finishing the Photo Study

Woohoo! This one's done. Figure 10.66 (the Battle of Hastings figure) shows the final result. Don't just look at bad photos or photos with obvious flaws. Be a detective! Be an artist!

Figure 10.66
Subtle improvements are worth it.

Archiving

And now, let's take a break from retouching good photos and look at archiving. When I say archiving, I'm talking about preserving your photos electronically and then protecting that digital backup. Your photos could have been digital to start with, scanned photos that are now graphics files, and of course, the Paint Shop Pro Photo files that you generate as you work on restoring and retouching your photo collection.

Archiving protects your collection from things that could go wrong. This takes the form of backups and duplicates. I don't want to sound depressing, but the things that could go wrong are, well, almost endless. You have to decide which ones are most likely and therefore worth protecting yourself against and which ones are less likely and you're going to ignore. You should also make plans for your death. How hard or easy will it be for your survivors to find and manage your collection?

I'll break this down into two categories: bad things in general, and bad things relating to your computer.

The first category is pretty large and ranges from cosmic cataclysms to house fires. Which ones are you prepared for? If an asteroid the size of Texas hits the earth and we all die (unless Bruce Willis and crew save us), well, I don't think we need to prepare for that. If you live in an area that is prone to earthquakes, maybe you should pay attention to that one. House fires are possible in any residence.

The second category involves hard disk crashes, your computer getting fried by a lightning strike, power surges, accidental erasure, data corruption, operating system crashes, and the like.

It's best to prepare for any of these possibilities by making duplicate copies of your files (backups) and then physically separating the original from the backup.

Copies, Media Considerations, Physical Separation

Copies that protect you are easy to do. Make a backup copy of your files. You can put this on the same hard drive if you like as a start. I wouldn't keep it there forever, but it's good to get started.

Media type is an important consideration as well. How much storage space do you need and how long will it last? Extra hard drives benefit from huge storage capacities and are pretty cheap per gigabyte. However, they are more likely to wear out and break than CDs and DVDs. CDs hold far less data than a hard drive but aren't prone to the same types of calamities. DVDs hold more, but you still might only be able to fit a small portion of your collection onto a DVD. Do you know that we don't really know how long "home-burned" CDs and DVDs are going to last? There are some who contend their lifespan can be measured in just a few years, especially if you buy cheap ones. Others say 30, 50, 100 years. Tape backup is a good choice, but who among us has tape backup machines at home?

Find what you are comfortable with and go with it. Tape backup is the best and most reliable, but it isn't very convenient because you need the right machine and software to store and retrieve the data (which then locks you into that combination). CDs and DVD are much more convenient but hold less, and you may need to reburn new CDs or DVDs every so often to make sure your data is safe. I would buy a few extra hard drives and perform periodic backups to them and then remove them from the computer. Consider buying one or more external hard drives and putting them in a safe-deposit box somewhere for an ultimate backup. You can buy a few and rotate them. Make a backup once a year and take it to the safe-deposit box and switch it out with the one that's there. Bring it home and prepare for another backup. Make it a special day. Go out for dinner on your way to the bank. Have fun!

My final point is to prompt you to consider the physical location of your backups. If they are in the same computer and your computer gets fried by lightning, they will probably be lost. If they are in the same house and your house burns down, they are probably lost. The more the separation, the greater the security. Of course, this safety tends to come at the cost of practicality and convenience.

Don't lose all your great work because you didn't think about this. Don't lose your family's history because you never backed anything up. Start now. Build. Plan to succeed.

Artistic Restoration and Retouching

11

THIS IS THE LAST CHAPTER OF THIS BOOK. I can hardly believe it. When I started, I had no idea of the amount of work I was taking on, but this is the end. I've chosen to end on an artistic note, which is no less challenging than the more technical chapters and fun and rewarding in its own way. I've got a lot to show you in this chapter. Some of these photo studies are pretty involved, while a few are really simple. I envision this chapter, more than the others, as a starting point, a place to encourage or inspire you. Let's review before we get started.

▶ **Photo Study 64: Cool Cat**—Edge effects and equalizing the histogram turn a photo of my former cat, Beetlejuice, into an artistic print.

▶ **Photo Study 65: Roses Are Red**—This photo draws attention to our wedding flowers by oversaturating them.

▶ **Photo Study 66: Blue Heisey Mosaic**—Here, I apply a mosaic effect to a subject (the horse) that has the background masked out.

▶ **Photo Study 67: Casa Loma Print**—Let's turn a photo of a barn into a sketch.

▶ **Photo Study 68: Liquid Sky**—You can create a liquid border around an artistically enhanced photo.

▶ **Photo Study 69: Unleashed Talon**—Here is a black-and-white print made to look like it is an action shot.

▶ **Photo Study 70: Frosted Flowers**—I take a normal shot of Anne's hens and chicks and make it look frosted.

▶ **Photo Study 71: Canvas Fiddlesticks**—I use texture effects in this study to create artistic photos.

▶ **Photo Study 72: Reflections**—I make a building look like it is a reflection in water.

▶ **Photo Study 73: Vanilla Sky**—I transformed this photo I took from the backyard into a beautiful scene.

Photo Study 64: Cool Cat

OUR FAMILY ALWAYS HAD ONE or more cats running around when I was growing up, and when I got out on my own after college, I went down to a corner pet store and fell in love with Beetlejuice (see Figure 11.1). He was scampering around on the floor near the back and was the cutest little guy. I couldn't get a dog because I lived in an apartment alone and was gone a lot at work. A cat was more self sufficient.

That day began an 11-year relationship that saw me through the Air Force and back home and into the beginning of my marriage. We were best buds, Beetlejuice and I. He was a faithful companion. He was also fearless and grew to be pretty big. I had to ask Mom to take care of him a few times when I went away on temporary duty assignments. Much to her chagrin (she loved him dearly, though), when he got to her house, he was in charge. He camped out under the kitchen table and ran her dog out of the room.

When I got married, Anne said he would nap all day waiting for me to come home from work and then, right on time, head to the kitchen and wait for me by the back door.

Prepping

Like cooking a good meal, prepping is an important part of creating artwork in Paint Shop Pro Photo. In this study, I will duplicate the photo layer twice in order to create two different effects, which I will end up blending together.

Figure 11.1
A little too much flash.

I'm in the process of duplicating for the first time in Figure 11.2. I rename these duplicate layers to keep things straight. It gives me situational awareness so that I know where I am in the process. That awareness helps tremendously if you need to save, close your file, and come back at a later date. The other point, which I have been trying to emphasize without becoming tiresome, is to preserve the original photo on the Background layer. It's nice and convenient there, in case you need it.

Generally speaking, I go a step or two at a time and then go back. I figure out what looks good and then go back and rename the layers. For things like Histogram Adjustments, it's easy to know beforehand what I'm going to do because I know in advance what I want. For other things, especially things like "white selection layer," I don't know until after the fact.

Figure 11.2
Creating our working layers.

So I've gone back and renamed the layers and created this working file for you, as seen in Figure 11.3. What I'm going to do next is manipulate the histogram on the middle layer, then create a different effect on the top layer, and finally blend them together.

Figure 11.3
Laying them out.

Layer Effects

I am adjusting the histogram of the appropriate layer in Figure 11.4. I slid the Low slider pretty far up. That darkens the photo to the point where you can just see Beetlejuice. My legs and feet on the coffee table in the left windowpane are gone from the right. Good. This is the main effect I'm after. The flash was too bright for his white fur, which has always bothered me. This settles that down and also makes it very artistic.

Figure 11.4
Histogram Adjustment for the main effect.

My next step came about completely by accident. I was looking to select the white parts of Beetlejuice to tone them down and tried the Histogram Equalize (Adjust ➤ Brightness and Contrast ➤ Histogram Equalize) menu.

I'm re-creating that for you in Figure 11.5. This is taking place on the top layer, and you'll notice that I've unchecked Contiguous so that I get all the white pixels in a particular range.

Figure 11.5
Selecting the white areas.

Figure 11.6 shows the effect of equalizing the histogram.

Figure 11.6
Equalizing the histogram.

Of course, that doesn't look too cool by itself, but I thought if I could blend it in, it might be neat. Rather than adjust the opacity (which I tend to do first), I played with the Blend modes. I'm changing to Burn in Figure 11.7. This darkens the photo even more.

Figure 11.7
Changing the Blend mode.

Finishing the Photo Study

With that, I am done. The resulting image (Figure 11.8) shows a photo transformed. It captures the essence of Beetlejuice perfectly. He was one cool cat. He ruled the roost, and we were good friends. I still miss him.

Figure 11.8
Cool cat.

Photo Study 65: Roses Are Red

ANNE KEPT HER BOUQUET OF ROSES that she carried when we got married, brought them home, and dried them, and then I put them in this old jar I had. It's a beautiful jar. I'm also a woodworker, and I copied some shelves for Anne that she saw in a magazine. It was simple. I went out and got some crown molding, cut it to length, mitered the sides, and mounted them on our living room wall. Figure 11.9 is that combination of memories and construction.

Working the Roses

Sometimes I have an idea of what it is I'm trying to do before I try to do it. But for this photo, I knew at the outset that I wanted to make something artistic out of it, and I knew I wanted to work with the color of the roses. They are the focal point, both of the photo and also of the symbolism of what I wanted to create.

I knew I had original pictures of those roses from our wedding, so my first step was to open one up and sample the color. I'm doing that in Figure 11.10. It's always good to use actual colors if possible. I'll try to use the blue of a sky sometimes, when I'm working in blue, or the brown of sand. It's more authentic to me.

Figure 11.9
Nice photo, but a little lifeless.

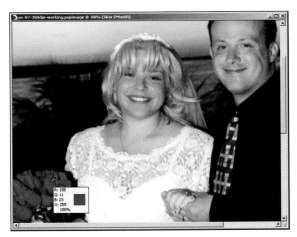

Figure 11.10
Their original color.

Next, I'm going to do something a little unexpected. Instead of just painting the color over the old roses, I used the Change to Target Brush in Saturation mode to change the saturation of the older, darker roses to match the original. I'm using the brush in Figure 11.11, making a few highlights on the roses with a brush at 50% opacity.

Figure 11.11
Matching saturation.

When I got comfortable with what I was doing, I ended up working over all the roses. I tried changing the hues to match, but for some reason it never really looked good. Changing their saturation brought out a color that I liked better.

So I switched to the Saturation Up/Down Brush in Figure 11.12 to strengthen the roses' color. I've got it set to 100% opacity for a very strong effect, which is creating a golden glow inside.

That gold color was quite by accident, really. If you had told me "go make the jar glow with gold," I would have done something completely different. As it was, I was working on the saturation of the roses.

Figure 11.12
Enhancing saturation.

Enhancing the Rest of the Photo

With the roses done, I turned my attention to the rest of the photo. The color of the walls looked off, so I used Color Balance (Adjust ➤ Color Balance) to cool things down a bit. Figure 11.13 shows the effect, which takes the yellow out and enhances the blues a bit.

Figure 11.14
Lightening the walls.

Figure 11.13
Making the photo cooler.

Finally, I thought the walls looked a little dingy. I used the Lighten/Darken Brush to whiten the walls.

Finishing the Photo Study

Figure 11.15 shows the final result. I'm very excited, because this is exactly what I want to show you in this chapter. I used this photo as the beginning of something. I didn't perform a routine touch-up. What I did was Artistic Retouching.

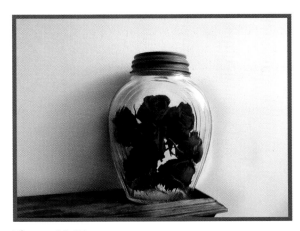

Figure 11.15
Roses are red.

Photo Study 66: Blue Heisey Mosaic

FIGURE 11.16 IS A PHOTO OF A BLUE Heisey Horse that was made for The Longaberger Company (they make baskets and other household furnishings). My mother had a collection of horses in her living room. They were sculptures, mostly. Some were refined, and some were crude. When Longaberger offered this horse, we grabbed it up, thinking it would make a great addition to her collection. She was very pleased to receive it as a gift, and I'm still proud of giving her that one.

One bright winter day, I decided to take some photos of the horse (we should name it someday) and asked Anne to help me. She's actually taking this picture, and I am standing behind the mirror that is on the opposite side of the horse. I'm trying to use it to catch the light coming in from the window. The horse is resting on computer printer paper placed on some shoeboxes, resting on the kitchen table.

Masking

First, I wanted to create a mask, and to do that I needed to duplicate my Background layer (see Figure 11.17). I do this because (as you undoubtedly know, but I keep repeating in case someone jumps into a random spot in the book) I keep my Background layer separate from everything else, including masks. When you create a mask, it places the layer you have selected in the mask group. If that's a Background layer, it loses its status as a Background layer (becoming a normal raster layer) and is more susceptible to alteration, which is something I really avoid like the plague.

Figure 11.16
Ignore the man holding the mirror.

Figure 11.17
Creating the working layer for the mask.

Figure 11.18 shows the mask layer in place. I use "Show All" masks and then paint in the black with a brush. (I have to be careful to hide my Background layer before I do this or I won't be able to tell what I'm doing.) You can see the mask layer is currently white, which means nothing is hidden. White reveals, black hides.

Figure 11.19
Hiding the background.

Figure 11.18
Creating a "View All" mask.

I've selected a large brush to start painting in the mask, as you can see in Figure 11.19. It's a hard brush because at this stage I don't want any semi-transparent pixels left behind to mess things up. I'll take a few passes with the brush, getting closer to the horse, and in the end, I'll lower the hardness of the brush so the mask edge is soft. Notice that my Background layer is hidden at this stage.

Figure 11.20
Mask completed.

Figure 11.20 shows the completed mask. My attention up to this point has been entirely on getting the mask completed. The horse is sitting off center and kind of small. I'll handle that later, after I apply the final effect and save this to a new file.

Creating the Mosaic Effect

This is another one of those tricky stages. You can use the mask layer if you want, but if you try to apply an effect, it will be rendered down to a raster layer, and you'll lose the mask. Go ahead and try it. What I do is select all (making sure the Background layer or any other intervening layers are hidden and the mask is working), perform a merged copy, and then paste this "masked copy" as a new layer. The result is shown in Figure 11.21.

Figure 11.21
Merged copy pasted as new layer.

My mask is still there, underneath this layer. I can hide it and keep it out of the way and come back to it if I ever need it. Okay, that was a lot of work to get to this point, the point where we're going to see something artistic!

I've played around with photos of this horse for a long time, and there hardly seems to be an effect that doesn't look great with it. Find photos like this, where you come back and try different things over time. It's fun. I haven't tried a mosaic effect yet, and this seems like a good time. Figure 11.22 shows the Mosaic—Antique dialog box. You can get to this effect through the Effects ➤ Texture Effects menu in the department of duplicate redundancy.

Play around with these settings. It's a whole new world in here. You can start out with a ready-made preset and tweak around the edges or jump in and make dramatic changes of your own.

Figure 11.22
Mosaic effect.

Finishing the Photo Study

Figure 11.23 shows the Blue Heisey mosaic in all its glory. It's fun to use masks to separate a subject from the background and then apply interesting effects to the subject alone.

Figure 11.23
Blue Heisey mosaic.

Photo Study 67: Casa Loma Print

IGURE 11.24 IS A PICTURE OF BUD and Louise's barn, which carries the name of their property, Casa Loma. Casa Loma literally means House on the Hill in Spanish. The barn is an archetypal American red barn from long ago. The wooden beams inside this thing are huge.

I love the way the name is put on the barn on both sides of a circular window. It's completely picturesque!

Creating the Effect

This is really a simple effect. I'm almost embarrassed to show you. But you know, it doesn't all have to be excruciatingly hard.

Canadian Castle

If you look it up, there is a tourist attraction in Canada called Casa Loma. It predates ours by a little. The Canadian castle was completed in 1914, and Mary Anne tells me that her parent's barn (and hence the name Casa Loma) was built in the early 1920s (well before her parents bought the property).

Figure 11.24
Standard photo of a barn.

Step one is to protect my Background layer. I've duplicated it in Figure 11.25, renamed the new layer, and am ready to rock.

Figure 11.25
Working layer ready for effect.

The next step is to enhance the edges.

I applied two effects to this photo, but I can't show you a meaningful figure—aside from the final shot. I applied the Effects ❯ Edge Effects ❯ Enhance effect to set up the next effect, the Effects ❯ Edge Effects ❯ Find All Edges effect. The edge enhancement made the second effect much stronger.

Finishing the Photo Study

Figure 11.26 shows the final result. It looks like a drawing made on newspaper. It has lost its color, and the attention is now drawn to the lines. I particularly like the way the effects captured the texture of the barn siding, which is not painted. The red siding on this barn is actually something closer to shingles that you put on a roof.

Figure 11.26
Casa Loma print.

Photo Study 68: Liquid Sky

FIGURE 11.27 IS A PICTURE of the sky. I'm not sure why, but there are times when the sunset around here is simply phenomenal. The sky turns a darker blue, and the setting sun radiates off the undersides of the clouds, turning them a beautiful shade of gold. You have to see it.

Figure 11.27
This sunset was beautiful.

Prepping the Canvas

This artistic study has a lot of prep work. I realized this only after playing with the main effect for a while, trying to find out how it worked and under what conditions it looked best.

First, I created my ubiquitous working layer (Figure 11.28), a duplicate of the Background layer.

Figure 11.28
Working layer ready.

Next, I needed to enlarge the canvas (Figure 11.29). This has the side effect of filling the extra room on the Background layer with the background color, but that can't be helped. (You can't choose a transparent background color from the Canvas Size dialog box.) This is why I duplicated the Background layer before I enlarged the canvas. If I hadn't, I would be duplicating my photo with a colored border, which is not what I want to do. By performing the steps in this order, my duplicate layer will have a transparent border around it, rather than what happened to the Background layer. Sometimes you have to be tricky!

Figure 11.29
*Enlarging
canvas size.*

Layer Work

Next, I created a new raster layer to have a white background. I'm creating and naming it in Figure 11.30. This will be my "rock bottom" layer—the layer everything else will rest on visually. I could have chosen any color or texture, but white looked good.

Figure 11.30
Creating a new layer.

After the White layer was created, I arranged it so that it was underneath my working layer but above the Background layer. Figure 11.31 shows this and also reveals what I meant about the canvas change and how it affected the Background layer but not my working layer, whose border is transparent.

Figure 11.31
Layers ordered.

The last step in this process was to duplicate the working layer four times, as seen in Figure 11.32. As you can see, I've finished my duplication (easier than copy and paste, and everything is perfectly lined up) and have everything ordered and named.

Layers 1 through 4 are going to be the layers I apply the Displacement maps on. The working layer will be the top, unaffected layer (you'll see why I want the top layer left alone later), and the White layer is my background.

Figure 11.32
Duplicated layers ready for effects.

Figure 11.33
First Displacement map.

Displacement Maps

The Displacement Map effect is located under the Effects ❯ Distortion Effects menu, and I am using the "Under ice" preset as a starting point. I've changed the intensity to 100 and the Displacement map to Asphalt in Figure 11.33. This is the first application, on Layer 1, and the rotation is set to 0. Displacement maps have an orientation, and I want my effect to extend out from all four sides of the top layer. This is why I duplicated that working layer four times. I'm going to apply the same Displacement map on each of those four layers, but with different orientations.

Figure 11.34 shows the second application, on a different layer, with an orientation that is 90-degrees out from the first. I'll do this two more times for the other layers. Then I'll have the Displacement map effect equally strong on all four sides.

Figure 11.34
Second Displacement map with different rotation.

Blending and Tweaking

Remember, I have a top, working layer that I haven't touched yet. I want it to be unaffected in the center but blended with the lower displacement layers on its edges. I'm erasing its straight border on all four sides in Figure 11.35 to blend it in with the lower layers.

Figure 11.36
Histogram Adjustment.

Figure 11.35
Erasing border of top layer to blend.

Finally, I'm going to select all, copy everything (merged), and paste that as a new layer. I'm making a Histogram Adjustment in Figure 11.36 to make the colors more vibrant. I've selected each channel and am making separate adjustments so I can manage the color balance better.

Finishing the Photo Study

The final work is shown in Figure 11.37. It really does look like liquid sky being poured out on a white surface. We owe that to the Displacement map.

Figure 11.37
Liquid sky.

Photo Study 69: Unleashed Talon

I'VE ALWAYS LIKED TAKING PHOTOS of airplanes on static display. This photo (Figure 11.38) dates back to the mid 1980s when I was a student at the United States Air Force Academy. It's a Northrup T-38 Talon, which is a two-person jet trainer. It was also the aircraft the Thunderbirds (the Air Demonstration Squadron of the United States Air Force) flew from 1974 to 1981. This particular T-38 is painted as a Thunderbird, mounted beautifully, and placed on an overlook in view of the airstrip at the academy.

I landed very near this plane when I was getting my parachute wings. It was my third or fourth jump (out of five needed to qualify), so I was getting pretty used to it. It had stopped being terrifying (jumping out of a plane at 4,000 feet above the ground isn't a natural act) and was becoming fun. I was very proud of myself. There were tourists at the overlook who got to see an Air Force cadet (me) guide his parachute towards them, make a perfect PLF (parachute landing fall), casually gather his chute, and then walk over to the control buildings to receive his grade.

My first jump was absolutely terrifying. I remember looking at the guys who went before me (bad idea). I'm not a big fan of heights anyway, and most of the time the point is to hang on, not jump off or out. I remember very clearly jumping out and thinking (because that's what I felt) "I'm FALLING!!!" For some reason, I didn't think it would feel like falling, but it did. It felt like someone had just pushed a brick, me, out the door of the plane.

Figure 11.38
A favorite subject of mine.

First Steps

First, I'll take care of the scratches and dust in this print. It's pretty old now (youch, over 20 years) and because it's a physical print is subject to damage. I'm merrily cloning away in Figure 11.39. It's funny, even working on a photo that I'm going to artistically retouch starts with cloning out some of the imperfections.

I'm going to jump right in and start making things look different. I'll apply a film filter in Figure 11.40. I've chosen Effects ❯ Photo Effects ❯ Black and White Film to open this dialog box, and I'm selecting a pretty strong red filter. The filter alters the tone of the photo. It's gone from a partly greenish tint (that I didn't realize was there) to a more pure grayscale. Since this is a black-and-white picture, that's great.

Figure 11.39
Cloning dust away.

Figure 11.41
Adding grain for stippled effect.

Figure 11.40
Applying a film filter.

Next, I'm going to go overboard on the film grain to create a powerful artistic effect. Add film grain just like you add noise. In fact, it's right there in the same menu. I chose Adjust > Add/Remove Noise > Add Noise to open the dialog box you see in Figure 11.41. Film grain (in a few varieties) is a preset and is easy to choose.

Letting Loose

A sunburst can make a photo more realistic and artistic at the same time. You can apply one by selecting the Effects > Illumination Effects > Sunburst menu, which brings up the dialog box in Figure 11.42. There are quite a few options here. The biggest things you need to decide are where to put the sunburst and what you want it to look like. You can drag the sunburst around the left-hand window or enter numeric values in the Light Spot area (where it says Horizontal and Vertical).

Click the color swatch to change the color, increase or decrease the brightness, and alter the rays and circles that are produced to make it look like the light is causing these artifacts in the camera. This is going to give the impression that the plane is "slipping the surly bonds of Earth and dancing the skies on laughter-silvered wings" (that's from the poem, "High Flight," by John Magee, Jr.).

Figure 11.42
The sun, bursting upon the scene.

I'll add a radial blur to further the impression that the plane is flying and not anchored in concrete by the side of the road. I've chosen the Adjust ❯ Blur ❯ Radial Blur menu to access the dialog box you see in Figure 11.43. The type of blur I've selected is Zoom, which makes it appear that you're looking at one spot on the photo and everything else is zooming in or out. This fools you into thinking the plane is moving, too, but at the same time focuses your attention on one spot.

Figure 11.43
Adding Radial Blur focused on front cockpit.

Finally, I'll apply Smart Photo Fix (see Figure 11.44) to finish. This helps increase the brightness.

Figure 11.44
Smart Photo Fix to finish.

Finishing the Photo Study

Another one in the bag (see Figure 11.45). I love working with planes, and I get a real kick out of creating the impression an aircraft on static display is a wild plane dancing in the skies. This is why I'm writing this chapter. I often take these sorts of photos for this exact reason: creating art.

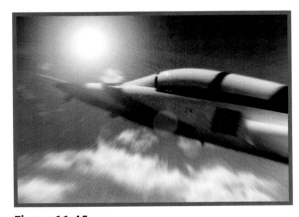

Figure 11.45
Unleashed Talon.

Photo Study 70: Frosted Flowers

FIGURE 11.46 IS A PHOTO OF ONE OF Anne's proud achievements early in our marriage. These are her "hens and chicks," and they filled a planter we had on our back deck to the point of bursting. The plants are succulent evergreen perennials, and they look like little cacti.

I took a series of photos from directly above, and I got this photo. Figure 11.46 is a great starting point to do something artistic. Let's try, shall we?

Creating the Frosted Effect

To create this effect, I'll duplicate the background photo layer first, so I have a working layer to apply the effect to.

I've applied the Effects ❯ Edge Effects ❯ Find All effect in Figure 11.47. This is the same effect I applied to the barn in Photo Study 67, but I'm going to do something different afterwards to make it look frosted in this study.

The way I do this is to alter the opacity of the effect layer and blend it in with the original photo. I'm lowering the opacity of the Find All (edges) effect on the layer called "Working" in Figure 11.48. I've reached 67 percent, which is where I'll stop. That means it's 67 percent opaque.

I call this effect "frosting" (as in cold-weather, not cake frosting).

Figure 11.46
Hens and chicks.

Figure 11.47
Effect on working layer.

Figure 11.48
Blending with lower layer.

The effect is complete, but I want to spice it up by adding a picture frame. I've chosen the Image > Picture Frame menu and selected an unusual style in Figure 11.49.

Figure 11.49
Applying frame.

Finishing the Photo Study

The final shot is shown in Figure 11.50. I took a straightforward shot of some plants and, through the use of Paint Shop Pro and the built-in effects, transformed it into an artistic rendering of the same scene.

Figure 11.50
Frosted flowers.

Photo Study 71: Canvas Fiddlesticks

I TOOK THIS PHOTO (FIGURE 11.51) OF one of our cats, Fiddlesticks, at the duplex. He's sitting on the back of our blue leather couch on an afghan my mother crocheted. Fiddlesticks was a stray cat that showed up on our back porch one evening as we were going out to the movies. We told ourselves that if he was there when we got back, we would feed him. He wasn't. Some time later, he showed up again, and we invited him inside. We like naming our cats with interesting names. Beetlejuice, Fiddlesticks, Bullwinkle.

Fiddlesticks looks like some sort of ancient Egyptian statue in all his cat-like royalty in this photo.

Creating the Texture Effect

I've duplicated the Background layer with Fiddlesticks and have selected the Effects > Texture Effects > Texture menu to open the dialog box you see in Figure 11.52. Artistically applying textures involves a lot of trial and error. I tried stone, sandstone, sculpture, and other effects until I came across this nice wood grain, which made me think of a rough canvas. That just goes to show you, it doesn't matter what it's called; it matters how it looks. If they call a texture the "So smooth you will slip on it" texture, and it looks rough to you (and that's what you want), then use it! The area of this photo that strikes me most, with the texture applied, is the wall. Really nice!

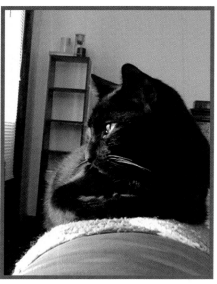

Figure 11.51
Fiddlesticks, relaxing on our leather sofa.

Figure 11.52
Applying wood texture.

Next, I want to enhance the texture. This texture generates a lot of edges, which leads me to the Edge Effects, or specifically, Effects > Edge Effects > Enhance. That did the trick (see Figure 11.53). The edges are much more prominent now. I think that's it!

Figure 11.53
Enhancing edges.

Finishing the Photo Study

This was a nice photo study that enabled me to integrate textures into this book. There's not much use for them in photo restoration and retouching, but when you start creating artwork, textures add another dimension to your work. The final photo is in Figure 11.54.

Figure 11.54
Canvas fiddlesticks.

Photo Study 72: Reflections

F IGURE 11.55 IS A PHOTO OF THE tallest building here in town. I was out shooting photos for another project and stopped at this vantage point. It caught my eye as I looked at the building through the trees. It was winter when I took this, so the trees are bare. The sky is a nice shade of blue, and the clouds make it interesting, too.

Figure 11.56
Smart Photo Fix to start.

Next, I'm going to apply a displacement map.

I've called up the Displacement Map dialog box in Figure 11.57. It's the Effects ❯ Distortion Effects ❯ Displacement Map menu. I've chosen the "Under ice" preset and have used it as a starting point. Remember, it doesn't matter what it's called. While choosing my settings, I applied the Plasma Displacement map (it's the "flamey" looking thing on the left side of the dialog box) and was struck by how interesting this looked.

Figure 11.55
Tall building through trees.

Creating the Reflection

I'll begin by running this photo through Smart Photo Fix and see what that looks like. I've selected a few new source spots in Figure 11.56, and the color balance and brightness have improved over the original.

Figure 11.57

Applying Displacement map.

Finishing the Photo Study

Figure 11.58 shows the final result. I used a Displacement map preset called "Under ice" to create something that, to me, looks like a reflection in water. It's not exactly still water; otherwise, there wouldn't be the impression of movement. I've called it *Reflections*.

Figure 11.58

Reflections.

Photo Study 73: Vanilla Sky

THE FINAL PHOTO STUDY FOR THIS chapter, and indeed for the entire book, is a recent shot (Figure 11.59) of another picturesque sunset. This time I went outside and started taking photos from the front of the house, but realized there were ugly power lines in the way. I ran around to the backyard to keep shooting. The clock is ticking when you take photos like this—and the window is very short to get just the right lighting.

This photo was an attempt to capture that scene. There were beautiful shades of blue, reddish gold, and white in the sky, as the sun went down. It was breathtaking.

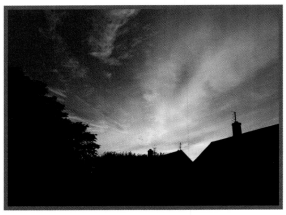

Figure 11.59
Good-looking sunset.

Artistic License

Artistic license is exactly that. It's a license to be creative and artistic. I've taken some good photos in this chapter—photos that didn't need to be changed—and changed them. Although the photo of this sunset is nice, I want you to know it pales in comparison with the real thing, which I'm not touching at all.

Getting Started

The first (and really the central) adjustment I made to this photo was a Histogram Adjustment. I really worked to bring out the colors. I've opened up the Histogram Adjustment dialog box in Figure 11.60, and I am working on the Red channel. Don't forget that you can work in luminance or in the separate Red, Green, and Blue channels. When I'm thinking about brightness and contrast, I will leave this setting on Luminance (after all, luminance means brightness). When I am trying to change the color (and don't go the Curves route), I'll work in the individual channels. I'm going for a nice, deep blue with vibrant reds and little to no greens. Perfecto.

Figure 11.60
Beginning with Histogram Adjustment.

That was the most important step in the entire
study. Everything else is gravy. Some noise removal
will smooth out the photo. I've applied One Step
Noise Removal in Figure 11.61, and you can see
from this close-up of the clouds that they look very
smooth now.

Figure 11.61
Smoothing with Noise Removal.

Next, I will bring out some details in the clouds
that are hanging down. That's an interesting part
of the photo. I chose Clarify (Adjust > Brightness
and Contrast > Clarify) to achieve this. Those lower
clouds stand out much better with a minor Clarify
tweak (see Figure 11.62).

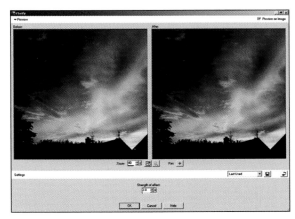

Figure 11.62
Clarify to bring out details.

Final Touches

Finally, I like the smooth look, but it's not enough.
I want to enhance it with another round of noise
removal. This time, I'll use the Digital Photo Noise
Removal tool. I've applied it, and you can see the
effect in Figure 11.63. Look closely at how the
clouds now are completely smooth.

Finally, I boosted the saturation to strengthen
the reds and golds. Figure 11.64 shows the
Hue/Saturation/Lightness dialog box, and I'm
increasing the saturation by 25.

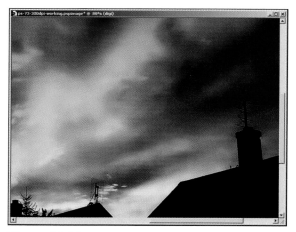

Figure 11.63
Continuing to smooth.

Figure 11.64
Even more saturation.

Finishing the Photo Study

Well, this is it. Figure 11.65 shows the final result of the final photo study of the final chapter in this book. I liked this one so much that it's now the background on my computer desktop. I'm glad I got to end on one that stirs me so much.

I hope you've learned through this chapter that as you create your own, original art, you can use many of the same photo retouching and restoration techniques that I cover elsewhere in this book. There are going to be differences, obviously. I hardly ever use effects when I'm doing a straight restoration. I also try to stay within a certain artistic limit and hide my presence as a restorer or retoucher for those jobs. Creating artwork brings me to the forefront and is a good change of pace.

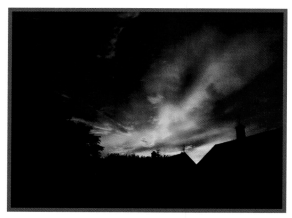

Figure 11.65
Vanilla sky.

So Long and God Bless

I had a blast restoring and retouching these photos, and I'm glad I got to share my techniques and stories with you. Drop me a line and let me know how you like the book and what you're up to. You can find my contact information in the Introduction.

Sincerely,
Robert Correll

Paint Shop Pro Tools

 Pan—Click and drag yourself around an image that's zoomed in. I rarely use it because most of the time I just zoom out and then back in where I want to see. Lots of people swear by panning, however.

 Zoom—Click in the image to zoom; right-click to zoom out. Another tool I rarely use. I like to use my mouse wheel to quickly zoom in and out. I also use the wheel on my Wacom Graphire4 6×8 pen tablet. There are times, however, when the wheels don't want to work, so I may select this tool to get back to zooming.

 Pick—Click to pick. A finicky tool if there ever was one. Make sure you are picking the right object. There are times when it's a good idea to hide a layer to get at the object you want on another layer. Despite what the name implies, you can move, scale, rotate, and deform objects with this tool.

 Move—Seemingly redundant, but I do find myself using it at times.

 Selection—Mucho importante. Selections are often the key to selectively applying effects or modifying parts of an image. This is many tools in one because you can change the type of selection in the Tool Options palette.

 Freehand Selection—Can be Freehand, Point to point, Edge Seeker, or Smart Edge. Each has its advantages. I use Point to point when I want to quickly make a selection where the borders don't need to be exact. Freehand is more exacting, and Edge Seeker and Smart Edge find edges for you. Try each of them out and compare.

 Magic Wand—Selects by matching pixels of an image (can be adjacent, not adjacent, and even on different layers) within a certain tolerance. Most of the time, you'll use color as the criterion, but you can change this.

 Dropper—Loads the color you click in your photo into the Materials palette. Left-click for foreground; right-click for background.

 Crop—Crops an image to the size and aspect ratio you choose. There are some minor differences in how the tool options are displayed in X2, and a new "Crop as New Image" button appears on the Crop Rectangle. This creates a new image with what you're cropping and leaves the original intact.

 Straighten—Most often used after scanning. Straightens an image. Be careful to select the right options. You can straighten individual layers and automatically crop.

 Perspective Correction—Useful in retouching when it's obvious that the perspective is a bit out of whack.

 Red Eye—Pretty self-explanatory. Click to correct someone's red eyes.

 Makeover—Five tools in one. The original Makeover tools are the Blemish Fixer, Toothbrush, and Suntan. Sounds like a pretty good spa treatment to me! Two tools make their appearance in X2: Eye Drop, which adds whitening eye drops to eyes, and Thinify, which compresses pixels to make people look thinner.

 Clone Brush—My all-time favorite tool. Take parts of a photo and paint them to another part. You'll use this to cover up things, remove things, and clean up dust and specks. Know it. Trust it. Clone it.

Long-time users of the Clone Brush will have to adjust to the new tool icon in Photo X2. The icon used to look like two brushes, one over the other.

 Scratch Remover—Pretty good tool, actually. It's like applying the Clone Brush in a straight line.

 Object Remover—I've used this, and it's very good for quickly removing objects. Your mileage may vary, depending on the complexity of the background.

 Paint Brush—Paints what you have in the Materials palette onto the canvas. Lots of options and different choices for brushes.

 Airbrush—To be truthful, I've never really figured out why this is needed. I just use the brushes.

When Selected

My entries in this list assume you have selected the tool you are reading about at the time and it is active. I got tired of typing, "When selected..." so I thought one note would do the trick.

 Lighten/Darken—Very useful when you want some artistic control over what you want to lighten or darken. Change brush properties and opacity to get different effects. Left-click to lighten and right-click to darken.

 Dodge—Essentially the same thing as Lighten, but with different tool options.

 Burn—Essentially the same thing as Darken, but with different tool options. These terms come from the photographer's darkroom. Dodging is the technique used to lighten a print by underexposing it, and burning is used to darken the print by exposing it longer.

 Smudge—Smudge pushes paint around with a brush and smudges it. Try it out for some interesting effects.

 Push—Push smudges paint around with a brush and pushes it. I couldn't resist that. Push is identical to Smudge except that Smudge picks up new colors as it smudges (like sticking your finger in wet paint), and Push doesn't as it pushes.

 Soften—A very useful tool. I use it when I clone and want to soften the edges of pixels or a border region between where I've cloned and the original photo.

 Sharpen—Another very useful tool for sharpening exactly what you need without applying an effect to the entire photo.

 Emboss—Cool effect where you brush over parts of the photo and it appears as if they are embossed.

 Saturation Up/Down—Changes the saturation where you brush. Left-click and brush to saturate; right-click and brush to desaturate.

 Hue Up/Down— Changes the hue where you brush. Left-click and brush to change hue in one direction on the color wheel; right-click and brush to go the other direction. This effect is best when it is used very subtly and the opacity is very low.

 Change to Target—Left-click to change where you brush to the foreground color in the Materials palette; right-click to use the background color. My first reaction to this tool was ambivalent, but I've been won over. I make good use of this tool in a few photo studies. Make sure to set the mode correctly in the Tools Options palette.

 Color Replacer—Replaces the color where you click with the foreground color.

 Eraser—Erases things. This doesn't work on vector objects or text created as a vector.

 Background Eraser—Detects the border between where you click and the edge of the brush and erases the background (which is where you should be clicking).

 Flood Fill—If you left-click, it fills an area with the current foreground color. You guessed it: If you right-click, it fills an area with the background color, pattern, or texture.

 Color Changer—New to version XI of Paint Shop Pro Photo. This replaces color ranges (as opposed to replacing a single color) pretty realistically. The Color Changer also preserves a photo's details as it changes the color.

 Picture Tube—Allows you to squish preset images out of a Picture Tube onto your canvas.

 Text—If a picture is worth a thousand words, this is where you add the words. I rarely use text when I am restoring or retouching. About the only time I use it is when I am re-creating text in the border, which was a common feature of photos in the 1960s and early 70s, or retouching house numbers.

 Preset Shape—Enables you to choose a preset vector shape, such as an arrow or thought balloon, and draw it on your canvas.

 Rectangle—Not surprisingly, this is the tool you should use to draw rectangles (and squares).

 Ellipse—Draws ellipses and circles.

 Symmetric Shape—Draws shapes. You can set the number of sides from 3 (triangle) to 1,000 (who knows what it's called, but it looks like a circle).

 Pen—Creates vector lines and nodes. Very powerful tool, but I don't use it that much in photo restoration and retouching.

 Warp Brush—Warps the photo in the mode of your choice. Modes include Push, Expand, Contract, Right Twirl, Left Twirl, and Noise.

 Mesh Warp—Instead of brushing a warp, use a mesh to drag nodes that warp the photo. This is an easy way to make people skinny.

 Oil Brush—Art Media tool that emulates oil painting. You must use this and the subsequent tools on an Art Media layer.

 Chalk—Art Media tool that emulates chalk drawing.

 Pastel—Art Media tool that emulates pastels.

 Crayon—Art Media tool that emulates crayons.

 Colored Pencil—Art Media tool that emulates drawing with colored pencils.

 Marker—Art Media tool that emulates marking with a marker.

 Palette Knife—Art Media tool that emulates using a palette knife to lay down oil paint on a canvas, much like Bob Ross, my favorite PBS personality of all time.

 Smear—Art Media tool you should use to smear paint (or the other media) around the canvas.

 Art Eraser—The tool you use to erase Art Media.

Index